Typographics Four

ANALYSIS+IMAGINATION=COMMUNICATION

General Editor: Roger Walton

HDi

**HARPER
DESIGN
international**

An Imprint of HarperCollins*Publishers*

TYPOGRAPHICS 4 IS PUBLISHED
HERE FOR THE FIRST TIME WITH
TYPOGRAPHICS 3

Each title published separately by Hearst Books
International. Now published by
Harper Design International, an imprint of
HarperCollins Publishers
10 East 53rd Street
New York, NY 10022
United States of America

ISBN 0-06-053120-7

Distributed throughout the world by:
HarperCollins International
10 East 53rd Street
New York, NY 10022
United States of America
fax: (212) 207-7654

Each title first published separately in Germany by Nippan
Nippon Shuppan Hanbai Deutschland GmbH
Krefelder Str. 85
D-40549 Düsseldorf
Tel: (0211) 504 80 80/89
Fax: (0211) 504 93 26
E-Mail: nippan@t-online.de

Conceived, created, and designed by:
Duncan Baird Publishers
6th Floor, Castle House
75–76 Wells Street, London W1T 3QH

Designer: Dan Sturges
Editor: Simon Ryder
Project Co-ordinator: Tara Solesbury

03 04 05 06 07 / 10 9 8 7 6 5 4 3 2 1

Typeset in MetaPlus
Color reproduction by Colourscan, Singapore
Printed in China

NOTE
All measurements listed in this book
are for width followed by height.

Contents

Foreword

T4: Typographics Four—communication IN print and ON screen.

T4 ADDS to the collection of work published in the "Typographics" series.

T4 EMBRACES work from all over the world. Work designed for viewing: on hand-held paper and other materials, on desk-based screens, in public-space environments.

T4 CELEBRATES some of the wildest, strangest, most provocative, analytical, questioning, experimental, influential, and inspirational design activity recently engaged in anywhere.

T4 LEADS us to the forefront of developments in visual communication.

T4 IS ESSENTIAL.

RW

communication IN print and ON screen

Part 1

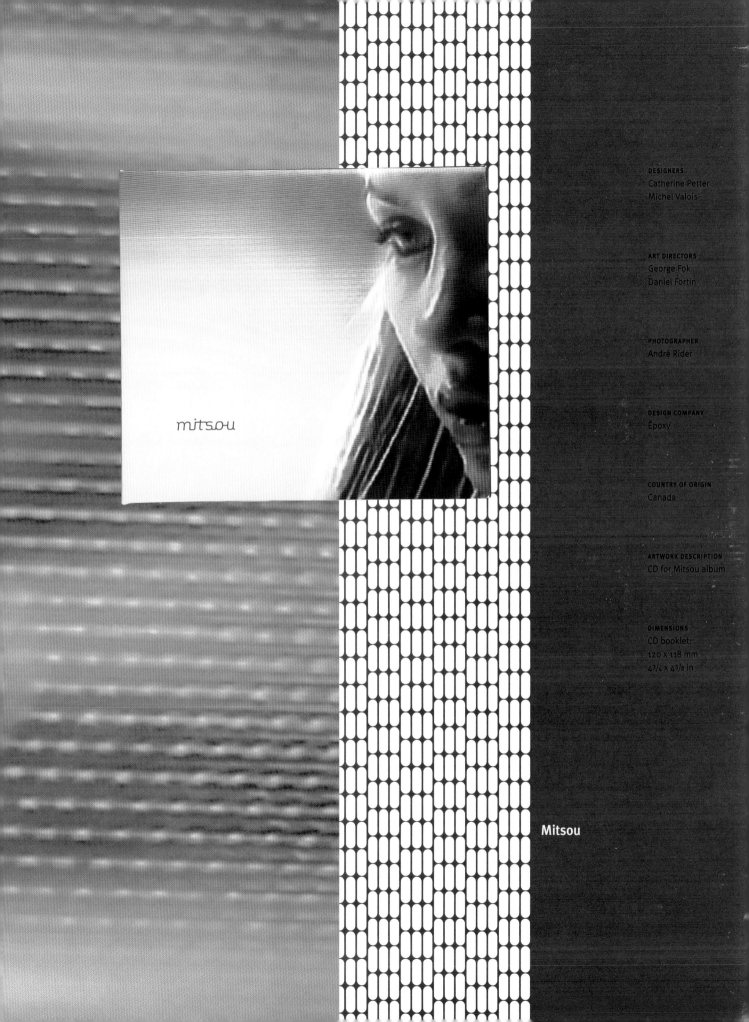

DESIGNERS
Catherine Petter
Michel Valois

ART DIRECTORS
George Fok
Daniel Fortin

PHOTOGRAPHER
André Rider

DESIGN COMPANY
Époxy

COUNTRY OF ORIGIN
Canada

ARTWORK DESCRIPTION
CD for Mitsou album

DIMENSIONS
CD booklet:
120 x 118 mm
4³/₄ x 4⁵/₈ in

Mitsou

The Body of the Line:
Eisenstein's Drawings

DESIGNERS
Danielle Gingras
George Fok

ART DIRECTORS
George Fok
Daniel Fortin

ILLUSTRATOR
Sergei Eisenstein

DESIGN COMPANY
Époxy

COUNTRY OF ORIGIN
Canada

ARTWORK DESCRIPTION
CD-ROM catalog of
Russian film director
Sergei Eisenstein's
drawings, produced
to accompany the
first-ever exhibition of
this work.

DIMENSIONS
CD booklet:
120 x 118 mm
4³/₄ x 4⁵/₈ in

LE CORPS DE LA LIGNE . LES DESSINS D'EISENSTEIN

Remerciements
Préface de Daniel Langlois
Présentation de l'exposition

Eisenstein dessinateur
Le corps de la ligne
Caricatures : anthropomorphisme
et animalité

Dédoublement et androgyne
Le pouvoir magique des images

Biographie
Théâtrographie
Filmographie
Bibliographie

Listes des expositions de dessins
d'Eisenstein depuis 1948

Crédits

Né à Riga le 23 janvier 1898 d'un père juif allemand, architecte et ingénieur civil, et d'une mère russe, Yulia Ivanovna Konetskaya, issue d'une riche famille commerçante, le jeune Sergueï, enfant unique, reçoit une éducation cosmopolite et apprend très jeune le français, l'anglais et l'allemand. De 1918 à 1920, il est volontaire pour la construction de défenses sur différents fronts durant la guerre civile. De 1917 à 1923, Eisenstein se lance dans de nombreux projets de théâtre qui nous sont connus notamment grâce à des dessins de costumes et de décors ainsi qu'à des indications de mise en scène. Au printemps 1921, il étudie le théâtre en direction avancée à l'Atelier d'État sous la supervision de celui qu'il considérait comme un maître, Vsevolod Meyerhold (1874-1940), et dont la méthode théâtrale basée sur la biomécanique et le grotesque l'influencera énormément. Durant l'hiver 1922-1923, il travaille avec l'atelier cinématographique de Koulechov qui fut l'un des premiers à élaborer une théorie du montage au cinéma. C'est au Proletkoult, en 1923, qu'Eisenstein réalise son premier film, *Le Journal de Gloumov*, une courte « attraction filmée » faisant partie d'un spectacle théâtral, *Le Sage*, d'après Alexandre Ostrovski. C'est également en 1923 qu'il publie son premier texte théorique, « Le montage des attractions », dans le numéro 3 de la revue LEF (le Front gauche de l'art). En 1925, Eisenstein devient célèbre dans le monde entier grâce au succès de son deuxième film, le *Cuirassé Potemkine*. Eisenstein meurt à la suite d'une crise cardiaque en février 1948. Il avait à peine cinquante ans.

Les dessins présentés dans cette exposition et reproduits dans ce cédérom proviennent de deux sources. La collection des Archives d'État russes de la littérature et de l'art qui ont la garde de plusieurs milliers de dessins du cinéaste et une collection particulière de quelques 92 dessins également à Moscou.

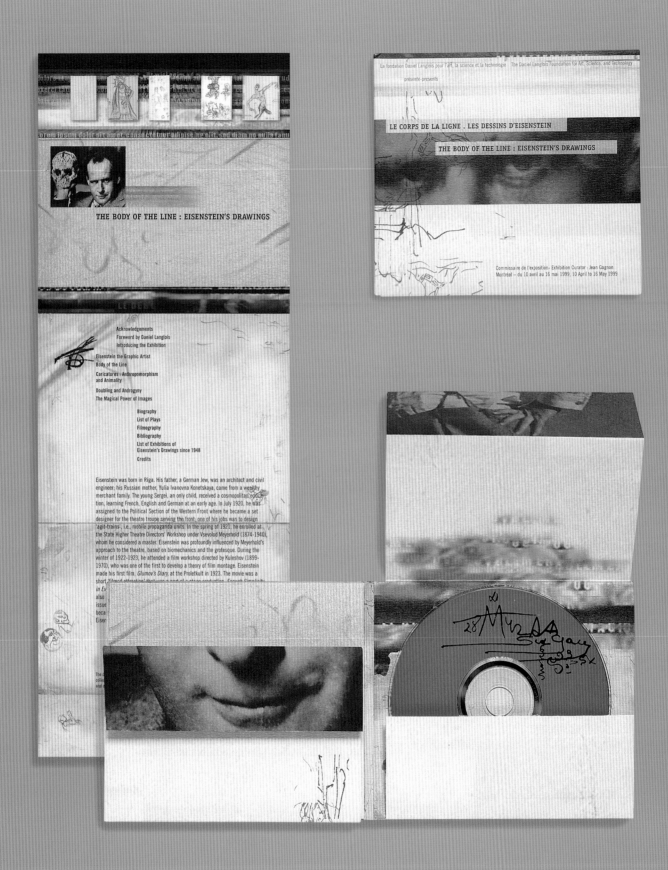

La fondation Daniel Langlois pour l'art, la science et la technologie The Daniel Langlois Foundation for Art, Science, and Technology

présente-presents

LE CORPS DE LA LIGNE . LES DESSINS D'EISENSTEIN

THE BODY OF THE LINE : EISENSTEIN'S DRAWINGS

Commissaire de l'exposition- Exhibition Curator : Jean Gagnon
Montréal – du 10 avril au 16 mai 1999, 10 April to 16 May 1999

THE BODY OF THE LINE : EISENSTEIN'S DRAWINGS

Eisenstein was born in Riga. His father, a German Jew, was an architect and civil engineer; his Russian mother, Yulia Ivanovna Konetskaya, came from a wealthy merchant family. The young Sergei, an only child, received a cosmopolitan education, learning French, English and German at an early age. In July 1920, he was assigned to the Political Section of the Western Front where he became a set designer for the theatre troupe serving the front; one of his jobs was to design 'agit-trains', i.e., mobile propaganda units. In the spring of 1921, he enrolled at the State Higher Theatre Directors' Workshop under Vsevolod Meyerhold (1874-1940), whom he considered a master. Eisenstein was profoundly influenced by Meyerhold's approach to the theatre, based on biomechanics and the grotesque. During the winter of 1922-1923, he attended a film workshop directed by Kuleshov (1899-1970), who was one of the first to develop a theory of film montage. Eisenstein made his first film, *Glumov's Diary*, at the Proletkult in 1923. The movie was a short filmed attraction that was a part of a stage production, *Enough Simplicity in Ev...*

ARTWORK DESCRIPTION

CD for Dubmatique
album, with Coroplast
cover and Velcro
fastener.

DIMENSIONS

141 x 125 mm

5 9/16 x 4 15/16 in

Dubmatique

...IGNER

...chel Valois

DIRECTORS

...orge Fok

...niel Fortin

...IGN COMPANY

...oxy

...NTRY OF ORIGIN

...ada

www.dubmatique.com

DUBMATIQUE

¶ Changer de femmes comme un scénario ¶ Changer constamment de décor ¶ Mais notre vision des choses est beaucoup plus modeste ¶ C'est seulement ce qu'ils veulent ¶ On ne possède pas de Rolex ¶ My whole text flows like sex and grows like clones ¶ Et Winner RCKO? pour le -zer- ¶ L'xpress comme notre technique de Montréal à Paris ¶ Comme la -Fonky-, on fait du rap une -tuerie- ¶ On nous parle de compression, sans cesse d'augmentation ¶ D'irritation, sous pression, certains nous supportent des plus sincères ¶ Toujours alertes, très prêts pour une réplique ¶ With every step we take, we take it Stéphane, nous continuerons de nous battre ¶ D'Stéphane, D'winner, Dubmatique, the combo's magic ¶ I'm a 100 pounds but a fat kid that's mad quick ¶ In blazing stages so put the mics back in the holsters ¶ While we're completing moves over tu peux comprendre- devant de cette ¶ Et ton cœur est en vent ¶ De nos jours, on ne peut plus tu savais, comment les choses ont changé ¶ With the fam tying to excel and at times it's hard as hell ¶ On avoir confiance en personne ¶ Âme la personne c'est tout tout ce qui compte voilà aujourd'hui on persévère ¶ Avec une attitude qui se fera ¶ But Sharks are living on both so yo protect your sons and daughters ¶ Je ne serai jamais qu'ils vivent, mais le personnage devant la caméra ¶ Si tu savais le nombre d'heures ¶ Sans lit ni jongloté, Thabil ne l'art pas prisonnier des stéréotypes ¶ Quelque soit le temps, l'année je resterai toujours authentique ¶ Alors vite vite vite il faudrait prendre

[03] L'AVENIR? / > J'applique le mec comme pour reprendre de l'oxygène ¶ Aucune place pour la veine ¶ Les gladiateurs sont perpétuellement lâchés dans l'arène ¶ Là où personne ne se gène pour frapper sans retenue, compte tenu ¶ Sur le mic, en stéréo son typique ¶ Y'a pas moyen, je mourrai libre de tout stéréotype ¶ Typo mourant, c'est pas

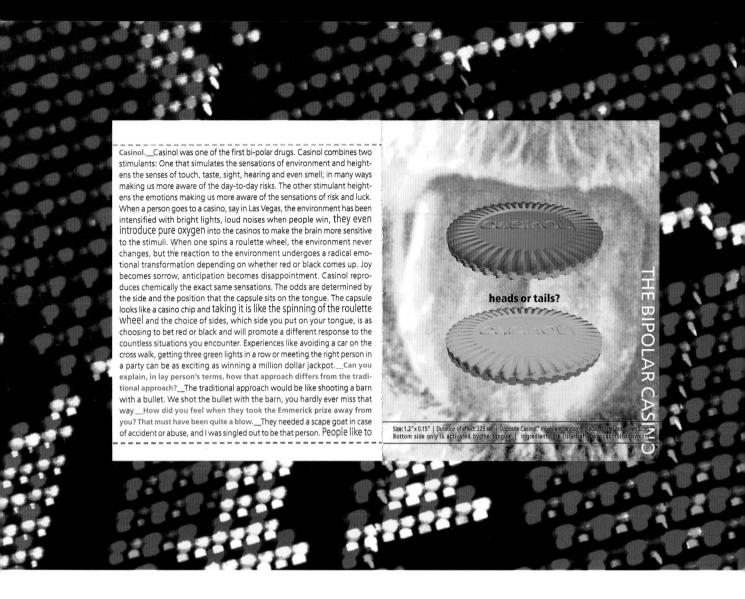

Casinol.__Casinol was one of the first bi-polar drugs. Casinol combines two stimulants: One that simulates the sensations of environment and heightens the senses of touch, taste, sight, hearing and even smell; in many ways making us more aware of the day-to-day risks. The other stimulant heightens the emotions making us more aware of the sensations of risk and luck. When a person goes to a casino, say in Las Vegas, the environment has been intensified with bright lights, loud noises when people win, they even introduce pure oxygen into the casinos to make the brain more sensitive to the stimuli. When one spins a roulette wheel, the environment never changes, but the reaction to the environment undergoes a radical emotional transformation depending on whether red or black comes up. Joy becomes sorrow, anticipation becomes disappointment. Casinol reproduces chemically the exact same sensations. The odds are determined by the side and the position that the capsule sits on the tongue. The capsule looks like a casino chip and taking it is like the spinning of the roulette wheel and the choice of sides, which side you put on your tongue, is as choosing to bet red or black and will promote a different response to the countless situations you encounter. Experiences like avoiding a car on the cross walk, getting three green lights in a row or meeting the right person in a party can be as exciting as winning a million dollar jackpot.__Can you explain, in lay person's terms, how that approach differs from the traditional approach?__The traditional approach would be like shooting a barn with a bullet. We shot the bullet with the barn, you hardly ever miss that way.__How did you feel when they took the Emmerick prize away from you? That must have been quite a blow.__They needed a scape goat in case of accident or abuse, and I was singled out to be that person. People like to

heads or tails?

Size: 1.2" x 0.15" | Duration of effect: 225 sec. | Opposite Casinol™ mixes are randomly placed on red and green sides
Bottom side only is activated by the tongue | Ingredients are listed at www.casinoltoday.com

THE BIPOLAR CASINO

Virtual Telemetrix Case Study
Casino Program

DESIGNERS
John Bielenberg
Erik Cox

ART DIRECTOR
John Bielenberg

PHOTOGRAPHERS
John Bielenberg
Erik Cox
Seva Dyakov

VT BRAND CASINO – Arthesia

Background

Virtual Telemetrix has approached arthesia to create a VT Brand Casino.

Virtual Telemetrix feels that they have reached a development cycle where it is important in order to work against the -> brand value shrink principle making this unique brand available to everybody.

The brand casino should explore the brands soul and identity. Generate a place where every-body can experience the VT brand world.

The VT Casino

Casinos get their fascination out of the contradiction built into their main purpose: they combine the aspect of playing with the pure capitalistic idea of enhancing your wealth.

This contradiction generates the magic - actually you can become rich by playing around.

The Virtual Telemetrix brand has a similar contradiction built into its generic code and also uses the playing aspect to generate solutions and added value to its customers and shareholders.

A Brand Casino is therefore the ideal representation environment for Virtual Telemetrix.

Theory

Brand Casino Themes

The unique brand USP of Virtual Telemetrix is -> Contradiction. It is built into the generic code of the VT brand. Therefore the foundation of Virtual Telemetrix is built upon four (4) themes:

Chaos – the constantly changing morphing element

Structure – the rigid formating element

Knowledge – the deep wisdom element

Consciousness – the emotional element

These four (4) themes create major contra-dictions that are the source of innovation and development.

The element that generates and enhances the innovative power constantly is the connector -> Play. Through playing and experimenting the four (4) themes are constantly exchanging their specific values. The influence of each theme is changing and new -> Theme Combinations are created.

Storyboard

DESIGN COMPANY
Bielenberg Design

COUNTRY OF ORIGIN
USA

ARTWORK DESCRIPTION
Book of satirical proposals for a Virtual Telemetrix Casino in Las Vegas, Nevada. The pink color on the cover disappears when heated.

DIMENSIONS
127 x 152 mm
5 x 6 in

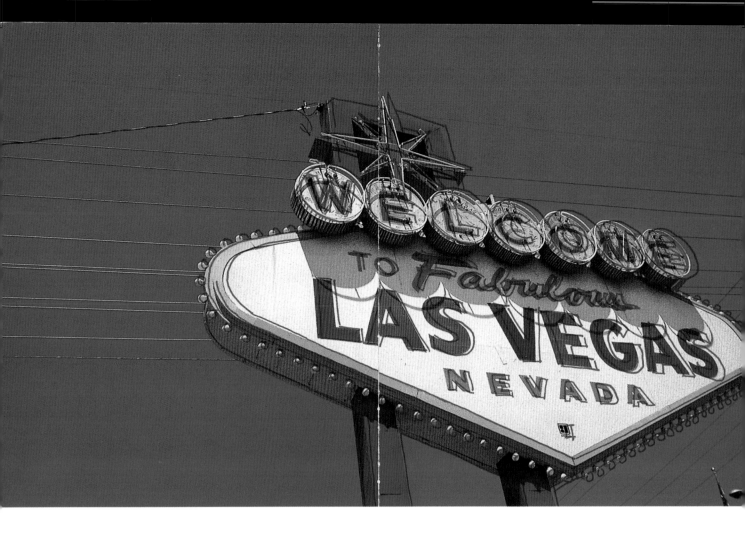

Virtual Telemetrix Case
Study Casino Program
(continued)

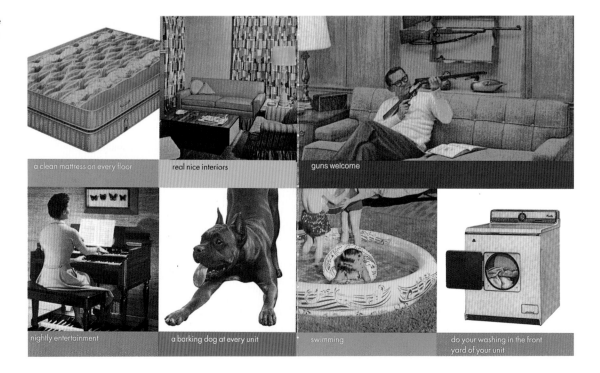

a clean mattress on every floor

real nice interiors

guns welcome

nightly entertainment

a barking dog at every unit

swimming

do your washing in the front yard of your unit

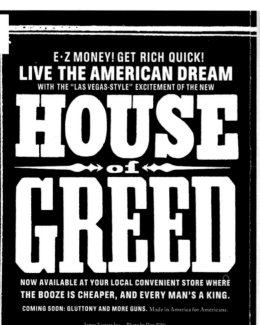
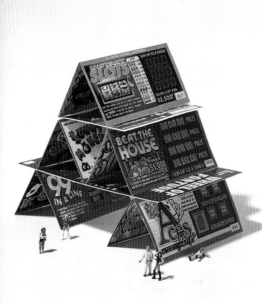

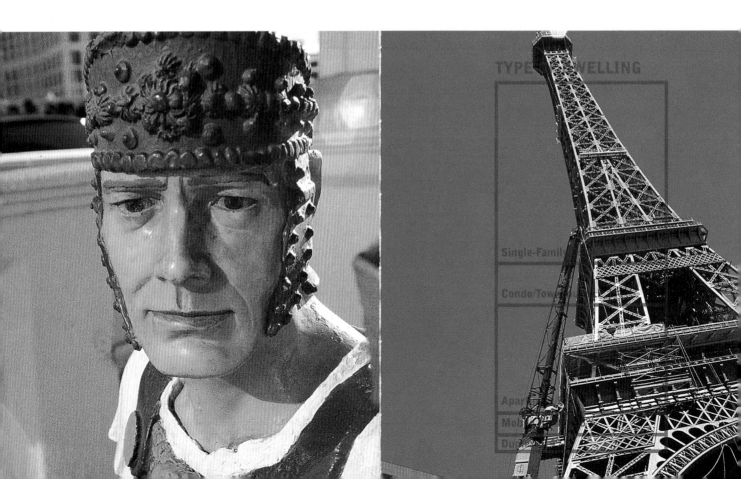

POOL AND WATERFALL AND A MAN-MADE VOLCANO THAT BELCHES FIRE AND WATER.

MIRAGE OWNER STEVE WYNN, WHO ALSO OWNS THE GOLDEN NUGGET HOTEL-CASINO IN DOWNTOWN LAS VEGAS, CONSTRUCTED THE 2,900-ROOM TREASURE ISLAND ADJACENT TO THE MIRAGE AT A COST OF $450 MILLION. THE HOTEL FEATURES BUCCANEER BAY WHERE A FULL SCALE PIRATE SHIP AND BRITISH FRIGATE ENGAGE IN A BATTLE OF CAN-NON FIRE. IN THE END, THE PIRATES BLAST THE BRITISH AND THE FRIGATE SLOWLY SINKS BENEATH THE CHURNING WAVES.

WITH TREASURE ISLAND, WHICH OPENED OCT. 27, 1993, AND THE MIRAGE SIDE BY SIDE ON THE LAS VEGAS STRIP, WYNN HAS NEARLY 6,000 ROOMS ON A 100-ACRE SITE.

ADDITIONALLY, WYNN PURCHASED THE 164-ACRE DUNES HOTEL AND COUNTRY CLUB ON THE LAS VEGAS STRIP FOR $75 MILLION IN 1992. HE SPENT $1 MILLION RENOVATING THE COUNTRY CLUB ON THE GOLF COURSE. IN OCTOBER 1993, THE FLAMBOYANT CASINO OWNER STAGED A $1.5 MILLION SPECTACULAR IN WHICH THE NORTH TOWER OF THE DUNES HOTEL WAS IMPLODED AND THE FAMOUS DUNES HOTEL SIGN DESTROYED AMID A SHOWER OF FIREWORKS NEVER BEFORE EQUALED WEST OF THE MISSISSIPPI. MORE THAN 200,000 PEOPLE CROWDED ONTO THE STRIP TO WITNESS THE SPECTACULAR. WYNN PLANS TO BUILD A RESORT NAMED BEAU RIVAGE ON THE DUNES SITE AND HAS ANNOUNCED A DEAL WITH GOLD STRIKE RESORTS TO CONSTRUCT A HOTEL/CASINO ON ANOTHER PART OF THE PROP-ERTY NORTH OF THE TROPICANA AVENUE AND THE LAS VEGAS STRIP INTERSECTION.

THE EXCALIBUR, A 4,000-ROOM COLOSSUS, OPENED JUNE 19, 1990. THE IMAGINATIVE MEDIEVAL "CASTLE" WAS DEVELOPED BY CIRCUS CIRCUS

ENTERPRISES INC. FOR BETWEEN $260 AND $290 MILLION. SOME FLOORS ARE DEVOTED SOLELY TO NON-GAMBLING ENTERTAINMENT FOR CHILDREN AND THE YOUNG AT HEART. COURT JESTERS PER-FORM IN PUBLIC AREAS. THE SHOWROOM FEATURES JOUSTING ON HORSEBACK BY KNIGHTS OF KING ARTHUR'S COURT. WILLIAM BENNETT, FOUNDER OF CIRCUS CIRCUS ENTERPRISES INC., CON-STRUCTED THE 2,526-ROOM, PYRAMID-SHAPED LUXOR A QUARTER MILE SOUTH OF THE EXCALIBUR.

THE LUXOR, A MODERN MARVEL WHICH COST $375 MILLION DOLLARS TO BUILD, IS LINKED TO THE EXCALIBUR BY MONORAIL.

THE LUXOR FEATURES A FULL-SCALE REPRODUC-TION OF KING TUT'S TOMB. THE WORLD'S MOST POWERFUL BEAM OF LIGHT SHINES FROM THE TOP OF THE PYRAMID. IT IS VISIBLE TO PLANES 250 MILES AWAY IN LOS ANGELES. THE ATRIUM IN THE MIDDLE OF THE PYRAMID COULD HOLD NINE BOEING 747S STACKED ONE ATOP OF ANOTHER.

THE MOST AMBITIOUS RESORT PROJECT IN THE HIS-TORY OF LAS VEGAS IS LOCATED AT THE INTERSECTION OF THE LAS VEGAS STRIP AND TROPICANA AVENUE. IT IS THE MGM GRAND HOTEL & THEME PARK — THE LARGEST RESORT HOTEL IN THE WORLD AND THE DREAM OF PIONEER LAS VEGAS HOTEL DEVELOPER AND MULTIMILLIONAIRE ENTRE-PRENEUR KIRK KERKORIAN.

THE $1 BILLION, 112-ACRE RESORT HOTEL, CASINO AND THEME PARK HIGHLIGHTS THE MGM HOLLYWOOD IMAGE. WITH THE 33-ACRE THEME PARK AS THE CENTER PIECE, THE 5,005-ROOM HOTEL BOASTS A 171,500-SQUARE-FOOT CASINO, 12 THEME RESTAURANTS, A 1,700-SEAT PRODUCTION SHOWROOM, A 630-SEAT PRODUCTION THEATER, THREE SWIMMING POOLS, FIVE TENNIS COURTS, A CHILD CARE CENTER AND A 215,000-SQUARE-FOOT,

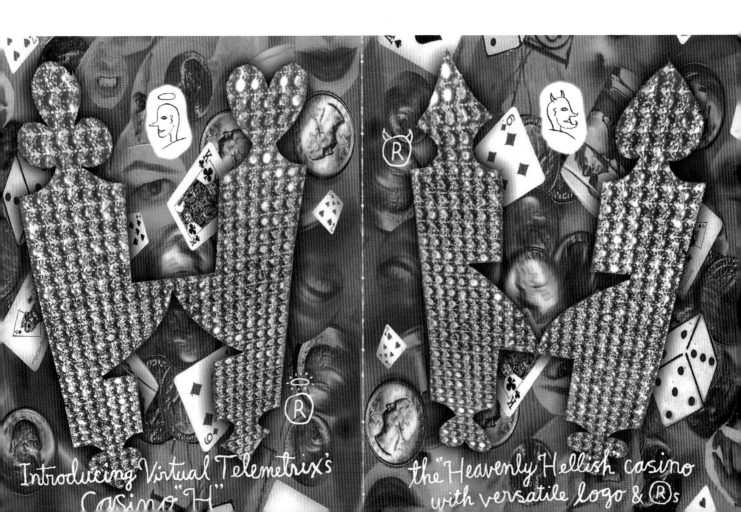

Introducing Virtual Telemetrix's Casino "H"

the "Heavenly Hellish" casino with versatile logo & ®s

THE APARTMENT

The Apartment Press Kit

*humans not included

DESIGNER
Martin Ogolter

ART DIRECTOR
Martin Ogolter

PHOTOGRAPHER
Roderick Angle

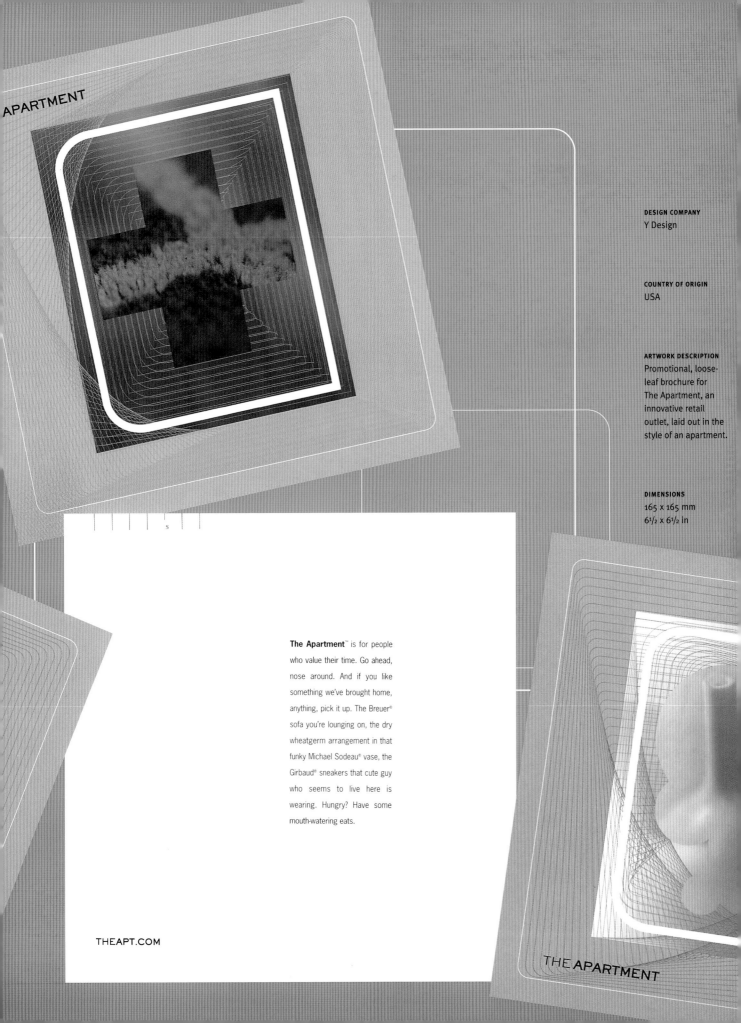

DESIGN COMPANY
Y Design

COUNTRY OF ORIGIN
USA

ARTWORK DESCRIPTION
Promotional, loose-leaf brochure for The Apartment, an innovative retail outlet, laid out in the style of an apartment.

DIMENSIONS
165 x 165 mm
6^1/$_2$ x 6^1/$_2$ in

The Apartment™ is for people who value their time. Go ahead, nose around. And if you like something we've brought home, anything, pick it up. The Breuer® sofa you're lounging on, the dry wheatgerm arrangement in that funky Michael Sodeau® vase, the Girbaud® sneakers that cute guy who seems to live here is wearing. Hungry? Have some mouth-watering eats.

THEAPT.COM

01 Go Mental. Tubular Vibes
Written and produced by J. Kyriacou. Published by
Go Mental Music. ℗ 1998 Go Mental. Licensed courtesy
of Go Mental.

02 Visa. All I Need
Written by M. Piperno, M. Picotto, R. Ferri, G. Bortolotti
& D. Leoni. Produced by S. Allen. Executive producer
P. Pritchard. Published by Media Songs SRL / Warner Bros
Music. ℗ 1998 Media Records Ltd. Licensed courtesy of
Nukleuz Records. Taken from the forthcoming Visa album.

03 Venus & Atomics. Dancing Through The Night
Written & produced by Venus & Atomics. Published
by Copyright Control. ℗ 1998 Venus & Atomics.

04 Dimenzions. Key Of Life
Written & produced by M. Brady. Published by Infinity
Music. ℗ 1998 Infinity Recordings.

05 Silk Cuts. The Moon
Written & Produced by Silk Cuts. Published by
Copyright Control. ℗ 1998 Silk Cuts.

06 Tayla. Hamburg
Written & produced by A. Taylor. Published by Hear,
There & Everywhere Publishing. ℗ 1998 Alphamagic Ltd.

07 DJ Slam. Come Back
Written & produced by DJ Slam. Published by Space 1000
℗ 1998 Unaware collective.

08 DJ Stompy. Ready To Fly
Written by L. Horton. Produced by L. Horton & Trixxy
Published by 4Tunes Music Ltd. ℗ 1998 New Era
Recordings. Licensed courtesy of New Era Recordings.

09 DJ Storm. The Only Way
Written & produced by A. Taylor. Published by Copyright
Control. ℗ 1998 Infinity Recordings.

10 Bananaman & Blitz feat. Clare Caprice. Tell Me
Written by D. Heavey, A. Broad, K. Kelly & C. Caprice
Produced by D. Heavey & A. Broad. Published by Paul
Rodriguez Music. ℗ 1998 FAB Music. Licensed courtesy
of Exceedingly Good Music Ltd.

11 Venus & Atomics. Control The Nation
Written & produced by Venus & Atomics. Published by
Copyright Control. ℗ 1998 Venus & Atomics.

12 DJ Kaos. Diamond Eyes
Written and produced by J. Kyriacou. Published by Go
Mental Music. ℗ 1998 Go Mental. Licensed courtesy
of Go Mental.

13 Ravers Choice. Ravers Choice 7
Written & produced by Ravers Choice. Published
by Copyright Control. ℗ 1998 Ravers Choice.

14 Vinylgroover. Rainbows
Written & produced by S. Attrill. Published by Copyright
Control. ℗ 1998 Obsession Recordings.

15 DJ Vibes. Life is a Mystery
Written & produced by DJ Vibes. Published
by Copyright Control. ℗ 1998 DJ Vibes.

DESIGNERS
Chris Harrison
Malcolm Buick
Neil Bowen

ART DIRECTORS
Peter Chadwick
Chris Harrison

ILLUSTRATOR
Joe Berger

DESIGN COMPANY
Zip Design Ltd.

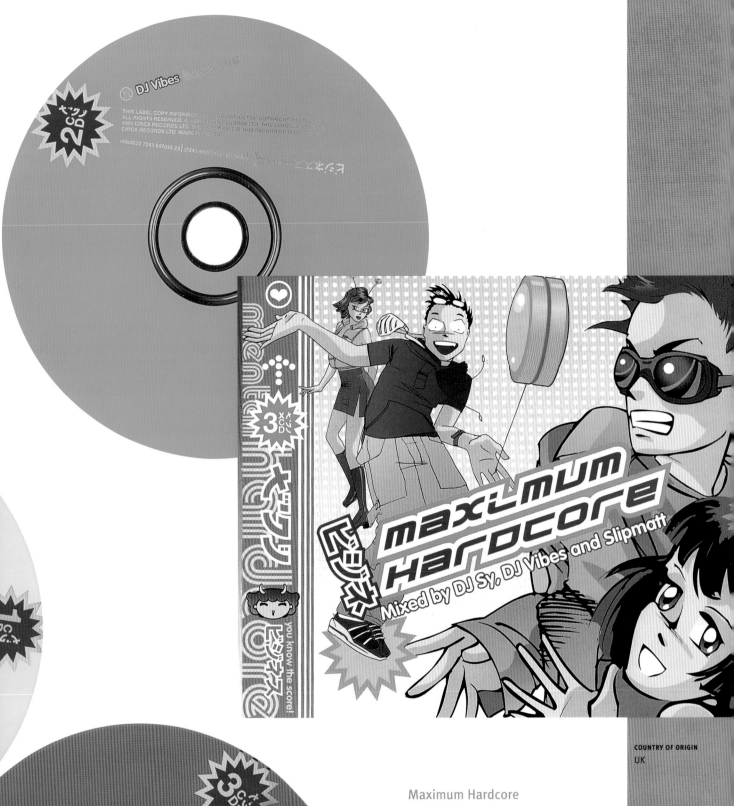

Maximum Hardcore

COUNTRY OF ORIGIN
UK

ARTWORK DESCRIPTION
CD box set

DIMENSIONS
120 x 120 mm
4⁷/8 x 4⁷/8 in

Armand Van Helden/Flowerz

DESIGNER
Peter Chadwick

ART DIRECTOR
Peter Chadwick

DESIGN COMPANY
Zip Design Ltd.

COUNTRY OF ORIGIN
UK

ARTWORK DESCRIPTION
Dayglo-orange record
sleeve for Armand Van
Helden.

DIMENSIONS
306 x 306 mm
12 x 12 in

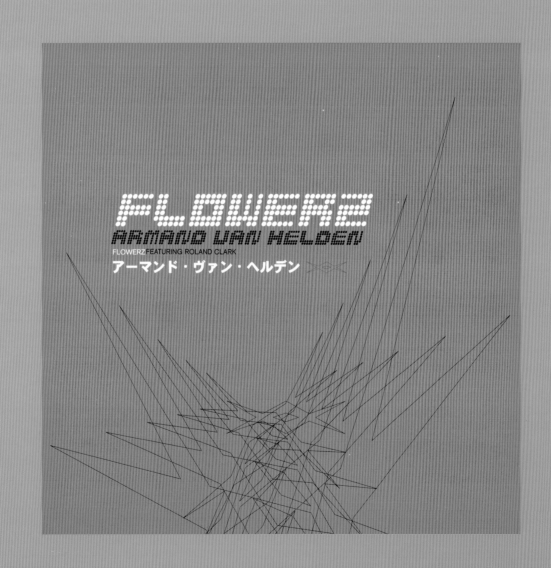

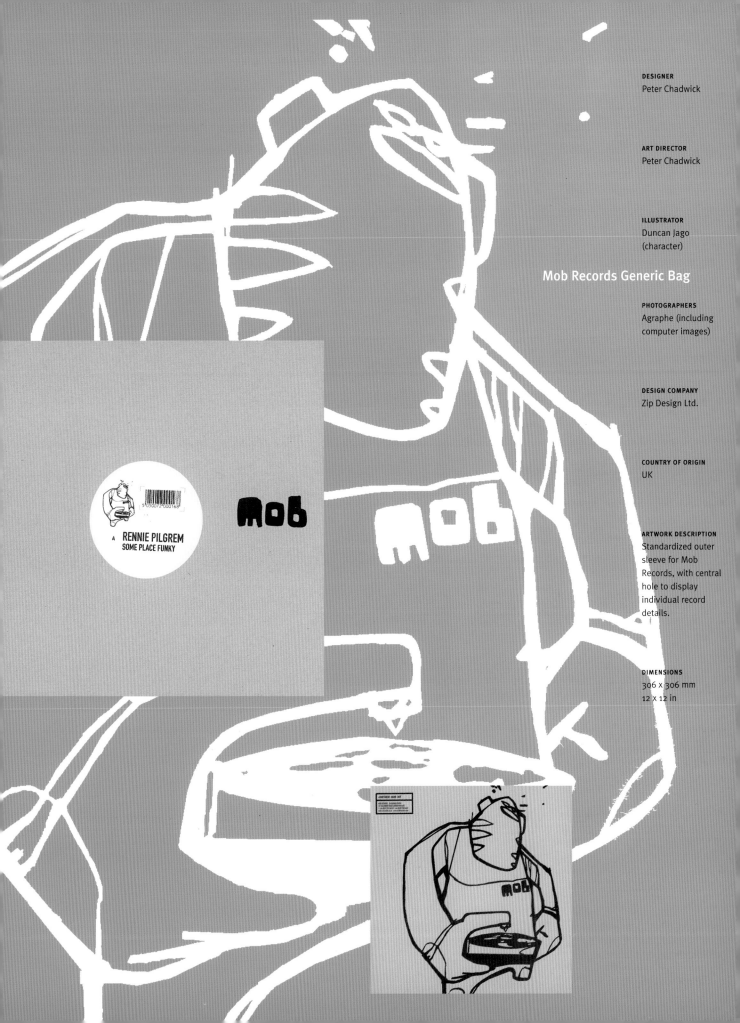

DESIGNER
Peter Chadwick

ART DIRECTOR
Peter Chadwick

ILLUSTRATOR
Duncan Jago
(character)

Mob Records Generic Bag

PHOTOGRAPHERS
Agraphe (including
computer images)

DESIGN COMPANY
Zip Design Ltd.

COUNTRY OF ORIGIN
UK

ARTWORK DESCRIPTION
Standardized outer
sleeve for Mob
Records, with central
hole to display
individual record
details.

DIMENSIONS
306 x 306 mm
12 x 12 in

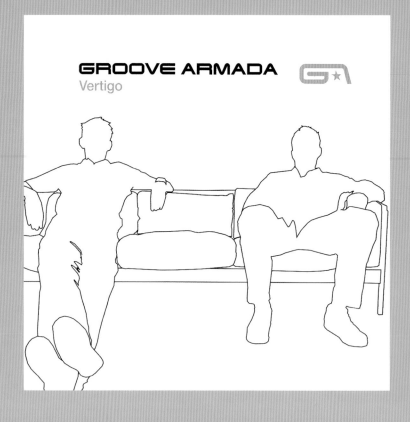

DESIGNERS
Peter Chadwick
Malcolm Buick
(original logo)

Groove Armada/Vertigo—Campaign and Logo

DESIGN COMPANY
Zip Design Ltd.

COUNTRY OF ORIGIN
UK

ART DIRECTOR
Peter Chadwick

ILLUSTRATOR
Neil Bowen

ARTWORK DESCRIPTION
Cover and double-
sided inner sleeves
for Groove Armada's
double album Vertigo.

PHOTOGRAPHER
Mario Godlewski

DIMENSIONS
306 x 306 mm
12 x 12 in

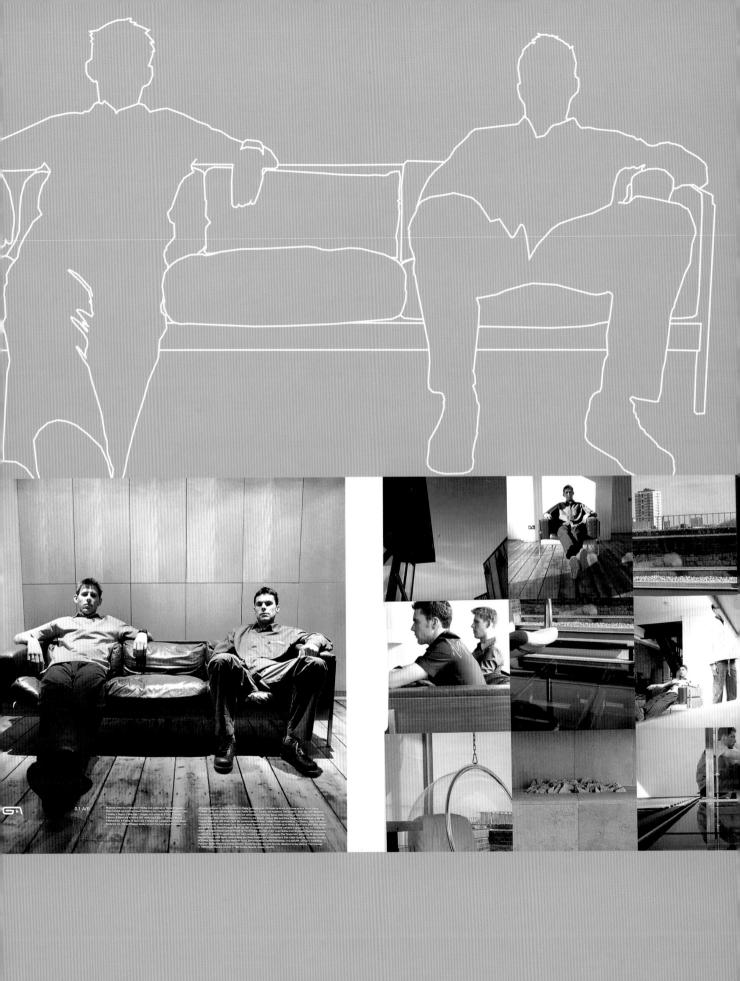

Plazm Poster

DESIGNERS
Andy Altmann
David Ellis
Patrick Morrissey
Iain Cadby
Mark Molloy

PHOTOGRAPHERS
Photodisc

DESIGN COMPANY
Why Not Associates

COUNTRY OF ORIGIN
UK

ARTWORK DESCRIPTION
Poster for *Plazm*
magazine on the
subject of cloning,
with text from
Mary Shelley's
Frankenstein.

DIMENSIONS
508 x 762 mm
20 x 30 in

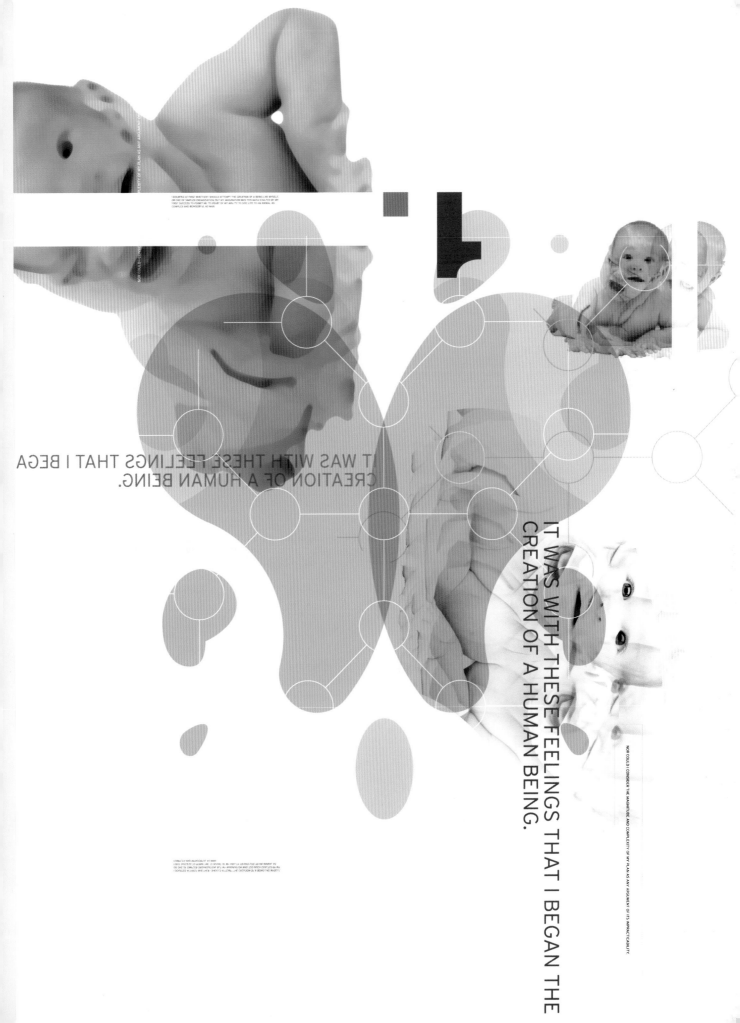

IT WAS WITH THESE FEELINGS THAT I BEGAN THE
CREATION OF A HUMAN BEING.

IT WAS WITH THESE FEELINGS THAT I BEGAN THE
CREATION OF A HUMAN BEING.

DESIGNERS
Andy Altmann
David Ellis
Patrick Morrissey
Iain Cadby
Mark Molloy

VIDEO PRODUCTION
The Mob Film
Company

DESIGN COMPANY
Why Not Associates

NCR Conference Video

COUNTRY OF ORIGIN
UK

ARTWORK DESCRIPTION
Conference video, on the theme of "relationship technology," for NCR (National Cash Registers).

DIMENSIONS
Vary according to screen size

DESIGNERS
Andy Altmann
David Ellis
Patrick Morrissey
Iain Cadby
Mark Molloy

PRODUCER
Caroline True

DESIGN COMPANY
Why Not Associates

Virgin Records Conference Video

COUNTRY OF ORIGIN
UK

ARTWORK DESCRIPTION
Conference video
for Virgin Records
Worldwide.

DIMENSIONS
Vary according
to screen size

LovE Me

just

OW!

WANT
YOUR

LovE Me

just

gently

Brainwash Marketing Stationery

DESIGNERS
Graphic Havoc
avisualagency

DESIGN COMPANY
Graphic Havoc
avisualagency

COUNTRY OF ORIGIN
USA

ARTWORK DESCRIPTION
Stationery for
Brainwash Marketing.

DIMENSIONS
Letterhead:
216 x 279 mm
8$^1/_2$ x 11 in
Business cards:
89 x 51 mm
3$^1/_2$ x 2 in

Soapbox Studios Stationery

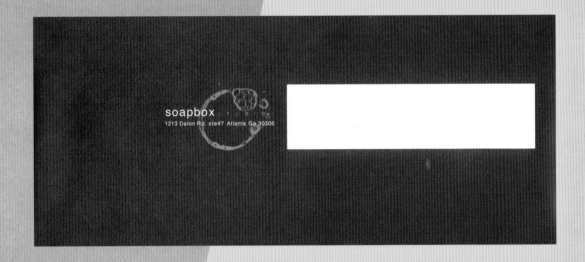

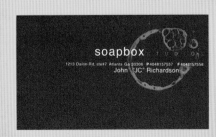

DESIGNERS
Graphic Havoc
avisualagency

DESIGN COMPANY
Graphic Havoc
avisualagency

COUNTRY OF ORIGIN
USA

ARTWORK DESCRIPTION
Stationery for
Soapbox Studios,
an audio, post-
production facility.

DIMENSIONS
Letterhead:
216 x 279 mm
8¹/₂ x 11 in
Envelope:
241 x 105 mm
9¹/₂ x 4¹/₈ in
Business card:
88 x 50 mm
3¹/₂ x 2 in

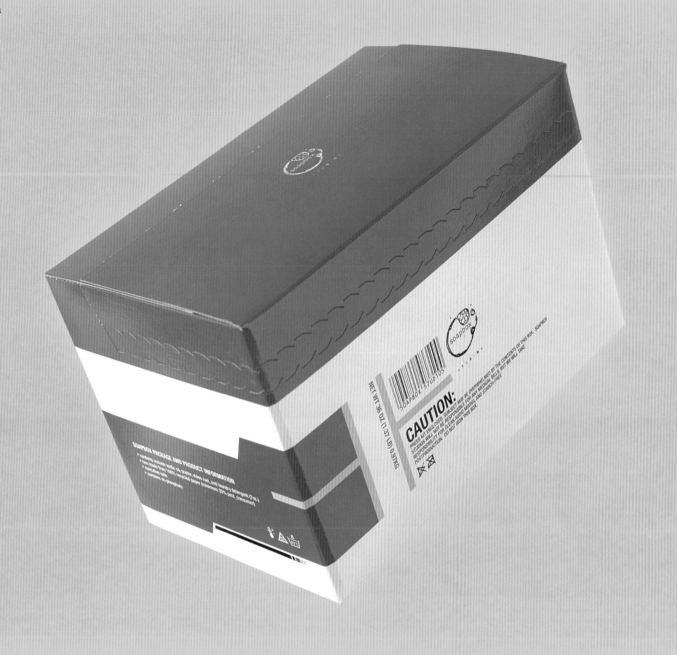

Soapbox Studios Media Kit

DESIGNERS
Graphic Havoc
avisualagency

DESIGN COMPANY
Graphic Havoc
avisualagency

COUNTRY OF ORIGIN
USA

ARTWORK DESCRIPTION
Media kit for Soapbox
Studios, including
presentation box,
video, poster, T-shirt,
business card, and
laundry detergent.

DIMENSIONS
Box:
209 x 127 x 140 mm
8¹/₄ x 5 x 5¹/₂ in

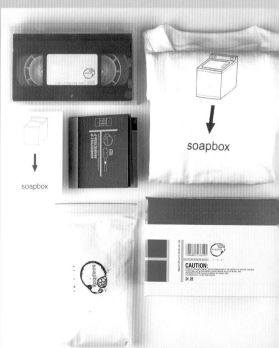

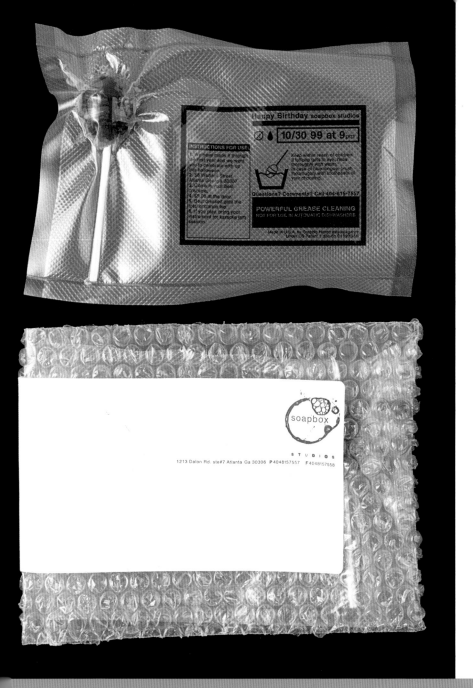

soapbox

Soapbox Studios Invitation

DESIGNERS
Graphic Havoc
avisualagency

ARTWORK DESCRIPTION
Invitation to celebrate
the first birthday of
Soapbox Studios.

DESIGN COMPANY
Graphic Havoc
avisualagency

DIMENSIONS
203 x 152 mm
8 x 6 in

COUNTRY OF ORIGIN
USA

DESIGNER
Lee Schulz

ART DIRECTOR
Lee Schulz

ILLUSTRATOR
Lee Schulz

PHOTOGRAPHER
Lee Schulz

DESIGN COMPANY
Lee Schulz

COUNTRY OF ORIGIN
USA

ARTWORK DESCRIPTION
The first in a series of three movies "exploring an obsession with astrophysics and quantum mechanics."

DIMENSIONS
640 x 486 pixels

THAT ONE COULD REALIZE
THE LINE FOLLOWED IN FALLING WASN'T WHAT IT SEEMED
BUT ANOTHER,

The Distribution of Matter

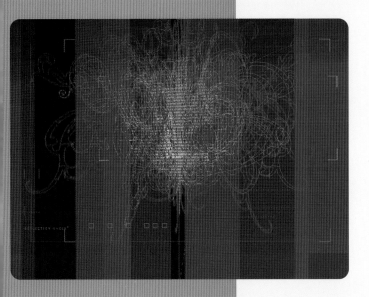

OR RATHER

Shift! Get Rich With Art

DESIGNERS
Anja Lutz
Jim Avignon
Dorothee Mahnkopf
Maren V. Stockhausen
Florian Thalhofer
(software)

ART DIRECTORS/CONCEPT
Anja Lutz
Jim Avignon

ARTISTS
See individual cards

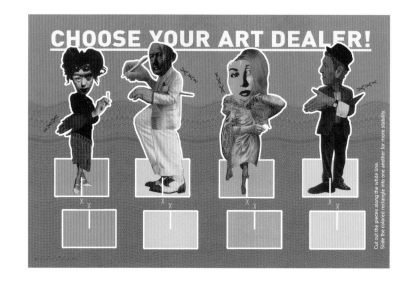

DESIGN COMPANY
Shift!

COUNTRY OF ORIGIN
Germany

ARTWORK DESCRIPTION
Board game about the art market, including box, game board, more than 100 cards, dice, playing pieces, and CD-ROM.

DIMENSIONS
Box:
135 x 200 mm
5⁵/₁₆ x 7⁷/₈ in

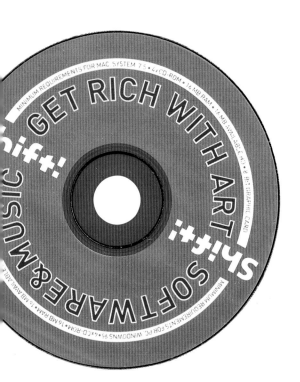

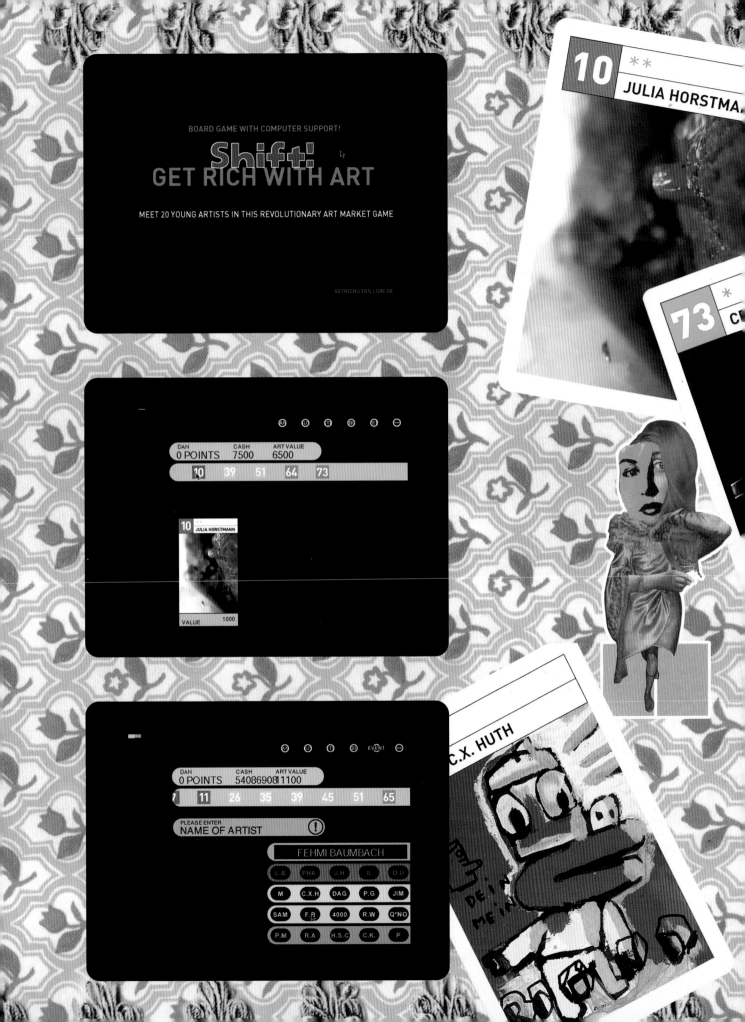

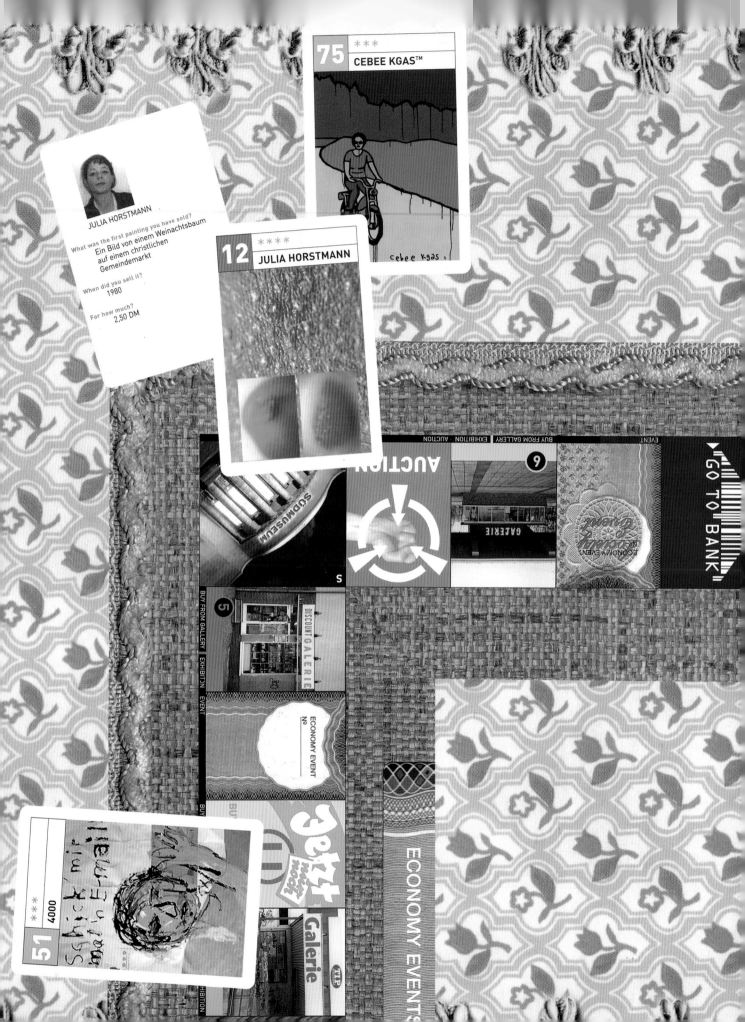

75 *** CEBEE KGAS™

cebee kgas

JULIA HORSTMANN

What was the first painting you have sold?
Ein Bild von einem Weihnachtsbaum
auf einem christlichen
Gemeindemarkt

When did you sell it?
1980

For how much?
2,50 DM

12 **** JULIA HORSTMANN

AUCTION

EXHIBITION · AUCTION

BUY FROM GALLERY

SÜDMUSEUM

S

9

GALERIE

EVENT

ECONOMY EVENT
Nº

GO TO BANK

BUY FROM GALLERY | EXHIBITION | EVENT

5

DISCOUNT GALERIE

ECONOMY EVENT
Nº

ECONOMY EVENTS

51 *** 4000

Schick mir
meine E-mail

Jetzt
noch

Galerie

VIP

EXHIBITION

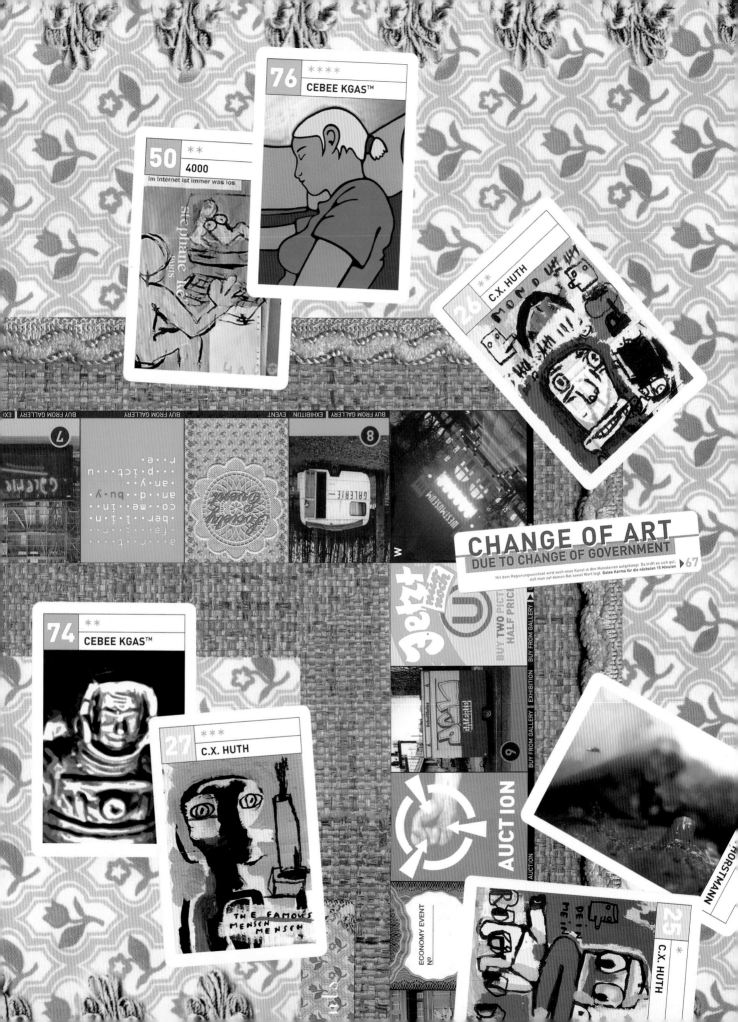

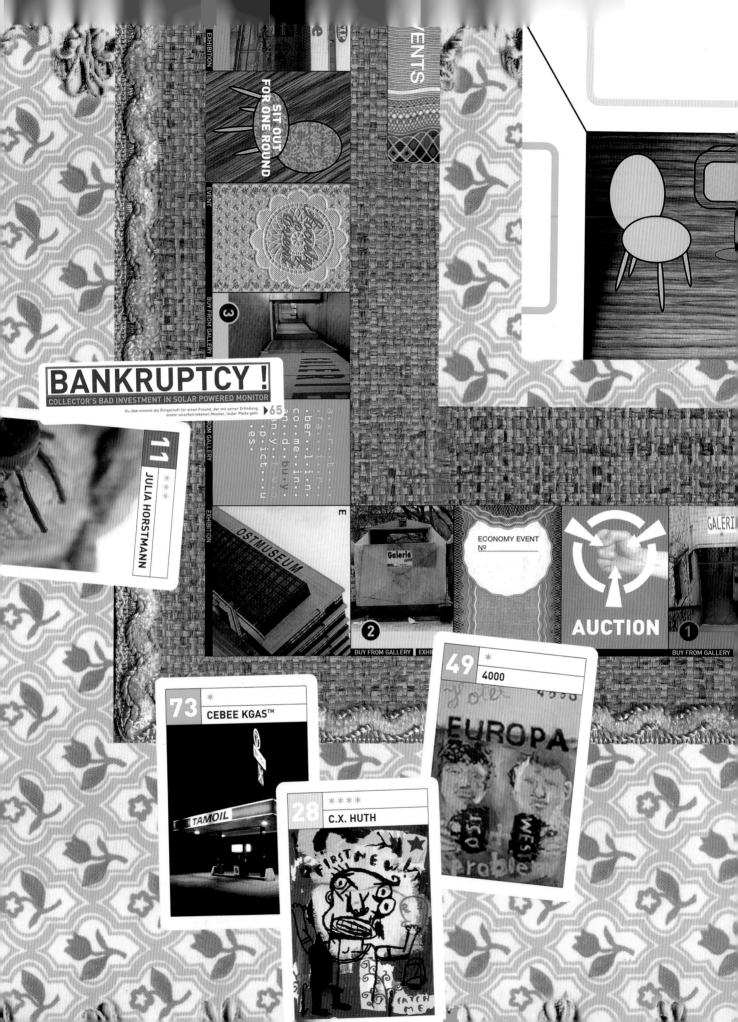

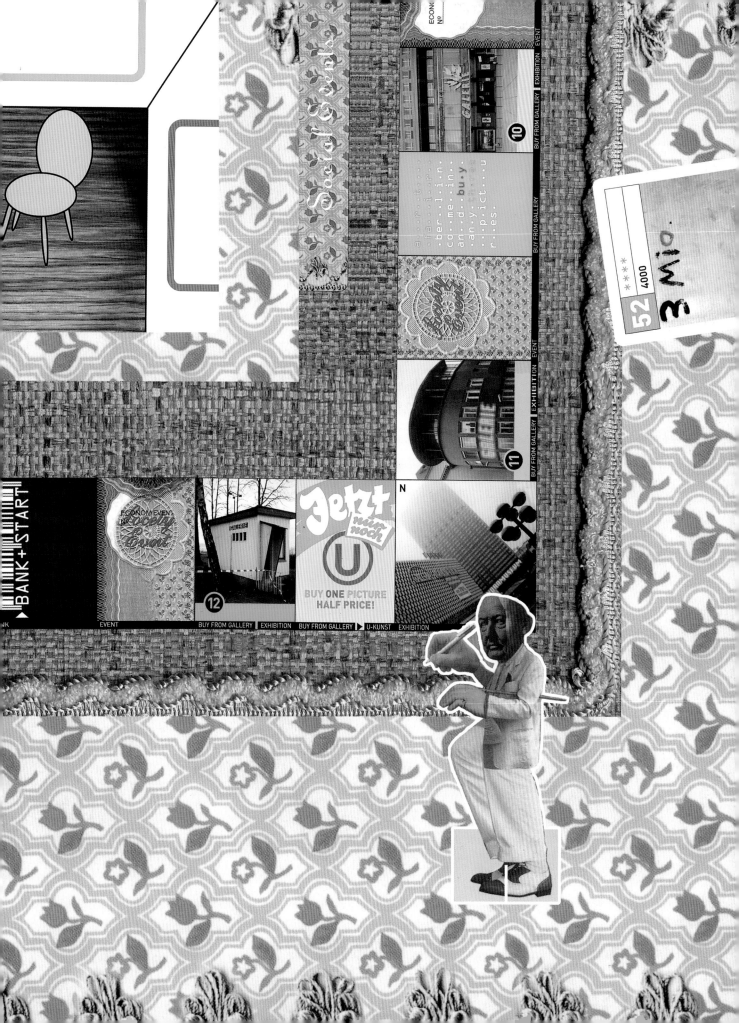

Gwand Fashion Events 99

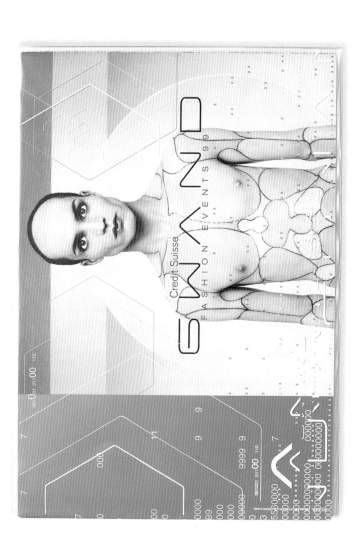

COUNTRY OF ORIGIN
Switzerland

ARTWORK DESCRIPTION
Promotional booklet,
with clear plastic
slipcase.

DIMENSIONS
210 x 148 mm
8¹/₄ x 5¹³/₁₆ in

SIGNERS
arco Simonetti
alter Stähli
rahim Zbat

OTOGRAPHS
tosolar

SIGN COMPANY
alhalla

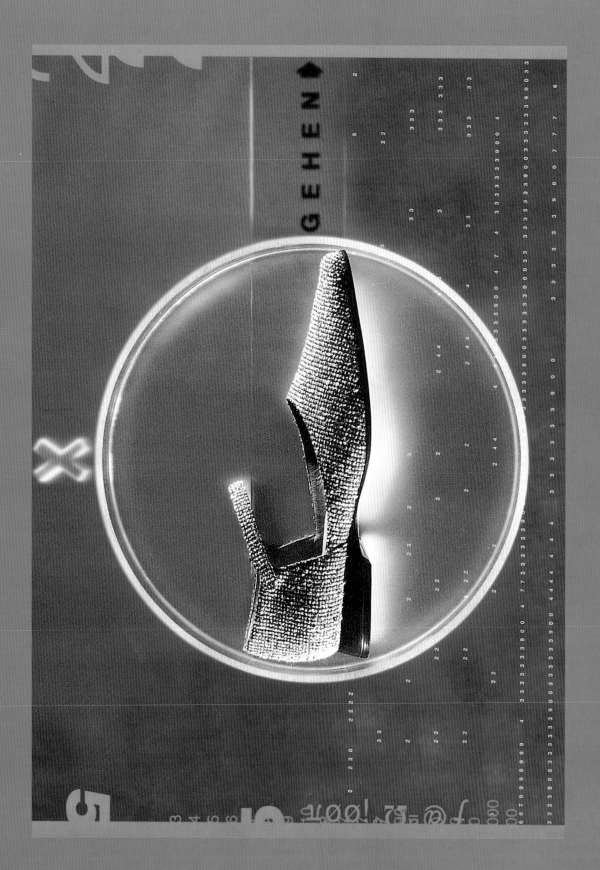

DESIGNERS
Red Design

ART DIRECTORS
Red Design

PHOTOGRAPHER
D. Breckon
Red Design

DESIGN COMPANY
Red Design

COUNTRY OF ORIGIN
UK

ARTWORK DESCRIPTION
Double-sided, self-
promotional poster,
with tear-off response
slips, mailed out to
existing and potential
clients.

DIMENSIONS
505 x 297 mm
19 7/8 x 11 11/16 in

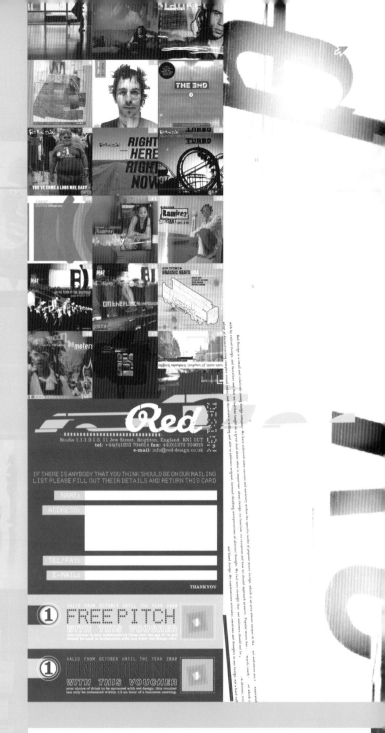

Red Design Promotional Poster

DESIGNERS
Red Design

ART DIRECTORS
Red Design

PHOTOGRAPHER
Harry Dillon
(business cards)

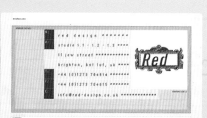

DESIGN COMPANY
Red Design

COUNTRY OF ORIGIN
UK

ARTWORK DESCRIPTION
Double-sided
stationery, including
staff business cards
and letterhead, for
Red Design.

DIMENSIONS
Letterhead:
210 x 297 mm
$8^1/_4$ x $11^{11}/_{16}$ in
Business cards:
85 x 49 mm
$3^3/_8$ x $1^{15}/_{16}$ in

DESIGNERS
Red Design

ART DIRECTORS
Red Design

PHOTOGRAPH
Stock library image

DESIGN COMPANY
Red Design

Nanasuma

·SUMA

MAY 99

EO TEMPLETON (PLUS EXTENDED FAMILY RESIDENTS ON ROTATION)
DAMIAN HARRIS (MIDFIELD GENERAL, SKINT, THE BOUTIQUE...)
ANDY MAC (SKINT/LOADED, CLUB FOOT...) CRISTIAN VOGEL (SUPER_COLLIDER, FREESKIN FRAME, ABROAD...)
RICH SPICE (ORGUNK, NO FUTURE, TRESOR-BERLIN...)
RICH THE RECORD (EUPHONIC, CITYFORCE-JAPAN...)
FELIX (ONLY MUSIC, TOMBA, HEAVEN...) HAMISH (MUFFLEWUFFLE, THE END...)
ROB (SLACK, AMNESIA, PLASTIC PEOPLE...) DRATUS (SLACK, MINISTRY OF SOUND, LIQUID ROOMS-JAPAN...)
AUDIO LOUNGE (SLY, WARM...)

DEEP—SOUL—NU—CLASSIC—GARAGE—JAZZ—TECHNO—DISCO

NANASUMA

1ST MAY
CRAIG WOODROW & HAMISH
(THE ZAP, HYPE CHART, SUNDAY SUNDAY) (MUFFLEWUFFLE, THE CLINIC)

8TH MAY
EO & ROB
(RESIDENT, MUFFLEWUFFLE...) (SLACK...

15TH MAY
DAMIAN & EO
(SKINT, MIDFIELD GENERAL, ETC...) (RESIDENT, MUFFLEWUFFLE...)

22ND MAY
ANDY MAC & EO
(LOADED, SKINT, CLUB FOOT...) (RESIDENT, MUFFLEWUFFLE...)

29TH MAY
*AUDIO LOUNGE SPECIAL WITH MATT & MACCA
(WARM SOUNDSYSTEM, INSIDE OUT, ATOMIC JAM)

NIGMA SHIP STREET, BRIGHTON.
£5 B4 11 / £6

indian ropeman: ꤷꤷꤷ ꤷ ꤷꤷꤷ ꤷꤷ

indian ropeman: ꤷꤷꤷ ꤷ ꤷꤷꤷ ꤷꤷ

indian ropeman: ꤷꤷꤷ ꤷ ꤷꤷꤷ ꤷꤷ

indian ropeman: ꤷꤷꤷ ꤷ ꤷꤷꤷ ꤷꤷ

**Indian Ropeman/
Sunshine of Your Love**

DESIGNERS
Red Design

ART DIRECTORS
Red Design

PHOTOGRAPHERS
Red Design

DESIGN COMPANY
Red Design

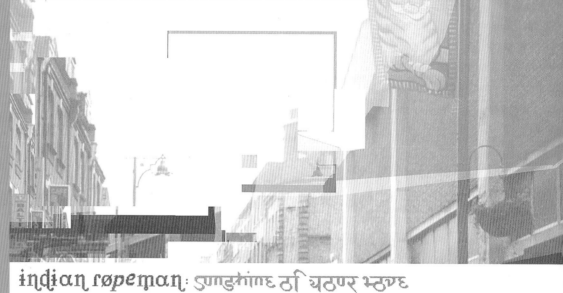

indian ropeman: ꤷꤷꤷ ꤷ ꤷꤷꤷ ꤷꤷ

indian ropeman: ꤷꤷꤷ ꤷ ꤷꤷꤷ ꤷꤷ

indian ropeman: ꤷꤷꤷ ꤷ ꤷꤷꤷ ꤷꤷ

indian ropeman: ꤷꤷꤷ ꤷ ꤷꤷꤷ ꤷꤷ

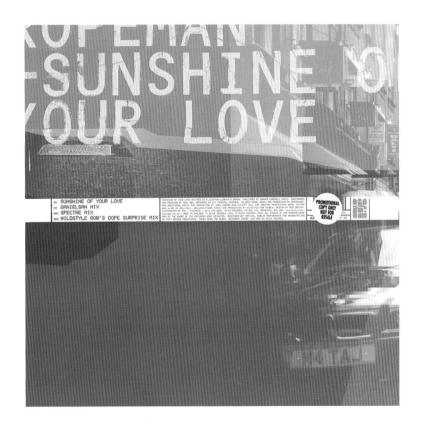

A1 SUNSHINE OF YOUR LOVE
A2 DANIELSAN MIX
AA1 SPECTRE MIX
AA2 WILDSTYLE BOB'S DOPE SURPRISE MIX

COUNTRY OF ORIGIN
UK

ARTWORK DESCRIPTION
Sleeve and label for
Indian Ropeman's
single "Sunshine of
Your Love."

DIMENSIONS
Sleeve:
315 x 315 mm
12 7/16 x 12 7/16 in

Brassic Beats USA

ARTWORK DESCRIPTION
Sleeve for Skint
Records' US
compilation album
"Brassic Beats."

DIMENSIONS
315 x 315 mm
12⁷/₁₆ x 12⁷/₁₆ in

skint

BRASSIC BEATS USA

THE SOUND OF SKINT, THE LABEL THAT BROUGHT YOU:

FATBOY SLIM
LO FIDELITY ALLSTARS

BRASSIC BEATS

BRASSIC

DESIGNERS
Red Design

ART DIRECTORS
Red Design

ILLUSTRATOR
Zeb McGann
Req 1

DESIGN COMPANY
Red Design

COUNTRY OF ORIGIN
UK

collectors' items

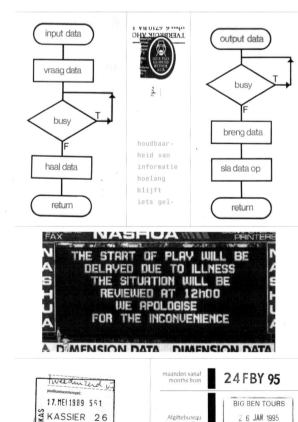

1972: Ard Schenk met de drie

DESIGNER
Martijn Oostra

ART DIRECTOR
Martijn Oostra

ILLUSTRATOR
Martijn Oostra

PHOTOGRAPHER
Martijn Oostra

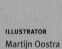

bot

Bot Magazine: "Houdbaarheid"
(Shelf Life) Edition

DESIGN COMPANY
Martijn Oostra

COUNTRY OF ORIGIN
The Netherlands

ARTWORK DESCRIPTION
Submissions, including cover and five-page article entitled Collectors' Items, for the "Shelf Life" edition of *Bot* (Bone) magazine, published by Stichting Jongehonden (Young Dog Foundation).

DIMENSIONS
210 x 297 mm
8¼ x 11¹¹/₁₆ in

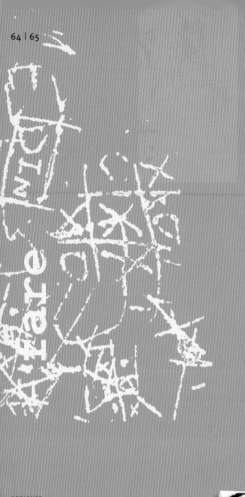

Bus Shelter Observations

DESIGNER
Sandra Armstrong

POET
Bob Beagrie

ART DIRECTORS
Heterogloss

PHOTOGRAPHER
Sandra Armstrong

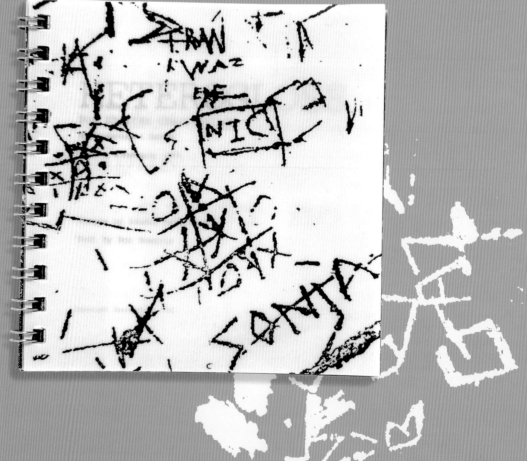

in a **passion**
play of pubescent desire

DESIGN COMPANY
Heterogloss

COUNTRY OF ORIGIN
UK

ARTWORK DESCRIPTION
Ring-bound book
of bus-shelter
graffiti, with a
poetic narrative.

DIMENSIONS
100 x 100 mm
3¹⁵/₁₆ x 3¹⁵/₁₆ in

pronouncements made **in layer**
upon layer of names scored in a game
of **naughts-n-crosses**, a palimpsest of ciphers
from **ceiling to floor**

passion

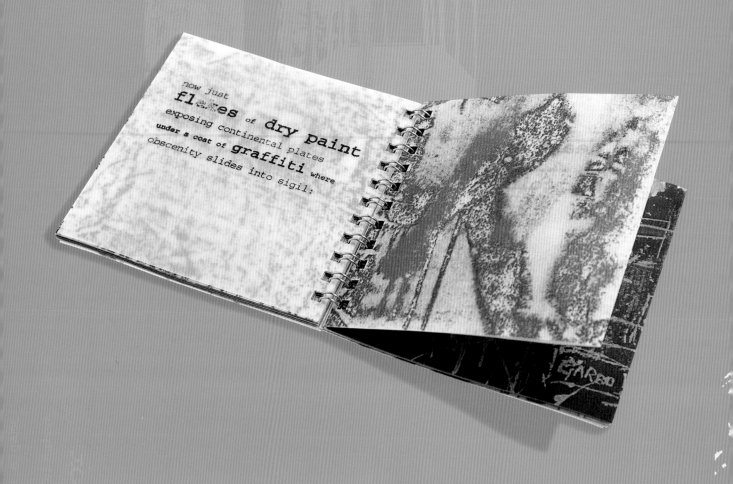

now just **flakes** of **dry paint**
exposing continental plates
under a coat of graffiti where
obscenity slides into sigil:

a heart

and a phallus hermetically seal with the **toss**

of a coin

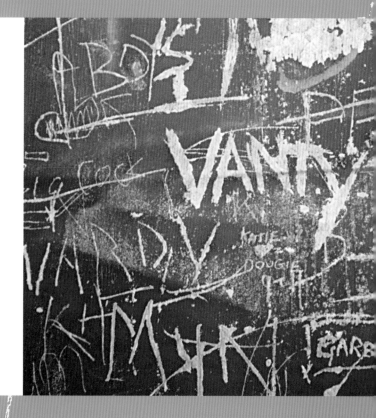

after

another **missed**

connection we're **caught**

on route,

in this **bedlemic cell, we crossed fingers**

kissed and recounted

the **fare**

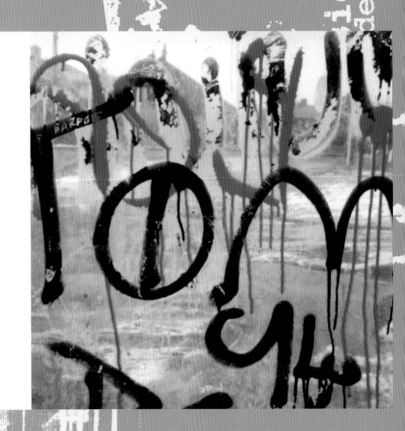

Neo Identity

DESIGNERS
Pierre Vermeir
Jim Sutherland

ART DIRECTORS
Pierre Vermeir
Jim Sutherland

DESIGN COMPANY
HGV Design
Consultants

COUNTRY OF ORIGIN
UK

Warpsgrove Lane Chalgrove **T** +44 (0)1865 891 444 **W** www.desking-neo.co.uk
Oxfordshire OX44 7TH **F** +44 (0)1865 891 427 **E** sales@desking.co.uk

neo

a Desking Systems range

ARTWORK DESCRIPTION
Brand identity and stationery for a new range of office furniture.

DIMENSIONS
Letterhead:
210 x 297 mm
$8^{1}/_{4}$ x $11^{11}/_{16}$ in
Compliments slip:
210 x 97 mm
$8^{1}/_{4}$ x $3^{13}/_{16}$ in
Parcel label:
210 x 97 mm
$8^{1}/_{4}$ x $3^{13}/_{16}$ in

Neo Website

DESIGNER
Dominic Edmunds

ART DIRECTORS
Pierre Vermeir
Jim Sutherland

ILLUSTRATOR
Roger Taylor

PHOTOGRAPHER
Christopher Warren

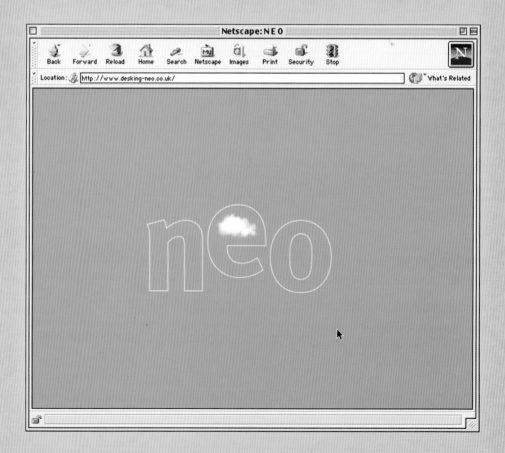

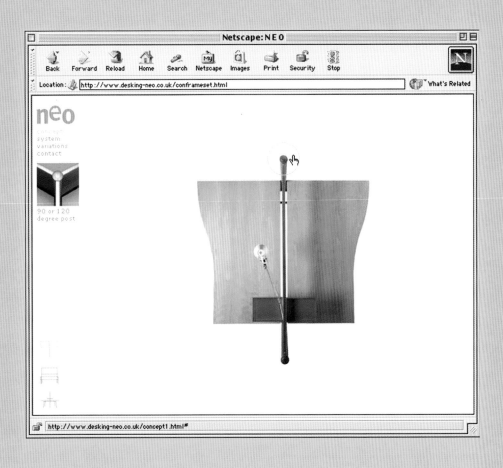

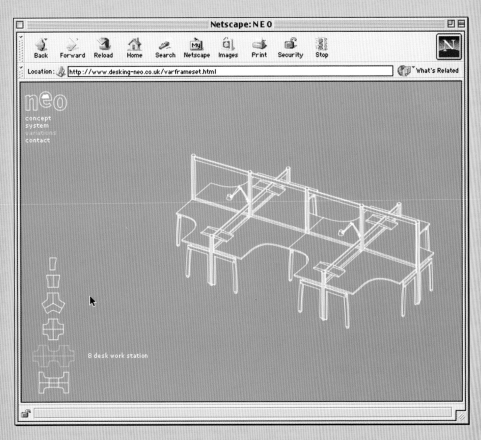

DESIGN COMPANY
HGV Design
Consultants

COUNTRY OF ORIGIN
UK

ARTWORK DESCRIPTION
Website for Neo,
a range of office
furniture, designed
"to reflect the
lightness and
simplicity of the
product."

DIMENSIONS
640 x 480 pixels

DESIGNERS :
Jackson Tan
Alvin Tan
Melvin Chee
William Chan
Perry Neo

ART DIRECTORS
Jackson Tan
Alvin Tan
Melvin Chee
William Chan
Perry Neo

DESIGN COMPANIES
:phunk
Trigger Publishing

COUNTRY OF ORIGIN
Singapore

ARTWORK DESCRIPTION
Issues 1 and 2 of
Trigger, a style
magazine published
in Singapore.

DIMENSIONS
148 x 210 mm
5⁷/₈ x 8¹/₄ in

ARTWORK DESCRIPTION
T-Shirt and box

DIMENSIONS
Box:
200 x 257 mm
7⁷/₈ x 10¹/₈ in

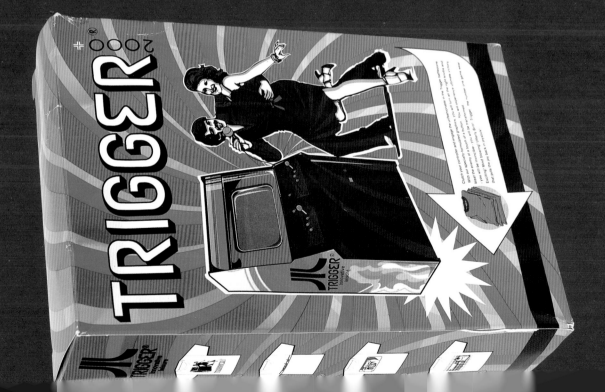

Trigger Magazine
Trigger T-Shirt Box

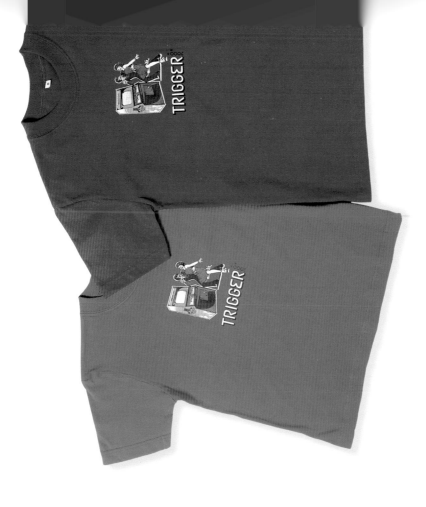

TRIGGER **+ STYLE IN PRINT**

ISSUE TWO > FREE

> METAL

FASHION + MUSIC + CULTURE

> IT'S IN THE MIX

So now you've been mixing hard behind the wheels of steel and think you've got what it takes, but you want an identity to your own personal style and maybe release your own mix CD. Here is how!

Subscribe to TRIGGER

METAL GEAR SOLID

Enter the radioactive video world of Metal Gear Solid and join PlayStation gamer Honz on a secret mission to >

単独潜入、極限の緊張感

BOHEMIAN WRAPSODY

anna sui

text: Vivien Wong

12:18 Blue textured knit dress from Anna Sui.

BIG MOMBASSA

"Some ideas are planted directly in my mind by perverted military scientists and others come from looking at books and adding to or subtracting from that which catches the eye."

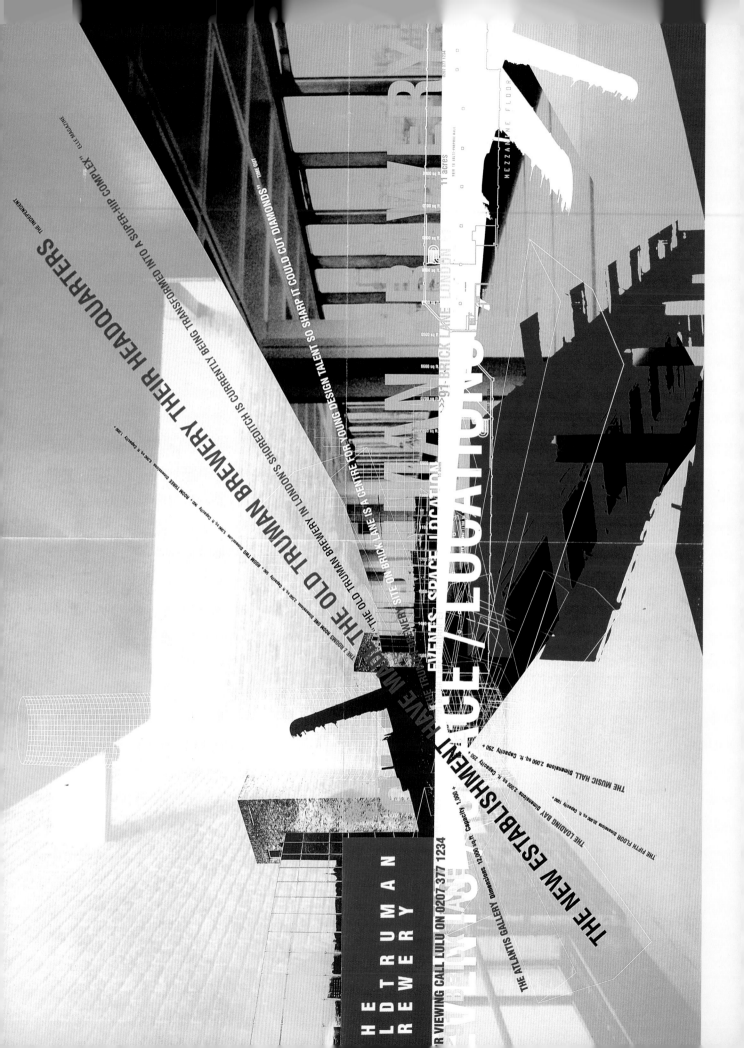

The Old Truman Brewery

DESIGN COMPANY
Insect

COUNTRY OF ORIGIN
UK

ARTWORK DESCRIPTION
Promotional leaflet for
the Old Truman
Brewery, London.

DIMENSIONS
594 x 420 mm
23³/8 x 16⁹/16 in

DESIGNERS
Paul Humphrey
Luke Davies

ART DIRECTORS
Paul Humphrey
Luke Davies

PHOTOGRAPHERS
Paul Humphrey
Luke Davies

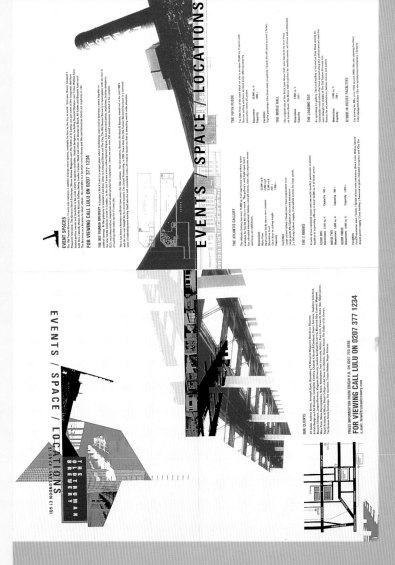

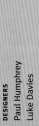

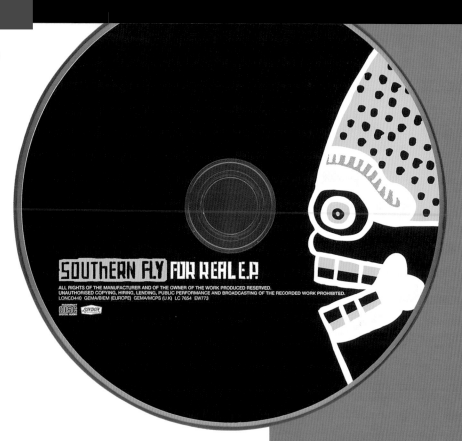

DESIGNERS
Paul Humphrey
Luke Davies

ART DIRECTORS
Paul Humphrey
Luke Davies

ILLUSTRATORS
Paul Humphrey
Luke Davies

Southern Fly/For Real

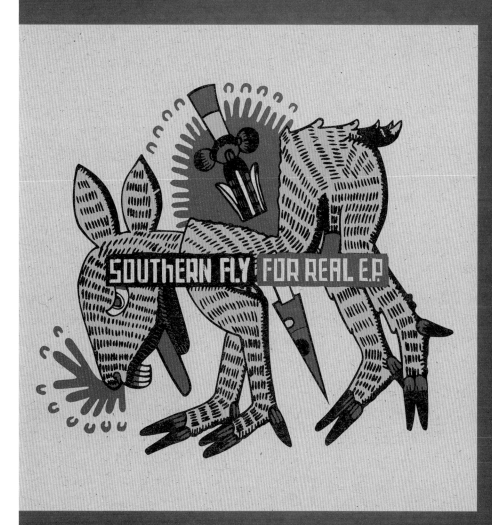

DESIGN COMPANY
Insect

COUNTRY OF ORIGIN
UK

ARTWORK DESCRIPTION
Outer wallet, inner
slipcase, and disk for
Southern Fly.

DIMENSIONS
Wallet:
125 x 125 mm
4¹⁵/₁₆ x 4¹⁵/₁₆ in

Southern Fly/Monkey Tale

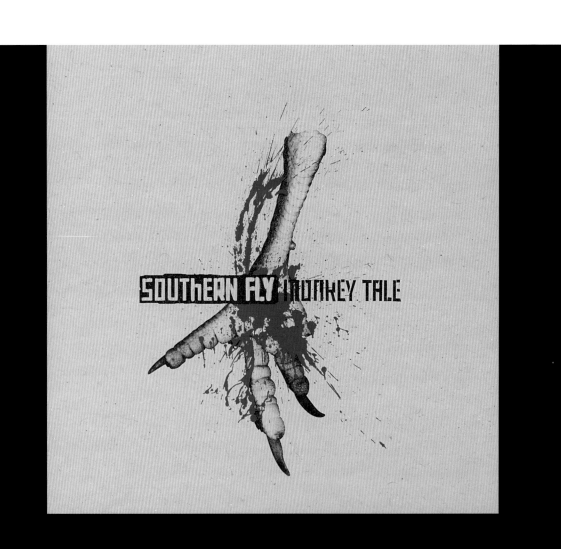

DESIGNERS
Paul Humphrey
Luke Davies

ART DIRECTORS
Paul Humphrey
Luke Davies

ILLUSTRATORS
Paul Humphrey
Luke Davies

DESIGN COMPANY
Insect

COUNTRY OF ORIGIN
UK

ARTWORK DESCRIPTION
Outer wallet, inner
slipcase, and disk for
Southern Fly's debut
CD single.

DIMENSIONS
125 x 125 mm
4^{15}/$_{16}$ x 4^{15}/$_{16}$ in

Monkey Do Dings Postcard

DESIGNERS
Sean Fermoyle
Tim Lilligan

ART DIRECTOR
Sean Fermoyle

ILLUSTRATOR
Tim Lilligan

DESIGN COMPANY
Simpletype

COUNTRY OF ORIGIN
USA

ARTWORK DESCRIPTION
Promotional
postcard for a
new dingbat font.

DIMENSIONS
206 x 140 mm
8½ x 5½ in

simpletype
213 n. morgan, 4b
chicago, il 60607
312.388.4545

This is Monkey Do Dings. It is an
illustrative font by Chicago artist
Tim Lilligan. It contains 72+ unique
illustrations that are all original mini
works of art. Monkey Do Dings will
soon be available from simpletype along
with several other unique fonts. Look
for them in early 2000.

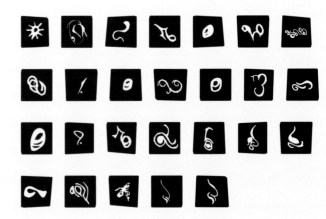

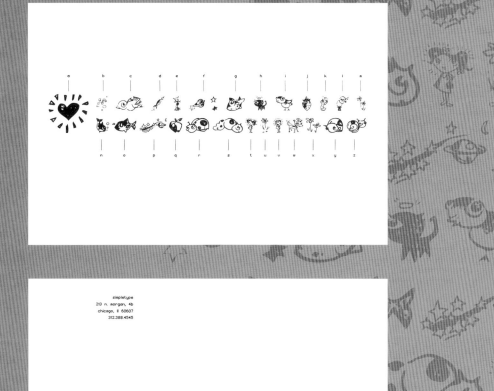

simpletype
213 n. morgan, 4b
chicago, il 60607
312.388.4545

This is Fissy. The second in a series from Chicago artist Phoebe Fisher. It contains 26 unique illustrations that tell a story or an "urban fairy-tale" of sorts. Fissy will soon be available from simpletype along with several other unique fonts. Look for them in early 2000.

Fissy Postcard

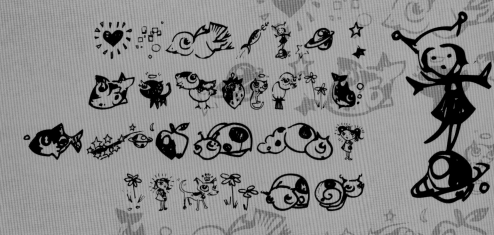

DESIGNERS
Sean Fermoyle
Phoebe Fisher

ART DIRECTOR
Sean Fermoyle

ILLUSTRATOR
Phoebe Fisher

DESIGN COMPANY
Simpletype

COUNTRY OF ORIGIN
USA

ARTWORK DESCRIPTION
Promotional postcard for a new dingbat font.

DIMENSIONS
206 x 140 mm
8$\frac{1}{2}$ x 5$\frac{1}{2}$ in

DESIGNERS
Ralf Sander
Petra Niedernolte

ART DIRECTOR
Ralf Sander

ILLUSTRATOR
Ralf Sander

ARTWORK DESCRIPTION
Corporate identity, stationery, and website for a picture agency specializing in photographers' leftover images.

PHOTOGRAPHERS
Petra Niedernolte
Ralf Sander

DESIGN COMPANY
Fehler Sieben

COUNTRY OF ORIGIN
Germany

Second Image

DIMENSIONS
Letterhead:
210 x 297 mm
8^1/$_4$ x 11^{11}/$_{16}$ in
Business card:
88 x 55 mm
3^1/$_2$ x 2^3/$_{16}$ in
CD-ROM packaging:
140 x 124 mm
5^1/$_2$ x 4^7/$_8$ in
Website:
773 x 580 pixels

Netscape: Willkommen bei Second Image

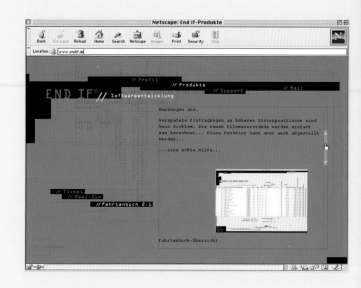

End if

DESIGNERS
Ralf Sander
Petra Niedernolte

ART DIRECTOR
Ralf Sander

DESIGN COMPANY
Fehler Sieben

COUNTRY OF ORIGIN
Germany

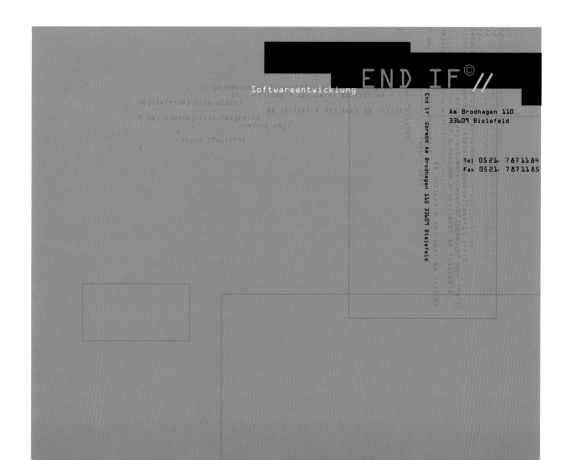

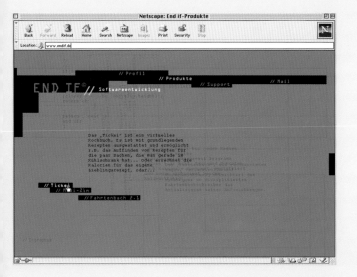

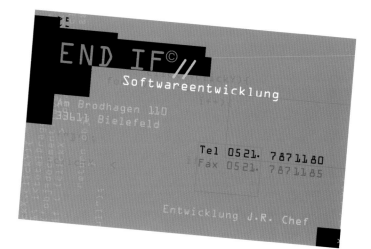

ARTWORK DESCRIPTION
Corporate identity
and website for soft-
ware-development
company End if.

DIMENSIONS
Letterhead:
210 x 297 mm
8 1/4 x 11 11/16 in
Business card:
88 x 55 mm
3 1/2 x 2 3/16 in
Website:
800 x 496 pixels

DESIGNERS
Petra Niedernolte
Ralf Sander

ART DIRECTOR
Petra Niedernolte

ILLUSTRATOR
Petra Niedernolte

PHOTOGRAPHERS
Ralf Sander
Petra Niedernolte

DESIGN COMPANY
Fehler Sieben

COUNTRY OF ORIGIN
Germany

ARTWORK DESCRIPTION
36-page brochure
about the beginning
of European
civilization, and
the "broken pieces"
of knowledge that
remain from that time.

DIMENSIONS
170 x 255 mm
6¹¹/₁₆ x 10 in

Bruchstücke

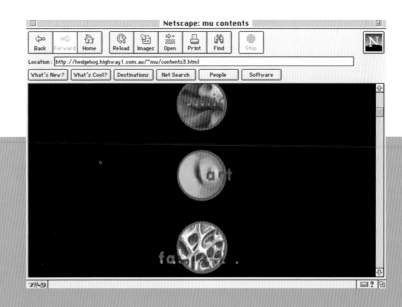

mu Website

DESIGNER
Deanne Cheuk

DESIGN COMPANY
Surfacepseudoart

COUNTRY OF ORIGIN
Australia

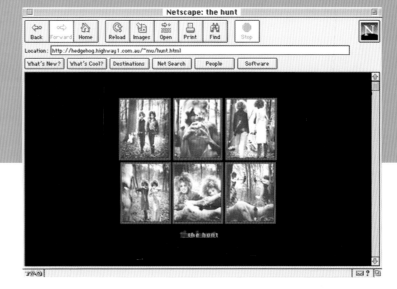

ARTWORK DESCRIPTION
Website for *mu*
magazine.

DIMENSIONS
Vary according
to screen size

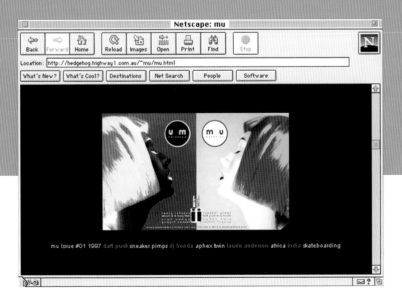

mouse on mars.

Storyview by Joep Vermaat
www.pjoe.net

domination, the traditional formula of bass, guitar and drums are now joined by synths, samplers and drum machines. And as many question of the whole 'cross-over' phenomenon is being taken a lot too far, it's bands like MOUSE ON MARS which this trend owes credit to.

It seems no band is complete these days without some aspect of electronica. As dance music continues on its plight of world

They went without a doubt the high point of the Togenmont festival in Paradiso, Amsterdam some three years ago. Back then the duo of Jan St. Werner and Andy Toma were one of the few bands combining the best of two worlds — making instrumental music using electronic production as well as rock instruments.

"We don't see ourselves as a techno band," Andi tells me. "The festival organisation asked us to describe our music and we said we had call it 'electro-kraut-dub-grind'. But they didn't understand that, so it became 'krautrock' on the flyer."

"I'm glad we don't have to behave like a techno band," Jan adds. "We have the freedom to do whatever we like. We're more into the development of ideas than focusing on the style of the band."

It is this renegade approach to composition which makes Mouse On Mars different. The sounds of everyday life are the sounds that Andi and Jan get excited about. "Our day we found out we forgot to listen," remarked Jan. "If you listen to your surroundings then you'll discover music in everything." As was shown in an experiment requested by the Finnish techno label Sähkö. For one week the label had started up a non-stop experimental techno radio station in Helsinki and the duo were allowed to fill an hour.

"Our contribution was a recording consisting of three levels," explained Andi. "First we had put up microphones all around the studio. Next to that we had sampled various everyday sounds in the city, and during all that our short-wave radio picked up all sorts of strange noises. We played everything live and it fitted perfectly!"

So how would one describe this rare collage of experimental sounds?

According to Andi, "I think we must be an electronic band making non-electronic music." or in Jan's perspective, "maybe more like a non-electronic band making electronic music."

Oh well, in one way or another there's a knot in there somewhere. "At the moment of creation we don't think about it too much," explains Andi. "The instruments are just tools. For us it's the cheapest way to work and that's why we do it."

Although Andi and Jan's musical direction does not always coincide, it is this difference in ideas which gives the band its original sound. "We do disagree from time to time, but that isn't such a bad thing because then you have to convince each other," rationalises Andi.

"But we aren't that easy to convince," adds Jan. "Not that we feel we know more. I'm always glad if I meet somebody who has a better idea than I do.

Today it looks like a lot of bands have exactly the same idea. In Germany alone there are many bands making electronic music out of a such genre. Kreidler, To Rococo Rot, Console, Tarwater are to enjoy the pioneering duo. According to Andi: "We do not like

"We still use conventional instruments, but I wouldn't want to use them all the time. We would probably get in a fight about who should play what — one playing drums, the other guitar — it wouldn't work out. Now it's much more democratic because we can complement each other on things the other doesn't. This way we don't have to fight the hierarchy in the band, just out the music itself."

use electronic instruments or not. It's just like a painting — a good painter will use a pencil at one time and then use black oil painting at another. It isn't about what resources you use, it's about the final product — the music," Jan continues. "People focus too much on the formulas and the designs behind the product, the form is seen as more important than the actual content. To us, the form is important — without form there can be no content, but people shouldn't place all attention on it. Form follows function. I have no idea if that's true, it's a cliche, but those show up if you start to reflect on music."

Andidinacker is a beautiful record.

To be compared. At the moment it's very sad to mix instruments with but for us it's the way of working possibility to do a live concert, but when I see many of these other bands play, I get disappointed with the way they present themselves. I [They] try to build their music around certain fixed elements which takes away the spontaneity in the music and that's a real shame. "I don't think it's of any importance if a band decides to

Digital continuation on their Spoon records label. Icon Dolft Sonig started a musique concrète collective in which he is making music by experimenting with tape loops and samplers, while Andi worked at recording and making one fruit of the Stereolab album Dots and Loops, and together they

worked at making a soundtrack. And now for one final question: When will you be popular? "I think we could really do well with the Eskimos," answers Jan. "Did you know that Eskimos have lots of different words for snow? Maybe there are people that have lots of words for bassdrum. Oh no, I shouldn't have asked, they already exist: Germans."

COUNTRY OF ORIGIN
Australia

ARTWORK DESCRIPTIONS
Fashion/style
magazine, issues
#4 and #5.

DIMENSIONS
Issue #4:
246 x 300 mm
$9^{11}/_{16}$ x $11^{13}/_{16}$ in
Issue #5:
215 x 265 mm
$8^{1}/_{2}$ x $10^{7}/_{16}$ in

mu Magazine

(m u)
M A G A Z I N E # 5

DESIGNER
Deanne Cheuk

PHOTOGRAPHERS
Nghi
Justin Chan (cover,
issue #4)

DESIGN COMPANY
Surfacepseudoart

5351

Story/Interview by Estelle Viskovich

I n Tokyo's Daikanyama where cool and cute themed shops vie for attention, rises a clear space of glass and bare concrete, cooling to the eye. It houses the gallery 'Speakfor', mainly modern, mainly photography, in its basement. On the ground floor is a concept store with labels from Abahouse International Company that offers a delicious smorgasbord of styles pitched to "those with international lifestyle and sensitivity". I wander upstairs to check out the label 5351 when I'm gripped by that sudden burst of heat that drives you with a credit card nestled in your pocket and a wicked gleam in your eye. I begin to thumb through the racks. White, slate, black, the colours of charred driftwood and smoke... shades of a whitesand beach on a bleak day... complete with a tangle of orange, a snarl of beacon red. The silhouettes are simple, often sleeveless, bagged at the neck, columns of stretch and bonded fabric, softened by drawstrings or strapped to the body with accessories including absolutely the best wrist-glove of the summer in white punched leather. A distillation of the past few decades when elegant has become practical, casual has become essential and streamlined.

It slowly becomes naggingly apparent that there is not one piece in this shop you would not gladly put on your body and slink out the door. The term "wearable" is much bandied about in fashion circles, often euphemistically meaning boring or tarting up featureless — this is not the case at 5351. The clothes beg to be slipped on, each garment promising to make you feel sexier, taller, probably younger, definitely up-to-the-minute by throwing a twist — a zip — something that can be styled according to each wearer's sensibility.

The feeling I get on stage, is like when you don't know if you want to pee or not. You go to the toilet feeling that you want to pee, but nothing comes out."

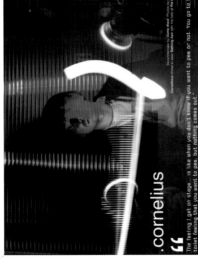

.cornelius

"

PIZZICATO FIVE

Story/Interview by Garreth Wills

IN OMIYA MAKI, Darlin' of Discotheque is often referred to as the most glamorous woman in Japan. This chameleon princess is simply one of the nicest women I have ever met. With all the reason to behave like a star, she is shy, quietly poised and unaffected by the glamour of her life. Having recently returned from her tour of Italy, I ran into Maki and her entourage in downtown Daikanyama and we ducked into a French café for an iced frappacino.

Pizzicato Five were invited to attend the Viennale to represent Japanese music. This year's Viennale was the biggest ever and Maki dazzled the audience with her exquisite voice and dime-sized sequins artfully arranged in the form of a dress by her stylist and costumier, Vaughan Alexander. A group accustomed to glamour, they arrived in Venice by water taxi on a balmy evening, and resided in the Hotel dei do Doges, Venice's premier lodging, with a romantic view of the city. This was the first leg of a tour of prestigious appearances.

Post Viennale high, Pizzicato and styling team took to the road, heading for the fashion capital, where they performed at an opening party to the Mulccia and Tom's of Milan. A Maki, La Dolce Vita style, at the entrance to the club, set on a lake outside of the city. It took seven security guards to get her through the crowd where again she mesmerized the audience, hundreds of young Italians singing in Japanese.

The next show was in Reggio Emilia for the International Lounge Festival as the headlining act. On the advice of her stylist, the tour bus made a detour through the Italian countryside to Lugo, Riviena. They descended like wolves to the slaughter on the store Angelo, "a nice story vintage Palazzo with racks and racks crammed with vintage designer clothing from every era", explains Vaughan. "There was a Louis Vuitton leather bomber jacket from the 80's, it was beautiful. We were following each other around the store competing for the best buys. Veronique Leroy was there, we followed her too, to make sure she got nothing better than we did." Maki bought two duffel bags full of clothes, almost all from the 60's and early 70's, among them seven hippie peasant smocks with ethnic embroidery.

INTERM

ISSION

Part 2

one love
one heart

(OUT OF MANY ONE PEOPLE)

this generation creates the link...

Rock Steady

COUNTRY OF ORIGIN
France

ARTWORK DESCRIPTION
Collage on the
theme of "cultural
exploration:
generational/social
quest."

DIMENSIONS
640 x 420 mm
24 3/16 x 16 9/16 in

DESIGNER
R. L. Holloway

ART DIRECTION
R. L. Holloway

ILLUSTRATOR
R. L. Holloway

DESIGNER
Andrea Tinnes

ILLUSTRATOR
Andrea Tinnes

COUNTRY OF ORIGIN
USA/Germany

Andrea: A Typeface Design Project in Progress

ARTWORK DESCRIPTION
Poster displaying the
typeface Andrea, and
illustrating the idea
behind its design.

DIMENSIONS
297 x 210 mm
11¹¹/₁₆ x 8¹/₄ in

The Ringing Grooves of Change

DESIGNER
Andrea Tinnes

ILLUSTRATOR
Andrea Tinnes

PHOTOGRAPHER
Andrea Tinnes

COUNTRY OF ORIGIN
USA/Germany

ARTWORK DESCRIPTION
Double-sided
invitation to celebrate
the designer's 30th
birthday.

DIMENSIONS
100 x 228 mm
3 15/16 x 9 in

DESIGNER
Roger Fawcett-Tang

ART DIRECTOR
Roger Fawcett-Tang

ILLUSTRATOR
Roger Fawcett-Tang

Struktur Design – Perpetual Kalendar

Perpetual Kalendar

ARTWORK DESCRIPTION
Ring-bound calendar containing 14 complete years, and a chart to find the correct page for the current year. The calendar can be used until the year 2343.

DIMENSIONS
210 x 210 mm
8¼ x 8¼ in

DESIGN COMPANY
Struktur Design

COUNTRY OF ORIGIN
UK

Densha Version 3

電車

SIGNERS
venty2product

T DIRECTORS
venty2product

UND DESIGN
sumu Hirasawa

NEMATOGRAPHY
venty2product

DESIGN COMPANY
Twenty2product

COUNTRY OF ORIGIN
USA

ARTWORK DESCRIPTION
Short video about
Tokyo's Shinjuku train
(densha) station.

DIMENSIONS
Vary according
to screen size

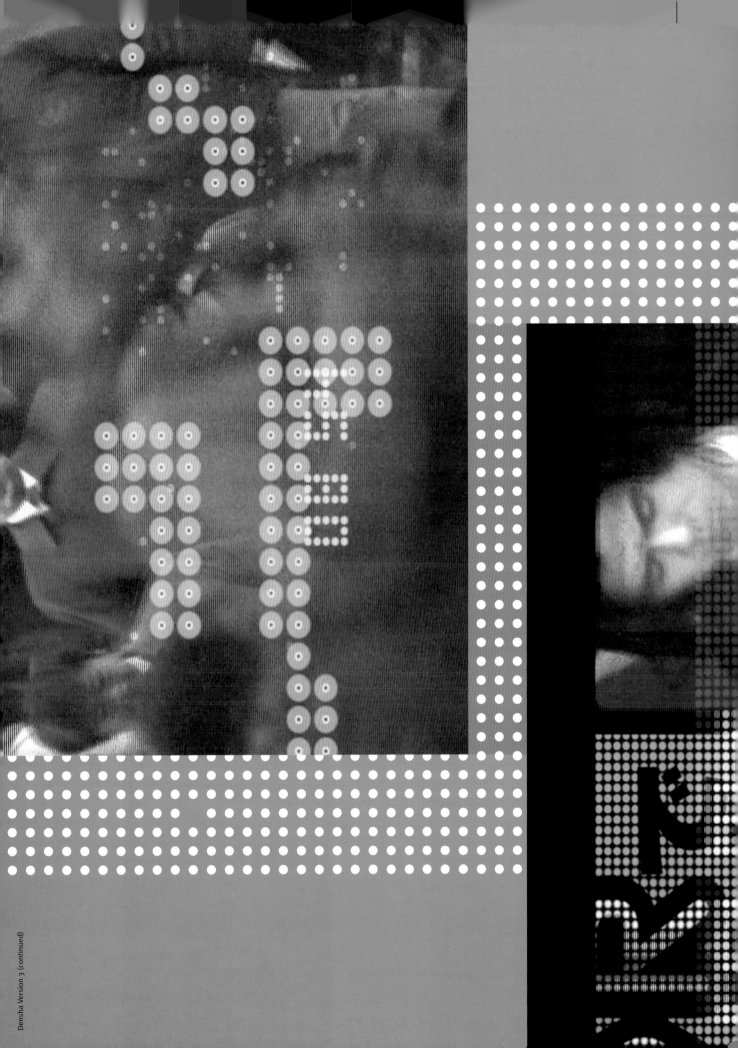

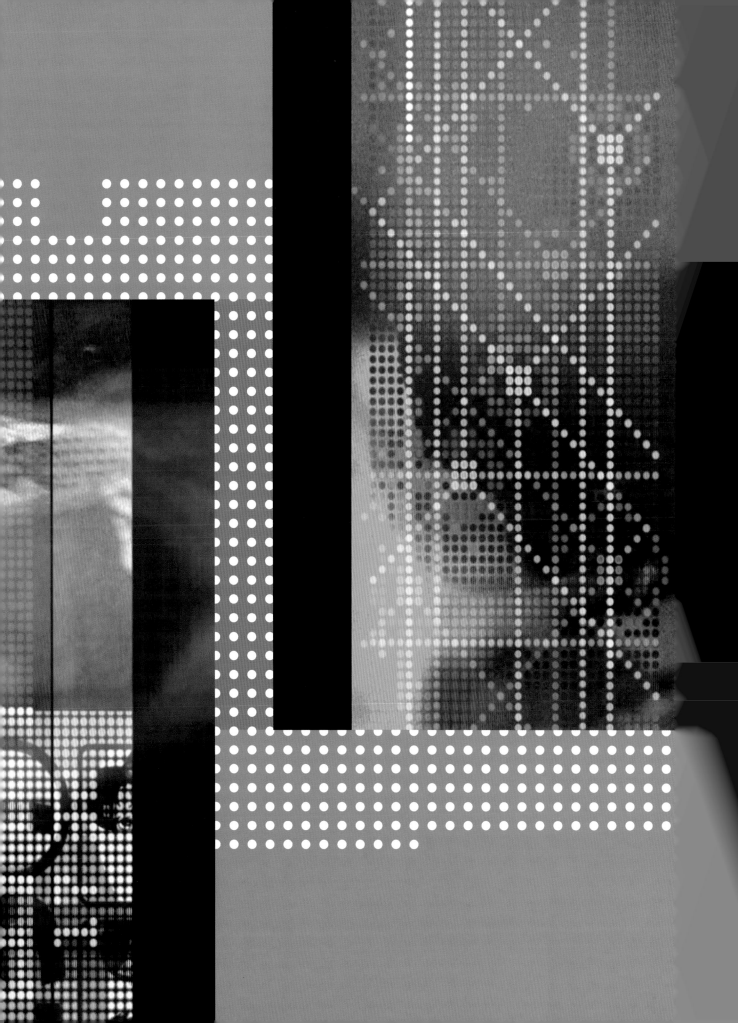

ARTWORK DESCRIPTION
Leaflet for the Design Support Centre, printed two-color with spot-UV varnish.

Design Support Centre

CRACKTHENUT

DO YOU KNOW YOUR PRODUCT USERS – AND HOW THEY USE YOUR PRODUCTS?
Product users are the people who actually use your product(s) – not necessarily the people who manufacture or buy them.

ARE YOUR COMPETITORS SUCCEEDING BECAUSE THEY ARE BETTER AT ADDRESSING THE NEEDS OF PRODUCT USERS?
DOES YOUR PRODUCT LIMIT – OR MAXIMISE – ADDED VALUE FOR THE USER?
WOULD YOU LIKE TO GENERATE INNOVATIVE PRODUCT DESIGN BRIEFS, DEVELOPED WITHIN CLEAR PARAMETERS AND FIXED PRICES?

CAN dsc HELPYOUCRACKIT?

We can work with you to investigate, analyse and develop concepts, using skilled creative thinking and problem-solving, informed by an in-depth understanding of user needs.

DOES YOUR COMPANY...
MAKE PRODUCTS USED BY PEOPLE, WHERE THE USER NEEDS ARE UNCLEAR OR CHANGED?
FACE DECLINING SALES OR MARKET SHARE?
WANT TO CHECK THAT YOU ARE GETTING MAXIMUM VALUE FROM EXISTING PRODUCT(S)?
WANT TO DEVELOP AND EXTEND THE LIFE-SPAN OF EXISTING PRODUCT(S)?
Research and experience prove that if the product brief is right "If you really want a product that works, a product that has a at the early conceptualisation stage, there is a higher chance sustainable future, a product that offers the most added value

design support centre yet it

1 IDENTIFY CLIENT PRODUCT NEEDS, SHORT & LONG-TERM

2 AGREE ON PROPOSALS FOR CONCEPT DEVELOPMENT BASED ON STAGE 1

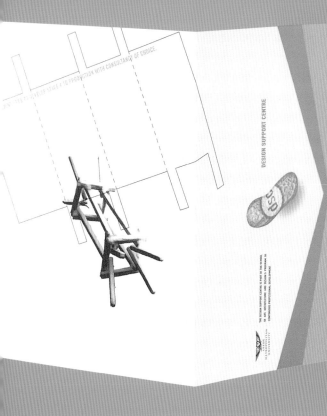

OPENINGUPYOURIDEAS...

We have the advantage of a transparent, fixed fee development process – each stage has an all-inclusive fee, so you know exactly what to budget before you commit. Retaining the ownership of the design rights can be included in the fee. If this is the case you are free to develop the ideas up to production with other consultancies – or choose to continue further development with DSC.

We promise you an enjoyable, profitable journey, based on a (dsc) fees to include all research and concept design and development including full scale mockup and can include client ownership of design rights (does not include materials used for mockup development) three-stage development process.

1 **IDENTIFY CLIENT PRODUCT NEEDS, SHORT & LONG TERM** 2 **AGREE ON PROPOSALS FOR CONCEPT DEVELOPMENT** BASED ON STAGE 1 3 **PRESENTATION OF DESIGN CONCEPTS IDENTIFYING** APPROACH AGREED AT STAGE 2 PLUS FULL SCALE DESIGN MOCKUPS 4 **CLIENT FREE TO DEVELOP STAGE 3 TO PRODUCTION WITH CONSULTANCY OF CHOICE.**

ASSESSING AN EXISTING PRODUCT OR NEW PRODUCT IDEA Rather than simply looking at what the competitors are doing, we take an in-depth look at changing user needs and help you to identify the true market need, where both you and the end-user will get the most value.

REDEFINING THE BRIEF Based on the agreed user needs, we look at the brief and include all the parties vital to the success of your product. As well as the actual production processes, we will analyse a range of other key factors that will affect your product potential, such as buyers, distributors and agents.

AND, DEVELOPING THE DEFINITIVE DESIGN At this stage we can work with you to get the idea ready for product and market evaluation, often including the creation of a working prototype, if you choose.

AREWEUSERFRIENDLY?

INANUTSHELL

CREATING A CENTRE OF EXCELLENCE IN DESIGN PRACTICE

ENABLING MORE BUSINESS PEOPLE (ESPECIALLY MANUFACTURERS) TO ACCESS KEY INITIAL ASPECTS OF THE DESIGN PROCESS MORE EFFECTIVELY

DESIGN SUPPORT CENTRE

DESIGNER
Pat Walker

PHOTOGRAPHER
Mark Harvey

DESIGN COMPANY
Eg.G

COUNTRY OF ORIGIN
UK

DIMENSIONS
148 x 600 mm
5 13/16 x 23 10/16 in

The Unusual Suspects

COUNTRY OF ORIGIN
UK

ARTWORK DESCRIPTION
Book, reviewing the Photo '98 art commissions in Yorkshire, printed five-color and die-cut.

DIMENSIONS
210 x 148 mm
$8^1/_4$ x $5^{13}/_{16}$ in

SIGNER
m Raban
t Walker

F DIRECTOR
m Raban

OTOGRAPHERS
rious

SIGN COMPANY
G

THE PHOTOGRAPHIC

RAILWAY STATION, FILEY *NORTH BEACH, BRIDLINGTON* *SEAFRONT, FILEY* *CEMETERY HILL, BRIDLINGTON*

stephen cornell point of departure

robert hardy

tzang hotland

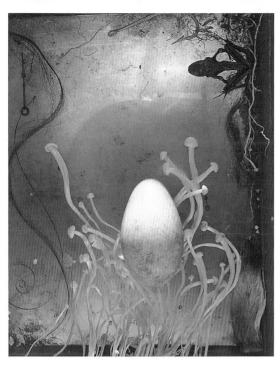

<< IT IS ENTIRELY REASONABLE TO CONSIDER SOME CELLS TO BE IMMORTAL... THE LIFE OF A SPECIES CAN STRETCH IN AN UNBROKEN CHAIN BACK TO SOME ORIGINAL CELL IN THE PAST >>

>> LUC SANTE, LOW LIFE

NIGHT IS THE TEXT OF A SECRET HISTORY... NIGHT IS A BRIDGE TO THE PAST

<< NIGHT IS THE TEXT OF A SECRET HISTORY... NIGHT IS A BRIDGE TO THE PAST >>

tim etheris & hugo glendinning with forced entertainment nightwalks

RALPH SMOKES TOO MUCH RALPH had a thing about removing his trousers – for weeks he had been trying to give up smoking – clothing removal, it appeared, was an essential part of the complex therapeutic process. **TRUDY** was unaware of this as she was preoccupied with a fraction she had about small children.

LILY'S DINNER PARTY LILY called **FRANK** one Autumn evening to tell her she'd finally got round to killing her husband **CLIVE**. She told **FRANK** how she'd shot **CLIVE** in the back of the head using an antique pistol she'd bought him for Christmas, and how surprised she was to find that it could be so effective after what must have been a century of not being fired. **FRANK** was a little taken aback at **LILY**'s seemingly casual attitude towards her husband's death – this become increasingly irrelevant as **LILY** relayed the rest of her story. That same evening she had invited **CLIVE**'s parents over to dinner – she told **FRANK** how fortunate she felt it was that they had recently installed a heated marble floor throughout the apartment – this meant the cleaning up operation became a lot less infuriating than had they stuck with the shagpile carpet – although **LILY**'s fondness for the retro-style design had been the one since she had written that article on seventies design for a fashionable magazine that is only available in galleries or by mail-order – she seemed pleased at the decision to go with **CLIVE**'s apparent fascination for minimalism. **FRANK**. *So how did the dinner party go?* **LILY** *A lot less of a problem than I thought.* **LILY** told **FRANK** the initial problem was finding **CLIVE**'s body in a place where **CLIVE**'s mother was unlikely to go. The bathroom was out of the question as **CLIVE**'s father **GEORGE** has had a severe bladder problem ever since he was hit in the face by a cricket ball whilst playing for his county team in the late sixties.

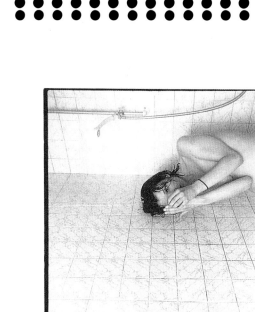

Eg.Gi.Sg.OODf.ORy.OU

DESIGNER
Pat Walker

PHOTOGRAPHER
Pat Walker

DESIGN COMPANY
Eg.G

COUNTRY OF ORIGIN
UK

ARTWORK DESCRIPTION
Self-promotional
CD-ROM

DIMENSIONS
Vary according
to screen size

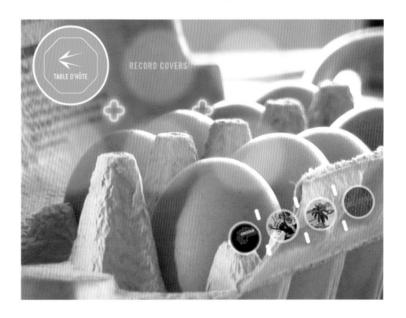

Promocard

illustration

DESIGNER
Susanne Saenger

ART DIRECTOR
Susanne Saenger

ILLUSTRATOR
Susanne Saenger

Arbeitsbeispiele
(miniaturisiert,
farblich verfremdet
und in Ausschnitten)

Grafik-Design (<)

1. **Visitenkarte**
 (Schmuckdesignerin)
2. **Webdesign**
 (Hewlett Packard),
3. Ausschnitt aus **CI**
 einer Apotheke
4. **Packaging**
 (Wella AG / yellow circle)
5. **Neujahrskarte**
 (yellow design)
6. **Logo / CI**
 (beta computer automation)

Illustration (>>)

a. **Hund** (bsb-sticker)
b. **Diva** (Süddeutsche
 Zeitung-Magazin)
c. **Landschaft** (SZ-Magazin)
d. **Fisch** (Allegra)
e. **Wolf** (Greenpeace Magazin)
f. **Kakerlake** (freie Arbeit)
g. **Keks** (Springer & Jacoby/
 Deutsche Telekom)
h. **zwei lustige Friseusen**
 (SZ-Magazin)
i. **Diverses** (Greenpeace,
 SZ-Magazin, Spiegel/S&J)

Susanne Saenger
Diplom Designerin
Badener Strasse
D-76227 Karlsruhe
Tel +49 721 941
Fax +49 721 941

e-mail Susanne.Sa
@t-online.de
http://home.t-onli
home/susanne.saen

anne saenger
+49 721 9416104

1

2

DESIGN

4

>

>>

grafik-design

all this and much more
ping **mr.joe** / space-
key, beautiful polly etc.)
http://home.t-online.de/
e/susanne.saenger
t to send an **e-mail** ?: ->
nne.saenger@t-online.de
urther information
inside! > > > > > > >

flowers

5

beta

6

with compliments

COUNTRY OF ORIGIN
Germany

ARTWORK DESCRIPTION
Self-promotional card

DIMENSIONS
210 x 150 mm
8^1/$_4$ x 5^7/$_8$ in

MTV Up Front

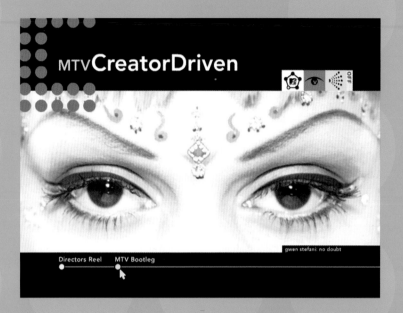

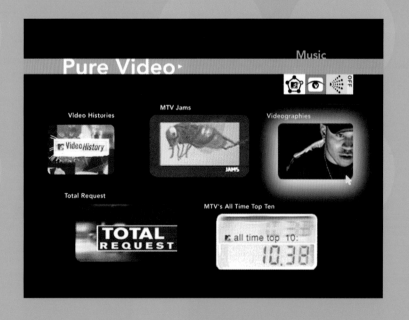

DESIGNERS
David Slatoff
Tamar Cohen
Rion Nakaya
Yael Eisele

ART DIRECTORS
David Slatoff
Tamar Cohen

PHOTOGRAPHER
Guzman

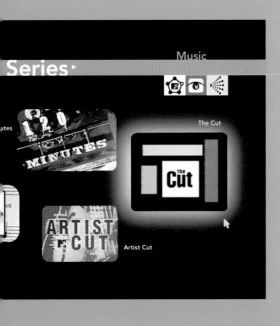

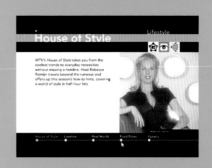

DESIGN COMPANY
Slatoff + Cohen
Partners Inc.

COUNTRY OF ORIGIN
USA

ARTWORK DESCRIPTION
Interactive CD-ROM
sales presentation
for MTV.

DIMENSIONS
Vary according
to screen size

Closefonts Website

DESIGNERS
Christina Glahr
Dirk Uhlenbrock
Peter Bruhn
Simon Schmidt

ART DIRECTOR
Simon Schmidt

DESIGN COMPANIES
Lorem ipsum
Signalgrau

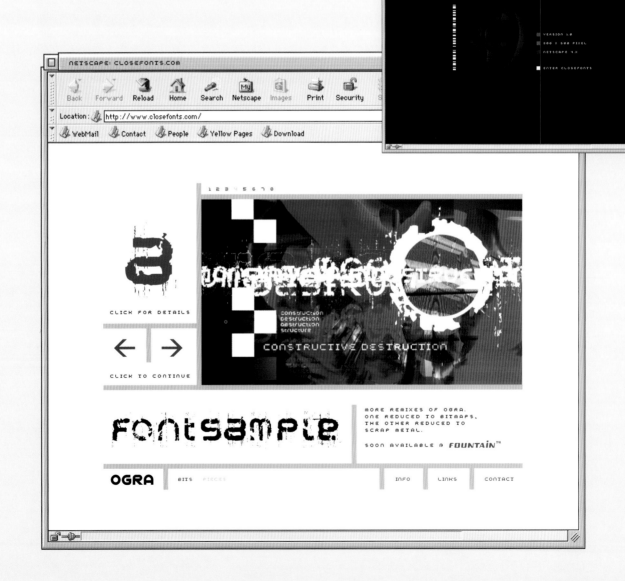

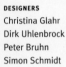

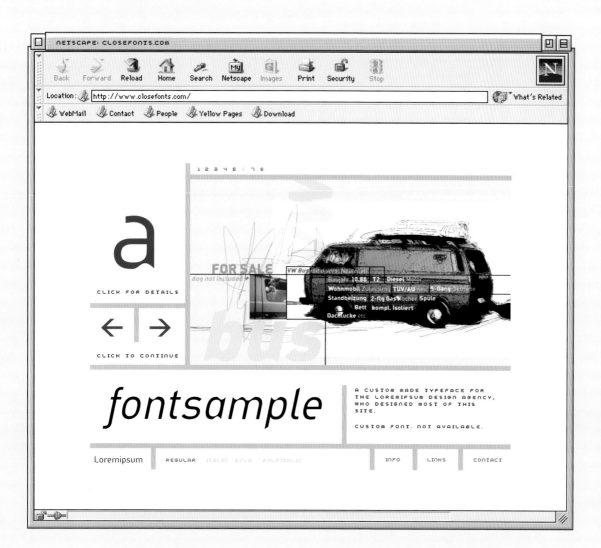

COUNTRY OF ORIGIN
Germany

ARTWORK DESCRIPTION
Website to promote Closefonts' typeface designs.

DIMENSIONS
800 x 600 pixels

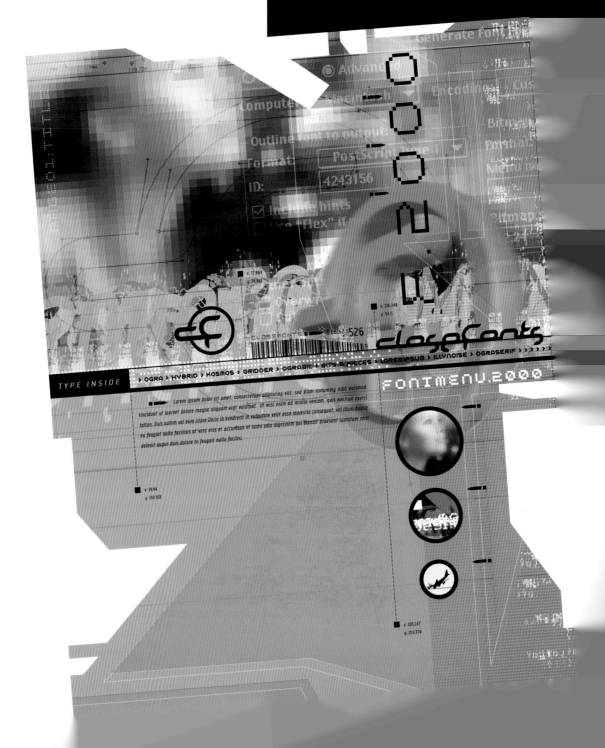

DESIGNER
Simon Schmidt

ART DIRECTOR
Simon Schmidt

DESIGN COMPANY
Lorem ipsum

COUNTRY OF ORIGIN
Germany

ARTWORK DESCRIPTION
Brochure to promote
Closefonts' typeface
designs.

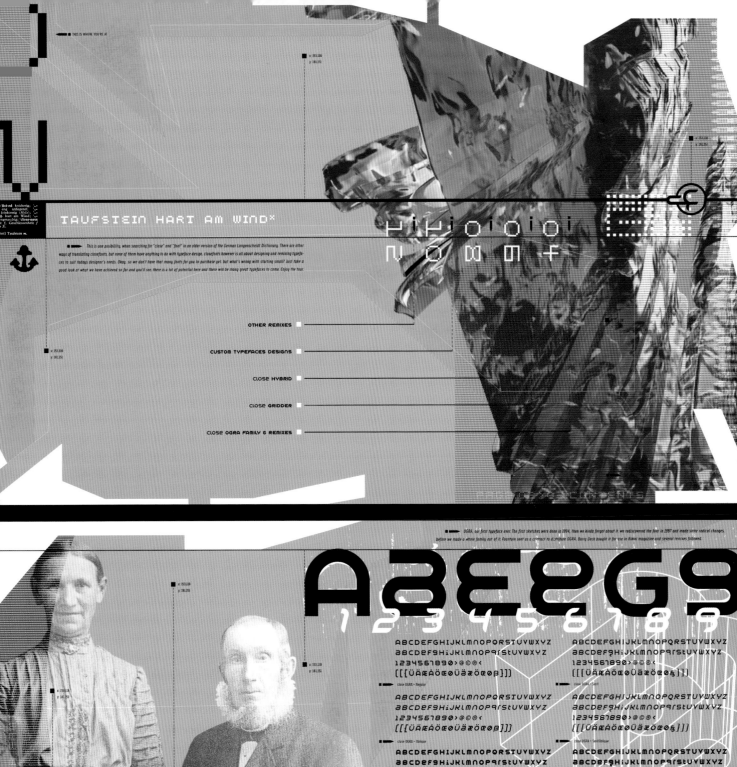

TAUFSTEIN HART AM WIND×

→ This is one possibility, when searching for "close" and "font" in an older version of the German Langenscheidt Dictionary. There are other ways of translating closefonts, but none of them have anything to do with typeface design. closefonts however is all about designing and remixing typefaces to suit todays designer's needs. Okay, so we don't have that many fonts for you to purchase yet, but what's wrong with starting small? Just take a good look at what we have achieved so far and you'll see, there is a lot of potential here and there will be many great typefaces to come. Enjoy the tour.

OTHER REMIXES

CUSTOM TYPEFACES DESIGNS

CLOSE HYBRID

CLOSE GRIDDER

CLOSE OGRA FAMILY & REMIXES

→ OGRA, our first typeface ever. The first sketches were done in 1994, then we kinda forgot about it. we rediscovered the font in 1997 and made some radical changes, before we made a whole family out of it. Fountain sent us a contract to distribute OGRA. Barry Deck bought it for use in Bikini magazine and several remixes followed.

ABEEGG
1234567890

ABCDEFGHIJKLMNOPQRSTUVWXYZ
ABCDEFGHIJKLMNOPQRSTUVWXYZ
1234567890>@©<
[[[ÜÄÆÅÖŒØÜÄÆÖŒØß]]]

→ close OGRA · Regular

ABCDEFGHIJKLMNOPQRSTUVWXYZ
ABCDEFGHIJKLMNOPQRSTUVWXYZ
1234567890>@©<
[[[ÜÄÆÅÖŒØÜÄÆÖŒØß]]]

→ close OGRA · Oblique

ABCDEFGHIJKLMNOPQRSTUVWXYZ
ABCDEFGHIJKLMNOPQRSTUVWXYZ
1234567890>@©<
[[[ÜÄÆÅÖŒØÜÄÆÖŒØß]]]

→ close OGRA · Boss

ABCDEFGHIJKLMNOPQRSTUVWXYZ
ABCDEFGHIJKLMNOPQRSTUVWXYZ
1234567890>@©<
[[[ÜÄÆÅÖŒØÜÄÆÖŒØß]]]

→ close OGRA · Serif

ABCDEFGHIJKLMNOPQRSTUVWXYZ
ABCDEFGHIJKLMNOPQRSTUVWXYZ
1234567890>@©<
[[[ÜÄÆÅÖŒØÜÄÆÖŒØß]]]

→ close OGRA · SerifOblique

ABCDEFGHIJKLMNOPQRSTUVWXYZ
ABCDEFGHIJKLMNOPQRSTUVWXYZ
1234567890>@©<
[[[ÜÄÆÅÖŒØÜÄÆÖŒØß]]]

→ close OGRA · BoldOblique

Remixes not included

+Remixes ∞

zwei boxkämpfer jagen eva quer durch sylt

A B C D E F G H I J K L M N O P Q R S T U V W X Y Z
abcdefghijklmnopqrstuvwxyz

ART DIRECTORS
David Harlan
Larimie Garcia

DESIGN COMPANY
Pop Glory

Putting the "M" in Music

COUNTRY OF ORIGIN
USA

ARTWORK DESCRIPTION
Station identity for
MTV.

DIMENSIONS
640 x 480 pixels

putting the M in music

Seagate

ESIGNER
avid Harlan

RT DIRECTOR
el Templin

ESIGN COMPANY
op Glory

COUNTRY OF ORIGIN
USA

ARTWORK DESCRIPTION
Seagate TV
commercial for Foote,
Cone and Belding.

DIMENSIONS
640 x 480 pixels

Workbook Pages (01.99)

DESIGNER
Paul Maye

ARTWORK DESCRIPTION
Workbook of ideas, sketches (for work in a variety of media), and typographic and design exercises.

PHOTOGRAPHER
Paul Maye

DIMENSIONS
297 x 180 mm
11^{11}/$_{16}$ x 7^1/$_8$ in

COUNTRY OF ORIGIN
Ireland

Page ②

Barcode Sequence: Printed transparency sheets. POS/NEG?

Positive. Background change for each frame.

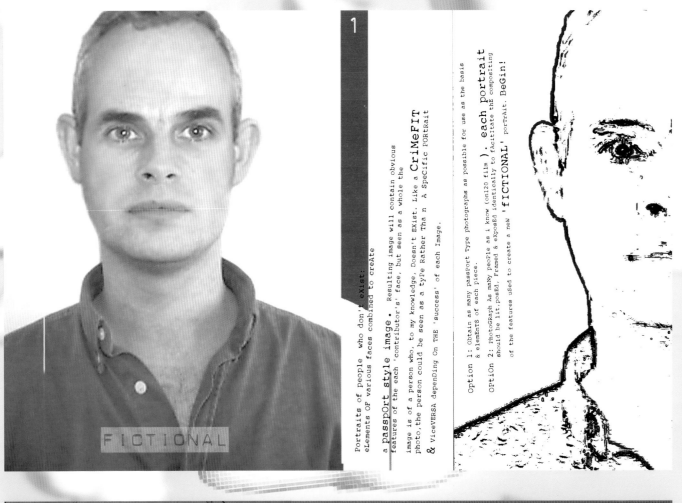

FICTIONAL

Portraits of people who don't exist: eLements OF various faces combined to create a passPOrt style image. Resulting image will contain obvious features of the each 'contributor's' face, but seen as a whole the image is of a person who, to my knowledge, Doesn't EXist. Like a CriMeFIT photo, the person could be seen as a tyPe Rather Tha n A SpeCific POrtrait & ViceVERSA depenDing On THE 'success' of each Image.

Option 1: Obtain as many passPOrt Type photographs as possible for use as the basis & eleMnTs of each piece.

OptiOn 2: PhotoGraph As mANy people as i know (onl20 film). each portrait should be lit:poEd, Framed & eXposEd identically to fAcititate thE compositing of the features uSed to create a new 'FICTIONAL' portrAit. BeGin!

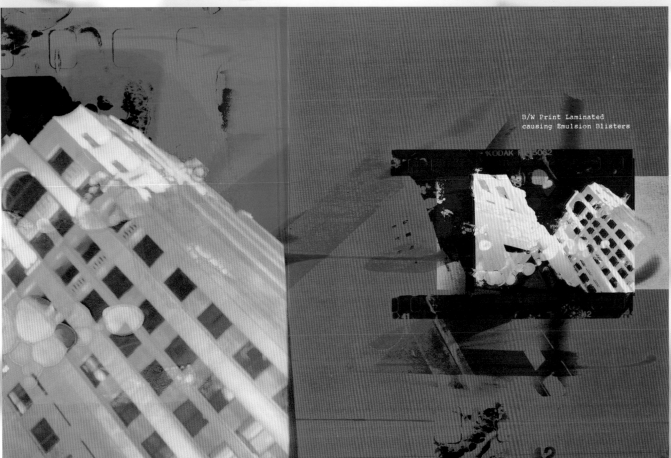

B/W Print Laminated causing Emulsion Blisters

KODAK

101010

MUSIC+ MATHEMATICS+ MAGIC

ELIXIR

01010+ 01001010100+ 01010

COUNTRY OF ORIGIN
UK

ARTWORK DESCRIPTION
Record sleeve and
disk labels for Elixir,
including a specially
designed binary font.

DIMENSIONS
305 x 305 mm
12 x 12 in

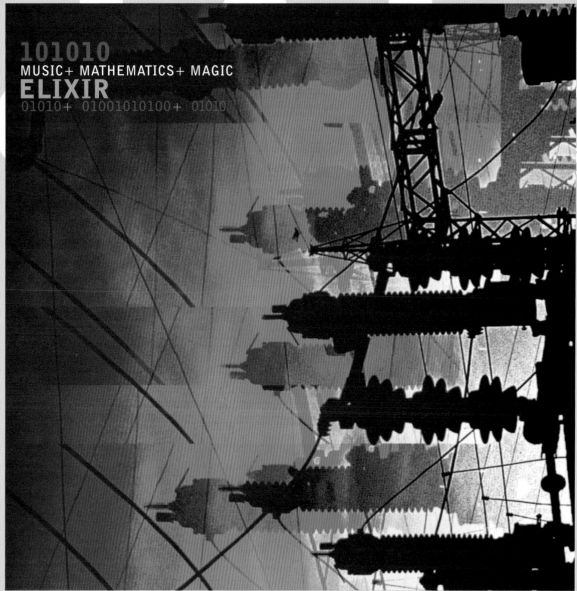

101010
MUSIC+ MATHEMATICS+ MAGIC
ELIXIR
01010+ 01001010100+ 01010

Elixir

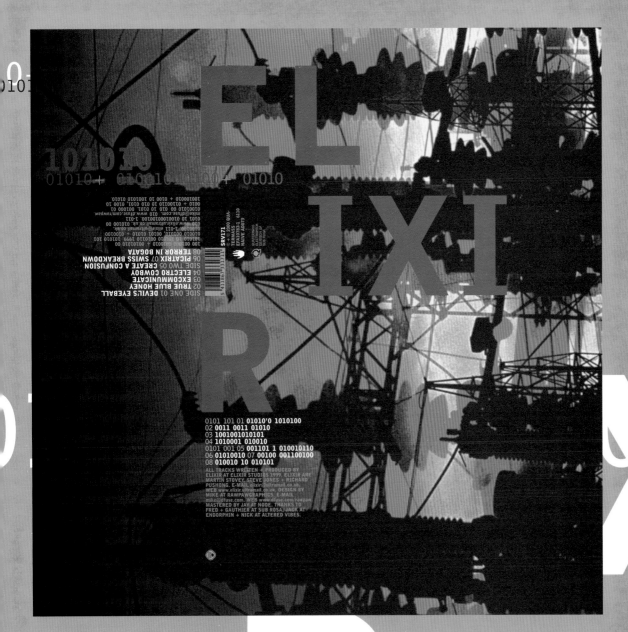

SIDE ONE 01 DEVIL'S EYEBALL
02 TRUE BLUE HONEY
03 EXCOMMUNICATE
04 ELECTRO COWBOY
SIDE TWO 05 CREATE A CONFUSION
06 PICATRIX 07 SWISS BREAKDOWN
08 TERROR IN BOGATA

0101 101 01 01010'0 1010100
02 0011 0011 01010
03 1001001010101
04 1010001 010010
0101 001 05 001011 1 010010110
06 01010010 07 00100 001100100
08 010010 10 010101

ALL TRACKS WRITTEN + PRODUCED BY
ELIXIR AT ELIXIR STUDIOS 1999. ELIXIR ARE
MARTIN STOVEY, STEVE JONES + RICHARD
PUSHONG. E-MAIL elixir@ultramail.co.uk.
WEB www.elixir.ultramail.co.uk. DESIGN BY
MIKE AT RAWPAWGRAPHICS. E-MAIL
mike@dfuse.com. WEB www.dfuse.com/rawpaw.
MASTERED BY JAY AT NODE. THANKS TO
FRED + GAUTHIER AT SUB ROSA, JACK AT
ENDORPHIN + NICK AT ALTERED VIBES.

DESIGNER
Michael Faulkner

ART DIRECTOR
Michael Faulkner

PHOTOGRAPHERS
Raw-Paw
Digital Vision

DESIGN COMPANY
Raw-Paw

DESIGNER
Stephen Schuster

DESIGN COMPANY
Element

COUNTRY OF ORIGIN
USA

ARTWORK DESCRIPTION
Poster for the typeface Inferno Alpha, a variation on Inferno. Both typefaces are "based on the first part of Dante's Divine Comedy."

DIMENSIONS
610 x 914 mm
24 x 36 in

Inferno Alpha
(this page)

Inferno
(opposite page)

DESIGNER
Stephen Schuster

DESIGN COMPANY
Element

COUNTRY OF ORIGIN
USA

ARTWORK DESCRIPTION
Poster featuring the typeface Inferno and a Photoshop collage focusing on the atmosphere of hell.

DIMENSIONS
203 x 152 mm
8 x 6 in

ABANDON HOPE, ALL YE WHO ENTER HERE

Paradiso Alpha

DESIGNER
Stephen Schuster

DESIGN COMPANY
Element

COUNTRY OF ORIGIN
USA

ARTWORK DESCRIPTION
Poster showcasing the typeface Paradiso, which is inspired by the celestial level of Dante's *Divine Comedy*.

DIMENSIONS
610 x 914 mm
24 x 36 in

DESIGNER
Stephen Schuster

DESIGN COMPANY
Element

COUNTRY OF ORIGIN
USA

ARTWORK DESCRIPTION
Poster displaying the typeface Purgatorio, which is based on the second level of Dante's *Divine Comedy*.

DIMENSIONS
610 x 914 mm
24 x 36 in

Purgatorio Alpha

COUNTRY OF ORIGIN
Switzerland

ARTWORK DESCRIPTION
Monthly club flyer

DIMENSIONS
130 x 130 mm
5 1/8 x 5 1/8 in

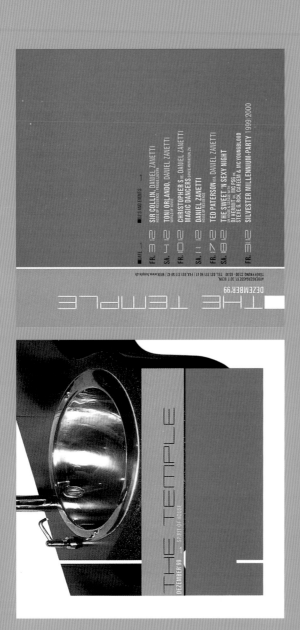

The Temple Programs

DESIGNERS
arco Simonetti
alter Stähli
rahim Zbat

PHOTOGRAPHERS
arco Simonetti
alter Stähli
rahim Zbat

DESIGN COMPANY
alhalla

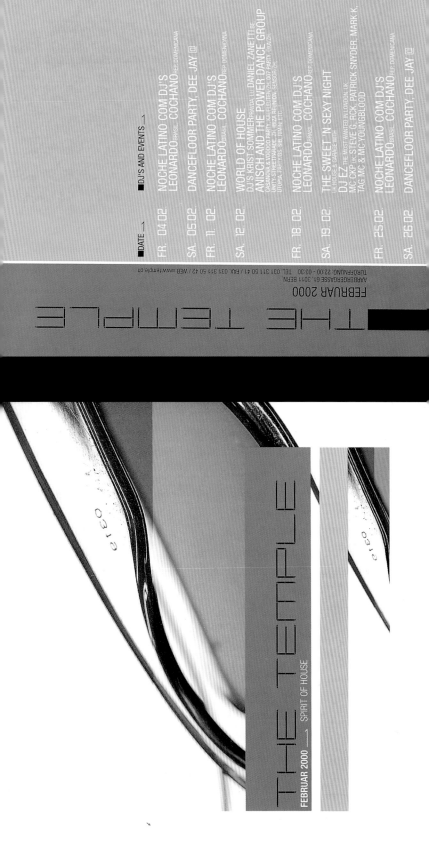

THE TEMPLE

FEBRUAR 2000 ——→ SPIRIT OF HOUSE

THE TEMPLE

FEBRUAR 2000

AARBERGERGASSE 61, 3011 BERN
TÜRÖFFNUNG: 22:00 – 03:30 TEL. 031 311 50 41 / FAX: 031 311 50 42 / WEB: www.temple.ch

■ DATE →

■ DJ'S AND EVENTS →

DATE	DJ'S AND EVENTS
FR. 04.02.	NOCHE LATINO COM DJ'S LEONARDO BRASIL. COCHANO REP. DOMENICANA
SA. 05.02.	DANCEFLOOR PARTY, DEE JAY CH
FR. 11. 02.	NOCHE LATINO COM DJ'S LEONARDO BRASIL. COCHANO REP. DOMENICANA
SA. 12. 02.	WORLD OF HOUSE DJ'S KRIST SOMMER PANDA LU DANIEL ZANETTI BE ANISCH AND THE POWER DANCE GROUP CASANOVA & VOODOO PARTY KOUFI ELTEN/ZH, 007 PARTY (MAX21), UNITY STREETPARADE /ZH, IBIZA REUNION, SENSOR /ZH, UTOPIA PARTY/BS, SBI, TIMAN, ETC...
FR. 18. 02.	NOCHE LATINO COM DJ'S LEONARDO BRASIL. COCHANO REP. DOMENICANA
SA. 19. 02.	THE SWEET 'N SEXY NIGHT UK-HOUSE & GARAGE WITH DJ EZ THE MOST WANTED IN LONDON, UK MC CKP UK, STEVE G, RCK, PATRICK SNYDER, MARK K. TAG MC & MC YOUNGBLOOD
FR. 25.02.	NOCHE LATINO COM DJ'S LEONARDO BRASIL. COCHANO REP. DOMENICANA
SA. 26.02.	DANCEFLOOR PARTY, DEE JAY CH

Guayas Flyers

DESIGNERS
Marco Simonetti
Walter Stähli
Ibrahim Zbat

DESIGN COMPANY
Walhalla

PROGRESSIVE/TRANCE
RELEASE PARTY
OF DJ MYSTERY'S FIRST RECORD "KISS THE FUTURE"
SAMSTAG, 11. SEPTEMBER 98, 22h00

guayas guayas bar und club, parkterrasse 16, 3012 bern tel 031 318 70 75 fax 318 70 76

PROGRESS
22h00
FRETTA

guayas guayas bar und

OBSESSION INKA IMPERIO
SONIC-T INKA IMPERIO
DYNAMIC OUTBREAK RECORD

RELEASE PARTY OF DJ MYSTERY'S FIRST RECORD "KISS THE FUTURE"
DJ MYSTERY
SPECIAL GUEST: DJ PURE

BASELS NUMMER 1 DJ schlägt
mit seiner ersten produktion zu.
"kiss the future" wird unter dem
projektnamen "dj mystery &
amadeus" auf modular records
veröffentlicht.

walhallaartforce
Parisienne partynews

walhallaartforce

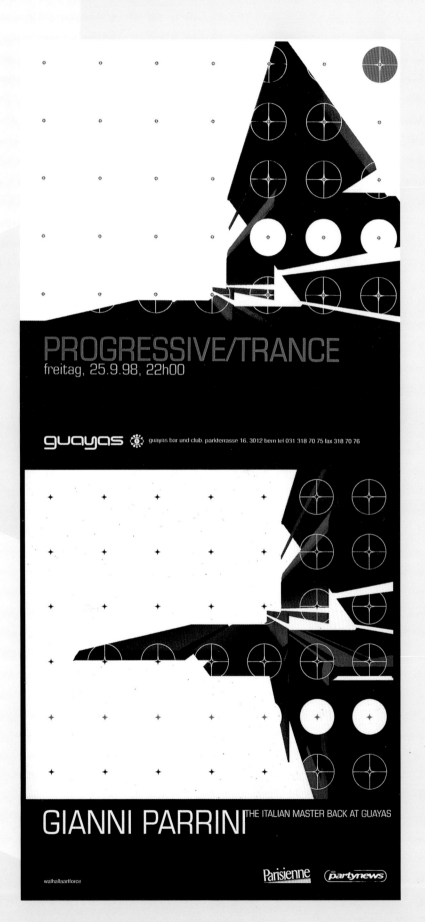

PROGRESSIVE/TRANCE
freitag, 25.9.98, 22h00

guayas guayas bar und club. parkterrasse 16, 3012 bern tel 031 318 70 75 fax 318 70 76

GIANNI PARRINI THE ITALIAN MASTER BACK AT GUAYAS

walhallaartforce

COUNTRY OF ORIGIN
Switzerland

ARTWORK DESCRIPTION
Club flyers

DIMENSIONS
104 X 104 mm
4¹/₈ X 4¹/₈ in

DESIGNERS

Marco Simonetti
Walter Stähli
Ibrahim Zbat

DESIGN COMPANY

Walhalla

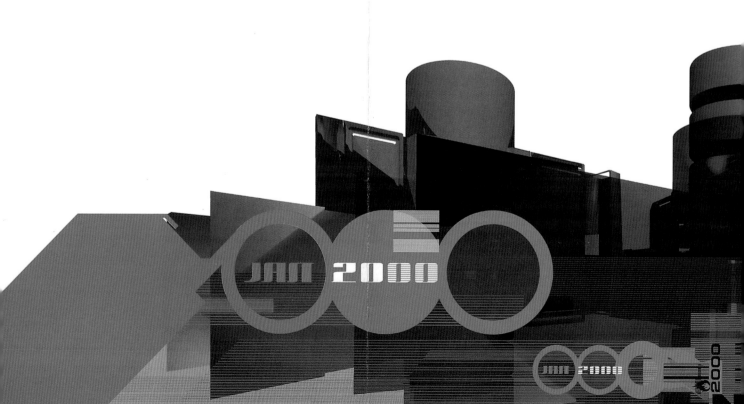

LOVEZOO
Scheibenstrasse 27A 33, 3600 Thun

JOURS OUVRABLES: VENDREDI ET SAMEDI DES 22H00
DJ'S RESIDENTS: DAVE DAVIS, NUKEM
CAPACITE: 700 PERS / TWO FLOORS
ENTREE: 15.-
EAU: 5.- **ALCOOL:** 10.- (6cl)
EVERY FRIDAY IN JANUARY: FREE ENTRY FOR LADIES

januier 2000

INFO LINE_ 079/689 06 57
FAX: 033/221 48 56
TEL. 033/221 48 55
WEBSITE: WWW.LOVEZOOCLUB.CH
BOOKING_PRAZ ISABELLE 079/689 06 57

MAILING LIST, ENVOI DE TAPES_
POUR RECEVOIR LE PROGRAMME, LES FLYERS ET
INVITATIONS, ENVOYEZ VOTRE ADRESSE A:
Scheibenstrasse 27A 33, 3600 Thun
CHAQUE ENVOI DONNE DROIT A UNE INVITATION GRATUITE.

LOVE ZOO MAGAZINE_
LA CARTE DE MEMBRE 2000 EST ARRIVEE! ELLE VOUS DONNE DROIT A:
L'ENTREE AVEC UN ACCOMPAGNANT, 5% CHEZ LE DISQUAIRE DJ BEAT A BERNE,
UN CD LOVEZOO OFFERT. L'ABONNEMENT AU MENSUEL TREND MAGAZINE
ALORS N'ATTENDEZ PLUS ET ADRESSEZ-VOUS AU CLUB OU A L'INFOLINE 079/689 06 57

LOVE ZOO MA
LOVE ZOO CLUB C
COMMERCIALE PO
CLUB A BERNE OU
FORTE RECOMPEN

01. 01.
MAIN FLOOR/LOVE TRANCE 100%
ANTONY CARTIER
HYPNOTIC
CENTURY

07. 01.
MAIN FLOOR/REMEMBER LOVE TRANCE '94/'96
DAVE DAVISBANSAI REC
DAVE VOUS FERA REVIVRE SES PLUS BELLES ANNEES TRANCE

08. 01.
MAIN FLOOR/LOVE HOUSE
ANIBALMEXICO CITY. RESIDENT 303
CHARLIE B. RESIDENT PARADOX
NUKEM

14. 01.
MAIN FLOOR/USA HOUSE!!!
JEFFERSON MARSHALLCHICAGO
NUKEM

15. 0
MAIN FLOOR/
DJ B
DIVIN

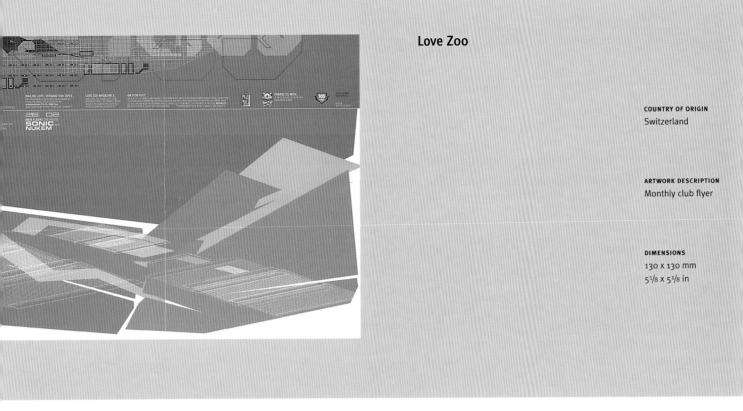

Love Zoo

COUNTRY OF ORIGIN
Switzerland

ARTWORK DESCRIPTION
Monthly club flyer

DIMENSIONS
130 x 130 mm
5^1/$_8$ x 5^1/$_8$ in

ON EST CONTENT POUR EUX_
APRES DE LONGS MOIS PASSES A COLOGNE, ISABELLE NOUS
REVIENT PLUS INSTRUITE... UNE CORDE DE PLUS A SON ARC!
APRES MAINTES CONVERSATIONS, NOUS AVONS CONCLU
QU'ELLE REPRENDRA LE FLAMBEAU.

BRAVO A NUKEM QUI MIXERA A L'OXA POUR LA
SOIREE DU 4. FEVRIER. AINSI QU'AU SUPERMARKET(ZH)
IL S' ENVOLERA ENSUITE POUR MEXICO CITY DANS LE
PLUS FAMEUX CLUB DE LA VILLE. LE "303".

LOVE ZOO MAGAZINE 2_
ENFIN TANT ATTENDU, LE DEUXIEME ALBUM DU LOVEZOO SORTIRA
PROCHAINEMENT! VOUS Y RETROUVEZ LES ARTISTES TELS QUE: COLIN DALE,
DAVE DAVIS, PURE, NUKEM, CHAB, P. BRUNKOW. EN VENTE SUR LE SITE INTERNET
WWW.LOVEZOOCLUB.CH. DANS LES MAGASINS SPECIALISES ET AU CLUB.

CONCOURS_
DEVINEZ QUI EST LA STAR DU MOIS?
AUX REPONSES GAGNANTES, UNE
INVITATION OFFERTE PAR RAPHAEL
SASSI VOUS SERA RETOURNEE.

NOM:
PRENOM:
ADRESSE:
LIEU:
REPONSE:

INFOLINE:
0800 888 1

21. 01.
MAIN FLOOR/PROG. TRANCE
SONIC-T TREND MAGAZINE
NONSDROME SENSOR, OXA

22. 01.
MAIN FLOOR/LOVE TRANCE
LADY TOM
CHAB PLATIPUS REC

28. 01.
MAIN FLOOR
FRANCTONE VIA FELSENAU
MASTRA VIA FELSENAU

29. 01.
MAIN FLOOR/LOVE HOUSE
X-RHYTHM OXA, SENSOR
NUKEM

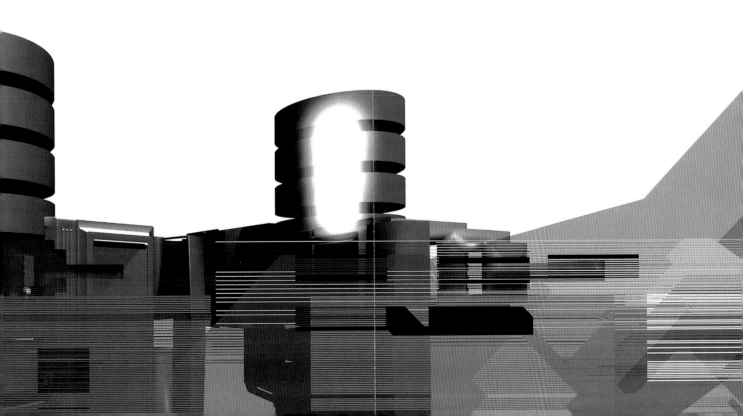

Super Natural Design

COUNTRY OF ORIGIN
USA

ARTWORK DESCRIPTION
Self-promotional
website

DIMENSIONS
Vary according
to screen size

DESIGNERS
Christie Rixford
Hajdeja Ehline

ART DIRECTORS
Christie Rixford
Hajdeja Ehline

ILLUSTRATORS
Christie Rixford
Hajdeja Ehline

DESIGN COMPANY
Super Natural Design

Netscape: msn 2

Location: http://www.supernaturaldesign.com/html/msn_2.html

Back | Forward | Home | Reload | Images | Print | Find | Stop

What's New? | What's Cool? | Destinations | Net Search | People | Software

multimedia | 5

music identities apparel environments multimedia about snd

web sites

MSN interface design

Client: Colossal

San Francisco

DESIGNER
Nitesh Mody

ART DIRECTORS
Nitesh Mody
Alan Carruthers

ILLUSTRATOR
Nitesh Mody

PHOTOGRAPHERS
Alan Carruthers
Nitesh Mody

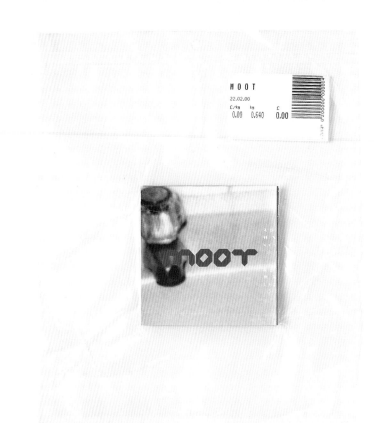

MOOT Promotional Mailer

DESIGN COMPANY
MOOT

COUNTRY OF ORIGIN
UK

ARTWORK DESCRIPTION
Vacuum-packed,
self-promotional
mailer featuring
client projects,
type designs,
and published
promotional work.

DIMENSIONS
Mailer: (folded)
100 x 100 mm
3¹⁵/₁₆ x 3¹⁵/₁₆ in
(unfolded)
100 x 800 mm
3¹⁵/₁₆ x 31½ in
Packaging:
250 x 250 mm
9⅞ x 9⅞ in

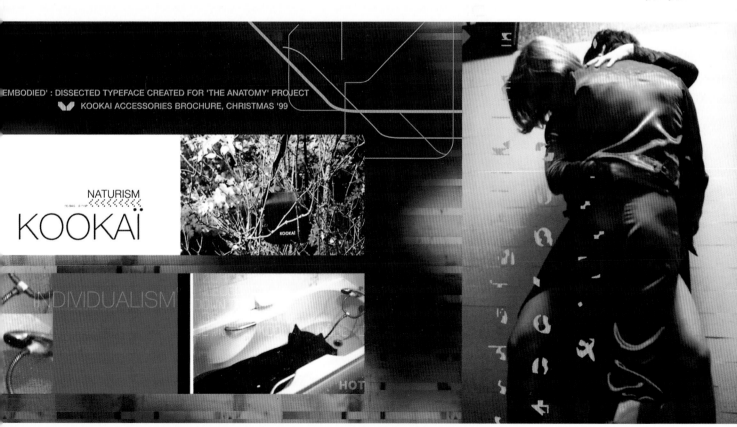

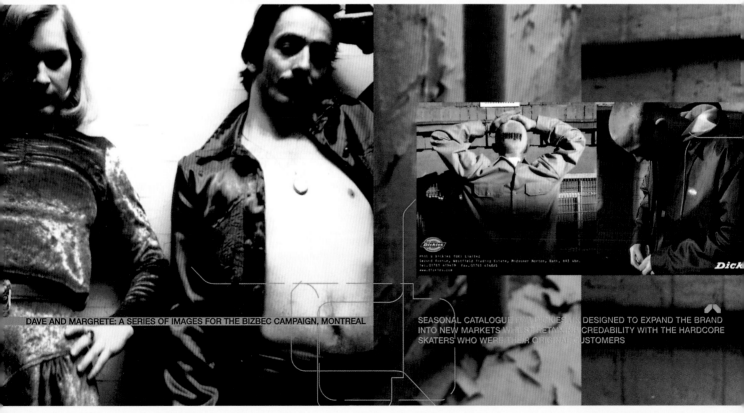

ART DIRECTION
ADVERTISING
TYPE
DESIGN
VIDEO
PHOTOGRAPHY
ILLUSTRATION

IDEAS

hayla cooper

HAYLO COOPER ADVERTISING CAMPAIGN

LYNE HAMNETT
LONDON

Vivienne
Westwood

KATHRINE HAMNETT AND VIVIENNE WESTWOOD IMAGES FROM THE INTERNATIONALLY PUBLISHED BROCHURE
FOR KEENPAC UK THE PREMISE WAS THAT BAGS HAVE HUMAN-LIKE QUALITIES, HOPES, FEARS, DREAMS ETC.

DAVE AND MARGRETE: A SERIES OF IMAGES FOR THE BIZBEC CAMPAIGN, MONTREAL

SEASONAL CATALOGUE FOR DICKIES UK DESIGNED TO EXPAND THE BRAND
INTO NEW MARKETS WHILST RETAINING CREDABILITY WITH THE HARDCORE
SKATERS WHO WERE THEIR ORIGINAL CUSTOMERS

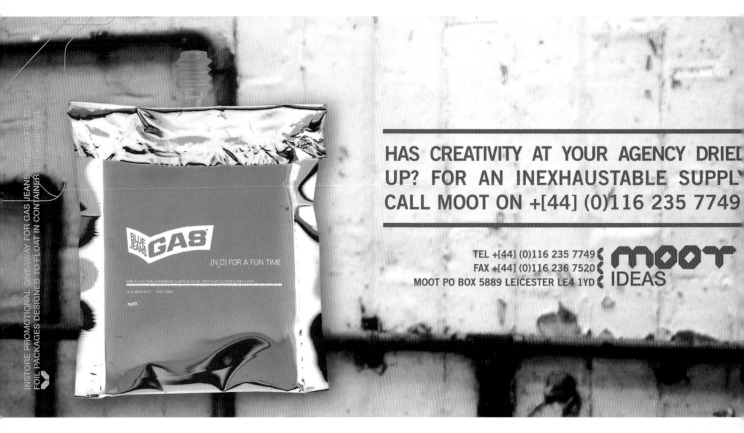

HAS CREATIVITY AT YOUR AGENCY DRIED UP? FOR AN INEXHAUSTABLE SUPPLY CALL MOOT ON +[44] (0)116 235 7749

TEL +[44] (0)116 235 7749
FAX +[44] (0)116 236 7520
MOOT PO BOX 5889 LEICESTER LE4 1YD

MOOT IDEAS

DESIGNER
Hitesh Mody

ART DIRECTOR
Hitesh Mody

ILLUSTRATOR
Hitesh Mody

DESIGN COMPANY
MOOT

COUNTRY OF ORIGIN
UK

ARTWORK DESCRIPTION
Symbol font, inspired by the shape of TV sets from the fifties and sixties.

Swedish TV Symbol Font

Wahwah Font

ARTWORK DESCRIPTION
Font, inspired by "the sound made by an electric guitar when using the wahwah pedal."

MOOT (E) Wahwah font 3/3

MOOT (E) Wahwah font 1/3

LET THE MUSIC PUMP THROUGH US. – FONT DESIGN BY NITESH MODY © MOOT COPYRIGHT 1999

DESIGNER
Nitesh Mody

ART DIRECTOR
Nitesh Mody

ILLUSTRATOR
Nitesh Mody

DESIGN COMPANY
MOOT

COUNTRY OF ORIGIN
UK

DESIGNERS
Nick Steel
Julian Harriman-
Dickinson

ART DIRECTORS
Nick Steel
Julian Harriman-
Dickinson

PHOTOGRAPHERS
Mat
Marcus

DESIGN COMPANY
Harriman Steel

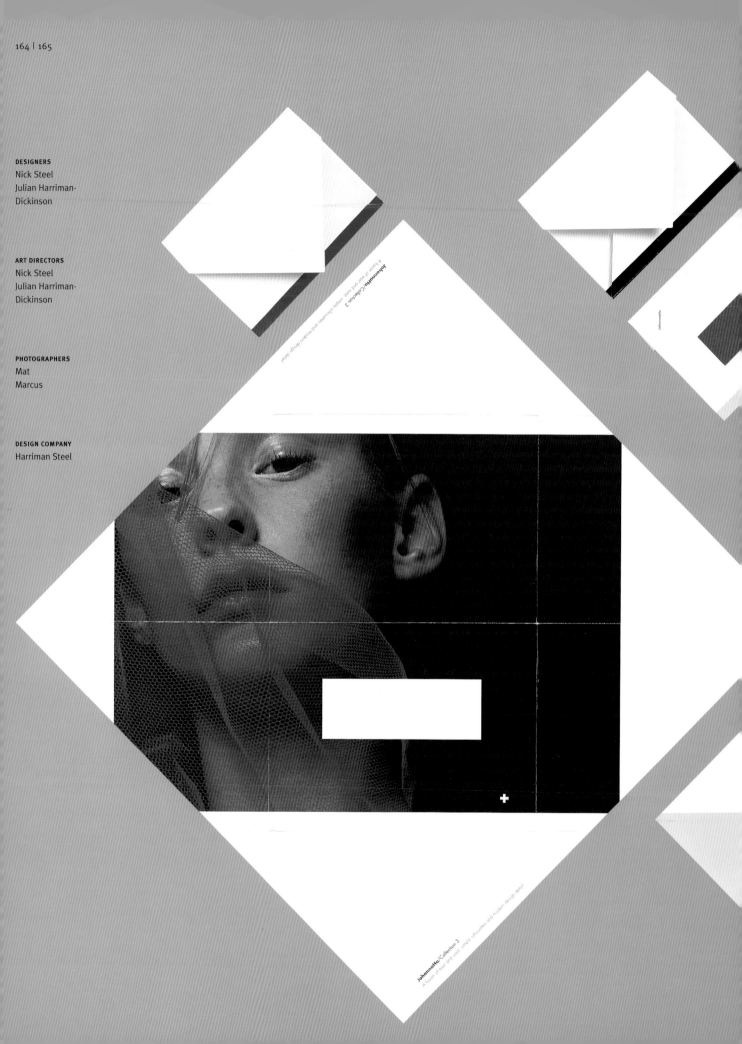

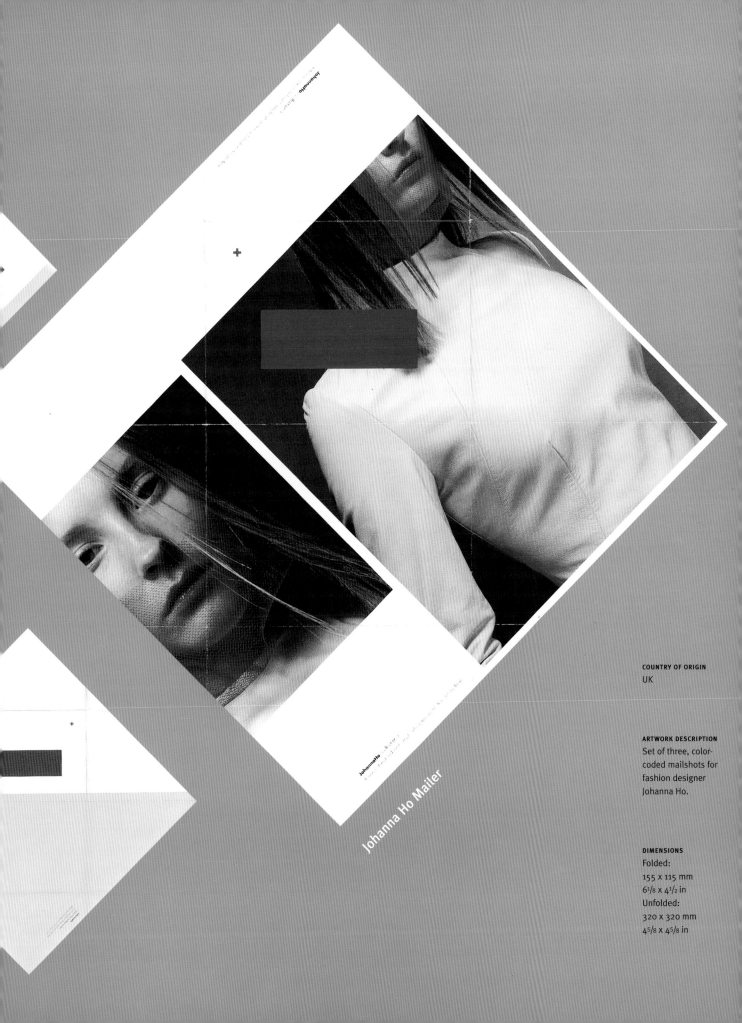

Johanna Ho Mailer

COUNTRY OF ORIGIN
UK

ARTWORK DESCRIPTION
Set of three, color-
coded mailshots for
fashion designer
Johanna Ho.

DIMENSIONS
Folded:
155 x 115 mm
6¹/₈ x 4¹/₂ in
Unfolded:
320 x 320 mm
4⁵/₈ x 4⁵/₈ in

Site Dimensions

9 metres - Ridge Height.

19 x 19 metres : Site dimension.

N

Introduction

Concept House 2000 is an international two-stage design competition which invites teams of creatives to invent a prototype model for domestic living in the year 2020; to produce an "intelligent" building which describes a new interdisciplinary blueprint for the future of domestic architecture.

The winning scheme will be a vision of design excellence which demonstrates the ways in which a cross-disciplinary approach to the future of housing will radically reinvent the traditional form, function and uses of the "home".

The organisers are looking for schemes which take an innovative stand on the issues which inform the future of domestic architecture and fulfil the following criteria:

• to provide innovative creative solutions which demonstrate the potential impact of technological, scientific and cultural advances on the domestic environment

• to anticipate and describe the impact of future developments in the fields of product and furniture design, as well as the impact of potential developments in new materials and structural engineering on the home

• to encompass developments in communication and information

• to accommodate five inhabitants (this may or may not adhere to the traditional nuclear family unit) and respond to predicted demographic and lifestyle trends

— and to explore the use of new, renewable and natural energy resources in the home.

The winning prototype will set a vision of the house of the future, and always reflect current trends in the above fields. It will explain and demonstrate a new domestic housing type for the near future, providing a blueprint for how people will live in the next century.

The winning scheme will be constructed at the Daily Mail Ideal Home Show, from the 16th of March, almost half a million visitors, over the 28 days of the exhibition, will experience the winning team's vision of a possible future for domestic architecture.

Entrants in the competition are required to form creative teams consisting of an architect or product designer working with at least one other representative from a diverse discipline. Each team should appoint a creative director to oversee the interdisciplinary collaborative input to their scheme. As Concept House 2000 is a speculative exploration into the future of housing, a built cost per square metre will not be principal by the organisers. However, it is desirable that the built scheme should be economically viable for production as a show case for ideas of the house of 2020 at an exhibition build cost of £120,000.

The winners will receive a prize of £15,000 (£5,000 plus a £10,000 design development award) and the runners-up prizes of £3,000 and £1,500 respectively. The short-listed designs will form the basis of an ideas exhibition with accompanying programme to be held at a central London venue.

Concept House 2000 will represent a return to The Daily Mail Ideal Home Show's historic position as a "future-gazing" show case for innovative design solutions to the domestic environment. This is the third international competition in a five year programme for the future of the home. Designs for the Concept House 2000 competition should reflect the predicted needs and lifestyle of the end user. When considering the future of domestic architecture, entrants should consider that house-holders in this year 2000 are not living in outer space as widely predicted in the 1950's.

Judges

The following list of judges represent the diverse range of disciplines which may influence the future of domestic living. The panel has drawn up the competition brief and will adjudicate on the design submissions.

Simon Allford
Architect and RIBA Assessor,
Allford Hall Monaghan Morris

Nigel Coates
Architect and designer,
Branson Coates and Professor of
Architecture, Royal College of Art

Geoff Crook
Director of the Sensory Design
Research Laboratory, Central Saint
Martin's College of Art & Design

Michael Franks
MD, dmg Home & Leisure, organisers
of the Ideal Home Show

Alistair Guthrie
Environmental Building Services,
Ove Arup & Partners

Colin Hayward
Quantity Surveyor, Boyden & Co

Anish Kapoor
Artist

Sarah Kent
Art critic, Time Out

Amanda Levete
Architect, Future Systems

Tim Macfarlane
Structural engineer,
Dewhurst Macfarlane

Daniel Miller
MD, Mute Records

Kevin Warwick
Professor of Cybernetics;
Reading University

Timetable

In conjunction with the competition entries administrators, the RIBA, the promoters has established the following arrangements for the competition. The competition programme, which may be subject to variation, is:

27th July 1999
Brief registration open to competitors

8th October 1999
Deadline for submissions

13th & 14th October 1999
Judging of entrants

18th October 1999
Interviews with short-listed entrants to assess ability to realise schemes

20th October 1999
Appointment of winning team

1st November 1999
Payment of prizes

13th December
End of winning design development for build in Earl's Court 1. Deadline for selection of furniture

Spring 2000
Exhibition of short-listed entries

5th March 2000
Construction of design at the Daily Mail Ideal Home Show

15th March 2000
Preview day of the Daily Mail Ideal Home Show

16th March 2000
Public opening of the Daily Mail Ideal Home Show

Prizes

1st £15,000
(£5,000 plus a £10,000 design development award)

2nd £3,000

3rd £1,500

The judges will short list a maximum of 20 schemes and will select three prize winners from within this group. Prizes will be paid by dmg Exhibition Group by 1st of November 1999. The £10,000 design development award will be issued following the completion of the design development stage by the 13th of December 1999.

At the discretion of the assessors the prize fund may be aggregated and divided among a different number of competitors, but an order or merit will be indicated.

Concept House 2000
Competition Brief

2c0ncepth0use0
Competition Brief

DESIGNERS
Nick Steel
Julian Harriman-
Dickinson

DESIGN COMPANY
Harriman Steel

COUNTRY OF ORIGIN
UK

ARTWORK DESCRIPTION
Mailshot, including
competition brief, for
an international
design competition.

DIMENSIONS
Folded:
310 x 255 mm
12⅛ x 10¹/₁₆ in
Unfolded:
620 x 500 mm
24¹/₄ x 19³/₄ in

DESIGNERS
Julian Harriman-
Dickinson
Nick Steel

ART DIRECTORS
Julian Harriman-
Dickinson
Nick Steel

**CAMERAMAN/DIRECTOR
OF PHOTOGRAPHY**
Julian Harriman-
Dickinson

Smirnoff "Clubbers' Guide"

DESIGN COMPANY
Harriman Steel

COUNTRY OF ORIGIN
UK

ARTWORK DESCRIPTION
Two 10-second
cinema commercials
for Smirnoff's radio
club guide.

DIMENSIONS
Vary according
to screen size

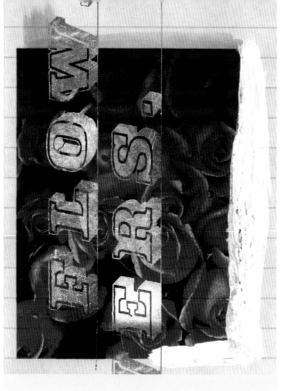

Ode to Typography

ARTWORK DESCRIPTION
Short film based on a
poem by Chilean poet
Pablo Neruda.

COUNTRY OF ORIGIN
UK

DESIGN COMPANY
Harriman Steel

CAMERAMAN/DIRECTOR
OF PHOTOGRAPHY
Julian Harriman-
Dickinson

ART DIRECTORS
Julian Harriman-
Dickinson
Nick Steel

DESIGNERS
Julian Harriman-
Dickinson
Nick Steel

Experimental Work

PHOTOGRAPHER
Lilly Tomec
Dag

COUNTRY OF ORIGIN
Germany

ARTWORK DESCRIPTION
Canvas prints
produced through
a combination of
computer graphics
and painting (by
the artist Dag).

DIMENSIONS
250 x 250 mm
9⅞ x 9⅞ in

DESIGNERS
Lilly Tomec
Dag

ART DIRECTORS
Lilly Tomec
Dag

ILLUSTRATORS
Lilly Tomec
Dag

three(3)weeks

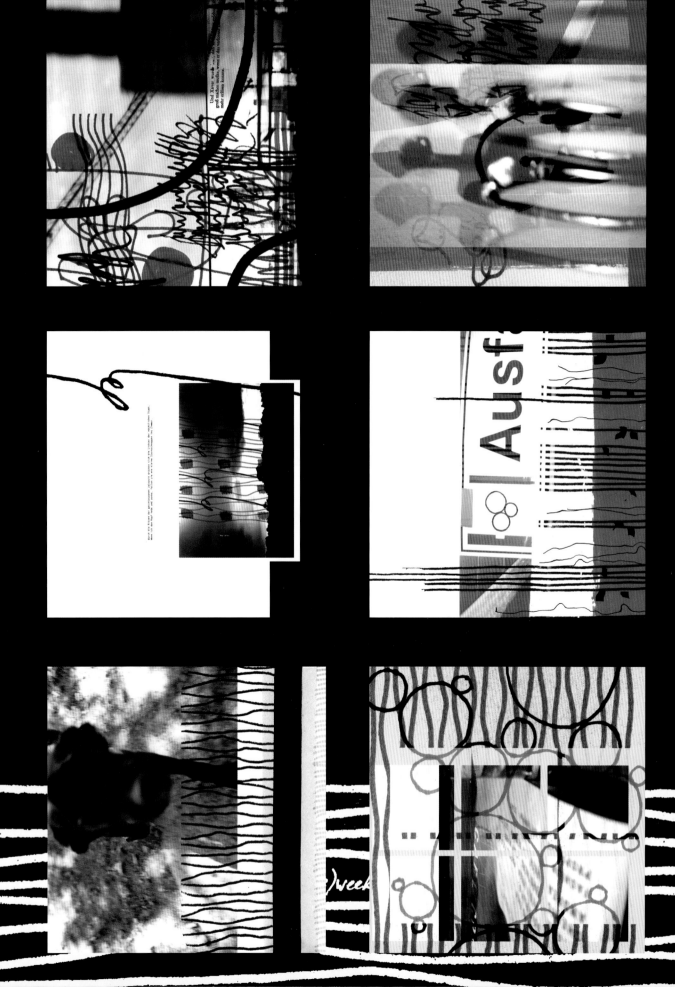

Arketype

DESIGNER
Lee Schulz

ART DIRECTOR
Lee Schulz

ILLUSTRATOR
Lee Schulz

PHOTOGRAPHER
Lee Schulz

DESIGN COMPANY
Lee Schulz

COUNTRY OF ORIGIN
USA

ARTWORK DESCRIPTION
Website of the
designer's graduate
work from CalArts.

DIMENSIONS
Vary according
to screen size

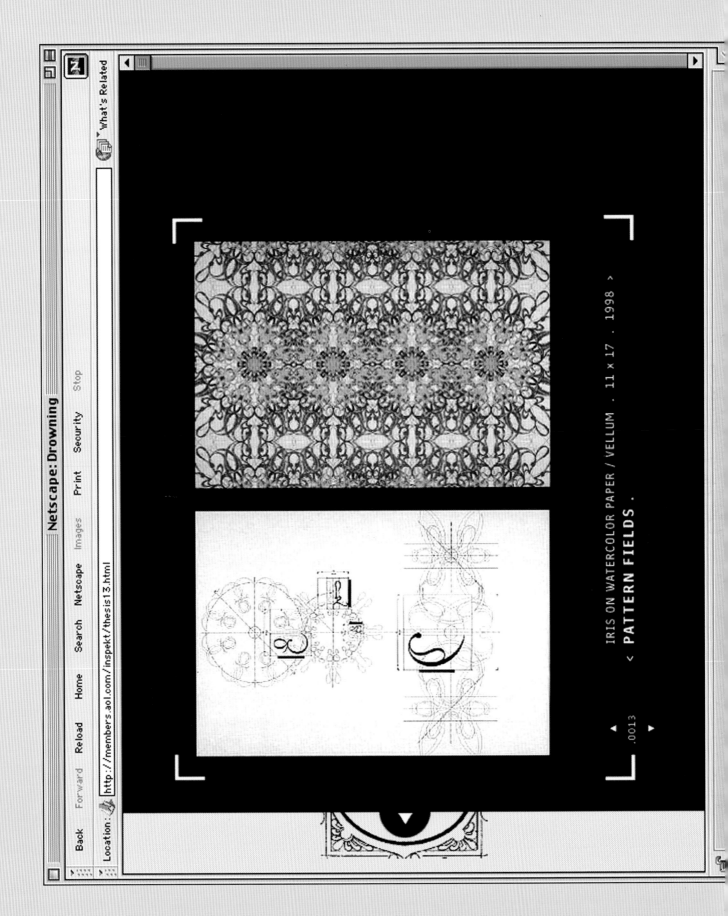

Netscape: Drowning

Back Forward Reload Home Search Netscape Images Print Security Stop

Location: http://members.aol.com/inspekt/thesis13.html

What's Related

< PATTERN FIELDS .

IRIS ON WATERCOLOR PAPER / VELLUM . 11 x 17 . 1998 >

.0013

DESIGNERS
Jens Gehlhaar
Vanessa Marzaroli
Jamandru Reynolds

CREATIVE DIRECTOR
Seth Epstein

ILLUSTRATORS
Jens Gehlhaar
Craig Tollifson
Ehren Addis
Brian Yarnell
Lenie Ramos-Ortegaso

DESIGN COMPANY
Fuel-Razorfish

SURFING

Skysurfing
13,000 FEET ABOVE MONTEREY, CA

WAKEBOARDING
MEN'S FINAL

| Bill Carson | Chris Dawson | Daniel Edwards | Elliott Frank |

TALE OF THE TAPE

NE
1 OF 2

79.00
75.00
74.75
73.25
73.00

	Tony Ulrich	Zoe Abrams
HEIGHT	5'6"	6'3"
WEIGHT	125	160
SHOE	6	11
HAND	7.25	8.25

SPORT CLIMBING
MEN'S SPEED

QUARTERFINALS	SEMIFINALS
1 U. Vance	
8 S. Thomas	8 S. Thomas
4 V. Wallace	
5 T. Ulrich	5 T. Ulrich
2 W. Xieng	
7 X. Young	2 W. Xieng
3 Y. Zimmerman	
6 Z. Abrams	6 Z. Abrams

COUNTRY OF ORIGIN
USA

ARTWORK DESCRIPTION
Television graphics
for an annual
competition of
extreme and street
athletics, initiated and
broadcast by ESPN.

DIMENSIONS
720 x 540 pixels

SKATEBOARD
VERT RESULTS

GOLD	Ralph Schroder	USA
SILVER	Quentin Roberts	USA
BRONZE	Peter Quinn	USA

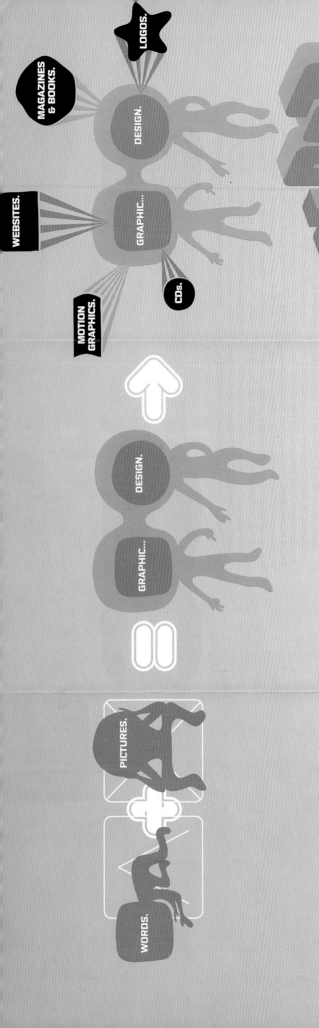

LOGOS.

MAGAZINES & BOOKS.

WEBSITES.

DESIGN.

GRAPHIC...

CDs.

MOTION GRAPHICS.

PICTURES.

DESIGN.

GRAPHIC...

WORDS.

CalArts

WHAT IS THIS THING, "GRAPHIC DESIGN"? UNLESS YOU LIVE ON MARS, YOU'RE TOTALLY SURROUNDED BY IT — ON WEB SITES, POSTERS, CD COVERS, BOOKS, BROCHURES, MAGAZINES, LOGOS, CLOTHING TAGS, PACKAGING, CONCERT FLYERS, FILM AND TELEVISION TITLES, BASICALLY, ANY COMBINATION OF WORDS AND PICTURES USED TO COMMUNICATE AN IDEA IS GRAPHIC DESIGN+

CalArts celebrates individual voice, attitude, and perspective. We teach our students to be progressive, informed, independent, experimental, critically-aware, self-motivated, skilled, and passionate. The small classes in the graphic design program at CalArts give you experience and skill at an intimate level.

What is graphic design at CalArts? At CalArts, students create graphic design that goes way beyond the transmission of simple messages, in favor of mind-blowing, award-winning pieces that redefine the way the world sees itself. Design that's both formally beautiful and conceptually clever: smart — and sexy.

ANDERS CARLEO: WEBSITE (3RD YEAR)

ANDREW HOGGE: LOGO (2ND YEAR)

JONATHAN NOTARO: POSTER (4TH YEAR)

JULIE SCHALLER: IMAGE CHAIN BOOKLET (1ST YEAR)

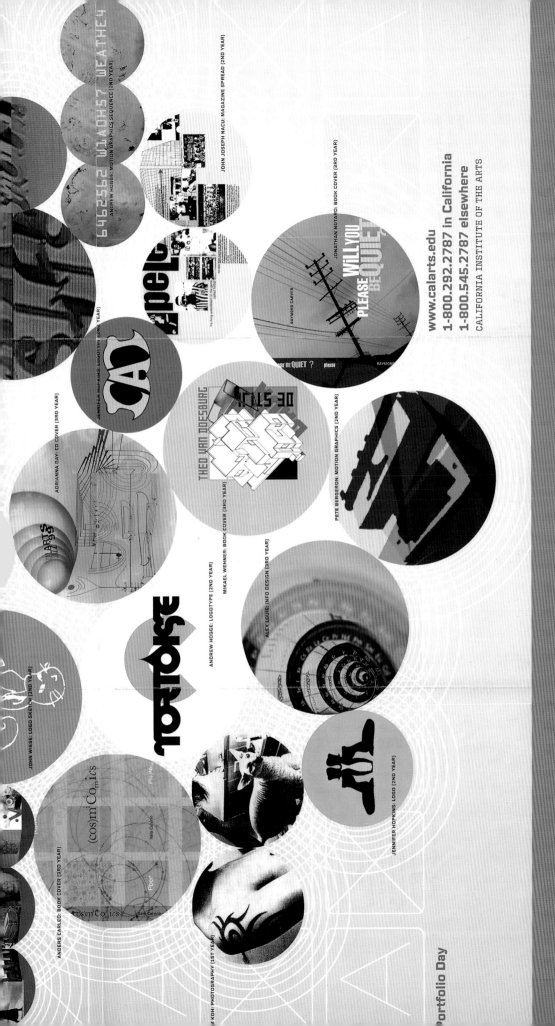

ARTWORK DESCRIPTION
Recruitment poster for the CalArts under-graduate program in Graphic Design.

www.calarts.edu
1-800.292.2787 in California
1-800.545.2787 elsewhere
CALIFORNIA INSTITUTE OF THE ARTS

CalArts
Graphic Design
Recruitment
Poster

DIMENSIONS
457 x 612 mm
18 x 24 in

COUNTRY OF ORIGIN
USA

DESIGN COMPANY
The Offices of Anne Burdick

Portfolio Day

ILLUSTRATOR
Geoff McFetridge

DESIGNERS
Anne Burdick
Jens Gehlhaar
Louise Sandhaus

KCRW Innerlevel

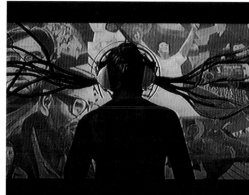

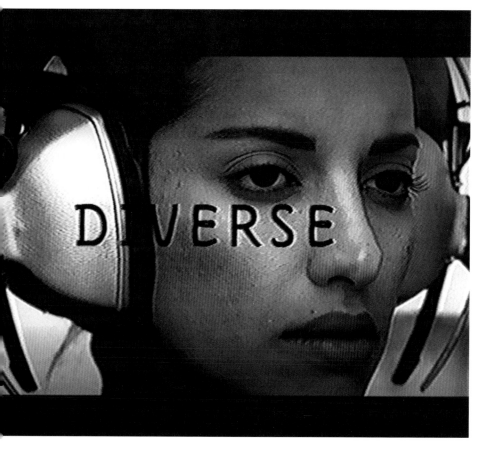

DESIGNERS
Jens Gehlhaar
David Vegezzi

DIRECTOR
David Vegezzi

ILLUSTRATOR
Jens Gehlhaar

DIRECTOR OF PHOTOGRAPHY
Helge Gerull

ARTWORK DESCRIPTION
Film commercial for
KCRW, a public radio
station.

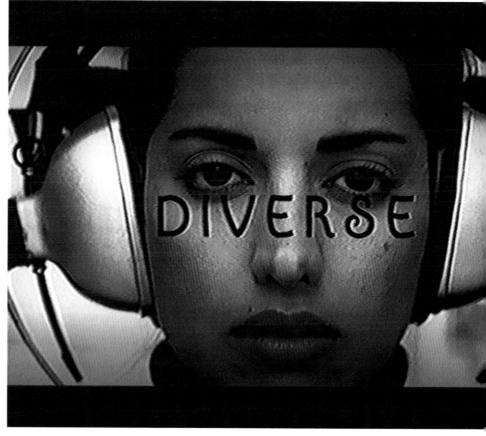

DESIGN COMPANY
Vegezzi Studios

COUNTRY OF ORIGIN
USA

DIMENSIONS
35mm film

Human Traffic DVD On-Screen Menu

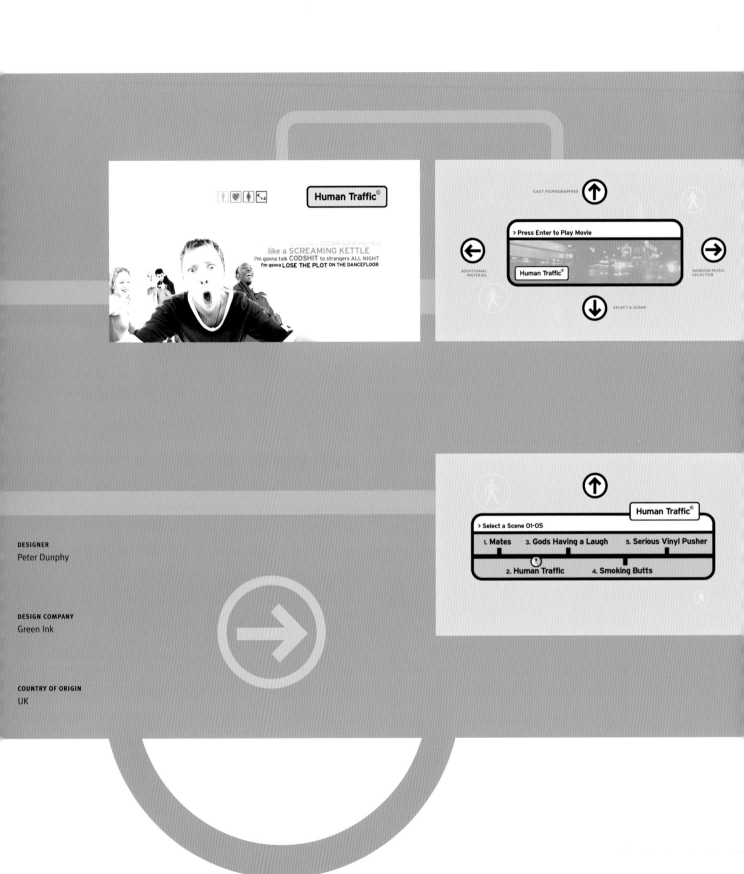

DESIGNER
Peter Dunphy

DESIGN COMPANY
Green Ink

COUNTRY OF ORIGIN
UK

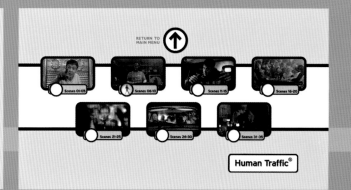

ARTWORK DESCRIPTION
Interactive moving menu screens for the Human Traffic DVD.

DIMENSIONS
Vary according to screen size

Old 97's

COUNTRY OF ORIGIN
USA

ARTWORK DESCRIPTION
Letterpress poster,
using both wood and
metal type.

DIMENSIONS
380 x 508 mm
15 x 20 in

DESIGNER
Kyle Blue

ART DIRECTOR
Kevin Bradley

DESIGN COMPANY
Yee-Haw Industries

COUNTRY OF ORIGIN
USA

ARTWORK DESCRIPTION
Poster for a student publication.

DIMENSIONS
635 x 991 mm
25 x 39 in

Windhover: Call for Entries

DESIGNER
Kyle Blue

PHOTOGRAPHER
Kyle Bluedl

ART COLLEGE
North Carolina State
University

http://ctrl-space.jodi.org

DESIGNER
Jodi

DESIGN COMPANY
Jodi

COUNTRY OF ORIGIN
The Netherlands

ARTWORK DESCRIPTION
A website-based
modification of
the computer game
Quake.1, with the
capacity for 16
people to play at the
same time.

DIMENSIONS
Vary according
to screen size

http://sod.jodi.org

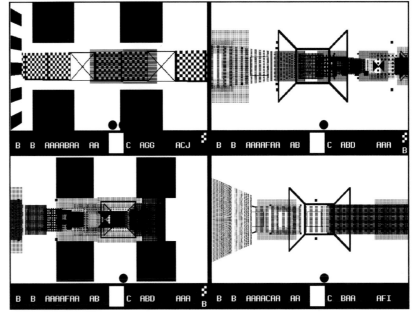

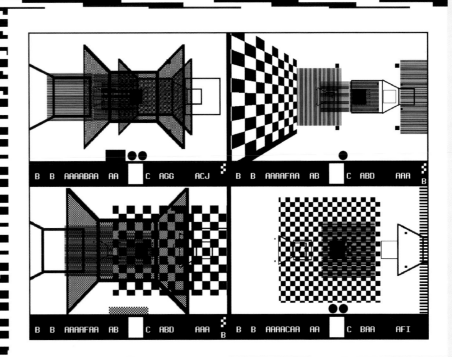

DESIGNER
Jodi

DESIGN COMPANY
Jodi

COUNTRY OF ORIGIN
The Netherlands

ARTWORK DESCRIPTION
A website based
modification of the
computer game
Wolfenstein.

DIMENSIONS
Vary according
to screen size

DESIGNER
Jon Forss

ART DIRECTOR
Jon Forss

PHOTOGRAPHER
Christian Hermansen

ARTWORK DESCRIPTION
CD front cover and
inside spread for
Lo Recordings.

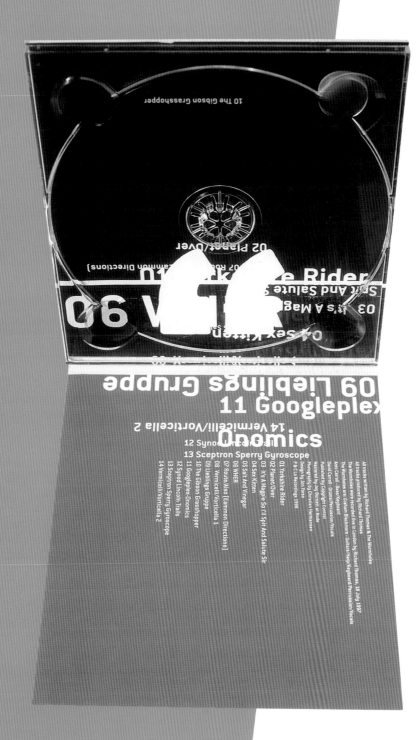

Seven Point Plan To Destroy Astrology

DESIGN COMPANY
EkhornForss

COUNTRY OF ORIGIN
UK

DIMENSIONS
140 x 125 mm
5 1/2 x 4 15/16 in

Rivers Become Oceans

DESIGNER
Jon Forss

ART DIRECTOR
Jon Forss

PHOTOGRAPHER
Christian Hermansen

Side A **Four Tet – Rivers Become Oceans** Side B **Rothko – Rivers Become Oceans (colour defines the cityscape)**
Sides A & B contain samples from the Rothko album *A Negative For Francis* (Lo Recordings LCD12)
Side B contains a sample of *Waxy Flexibility* by Richard Thomas from the album *Shoes And Radios Attract Paint* (Lo Recordings LCD06)
Side B contains a sample of *Fin* from the Twisted Science album *Blown* (Lo Recordings LCD04)
Side A P&C Hebden/Rothko 1999 Side B P&C Hebden/Rothko/Thomas/Tye 1999 Made in England Distributed by SRD
Photography by Christian Hermansen Design by Jon Forss
LOEP09

Four Tet / Rothko Rivers Become Oceans

DESIGN COMPANY
EkhornForss

COUNTRY OF ORIGIN
UK

DIMENSIONS
306 x 306 mm
12 x 12 in

ARTWORK DESCRIPTION
Front and back covers
of 12" EP for Lo
Recordings.

DESIGNERS
Kjell Ekhorn
Jon Forss

ART DIRECTORS
Kjell Ekhorn
Jon Forss

PHOTOGRAPHERS
Photodisc
Simona Dell'Agli

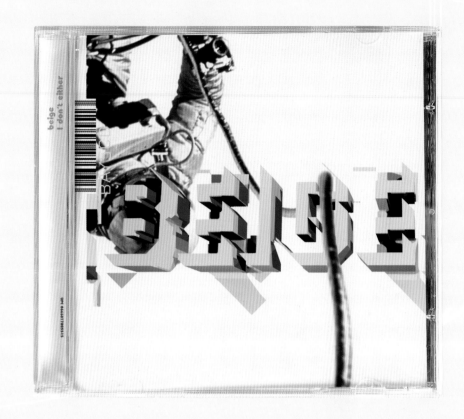

I Don't Either

DESIGN COMPANY
EkhornForss

COUNTRY OF ORIGIN
UK

ARTWORK DESCRIPTION
Front cover and inside
spread of CD booklet
for The Leaf Label.

DIMENSIONS
Front cover:
141 x 122 mm
5⁹/₁₆ x 4¹³/₁₆ in
Inside spread:
482 x 119.5 mm
19 x 4¹¹/₁₆ in

DESIGN COMPANY
General Working
Group

COUNTRY OF ORIGIN
USA

ARTWORK DESCRIPTION
Double-sided
promotional
postcard/invitation.

DIMENSIONS
140 x 203 mm
5¹/₂ x 8 in

Wall to Walrus

DESIGNERS
Gail Swanlund
Geoff Kaplan

ART DIRECTORS
Gail Swanlund
Geoff Kaplan

ILLUSTRATOR
Gail Swanlund

PHOTOGRAPHER
Hannah Kaplan

DESIGNERS
Gail Swanlund
Geoff Kaplan

ART DIRECTORS
Gail Swanlund
Geoff Kaplan

ILLUSTRATORS
Gail Swanlund
Geoff Kaplan

PHOTOGRAPHERS
Airedale Bros.
Matt Greene

DESIGN COMPANY
General Working
Group

COUNTRY OF ORIGIN
USA

ARTWORK DESCRIPTION
Double-sided poster

DIMENSIONS
406 x 559 mm
16 x 22 in

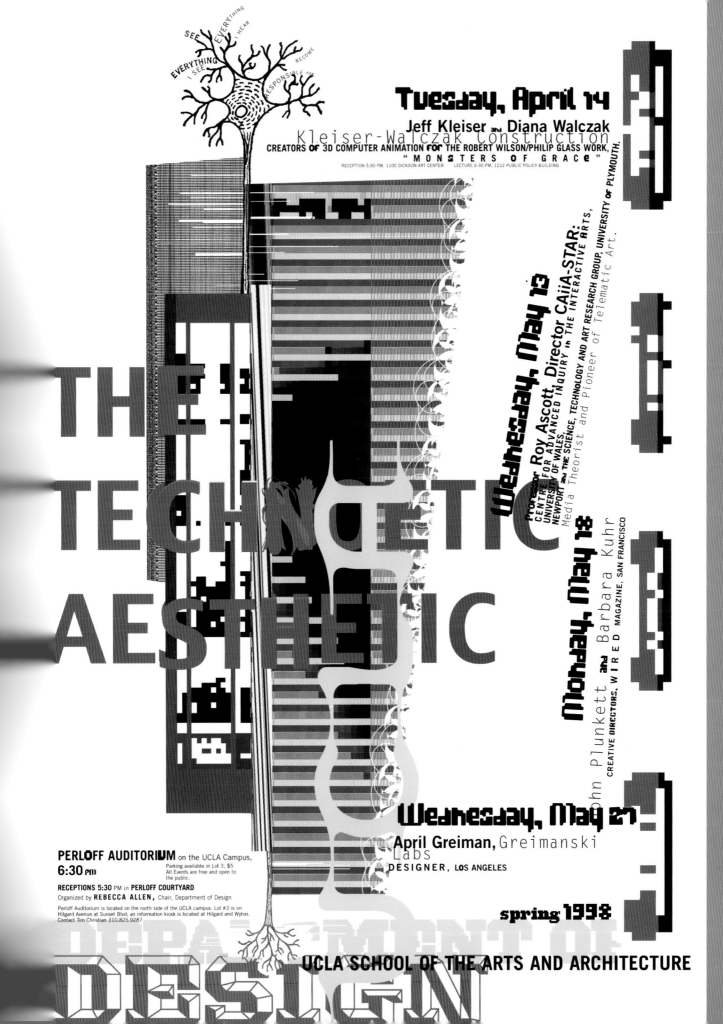

EVERYTHING I SEE SEE EVERYTHING I HEAR BECOME RESPONSIBLE FOR

THE TECHNETIC AESTHETIC

Tuesday, April 14
Jeff Kleiser and **Diana Walczak**
Kleiser-Walczak Construction
CREATORS OF 3D COMPUTER ANIMATION FOR THE ROBERT WILSON/PHILIP GLASS WORK,
"MONSTERS OF GRACE"
RECEPTION 5:30 PM, 1100 DICKSON ART CENTER LECTURE 6:30 PM, 1222 PUBLIC POLICY BUILDING

Wednesday, May 13
Professor **Roy Ascott**, Director CAiiA-STAR:
CENTRE FOR ADVANCED INQUIRY IN THE INTERACTIVE ARTS,
UNIVERSITY OF WALES,
NEWPORT and THE SCIENCE, TECHNOLOGY AND ART RESEARCH GROUP, UNIVERSITY OF PLYMOUTH.
Media Theorist and Pioneer of Telematic Art.

Monday, May 18
John Plunkett and Barbara Kuhr
CREATIVE DIRECTORS, W I R E D MAGAZINE, SAN FRANCISCO

Wednesday, May 27
April Greiman, Greimanski Labs
DESIGNER, LOS ANGELES

spring 1998

PERLOFF AUDITORIUM on the UCLA Campus,
6:30 PM
Parking available in Lot 3, $5
All Events are free and open to
the public.

RECEPTIONS 5:30 PM in **PERLOFF COURTYARD**
Organized by **REBECCA ALLEN**, Chair, Department of Design

Perloff Auditorium is located on the north side of the UCLA campus. Lot #3 is on
Hilgard Avenue at Sunset Blvd; an information kiosk is located at Hilgard and Wyton.
Contact Tim Christian 310.825.9287

DEPARTMENT OF DESIGN

UCLA SCHOOL OF THE ARTS AND ARCHITECTURE

Index

of
Designers,
Design Companies,
and
Art Colleges

ACKNOWLEDGMENTS

THE PUBLISHERS WOULD LIKE TO THANK BEN JENNINGS FOR THE PHOTOGRAPHY OF
ARTWORK IN THIS BOOK. A SPECIAL THANK YOU TO WHY NOT ASSOCIATES.

FUTURE EDITIONS

IF YOU WOULD LIKE TO BE INCLUDED IN THE CALL FOR ENTRIES FOR THE NEXT EDITION
OF TYPOGRAPHICS PLEASE SEND YOUR NAME AND ADDRESS TO:

TYPOGRAPHICS
DUNCAN BAIRD PUBLISHERS
SIXTH FLOOR
CASTLE HOUSE
75-76 WELLS STREET
LONDON W1P 3RE
UK

INDEX
EX

ENTRIES REFER TO PAGES ON WHICH
CAPTIONS APPEAR

onedotzero

1997

friday
25.04.97

saturday
26.04.97

sunday
27.04.97

onedotzero programme v1: fuel / tomato / underbelly / anti-rom / letterror / me company / stakkeraphex / warp / andy martin / rebus

restfest programme: spike jonze / h-gun labs / 52mm / p2 / koji morimoto / ian haig / cameron noble / adam gravois / uruma delvi / kasr serrie / koji matsuoka

institute of contemporary arts, the mall, london sw1 / box office 0171 930 3647
cinema tickets £6.50 / members £5 / cinematheque £5 / members £4
£3

Adobe

DigiLab

ICA

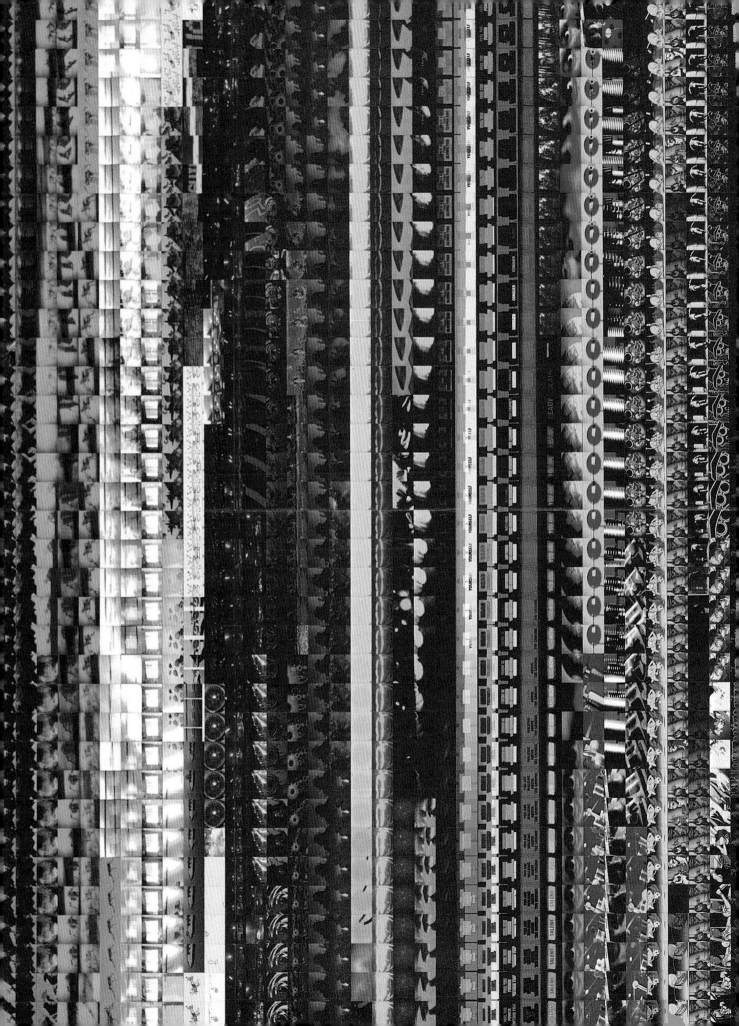

PAGES 198-9
DESIGNERS
Mark Breslin, Philip O'Dwyer
ART DIRECTORS
Mark Breslin, Mark Hough,
Philip O'Dwyer,
DESIGN COMPANY
State
COUNTRY OF ORIGIN
UK

WORK DESCRIPTION
Poster announcing the
onedotzero digital film
festival at the ICA in London
DIMENSIONS
594 x 820 mm
23⅜ x 32¼ in

23 7

MAIN HISTORICAL EVENTS

DATE	EVENT
1066	BATTLE OF HASTINGS
1086	DOMESDAY BOOK
1215	MAGNA CARTA
1216	FIRST PARLIAMENT
1348-49	BLACK DEATH
1381	PEASANT'S REVOLT
1415	BATTLE OF AGINCOURT
1492	COLUMBUS-AMERICA
1509-47	HENRY VIII
1558-1603	ELIZABETH I
1588	SPANISH ARMADA
1603-25	JAMES I
1645-49	CIVIL WAR
1649-60	COMMONWEALTH
1665	GREAT PLAGUE
1666	FIRE OF LONDON

ARCHITECTURAL CHRONOLO...

DATE	BUILDINGS
1078	TOWER OF LONDON
1106	SOUTHWARK CATHEDRAL
1120	ST MARGARET WESTMINSTER
1123	ST BARTHOLOMEW THE GREAT
1160	TEMPLE CHURCH
1205	ST HELEN'S BISHOPSGATE
1245	WESTMINSTER ABBEY BEGUN
1297	LAMBETH PALACE
1300	ST ETHELDRA
1350	ELTHAM PALACE
1350	TEMPLE CHURCH
1390	WESTMINSTER ABBEY NAVE
1394	WESTMINSTER HALL
1400	LINCOLN'S INN
1410	BISHOP'S PALACE, FULHAM
1411	GUILDHALL
1492	LINCOLN'S INN
1503	HENRY VII'S CHAPEL
1514	HAMPTON COURT PALACE
1520	ST ANDREW UNDERSHAFT
1530	ST JAMES'S PALACE
1586	STAPLE INN
1590	HOLLAND HOUSE
1607	CHARLTON HOUSE, GREENWICH
1616	QUEEN'S HOUSE, GREENWICH
1619	BANQUETING HOUSE, WHITEHALL
1619	LINCOLN'S INN CHAPEL
1623	QUEEN'S CHAPEL
1631	ST PAUL'S COVENT GARDEN
1640	LINCOLN'S INN FIELDS
1640	LINDSEY HOUSE
1661	KENSINGTON PALACE
1665	GREENWICH PALACE
1670	ST MICHAEL CORNHILL
1670	ST LAWRENCE JEWRY
1670	ST MARY-AT-HILL
1670	ST BRIDE, FLEET STREET
1670	ST MARY-LE-BOW
1671	ST MAGNUS
1672	MONUMENT
1674	ST STEPHEN WALBROOK
1675	ST JAMES GARLICKHITHE
1676	ST PAUL'S CATHEDRAL
1677	ST JAMES'S PICCADILLY
1677	ST ANNE ST AGNES
1677	CHRIST CHURCH, NEWGATE STREET
1681	ST MARTIN, LUDGATE HILL
1681	ST MARY ABCHURCH
1682	ROYAL HOSPITAL, CHELSEA
1683	ST MARY ALDERMARY
1685	ST CLEMENT EASTCHEAP
1689	ST ANDREW-BY-THE-WARDROBE

THE URBANIZATION OF NOTTING HILL, THE AREA TO THE NORTH OF HOLLAND PARK AVENUE, BEGAN IN THE FIRST HALF OF THE NINETEENTH CENTURY, WHEN THE LEAFY AVENUES AND MAJESTIC CRESCENTS OF THE NORLAND AND LADBROKE ESTATES WERE LAID OUT. IN THOSE DAYS, THE AREA WAS STILL KNOWN AS THE POTTERIES (AFTER THE GRAVEL PITS AND POTTERY WORKS ON WALMER ROAD) OR THE PIGGERIES (AFTER THE DISTRICT'S THREE-TO-ONE RATIO OF PIGS TO PEOPLE). EVEN FORTY YEARS AGO NOTTING HILL WAS DESCRIBED AS "A MASSIVE SLUM, FULL OF MULTI-OCCUPIED HOUSES, CRAWLING WITH RATS AND RUBBISH", AND POPULATED BY OFFSHOOTS OF THE SOHO VICE AND CRIME RACKETS. THESE INSALUBRIOUS DWELLINGS BECAME HOME TO A LARGE CONTINGENT OF AFRO-CARIBBEAN IMMIGRANTS, WHO HAD TO COMPETE FOR JOBS AND LIVING SPACE WITH THE AREA'S SIMILARLY DOWNTRODDEN WHITE RESIDENTS.
FOR FOUR DAYS IN AUGUST 1958, PEMBRIDGE ROAD BECAME THE EPICENTRE OF THE COUNTRY'S FIRST RACE RIOTS, WHEN BUS-LOADS OF WHITES ATTACKED WEST INDIAN HOMES IN THE AREA. THE NOTTING HILL CARNIVAL BEGAN UNOFFICIALLY THE NEXT YEAR AS A RESPONSE TO THE RIOTS: IN 1965 IT TOOK TO THE STREETS AND HAS SINCE GROWN INTO THE WORLD'S BIGGEST STREET FESTIVAL OUTSIDE RIO.

12
94

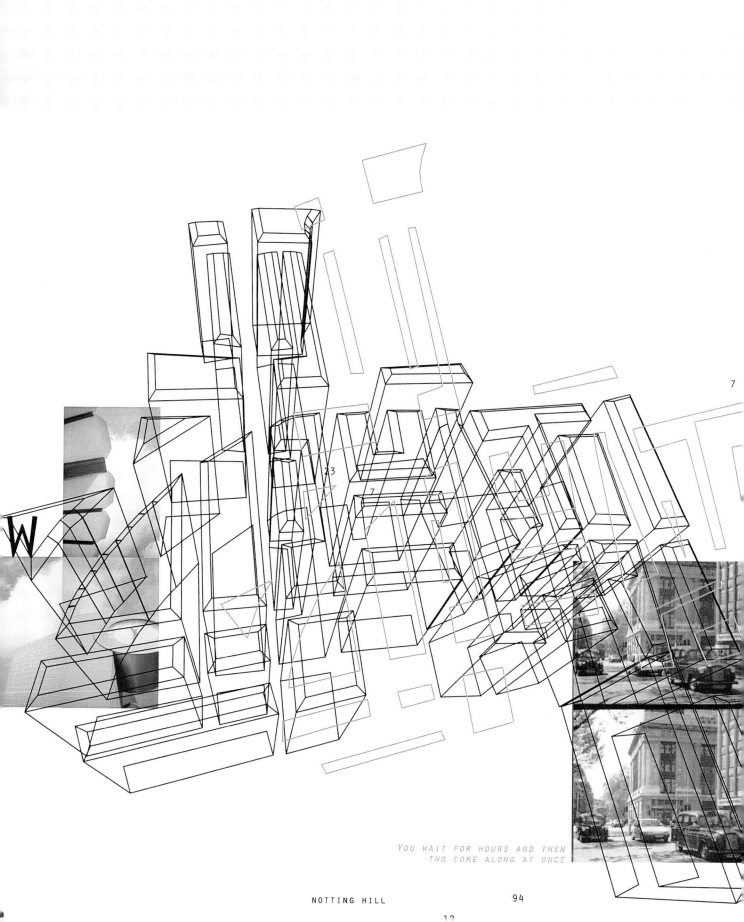

YOU WAIT FOR HOURS AND THEN
TWO COME ALONG AT ONCE

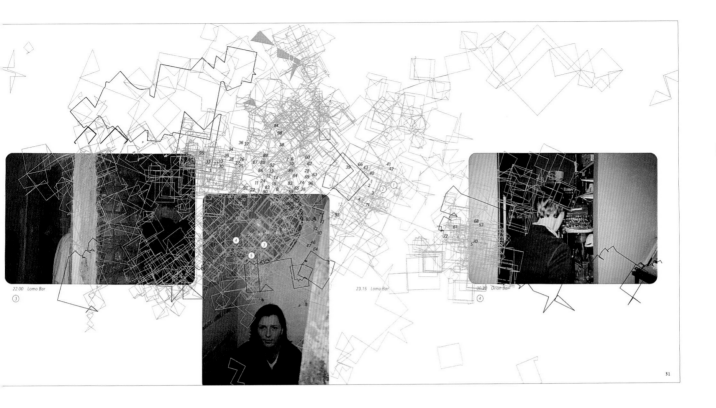

22.00 Lomo Bar
③

23.15 Lomo Bar

00.20 Orion Bar
④

31

PAGES 194–7
DESIGNER
Antonia Henschel
(Central Saint Martin's College
of Art and Design)
ART DIRECTOR
Antonia Henschel
PHOTOGRAPHER
Antonia Henschel
COUNTRY OF ORIGIN
UK

WORK DESCRIPTION
Cover (opposite, top) and
spreads from *Cityscapes* –
an experimental magazine
investigating the city and
its visual significance
DIMENSIONS
280 x 280 mm
11 x 11 in

CITY
SCAP
ES

THE
CITY AS VISUAL
NARRATIVE

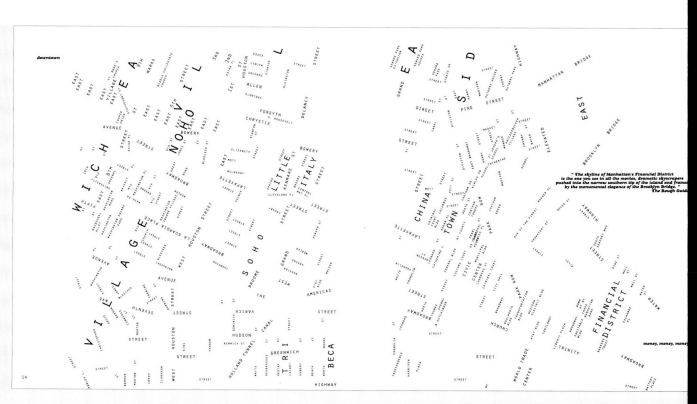

nature of the Latin alphabet, there have been many attempts to illustrate the language. Guillaume Apollinaire's calligrams are a good example of using the expressive values of writing to enhance a text. The main difference in the work of the futurists or the dadaists is differentiation of role. It is not the author of the text who affects the way of reading it, it is a designer—a person from a different background. If the author of the text and author of its visual representation is not the same person, the task of analyzing the intent and visualizing becomes extraordinarily complex.¶

Ideally, form matches content. More often, however, one dominates the other. It is not clear which one is more important in the process of reading. Human beings tend to judge experience as a sensory whole; we do not separate experiences into discrete parts. Therefore, we cannot separate images from text; they only exist bound together. Images, then, ha-

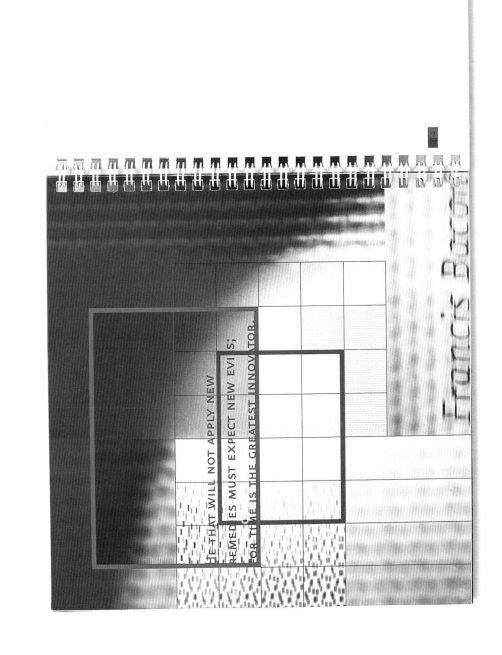

NEITHER LANGUAGE NOR WRITING NOR THE

ALPHABET ARE TRANSPARENT ENOUGH

WE TRANSMIT IDEAS VERBALIZE

Thanks to low-priced com- puters and user-friendly software, almost anyone can create a typeface. This has resulted in a very wobbly quality of type de- sign. Some of new typefa- ces are considered illegible. Illegibility is a topic in graphic design which has been discussed many ti- mes. The word "illegible" has changed its meaning to "not communicative eno- ugh." In judging legibility, people talk about what they don't see rather than talking about what they do see. Illegible type may so- metimes convey more me- aning than a text set in the most readable typeface. Thanks to designers like David Carson legibility has acquired a new meaning, ie. offering us new visual ex- perience. "Legibility pre- sents information as facts rather than as experi-

Thanks to low-priced com-tváre a situácie, v ktorej sa ence," says namom je previazaná. Typografia môže puters and user-friendly nachádzame. Z rozhovoru Phil Baines, a pripraviť čitateľa na to, čo má od textu software, almost anyone v novinách môže, napr.-London-based očakávať, alebo naopak, prekvapiť ne- can create a typeface. This klad, čitateľ získať iba 20 % typographer. očakávaným. Neočakávané riešenia majú has resulted in a very informácií zachytených David Byrne, oveľa efektívnejší dosah, znepokojujú, wobbly quality of type de- v texte. Pisateľ sa môže the multita- alebo nadchnú publikum. Avšak pre au- sign. Some of new typefa- snažiť obohatiť rozhovor lented artist, tora je omnoho riskantnejšie pohybovať ces are considered illegible. fotografiami a popisom mi- writes in a sa za hranicou očakávania. Pôsobenie za Illegibility is a topic in esta rozhovoru. Ani to ne- book on David jej limitmi je to, čo nazývame kreatívi- graphic design which has musí stačiť. Ako môžeme Carson: "Da- ta a najsilnejšie myšlienky ovplyvňujú been discussed many ti- preniesť rozhovor, ktorý je vid's work co- spoločnosť.¶ mes. The word "illegible" plný emócií a je viaczmy- mmunicates. Navrhovanie experimentálnych fontov has changed its meaning to selný na stranu textu? But on a level nie je pokusom o komplikovanie procesu "not communicative eno- Odpovedou na túto otázku beyond wo- čítania. Naopak, je to pokus o zblíženie ugh." In judging legibility, môže byť efektívnejšie po- rds. On a le- čitateľa a pisateľa. Používanie veľkej people talk about what užívanie typografie. Vhod- vel that by- zbierky fontov môže pomôcť pri nájdení they don't see rather than ným kombinovaním textu, passes the lo- toho "pravého" pre špecifickú príležitosť. talking about what they do a grafických prv- gical, ratio- Reč je farebnejšia ako čierno biely text. see. Illegible type may so- dosiahneme plniš vi- nal centers of je prirodzene emotívna a expresívna. metimes convey more me- zuálny zážitok. Čitateľ má the brain and Dialog obsahuje okrem slov obrovské aning than a text set in the možnosť pozerať sa na rov- goes straight množstvo iných informácií. Gestá, mimi- most readable typeface. naku informáciu z rôznych to the parcka a tón hlasu, sú pre poslucháčov rozho- Thanks to designers like pohľadov a vybrať si ten, that under- dujúce. Už malá zmena v hlase ho- David Carson legibility has ktorý mu najviac vyhovu- stands with- voriaceho môže znamenať veľký posun acquired a new meaning, ie. je. Text je síce lineárny, no out think- vo význame prednesenutého. Tónom hlasu offering us new visual ex- sám čitateľ rozhodne, kto- ing." Conte- v texte sa môže stať písmo. Správne vy- perience. "Legibility pre- rým smerom. Vizuálna zlož- nporary gra- brane písmo prenáša farbu pocitov: lás- sents information as facts ka nemá za úlohu zdvojná- phic design ku, sarkazmus, nadradenosť, uvoľnenie, rather than as experi- sobiť jeho význam, s vyz- is about cre- sterilnosť atd., vlastností, ktoré inak

PAGES 190-3
DESIGNER
Peter Bil'ak
ART DIRECTOR
Peter Bil'ak
ILLUSTRATOR
Peter Bil'ak
PHOTOGRAPHERS
Peter Bil'ak, PhotoDisc
COUNTRY OF ORIGIN
Slovakia

WORK DESCRIPTION
Spreads and acetate sell from
Transparency – a book on
language and typography
DIMENSIONS
210 x 210 mm
8¼ x 8¼ in

...phonetic writing je...

Slavic languages. The Eastern-European languages...

Slavic languages use more characters in order te...

...ambiguities in spelling. The Slovak langu-

...for example, uses up to 44 signs, nearly twi-

...key as English. Although written Slovak

...linked to its pronunciation, Slovak too

...significant number of exceptions in wri-

..."Fuse" vphonetic language would probab-

...on characters.¶

...the French artist Pierre di...

...ference in Berlin. A de-

NIGHTDAY

DESIGNERS
Cover:
Beth Elliott,
Denise Gonzales Crisp,
Sibylle Hagmann
Spreads:
Weston Bingham, Bele Ducke,
Beth Elliott, Dave Ewald,
Denise Gonzales Crisp,
Jens Gehlhaar,
Sibylle Hagmann, Kevin Lyons
Unpublished fonts:
Weston Bingham, Joel Decker,
Jens Gehlhaar, Sibylle Hagmann
(California Institute of the Arts
Graduate Graphic Design
Students)
COUNTRY OF ORIGIN
USA
WORK DESCRIPTION
Front cover (opposite) and
spreads from *Offramp* 6 – a
magazine edited by Southern
California Institute of
Architecture (SCI-Arc)
DIMENSIONS
235 x 298 mm
9¼ x 11¾ in

189

FIG. 14: GESTALT SUBVERTISING

Modern practices devoid of any city-making involve a similar paradox. Policies governing planning processes, zoning ordinances, design review boards, as well as the specialization of services and infrastructures are the accepted traditions of the Late Modern city.

The urban realm is no longer developed as a cohesive environment, but instead as a network of independent and autonomous systems, creating a homogeneous repetition of the urban experience.

no longer a cohesive environment

FIG. 15: CHILE, 1968

FIG.12: SUBORDINATE ARCHITECTURE

Subsequent Heading #: UC. DOC. 059501 - REVS. 119502
Subsequent Heading title: TRANSPARENT NARRATIVE OF INFRASTRUCTURE
 —NOTES ON INCITING A NEO-MANNERIST REVOLT
Field Officer: FERGUSON, J. MICHAEL № UC01
Exhibits Listing Field Anomalies: A – R
Exhibit Description: URBAN FICTION (78.2% ANALYTICAL SUBJECTIVITY)
Summary: EXHIBITS DESCRIBE CURRENT SIX MONTH STATUS REPORT OF
 AREA AND COMMUNITY SURROUNDING EXPERIMENTAL METRO
 STATION DESIGN AT VERMONT AND SANTA MONICA
 BOULEVARDS. NUMBER OF PICTORIAL
 SUPPLEMENTS INCLUDED—(04)

FIELD REPORT

FIG. 01: MINI-MALL—A COLLAGE OF URBAN FUNCTIONS INTO A NON-HIERARCHICAL FRAME (SEE EXHIBIT A)

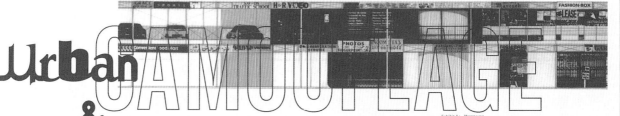

Urban CAMOUFLAGE

Art & Camouflage are twins...
The one makes something unreal
recognizable...the other makes something
real unrecognizable.
—H.B. Cott [1]

by MICHAEL FERGUSON

Camouflage, the military act of concealment, dates back to 4th century B.C. during a battle between the Thebans and Spartans. The Thebans, largely outnumbered, sent out a small calvary which stirred up a dense dry dust cloud, obscuring them upon attack and aiding them to victory. Modern applications of camouflage date to WW1 and are rumored to have roots aligned with cubist art. While strolling along Boulevard Raspail, Gertrude Stein and Pablo Picasso watched as a convoy of camouflaged cannons passed by. "C'est nous qui avons fait ça!", exclaimed Picasso "It is we who have made this!" [2]
see fig. nd

Exhibit A: MINIMAL(L)
Subject: [EVENT] RETAIL INFRASTRUCTURE OF THE TYPE IV CATEGORY
Location: CORNER OF VERMONT AND SANTA MONICA BLVDS.
Typ. Usage: OMNI-PRESENT NON-HIERARCHICAL FRAME, HOUSING A COLLAGE OF PROGRAMMATIC ACTIVITIES. POPULAR LOCATION FOR CHINESE DONUT SHOPS, AND SOME OF LA'S BEST RESTAURANTS. OFTEN IDENTIFIED AS MAJOR FACTOR FOR THE DECLINE OF THE AMERICAN CITY.
Camouflage Type: MINIMALIST DAZZLE (COMPRESSION OF ELEMENTS)
Suspected Nonconformance: MINIMALL RECONFIGURED ON 5 POINT PART:
1: PILOTIS: STRUCTURE IS ELEVATED ON LARGE YELLOW CONCRETE PILOTI THAT ALLOW PARKING UNDERNEATH. 2: ROOF GARDEN: MORE PARKING, HVAC, TWO UNCLAIMED LAWN CHAIRS. 3: FREE PLAN: PARTY WALLS FREED FROM STRUCTURE OF BLDG.- ALLOWS FOR FLEXIBILITY OF LEASEABLE SPACE. 4: FREE FACADE: TENANTS ARE 'FREE' TO INCORPORATE THEIR OWN STOREFRONTS AND TERTIARY SIGNAGE INTO THE STRUCTURAL FRAME OF THE BLDG. 5: RIBBON WINDOWS: PRAGMATICALLY CONVERTED INTO RIBBON LIGHTBOX SIGNAGE.

cn//KODAK 5054 TMX
VIEW OF SUBWAY/MINI-MALL LOOKING SOUTH (VERMONT AVE REMOVED FOR VIEWING CONVENIENCE.)

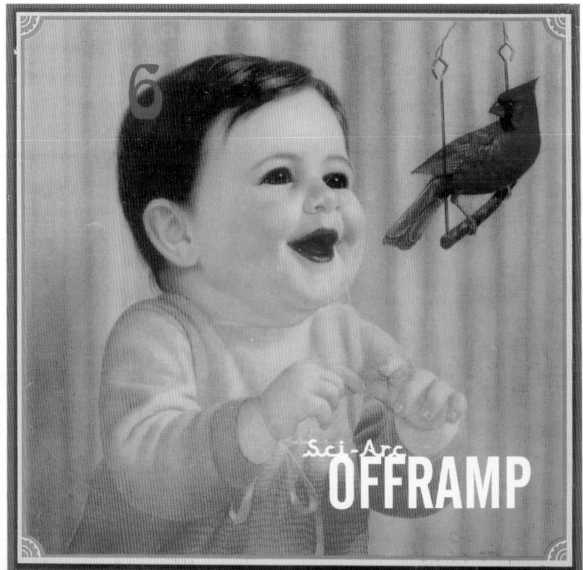

Sci-Arc
OFFRAMP

Attractions

AWARDS
As parts of our opening festivities on Thursday evening, a visual presentation will honor the most recent winners of the industry's most distinguished award, the AIGA Gold Medal.

THURSDAY OPENING PARTY
After the opening session in the Saenger Theatre, a special event will take place for all attendees. Talk, eat, drink and listen to music. Come see who's at this year's conference, hook up with old friends and meet some new ones.

FRIDAY SPONSORS RECEPTION
Friday evening the AIGA will host a Sponsors' Reception from 6:00 to 8:00 pm in the Resource Center for all conference attendees to meet our sponsors. Sponsors will be on hand with demonstrations, product samples, and more. Come socialize and visit our sponsors' exhibit booths!

SATURDAY CELEBRATION PARTY
Sponsored by Appleton Papers. We'll wrap up the conference with an evening of local jazz, New Orleans cuisine, and entertainment at Mardi Gras World. This will be a party not to be missed!

SUNDAY GOSPEL SEND-OFF
Sponsored by Microsoft Corporation. Featuring a traditional gospel music send-off, the one and only way to leave this inspiring four days of meetings, debates, parties and fun.

Schedule

Thursday	afternoon	registration at New Orleans Marriott Hotel
	evening	opening session at Saenger Theatre, 6:30 pm
	evening	opening party
Friday	morning	general sessions at the Saenger Theatre
	afternoon	parallel sessions at the New Orleans Marriott Hotel
	evening	sponsors' reception at the New Orleans Marriott Hotel
Saturday	morning	general sessions at the Saenger Theatre
	afternoon	parallel sessions at the New Orleans Marriott Hotel
	evening	celebration party sponsored by Appleton Papers
Sunday	morning	closing remarks at the Saenger Theatre
	morning	gospel send-off sponsored by Microsoft Corporation
	noon	conference concludes

CAFE CONVERSATIONS

AIGA EXHIBITIONS

EXHIBITIONS
CRANE BUSINESS PAPER EXHIBITION

RESOURCE CENTER

MEDIA TECHNOLOGY GRAS CENTER

FAMOUS FETISHES

MAIN stage

Each morning of the conference, attendees will come to the landmark Saenger Theatre for a series of speakers. NBC News commentator John Hockenberry will serve as moderator for each morning's discussion of the conference themes.

BRIAN BOIGON: ENTERTAINMENT IN THE NEW MILLENNIUM

TODD GITLIN: THE ... AND THE DISOR...

WILL BRUDER: THE SENSUAL VS. THE INTELLECTUAL
BUILDING REAL SPACE IN THE AGE OF CYBERSPACE

FRANÇOISE MOULY: FROM UNDERGROUND COMIX

ANDREI CODRESCU: THE CITY IS WILDERNESS
WITH FREQUENT REFERENCES TO MY OWN MYSTERIOUS BACKYARD

OSBERT PARKER: INTO THE CORRIDOR

STEPHEN DOYLE: THE TANGIBLE TOUCH

BARBARA MARIA STAFF... OR WHATEVER HAPPENED TO INTELL...

MIKE ALBO: "SERVICE" AND SUPERABUNDANCE

COCO FUSCO: ENGLISH IS BROKEN HERE
THE POLITICS OF PERFORMANCE

LORRAINE... WILD

CONFERENCE Registration
PLEASE SIGN UP NOW!

○ MEMBER		$525
○ NONMEMBER		$615
○ STUDENT member		$275
○ STUDENT nonmember		$350

*please send photocopy of student ID

NAME
TITLE / COMPANY
ADDRESS
CITY / STATE / ZIP
PHONE / FAX
E-MAIL

I REQUIRE THE FOLLOWING SPECIAL SERVICES BECAUSE OF A DISABILITY:

○ CHECK ENCLOSED
○ PLEASE CHARGE MY CREDIT CARD
 ○ VISA ○ MASTERCARD ○ AMERICAN EXPRESS
 AMOUNT $
CARDHOLDER (PLEASE PRINT)
CARDNUMBER: / EXP. DATE:
SIGNATURE (AS IT APPEARS ON CARD):

FOR SPECIAL STUDENT GROUP RATES CALL (212) 807-1990

Registration
Registration will take place at the Marriott Hotel on Thursday afternoon, where you will pick up your name badge and registration materials. All sessions are open to all attendees—no additional sign-ups are required.

Hotel
The official conference hotel is the New Orleans Marriott. Located on Canal Street just two blocks from Bourbon Street, the Marriott offers a complete on-site health club, two swimming pools, several notable restaurants and lounges, and is near shopping and recreational activities. It is approximately a 30-minute drive from the airport. Special discounted AIGA room rates are $139 single and $149 double. You must reserve before October 23, and mention the AIGA conference to obtain these special rates. Space is limited—make your reservations early.

RETURN THIS FORM WITH YOUR PAYMENT TO:
AIGA Conference
164 Fifth Avenue
New York, NY 10010
TEL: 212 807-1990 FAX: 212 807-1799
E-MAIL: conferences@aiga.org

All registrants will receive written confirmation by mail.

REGISTRATION FEES
You may photocopy this form if registering more than one person. There is no partial registration.

CANCELLATION FEES
Before September 12: $100
September 12 – November 7: 50% of registration fee
After November 7: no refund

PAYMENT
By check. Mail this form with your full payment. Make check payable to the AIGA.
By credit card: VISA, MasterCard and American Express. Fax or mail this form with your credit card information.

AFTERNOON PANEL DISCUSSION

FRIDAY
Every afternoon, the New Orleans Marriott will brim with sessions on a dazzling range of topics.

READING NEW ORLEANS
Richard Sexton, Michael Stanton, Tom Varisco, Susan Yelavich

OPENING SHOTS: FILM TITLES DESIGN
Kyle Cooper, Marlene McCarty

VIRTUAL VISUAL IDENTITIES: THE CUSTOMIZED BODY IN CYBERSPACE
Ted Polhemus, David Karam, Linda Stone

RE/PRESENTING CULTURE MUSEUMS AND THE ARTS OF DISPLAY
Ralph Appelbaum, Barbara Maria Stafford, Fred Wilson

FUTURES AND OPTIONS: CAREER PATHS IN DESIGN
Roz Goldfarb, Pam DeCesare, Lindon Leader, Jill Savini

GRAPHIC DESIGN AFTER THE END OF PRINT
David Carson, Mara Kurtz

HOW TO DRAW A STRAIGHT LINE BETWEEN DESIGN & MANAGEMENT
Bonnie Briggs, Larry Oakner, Earl N. Powell

TRENDS AND TRANSITIONS IN THE WORLD OF EGD
Jack Biesek, Gretchen Coss, Carol Naughton

BRAND THAT CHANNEL!
Tom Corey, Emily Oberman, Bonnie Siegler, Alexei Tylevich

FUN WITH FONTS OR BLOWING A FUSE
Tobias Frere-Jones, Jonathan Hoefler, Teal Triggs

BIG BOOKS
Irma Boom, Bruce Mau

CORPORATE IDENTITY AND ITS DISCONTENTS
Lindon Leader, Randall Rothenberg, Erik Spiekermann

PUMP UP THE VOL...
Jim Sherraden, ...

THE TYPE DIRECTORS...
Laurie Haycock Ma...

SMALL ST...
Jack Biesek, ...

SATURDAY MORE AFTERNOON PANEL DISCUSSION

DINING BY DESIGN
David Rockwell, Sharon Werner

INSIDER STORIES: THE FUTURE OF NEWS
Ralph Appelbaum, Mario Garcia, Ty Ahmad-Taylor

WHO WILL OWN THE MONA LISA? THE MUSEUM IN THE DIGITAL AGE
Brian Boigon, Laurie Haycock Makela, Doug Rowan, Jennifer Trant

THE MUSIC INDUSTRY NOW
Roger Trilling, Carol Chen, Robin Lynch, Robynne Raye

THE USES OF LITERACY
Sven Birkerts, Bill Drenttel, Todd Gitlin

CREATIVE MANAGEMENT
Jeffry Corbin, Janet Martin, Shel Perkins

THE 'ZINE SCENE
Martin J. Venezky, Paul Lukas, Sean Tejaratchi, Darby Romero

CLASH OF THE INFO TITANS
Erik Spiekermann, Loretta Staples, Andrew Zolli

THE REMARKABLE ART OF MAKING A MARQUE
Margo Chase, Mike Salisbury, Tom Corey

THE ART OF PENMANSHIP
Tamara Plakins Thornton, Shirin Neshat, Brody Neuenschwander

DIGITAL D... THE LES...
John Hudson, ...

WRITIN...
BJ Krivanek, Pau...

GALLS...

AIGA Membership APPLICATION

MEMBERSHIP

○ PROFESSIONAL	$225.-	(practicing or teaching graphic design for four or more years, or practicing or teaching in an allied field.)
○ ASSOCIATE	$140.-	(practicing graphic design for fewer than four years or current full-time faculty member (with proof of status).)
○ ENTRY LEVEL	$90.-	(practicing or teaching graphic design for fewer than two years.)
○ STUDENT	$45.-	(full-time student who presents a copy of a dated bursar's receipt or current ID from accredited college/university.)
○ RETIRED	$90.-	(65 years or older and retired from full-time practice.)
○ GROUP MEMBERSHIP	$1125.-	(six transferable professional memberships for the price of five, owned by a firm or corporation.)
○ MR. ○ MS.		

FIRST NAME
LAST NAME
TITLE
COMPANY
ADDRESS
CITY
STATE/ZIP
BUSINESS PHONE ()
HOME PHONE ()
FAX ()
WEB SITE ADDRESS http://www.
E-MAIL @

The address you provide will be used for all AIGA correspondence and will appear in the AIGA Membership Directory.

Are you primarily a: ○ Graphic designer ○ Educator ○ Service provider to the industry

AREA CHAPTER =
YEARS OF EXPERIENCE =

MEMBERSHIP CATEGORY =
MEMBERSHIP FEE = $
APPLICATION FEE $20.- THE FEE IS WAIVED FOR STUDENTS
TOTAL $

Please make checks payable to American Institute of Graphic Arts

METHOD OF PAYMENT ○ CHECK ○ MASTERCARD ○ VISA ○ AMEX
CARD NUMBER
CARDHOLDER NAME
EXPIRATION DATE
SIGNATURE

ROOM FOR A LITTLE STORY THAT MY PRINTER TOLD ME:
So, my printer in Jersey works on this very large job for a Fancy Food Fair in New Orleans. His client is the market leader in that segment, a magazine called "FROZEN VEGETABLES". It was a rush job, they had worked several night shifts to get a special Fancy Food Fair issue down to New Orleans in time for the show opening on...

DESIGNER
Stefan Sagmeister
DESIGN COMPANY
Sagmeister Inc.
ILLUSTRATORS
Dalton Portella (Paint Box),
Stefan Sagmeister,
Peggy Chuang,
Kazumi Matsumoto,
Raphael Rüdisser
PHOTOGRAPHER
Bela Borsodi
COUNTRY OF ORIGIN
USA

WORK DESCRIPTION
Fold-out invitation/poster for
the 1997 biennial conference of
the American Institute of
Graphic Arts, New Orleans
DIMENSIONS
965 x 660 mm
38 x 26 in

CCAC

we now add environmental responsibility to the established design criteria of function, aesthetics and economics.

Tuesday, September 9, 5:30–7:30 pm

opening reception

September 9–October 31, 1997

Tecoah and Thomas Bruce Galleries

Still Life composition of contemporary
ts in clay allows the artist to incorporate
ety of ideas and concerns. Some artists
ing in this mode use what appears to be
ional table ware, while others use repli-
f books, bottles, fruit, cloth and writing
ements combined in different settings
arying relationships.

Historically, in painting, the still life
position consisted of a number of these
ents usually arranged on a desk or table,
ted with trompe l'oeil accuracy. One sev-
enth century Dutch painting showed the
ants of a meal. Left in disarray, the set-

cal vase and pieces of fruit. An oversize plat-
ter supports Clayton Bailey's jugs and jars.
The forms recall early New England earthen-
ware but the strange noises produced by
Laboratory Still Life (1990-95) reflect Bailey's
consistent additions of unexpected sensory
elements to his work. Two colorful, super
realistic birds perched on tree stumps in
Annette Corcoran's *Redstart Pair* (1997) look
as though they should chirp.

The presentation choice for Juta Savage
and James Shrosbree is a three-foot high
table with thin legs of wood or metal. Both
seem less than sturdy which sets up a ten-
sion between objects and their support.
More stable in appearance is the table in
Helaine Melville's life-size *A Slice of
Life–Mom's Kitchen.* Surrounded by kitchen
implements, the all-white work is a ghost-
like environment, perhaps a memory of a
special place in her past.

Like an advertisement for a restaurant's
menu, a few fruits with wine and a goblet

ELSA RADY *Still Life #56-1*
1995 PORCELAIN,
PAINTED ALUMINUM SHELF

OPPOSITE
DESIGNER
Bob Aufuldish
DESIGN COMPANY
Aufuldish & Warinner
COUNTRY OF ORIGIN
USA
WORK DESCRIPTION
**Announcement for 'Re(f)use' –
an exhibition of objects made
from recycled and/or reused
materials at the California
College of Arts and Crafts Oliver
Art Center**
DIMENSIONS
**152 x 229 mm
6 x 9 in**

DESIGNER
Bob Aufuldish
DESIGN COMPANY
Aufuldish & Warinner
COUNTRY OF ORIGIN
USA
WORK DESCRIPTION
**Front cover (left) and spreads
(below right, center, and left)
from a catalog for 'Ceramic Still
Life' – an exhibition at the
California College of Arts and
Crafts Oliver Art Center**
DIMENSIONS
**76 x 114 mm
3 x 4½ in**

contents

DIRECTOR'S STATEMENT
Dyana Curreri
Director of Exhibitions and Public Programs
Oliver Art Center

CERAMIC STILL LIFE:
The Common Object
ELAINE LEVIN

OBJECT LIST

left and on cover:
YIOLA FAEY *Untitled (D)*, detail
1995 CERAMIC

CERAMI
STILL
LIFE

The Common Object

ELAINE LEVIN

Herron Visiting Artists Program.
Lecture Series.
1996–1997

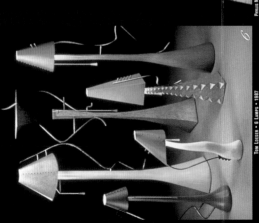

Herron School of Art
IUPUI

August 26, Monday
TAL STREETER
—"Giant Sculptures and Kites"—
—Co-sponsored by the
Indianapolis Museum of Art—
11:00 a.m.

October 7, Monday
KATHRYN HIXSON
—Critic, New Art Examiner—
"Issues in Contemporary Art
Seen Through Chicago Work"—
7:00 p.m.

October 29, Tuesday
PEG FIERKE
—Painter and printmaker—
1:00 p.m.

November 4, Monday
GLADYS NILSSON
—Mixed media, in conjunction
with "Gladys Nilsson and Jim Nutt:
Works on Paper"—
7:00 p.m.

November 6, Wednesday
CHRISTOPHER BROWN
—Painter—
7:00 p.m.

January 14, Tuesday
RONDA KASL
—Curator at the Indianapolis Museum of Art—
"Goya and His Contemporaries"—
1:00 p.m.

January 16, Thursday
TOM LOESER
—Studio art furniture—
1:00 p.m.

January 22, Wednesday
PHYLLIS McGIBBON
—Works on paper—
11:00 a.m.

February 27, Thursday
PEG BRAND
—"Feminism and Aesthetics"—Keynote Speech for
a symposium on "Unframing the Visual Arts:
Feminist Influence in American Culture Today."
—Co-sponsored by Women's Studies
and American Studies at IUPUI—
1:00 p.m.

March 5, Wednesday
JEANNE DUNNING
—Creates photographs and videotapes—
7:00 p.m.

April 9, Wednesday
PHIL TENNANT
—Woodworker—
1:00 p.m.

| 1996– | August | September | October | November | December | 1997– | January | February | March | April | May |

Herron Gallery Exhibition Schedule.

DEBORAH BUTTERFIELD/JOHN BUCK
Exhibition dates August 23–September 26
Reception August 23, 5–9p.m.

TEACHER'S PETS
Selections from Herron
Faculty Collections
Exhibition dates
October 11–October 26
Reception October 11, 5–8p.m.

GLADYS NILSSON AND JIM NUTT
WORKS ON PAPER
Exhibition dates November 1–December 12
Reception November 1, 5–8p.m.

CLAYFEST
Exhibition date January 17–February 8
Reception TBA

PAINTERS CHOOSE PAINTERS
Exhibition dates February 14–March 20
Reception February 14, 5–8p.m.

STUDENT SHOW
—Herron School of Art—
Exhibition dates March 28–April 17
Reception March 28, 7–9p.m.

SENIOR SHOW
—Herron School of Art—
Exhibition dates April 24–May 13
Reception April 24
—following the Honors & Awards program.

Gallery Hours: Monday, Tuesday, Wednesday: 10am–5pm • Thursday: 10am–8pm • Friday, Saturday: 10am–2pm • Sunday: Closed

Herron School of Art|IUPUI
1701 North Pennsylvania Street
Indianapolis, IN 46202-1414

HERRON SCHOOL OF ART

VISITING ARTIST SERIES + EXHIBITION SCHEDULE

Herron Gallery Exhibition Schedule

AUGUST 27 THROUGH SEPTEMBER 27
Opening: Wednesday, August 27 [5:00 – 7:00pm]

① **ROBERT COLESCOTT**

Paintings, drawings, and prints by the artist chosen to represent the United States at the 1997 Venice Biennale. A student of Fernand Leger, Colescott is considered by many the most important figurative painter of his generation. Colescott's work is represented in the permanent collections of most of the country's prominent museums including: The Metropolitan Museum of Art, The Museum of Modern Art, The Whitney Museum of American Art and the Hirshorn Museum and Sculpture Garden. [ABOVE, *Alternatives,* acrylic on paper]

OCTOBER 8 THROUGH NOVEMBER 15
Opening: Wednesday, October 8 [5:00 – 7:00pm]

⑥ **UNBOUND: ART IN BOOKFORM
— BOOK AS ARTFORM**

An exhibit of contemporary sculptural works which will feature artists Mark Arctander, Amos Kennedy, Ronald Leax, Buzz Spector, and Margaret Wharton. Each of these artists has utilized the book as a central motif or symbol. This exhibit will also explore book-related artists such as hand-printed books, rare books, artists' books, comic books, and more [ABOVE: Mark Arctander, *Book Ends*]

DECEMBER 3 THROUGH DECEMBER 27
Opening: Wednesday, December 3 [5:00 – 9:00pm]

STUDENT EXHIBITION

This annual exhibition of work created by more than 200 students includes pieces that encompass a variety of media: painting, sculpture, photography, ceramics, woodworking, printmaking and visual communication.

GALLERY HOURS:
Monday, Tuesday, Wednesday 10 – 5
Thursday 12 – 8
Friday, Saturday 10 – 3
Sunday closed

GALLERY PHONE 920.2420 • GALLERY OFFICE 920.2421

JANUARY 14 THROUGH FEBRUARY 14
Opening: Wednesday, January 14 [5:00 – 7:00pm]

**SMALL WORKS: THE BUTLER INSTITUTE
OF AMERICAN ART**

Drawn from the permanent collection of the nation's oldest museum, solely devoted to acquisition of works by American artists, this exhibit will include works by Aaron Borrod, Lichtenstein, Reginald Marsh, Joan Mitchell, Horace Pippin, and Andy Warhol.

&

**ROADWORKS: PHOTOGRAPHY
BY LINDA McCARTNEY**

Most popularly known as the wife of ex-Beatle Paul McCartney, Linda McCartney has been a photographer for over thirty years. The works (gelatin & iris prints) in this exhibit span that time, and chronicle the many roadtrips McCartney has taken in search of her candid, offbeat images.

MARCH 11 THROUGH APRIL 11
Opening: Wednesday, March 11 [5:00 – 7:00pm]

**TIME ON THEIR HANDS:
THE TRAMP ART TRADITION**

The first in a series of Herron exhibits that will examine "self-taught art." Tramp Art is the easily given to works produced by people put out of work (and often migrant) by the Great Depression of the 1930s. These highly decorative, but often useful, one-of-a-kind works illustrate the patience and resourcefulness of their anonymous creators. This exhibit will examine an American wood-working tradition too often overlooked.

APRIL 22 THROUGH MAY 16
Opening: Wednesday, April 22 [5:00 – 9:00pm]

SENIOR EXHIBITION

This annual exhibition of work is produced by the entire graduating class surveys all media, painting to visual communication. Each student is represented by three or four major works completed during the year. The show extends throughout the gallery and various locations within the Museum Building of the Herron School of Art.

Herron Visiting Artist Program · Lecture Series

September 18, Thursday [2:30pm]
PAUL SASSO
– woodworker –
[ABOVE] *[visual cabinet]*
⑤

September 23, Tuesday [6:00pm]
**ELLEN
DISSANAYAKE**
– independent scholar –
Emeritus Distinguished Visiting Professor of Fine Arts at Ball State University, Fall 1997 – *[ABOVE: [portrait]]*

September 25, Thursday [2:30pm]
DAVID NELSON
– sculptor –
[ABOVE] *[arrangement – Calabash with Green Drawer; pine, wood, walnut]*
④

October 9, Thursday [2:30pm]
EVA KWONG
– ceramist –
[ABOVE] *Nude II*
⑧

October 15, Wednesday [10:30am]
**WAYNE
KIMBALL**
– printmaker –
[ABOVE] *Portrait of a man and his horse, the horse having bitten the man, lithograph]*
②

November 6, Thursday [10:30am]
**DANIEL
LOEWENSTEIN**
– sculptor –
[ABOVE] *Feeding Bulimia III: (something about being tossed)]*
③

November 17, Monday [6:00pm]
**BARBARA
DE GENEVIEVE**
– photographer and video artist –
[ABOVE] *Untitled ("Someone's flesh is under my fingernails")*
⑨

February 12, Thursday [2:30pm]
**VALERIE
EICKMEIER**
– sculptor –
[ABOVE] *Export Trees, wood, resin, steel]*
⑩

March 9, Monday [7:00pm]
DAVID KLAMEN
– painter –
[ABOVE] *Untitled, oil on linen]*
⑦

April 7, Tuesday [2:30pm]
AL WASCO
– interactive media artist –

All lectures are free and open to the public. · All lectures are in the Hefron auditorium, located in the Museum Building, 1701 North Pennsylvania Street. The auditorium is wheelchair accessible.

For more information, contact the Visiting Artist Program at 317.920.2460

With the generous support of the Herron Foundation, Indiana Arts Commission, and National Endowment for the Arts.

PAGES 176–9		
DESIGNERS	COUNTRY OF ORIGIN	DIMENSIONS
Elisabeth Charman, Brad Trost	USA	1997–8:
DESIGN COMPANY	WORK DESCRIPTION	610 x 914 mm
loft 219	Posters announcing the Herron	24 x 36 in
PHOTOGRAPHER	School of Art visiting artist	1996–7:
Brad Trost (pages 178–9)	series 1997–8 and 1996–7	495 x 635 mm
	(pages 178–9)	19½ x 25 in

U.S. Postage Paid
Permit #1515
Indianapolis, Indiana 46202

HERRON SCHOOL of ART

IUPUI

1997–1998

VISITING ARTIST PROGRAM & GALLERY EXHIBITION SCHEDULE

1701 North Pennsylvania Street
Indianapolis, Indiana 46202

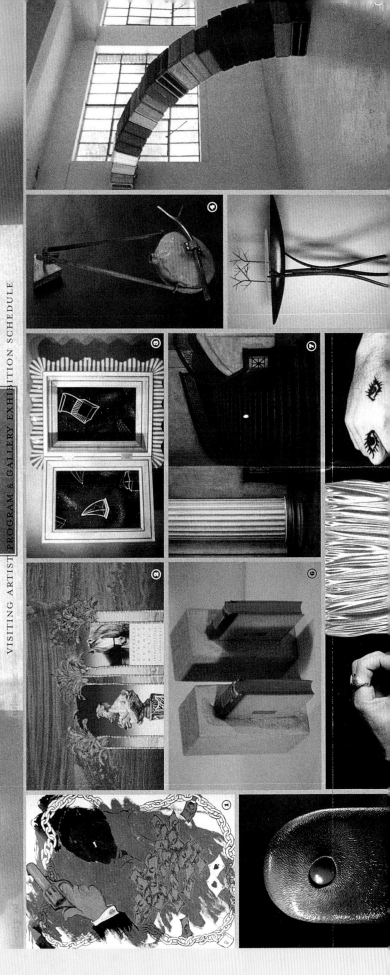

CAUTION!!

EOPLE OF SOUTHAMPTON
COUNTY, VIRGINIA,
one and all, you are hereby advised that

NAT TURNER

INSURRECTION: HOLDING HISTORY

INSURRECTION

THE PUBLIC THEATER
425 LAFAYETTE STREET
(212) 260-2400

BY ROBERT O'HARA

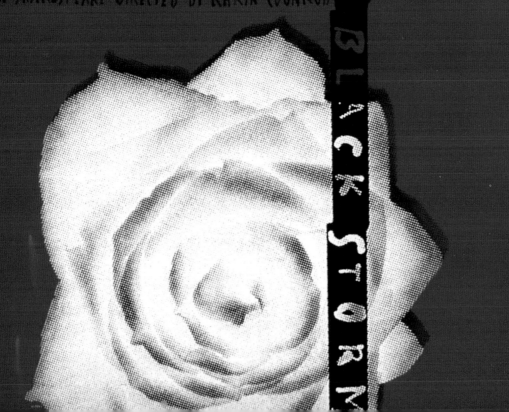

PIRIF
EATER
285-2400

PART 1: THE EDGED SWORD

PART 2 BLACK STORM

HENRY VI

WILLIAM SHAKESPEARE DIRECTED BY KARIN COONROD

PAGES 172–5
DESIGNERS
Lisa Mazur, Anke Stohlmann
ART DIRECTOR
Paula Scher
DESIGN COMPANY
Pentagram Design
COUNTRY OF ORIGIN
USA

PAGES 172–3
WORK DESCRIPTION
Posters in the tradition of
old-fashioned English theater
announcements for the New
York Shakespeare Festival in
Central Park 1996–7
DIMENSIONS
1207 x 1753 mm (left)
48 x 69 in
1067 x 2134 mm (right)
42 x 84 in

PAGES 174–5
PHOTOGRAPHER
Tar (Insurrection)
WORK DESCRIPTION
Posters for the 1996–7 Public
Theater season designed to
reflect street typography,
juxtaposing photography
and type
DIMENSIONS
762 x 1168 mm
30 x 46 in

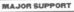

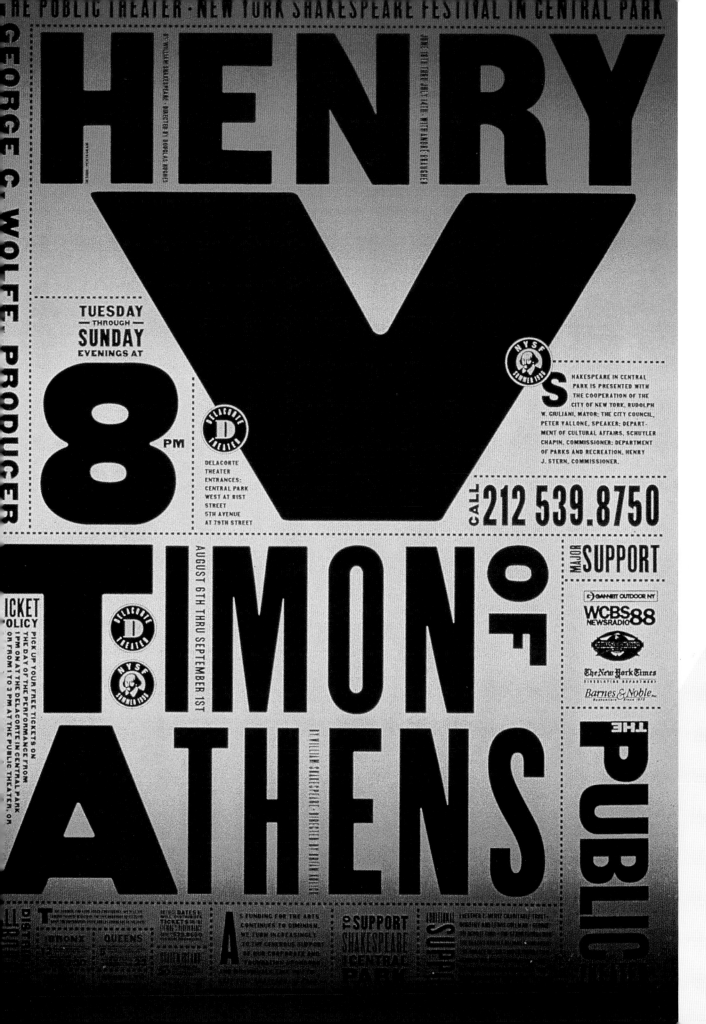

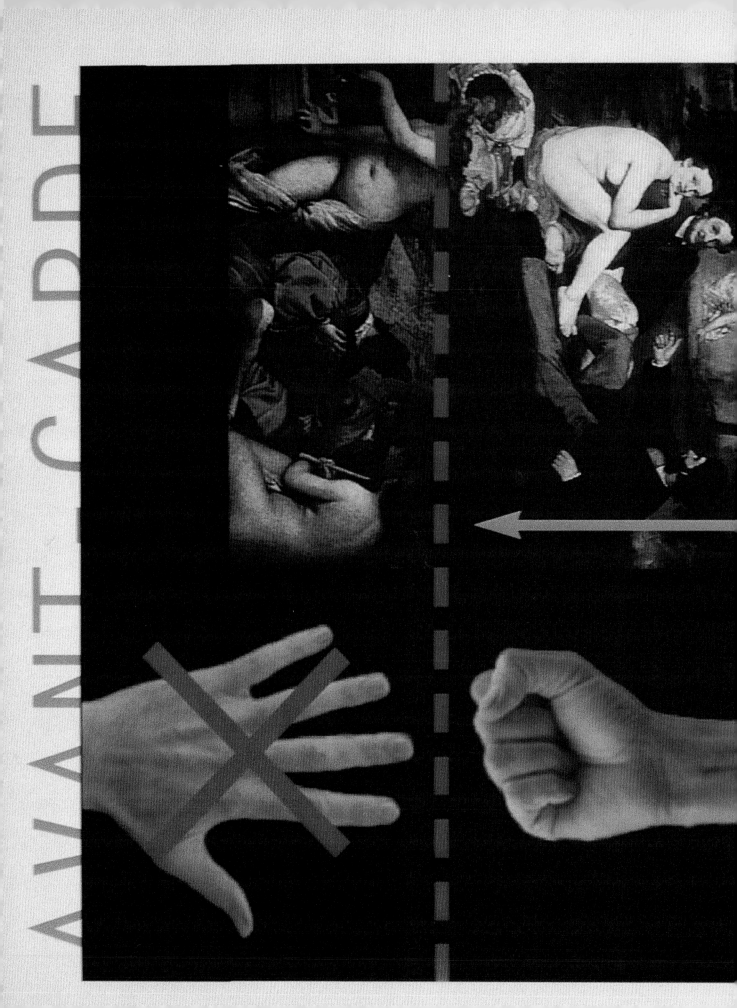

ABOVE

DESIGNER
David Kasparek (North Carolina
State University)

ART DIRECTOR
David Kasparek

COUNTRY OF ORIGIN
USA

WORK DESCRIPTION
Poster questioning the pros
and cons of 'pro-active design'
– part of a project assigned by
visiting designer Nick Bell

DIMENSIONS
254 x 838 mm
10 x 33 in

DESIGNER
David Kasparek (North Carolina
State University)

ART DIRECTOR
David Kasparek

PHOTOGRAPHER
David Kasparek

COUNTRY OF ORIGIN
USA

WORK DESCRIPTION
One of a series of posters
about safety in on-campus
housing

DIMENSIONS
610 x 1219 mm
24 x 48 in

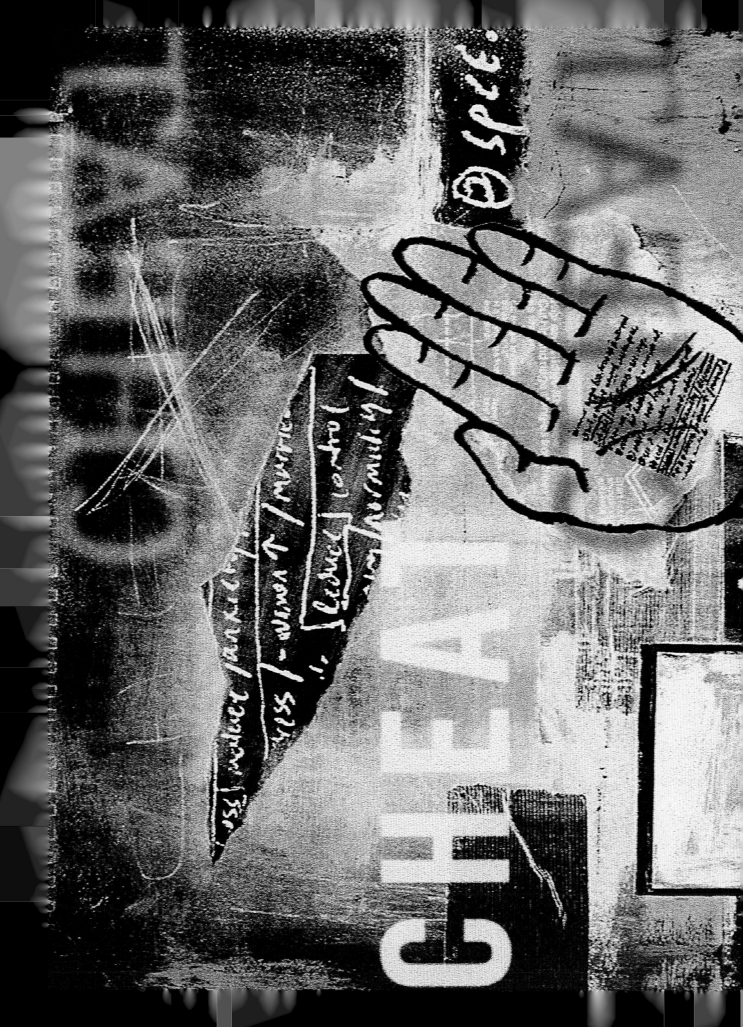

DESIGNER
David Kasparek (North Carolina
State University)
ART DIRECTOR
David Kasparek
ILLUSTRATOR
David Kasparek
COUNTRY OF ORIGIN
USA

WORK DESCRIPTION
Mixed-media postcard design
inspired by a 'cheat sheet'
found on campus
DIMENSIONS
127 x 152 mm
5 x 6 in

DESIGNER
David Kasparek (North Carolina
State University)

ART DIRECTOR
David Kasparek

COUNTRY OF ORIGIN
USA

WORK DESCRIPTION
Flash card – part of a studio
project to interpret key terms
in theoretical design discourse

DIMENSIONS
127 x 178 mm
5 x 7 in

AVANT-GARDE

SPACE

UN_SAFE

de-FACE

de-SIGN

NON SIGN

blot
misspelled the

taint
spoil

corrupt
stain

disfigure
disfigure

mutilate
mangle

squelch
quash

impair
limit

destroy
finish

prompt
urge

enhance
clarify

induce
guide

invigorate
brighten

motivate
encourage

stimulate
enlighten

the profession
play

the profession
play

All that is solid explores the repackaging of the United States' "industrial heritage" for tourist and affluent consumption in the post-industrial era. As a long-time resident of the former core regions of U.S. industrial production (Chicago and New England), Bright has witnessed the conversion of factory complexes into gentrified condominiums, shopping malls and high-tech office parks. Meanwhile, entire cities, towns and regions which once depended on manufacturing have been left to fall into destitution. Lawrence, MA, site of the famous "Bread and Roses" strike of 1912, now resembles a third world city — sixty percent of its residents live on public assistance. In contrast, its sister mill-city, Lowell, was transformed by federal, state and private investment into a National Park where tourists can "see what mill life was like."

Non-Profit Organization
U.S. Postage
PAID
Permit #3069
Atlanta, GA

The Atlanta College of Art
The Woodruff Arts Center
1280 Peachtree Street, NE
Atlanta, GA 30309

Gallery Hours:
Monday: Closed
Tuesday, Wednesday & Saturday: 10-5pm
Thursday & Friday: 10-9pm
Sunday: 12-5pm

404-733-5050 (phone)

All that is solid an installation by Deborah Bright
January 24 – March 9, 1997

Opening reception for the artist:
Friday, January 24, 1997, 5:30-8:00pm
Atlanta College of Art Gallery.

Panel Discussion: "Repackaged: A Discussion of
America's Industrial History"
Thursday, January 23, 1997, 7:00-8:30pm
Hill Auditorium, Atlanta College of Art.
Panelists include: Chris Saccocia, Gallery Director; Deborah
Bright, artist; Charles Rutheiser, anthropologist; and others
to be announced.

Continued support for the Atlanta College of Art Gallery is funded, in part, by
the George County Arts Council and the City
of Atlanta Bureau of Cultural Affairs as well as generous contributions to the
College by individuals, foundations, and corporations.

Deborah Bright is associate professor of photography at the Rhode Island
School of Design. She has received numerous recognition for her various
including exhibitions at the National Museum of American Art, the MoMA and
Nexus Museum, the Vancouver Art Gallery, Durham Institute of Contemporary
Art, and the Canadian Museum of Contemporary Photography. Her various
writings on contemporary and cultural issues has been published in Afterimage,
Exposure, Afterimage, and others. Bright was awarded in creation solutions of
photographic criticism in 1991. Bright was awarded a Fulbright Fellowship to
establish residences, she is editing a collection of essays and critical studies on
photography and sexuality, The Passionate Camera, to be published by
Routledge in 1997.

All that is solid
an installation by Deborah Bright

Atlanta College of Art Gallery
January 24 – March 9, 1997

OPPOSITE AND PAGES 164–5
DESIGNER
Andrew Blauvelt (North Carolina
State University)
ART DIRECTOR
Andrew Blauvelt
DESIGN COMPANY
Andrew Blauvelt Graphic Design
PHOTOGRAPHERS
Andrew Blauvelt,
Deborah Bright
COUNTRY OF ORIGIN
USA

WORK DESCRIPTION
Two posters announcing *All That
is Solid* – an installation by
Deborah Bright examining the
plight of industrial society
DIMENSIONS
457 x 610 mm
18 x 24 in

OPPOSITE
DESIGNER
Tony Brock (North Carolina
State University)
ART DIRECTOR
Tony Brock
ILLUSTRATOR
Tony Brock
COUNTRY OF ORIGIN
USA
WORK DESCRIPTION
Self-published poster
examining views of personal
style in contemporary graphic
design
DIMENSIONS
610 x 965 mm
24 x 38 in

26

ABOVE AND PAGE 162
DESIGNER
Tony Brock (North Carolina
State University)
ART DIRECTOR
Tony Brock
ILLUSTRATOR
Tony Brock
COUNTRY OF ORIGIN
USA

WORK DESCRIPTION
Front cover and pages from
My Word Book – a lexicon
developed from readings in
cultural studies and design
DIMENSIONS
508 x 711 mm
20 x 28 in

con·ceit (kən sēt′) *n.*

1 *a)* an idea; thought; concept *b)* personal opinion **2** an exaggerated opinion of oneself, one's merits, etc.; vanity **3** *a)* a fanciful or witty expression or notion; often, specif., a striking and elaborate metaphor, sometimes one regarded, esp. formerly, as strained and arbitrary **4** a small, imaginatively designed item

DESIGNERS
David Harlan, Shelby Tiffany
ART DIRECTORS
David Harlan, Shelby Tiffany
DESIGN COMPANY
PopGlory
ILLUSTRATORS
David Harlan, Shelby Tiffany
PHOTOGRAPHERS
David Harlan, Shelby Tiffany,
various video captures
(opposite)
COUNTRY OF ORIGIN
USA
WORK DESCRIPTION
Invitation (below) and program
(opposite) for the California
Institute of the Arts'
graduation ceremony
DIMENSIONS
Invitation:
152 x 216 mm
6 x 8½ in
Program:
356 x 254 mm
14 x 10 in

RIGHT
DESIGNER
David Harlan
ART DIRECTOR
David Harlan
DESIGN COMPANY
PopGlory
ILLUSTRATOR
David Harlan
COUNTRY OF ORIGIN
USA
WORK DESCRIPTION
Front cover for a Reprise
Records compilation CD
DIMENSIONS
127 x 130 mm
5 x 5⅛ in

158

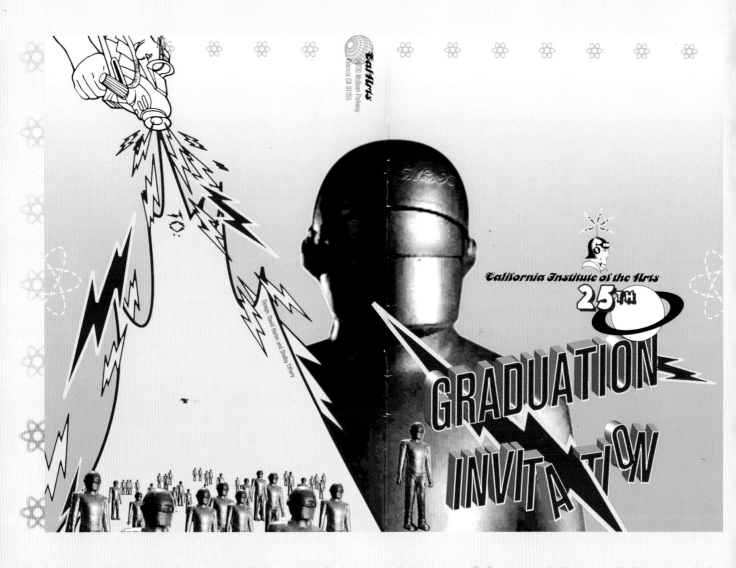

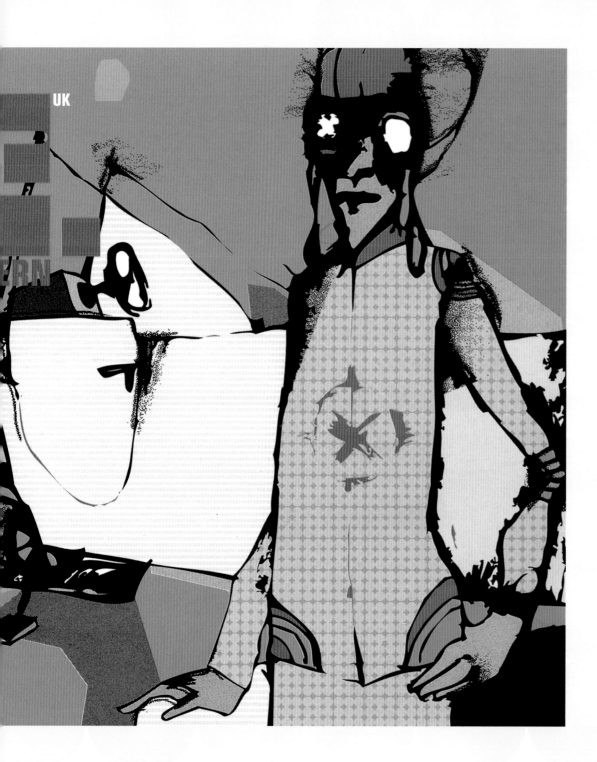

UK

DJ PESHAY

DRUM'N'BASS
FROM METALHEADZ LONDON
ADDITIONAL DJS FROM UTR: M.F + TONI B.
REITSCHULE DACHSTOCK BERN
FRIDAY 24.OCTOBER '97
22.00

EXKAN DALO!

FIESTA VON
TRANCE & HOUSE BIS
RUMBA MIT DJ PACO
MACROTEAM PRESENT: EXKANDALO! SAMSTAG:
 BIERHÜBELI NEUBRÜCKSTR.43 23.AUGUST
BERN 20.SEPTEMBER / 18.OKTOBER
 29.NOVEMBER / 20.DEZEMBER
HASTA LA VISTA! TÜRÖFFNUNG: 21:00 UHR DONNERSTAG: 1.JANUAR

dj's

METALHEADZ/TIMELESS
DIGITAL/SPIRIT/FLUID
DRUM'N'BASS
REITSCHULE BERN DACHSTOCK

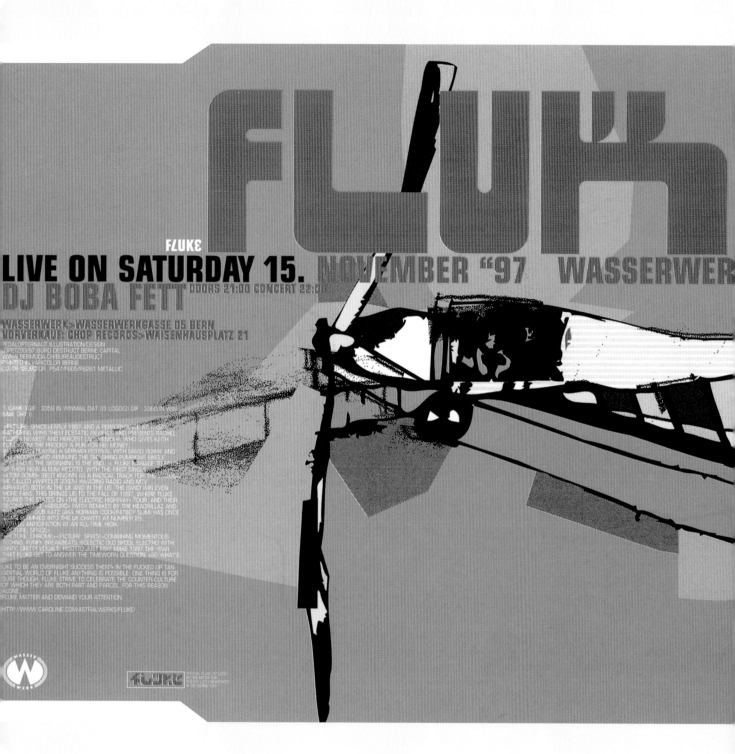

FLUKE

LIVE ON SATURDAY 15. NOVEMBER "97 WASSERWER

DJ BOBA FETT DOORS 21:00 CONCERT 22:00

WASSERWERK>WASSERWERKGASSE 05 BERN
VORVERKAUF: CHOP RECORDS>WAISENHAUSPLATZ 21

DESIGNER
Lopetz
DESIGN COMPANY
büro destruct
ILLUSTRATOR
Lopetz
COUNTRY OF ORIGIN
Switzerland
WORK DESCRIPTION
Concert flyer
DIMENSIONS
240 x 121 mm
9¼ x 4¾ in

OPPOSITE, LEFT AND RIGHT
DESIGNER
Lopetz
DESIGN COMPANY
büro destruct
COUNTRY OF ORIGIN
Switzerland
WORK DESCRIPTION
Club flyers
DIMENSIONS
120 x 120 mm
4¾ x 4¾ in

OPPOSITE, CENTER
DESIGNER
MBrunner
DESIGN COMPANY
büro destruct
COUNTRY OF ORIGIN
Switzerland
WORK DESCRIPTION
Club flyer
DIMENSIONS
140 x 140 mm
5½ x 5½ in

DESIGNER
H1reber
DESIGN COMPANY
büro destruct
ILLUSTRATOR
Lopetz
COUNTRY OF ORIGIN
Switzerland
WORK DESCRIPTION
Promotional poster
DIMENSIONS
287 x 593 mm
11¼ x 23⅜ in

alexone uk
neece

a walk on the future side

sa. 22. november
Wasserwerk
Wasserwerkgasse #5 bern

dj fatdilat (f.d.a.)
drum'n'bass, big beat
dj raphael delan
le delan house spectrum

vorverkauf: chop records, waisenhausplatz 2
Historisches Museum, Helvetiaplatz 5

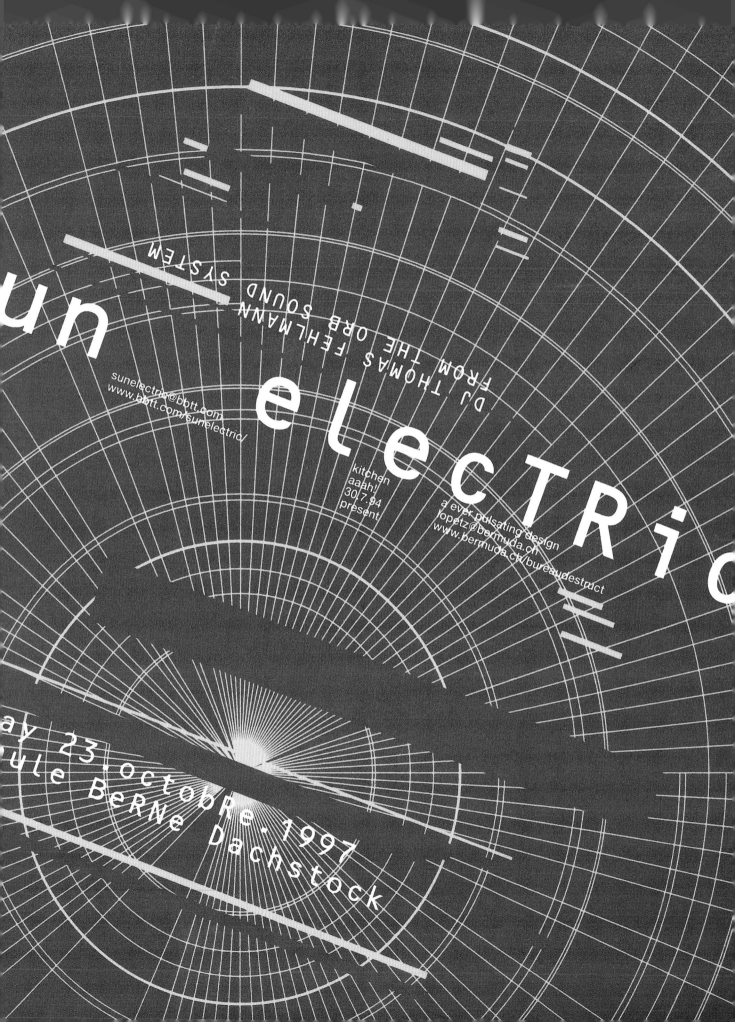

PAGES 150-1
DESIGNER
Lopetz
DESIGN COMPANY
büro destruct
COUNTRY OF ORIGIN
Switzerland
WORK DESCRIPTION
Fold-out CD booklet
from the techno-compilation
album *Berne Electronic*
DIMENSIONS
120 x 120 mm
4¾ x 4¾ in

DESIGNER
Lopetz
DESIGN COMPANY
büro destruct
COUNTRY OF ORIGIN
Switzerland
WORK DESCRIPTION
Club flyers
DIMENSIONS
120 x 120 mm
4¾ x 4¾ in

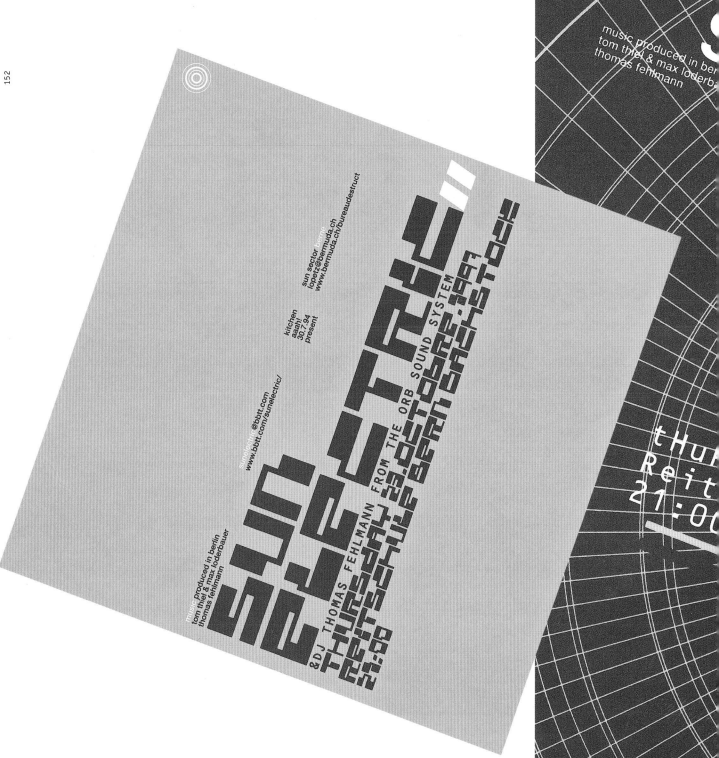

FEATURING: LEE & CHEN SEN
PUMPIN
GROOVE CONSTRUCTION
DJ DEETRONIC-9
DJ DEETREE
DJ SONICITON
DJ POBSESSION
SQUARUZNOPHONE
OVERLID
KALECHE
VOKAL
MARCO REPETTO

BERNE ELECTRONIC
compactdisc

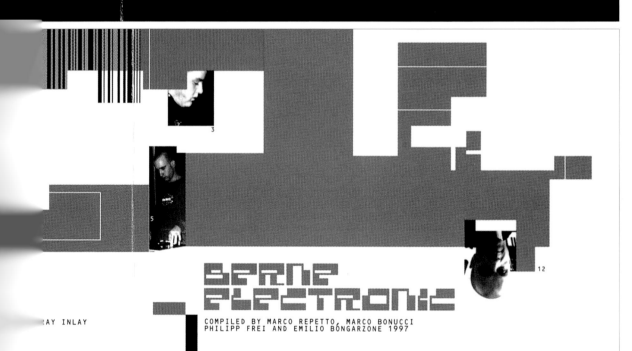

BERNE ELECTRONIC

AY INLAY

COMPILED BY MARCO REPETTO, MARCO BONUCCI
PHILIPP FREI AND EMILIO BONGARZONE 1997

THANKS TO:
ALL ARTISTS INVOLVED IN THIS PROJECT, DANI WIHLER FOR MASTERING,
SANDRO FISCHLI, MARCO "HOTHANDS" MALINVERNO, BDLOPETZ FOR ARTWORK,
URSULA AND ALEC @ DISCTRADE.

SPECIAL THANKS TO:
ABTEILUNG KULTURELLES - STADT BERN, PETER SCHRANZ
ABTEILUNG KULTUR - KANTON BERN, PHILIPPE WALKER

E)
5)
PARTS
NING ON

TS BREAK
8).
-12) THE
P AWAY
DS

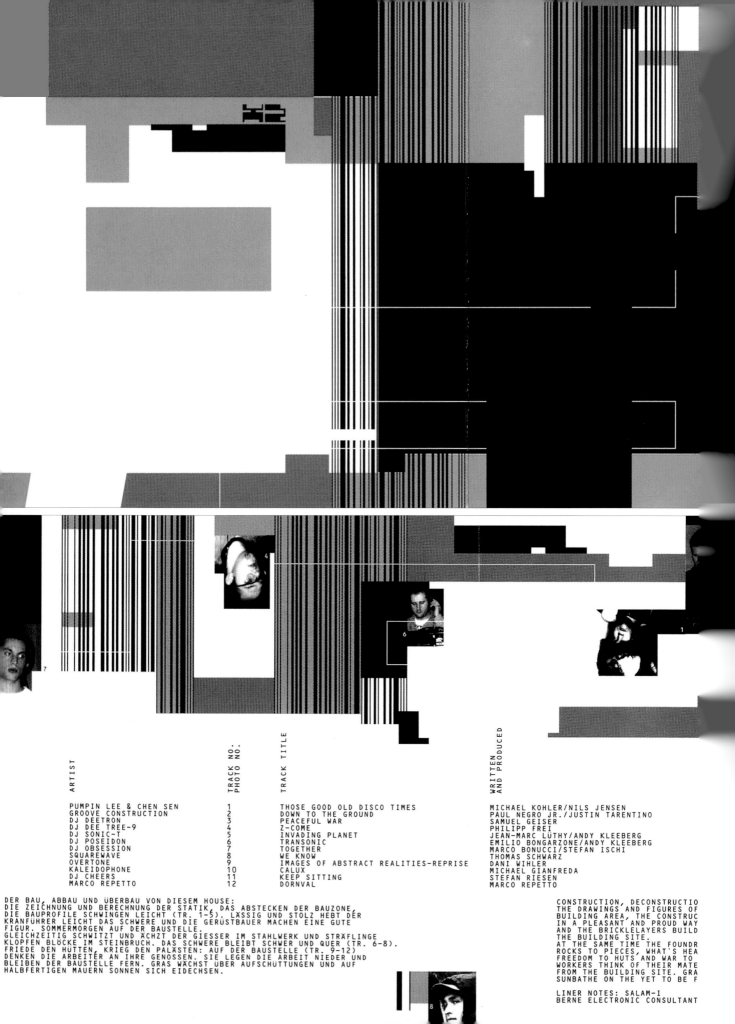

ARTIST	TRACK NO. PHOTO NO.	TRACK TITLE	WRITTEN AND PRODUCED
PUMPIN LEE & CHEN SEN	1	THOSE GOOD OLD DISCO TIMES	MICHAEL KOHLER/NILS JENSEN
GROOVE CONSTRUCTION	2	DOWN TO THE GROUND	PAUL NEGRO JR./JUSTIN TARENTINO
DJ DEETRON	3	PEACEFUL WAR	SAMUEL GEISER
DJ DEE TREE-9	4	Z-COME	PHILIPP FREI
DJ SONIC-T	5	INVADING PLANET	JEAN-MARC LÜTHY/ANDY KLEEBERG
DJ POSEIDON	6	TRANSONIC	EMILIO BONGARZONE/ANDY KLEEBERG
DJ OBSESSION	7	TOGETHER	MARCO BONUCCI/STEFAN ISCHI
SQUAREWAVE	8	WE KNOW	THOMAS SCHWARZ
OVERTONE	9	IMAGES OF ABSTRACT REALITIES-REPRISE	DANI WIHLER
KALEIDOPHONE	10	CALUX	MICHAEL GIANFREDA
DJ CHEERS	11	KEEP SITTING	STEFAN RIESEN
MARCO REPETTO	12	DORNVAL	MARCO REPETTO

DER BAU, ABBAU UND ÜBERBAU VON DIESEM HOUSE:
DIE ZEICHNUNG UND BERECHNUNG DER STATIK, DAS ABSTECKEN DER BAUZONE,
DIE BAUPROFILE SCHWINGEN LEICHT (TR. 1-5). LÄSSIG UND STOLZ HEBT DER
KRANFÜHRER LEICHT DAS SCHWERE UND DIE GERÜSTBAUER MACHEN EINE GUTE
FIGUR. SOMMERMORGEN AUF DER BAUSTELLE.
GLEICHZEITIG SCHWITZT UND ÄCHZT DER GIESSER IM STAHLWERK UND STRÄFLINGE
KLOPFEN BLÖCKE IM STEINBRUCH. DAS SCHWERE BLEIBT SCHWER UND QUER (TR. 6-8).
FRIEDE DEN HÜTTEN, KRIEG DEN PALÄSTEN: AUF DER BAUSTELLE (TR. 9-12).
DENKEN DIE ARBEITER AN IHRE GENOSSEN. SIE LEGEN DIE ARBEIT NIEDER UND
BLEIBEN DER BAUSTELLE FERN. GRAS WÄCHST ÜBER AUFSCHÜTTUNGEN UND AUF
HALBFERTIGEN MAUERN SONNEN SICH EIDECHSEN.

CONSTRUCTION, DECONSTRUCTIO
THE DRAWINGS AND FIGURES OF
BUILDING AREA, THE CONSTRUC
IN A PLEASANT AND PROUD WAY
AND THE BRICKLELAYERS BUILD
THE BUILDING SITE.
AT THE SAME TIME THE FOUNDR
ROCKS TO PIECES, WHAT'S HEA
FREEDOM TO HUTS AND WAR TO
WORKERS THINK OF THEIR MATE
FROM THE BUILDING SITE. GRA
SUNBATHE ON THE YET TO BE F

LINER NOTES: SALAM-I
BERNE ELECTRONIC CONSULTANT

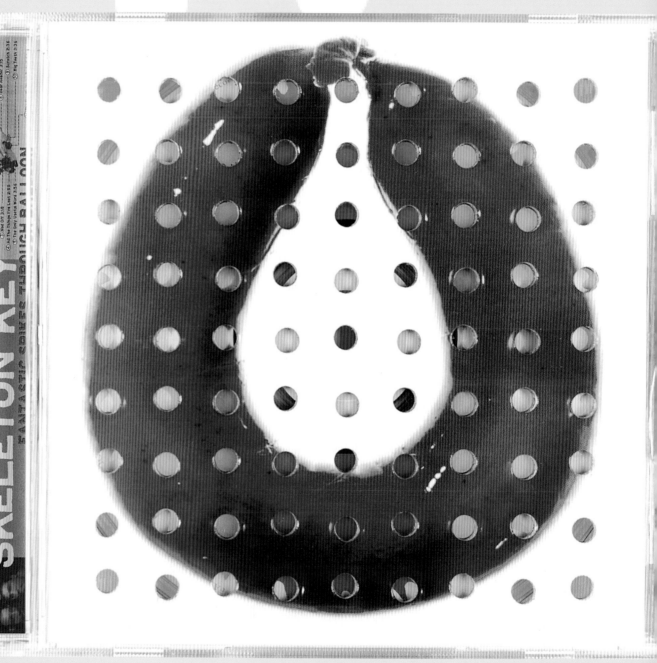

SKELETON KEY

FANTASTIC SPIKES THROUGH BALLOON

① Kick The Fat Man 2:42
② Wide Open 2:36
③ Mad Oil 2:10
④ All The Things I've Lost 2:55
⑤ The Only Useful Word 2:56
⑥ The World's Most Famous Undertaker 3:05
⑦ Vomit Ascot 1:51
⑧ Dear Reader 2:15
⑨ Scratch 2:36
⑩ Big Teeth 2:36

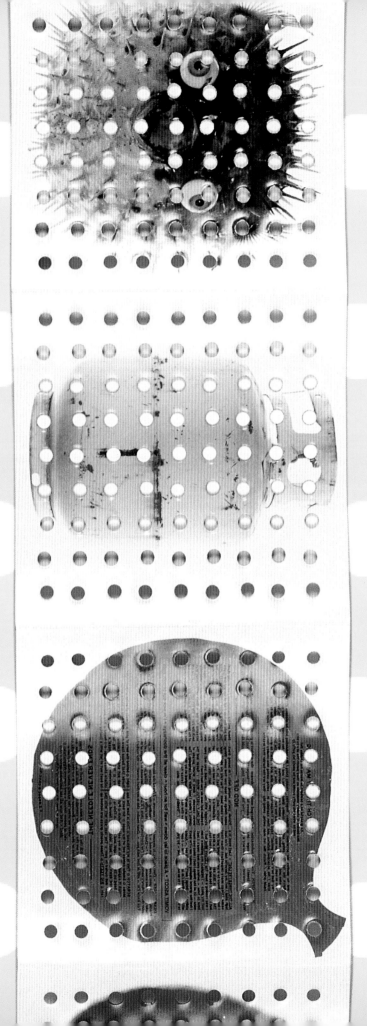

DESIGNERS
Hjalti Karlsson,
Stefan Sagmeister
ART DIRECTOR
Stefan Sagmeister
DESIGN COMPANY
Sagmeister Inc.
PHOTOGRAPHER
Tom Schierlitz
COUNTRY OF ORIGIN
USA
WORK DESCRIPTION
Front cover of CD box
(opposite) and booklet
spread from the album
Fantastic Spikes Through Balloon
by Skeleton Key
DIMENSIONS
140 x 127 mm
5½ x 5 in

DESIGNERS
**Stefan Sagmeister,
Hjalti Karlsson**
ART DIRECTORS
Stefan Sagmeister, David Byrne
DESIGN COMPANY
Sagmeister Inc.
MODEL-MAKER
Yuji Yoshimoto
PHOTOGRAPHER
Tom Schierlitz
COUNTRY OF ORIGIN
USA
WORK DESCRIPTION
**Front cover of CD box (bottom)
and booklet spreads from the
album** *Feelings* **by David Byrne**
DIMENSIONS
**140 x 127 mm
5½ x 5 in**

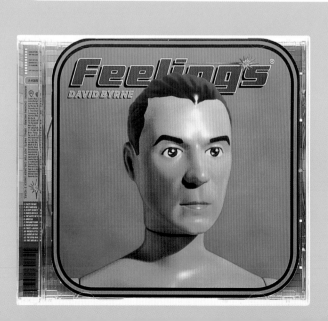

146

ALL SONGS WRITTEN BY

DAVID BYRNE

EXCEPT "MISS AMERICA"
WRITTEN BY DAVID BYRNE/JOE GALDO
AND "FUZZY FREAKY" WRITTEN BY
DAVID BYRNE/DANIELLE FOSSATI/CHRISTIAN DeANDRE.

PUBLISHED BY

MOLDY FIG MUSIC BMI.

"Fuzzy Freaky" contains elements from

"Nel Bene E Nel Male" (Fossatti/DeAndre)

EMI Music Publishing Italia/Gelar SAS/Blue

Team ED. Used by permission. All rights.

reserved. Performed by Christian DeAndre.

Used courtesy of WEA Records Italy.

MORCHEEBA PRODUCTIONS IS
PAUL GODFREY, ROSS GODFREY AND PETE NORRIS.

AKUA DIXON APPEARS COURTESY
OF SAVANT RECORDS, INC.

DESIGN BY

SAGMEISTER INC. NEW YORK, NY

PHOTOGRAPHY BY TOM SCHIERLITZ

DAVID BYRNE DOLL MODEL AND ADDITIONAL

MODEL MAKING BY YUJI YOSHIMOTO

DAVID BYRNE DOLL CLOTHES BY

ADELLE LUTZ WITH MICHAEL DAUBE

MASTERED BY TED JENSEN AT STERLING SOUND, NYC

TIPS AND HINTS:
STEVEN BAKER, SARAH CAPLAN,
MEREDITH CHINN AND SHAUNA SLE...

PRODUCTION COORDINATI...
BY KAT EGAN AND
VERONICA GONZALEZ

UNASKED FOR OPINION...
YALE EVELEV

TM

THE BALANESCU QUARTET APPEAR...
COURTESY OF MUTE RECORDS, IN...

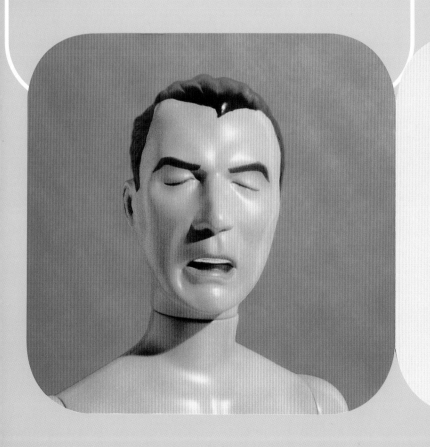

1. FUZZY FREAKY 4:56
2. MISS AMERICA 4:19
3. A SOFT SEDUCTION 3:00
4. DANCE ON VASELINE 5:07
5. THE GATES OF PARADISE 3:31
6. AMNESIA 3:26
7. YOU DON'T KNOW ME 2:28
8. DADDY GO DOWN 4:06
9. FINITE = ALRIGHT 2:24
 WICKED
10. LITTLE DOLL 2:54
11. BURNT BY THE SUN 4:21
12. THE CIVIL WARS 3:41
14. THEY ARE IN LOVE 4:08

Le voilà là dans ma loge
À me maquiller
Prêt à prendre place sur la scène
Où tous les soirs
On appelle Gaspar

Je défile dans ses habits
Les mots écrits pour lui
Défiant les idées folles
En trichant

Les rires croulent
Cousus à l'ombre
Tout me ment tout me rend sombre
On m'appelle Gaspar
Vous croyez en voir un autre
Sous les feux de la rampe
Au reflet sur les paupières
À l'armure tombée à l'eau
Par vous bordé
Porté par vous si haut
Des ailes
Des ailes jusqu'à la fin du spectacle

Après le numéro on tire le rideau
Sur celui qui se porte sur mon dos
À mille pas des bravos il se fait face
À peine le temps d'un mot devant la glace
Et de sa main l'esprit ailleurs s'efface
Étonnant dans ses habits
Des yeux trop grands pour lui
Soulevant les cabrioles
Au bout d'un parapluie

guitare
Michael Pucci
basse
Mario Légaré
Edgar BORI
Gustave et Gaspar
Edgar BORI,

Le voilà là dans ma loge
À se maquiller
Prêt à prendre place sur la scène
Où tous les soirs
On appelle Gaspar... Gaspar

DESIGNER
Marc Serre
ART DIRECTORS
Daniel Fortin, George Fok,
Marc Serre
DESIGN COMPANY
Époxy
ILLUSTRATORS
Marc Serre, Michel Valois,
Bob Beck
PHOTOGRAPHER
Italo Lupi

COUNTRY OF ORIGIN
Quebec, Canada
WORK DESCRIPTION
CD booklet spread from the
album *Bori* by Bori for
Les Productions de l'Onde
DIMENSIONS
137 x 124 mm
5⅜ x 4⅞ in

TAN'GO

TOUS LES PAS

Paroles et arrangements
Edgar BORI

Musique
Edgar BORI, Bernard-Pierre...

Louis Gagne

Photo inédite
Maurice Williams

Michael Pozzi guitares

Une larme au bord de l'oeil
Parce qu'un parle de s'en aller
Deux fois seul
Devant l'autre désolé
Baisser la tête
Cacher son désarroi

Se laisser perdant d'amour
Face au vide à porter
L'ombre des tours
Qu'on a si hautes érigées
Avec la haine avec la peine

Et les mots qui fondent sur la glace
Et les mains qui n'osent plus se rappeler
Gardent la place

Blessé à l'âme dans ses sabots
Un pont à traverser
L'ombre sur l'eau
Partir sans se retourner
La tête haute
Brusquer les autres

Loin les regrets loin les beaux jours
Que la vie peut continuer
Ces histoires d'histoires d'amour
Que le temps doit effacer
Malgré le doute
Prendre sa route

Une larme au bord de l'oeil
Parce qu'un parle de s'en aller
Deux fois seul
Devant l'autre désolé
Baisser la tête
Cacher son désarroi

PAGES 140–1
DESIGNERS
Neil Fletcher, Chris Ashworth
ART DIRECTOR
Neil Fletcher
DESIGN COMPANY
Substance
COUNTRY OF ORIGIN
UK
WORK DESCRIPTION
Promotional poster for Depth
Charge Records
DIMENSIONS
451 x 640 mm
17¾ x 25¼ in

DESIGNER
Marc Serre
ART DIRECTORS
Daniel Fortin, George Fok,
Marc Serre
DESIGN COMPANY
Époxy
COUNTRY OF ORIGIN
Quebec, Canada
DIMENSIONS
Box: 145 x 125 mm
5¾ x 4⅞
Booklet: 137 x 124 mm
5⅜ x 4⅞ in

BELOW LEFT AND RIGHT
ILLUSTRATOR
Marc Serre
PHOTOGRAPHER
George Fok
WORK DESCRIPTION
Front cover of CD box and
booklet spread from the album
Vire et Valse la Vie by Bori for
Les Productions de l'Onde

BELOW RIGHT AND OPPOSITE
ILLUSTRATORS
Marc Serre, Michel Valois,
Bob Beck
PHOTOGRAPHER
Italo Lupi
WORK DESCRIPTION
Reverse of CD box and two
booklet spreads from the album
Bori by Bori for Les Productions
de l'Onde

Des jours comme çà on pense... on en aurait assez
De courir après sa chance et on veut tout laisser là
En marchant sur la rue d'un pas de passant pressé
On se demande si on sait de quel côté aller

Autant y a de conquis qui se taisent à se plier
Aux pieds de pantins tous élus
Qui avec les ans ne bougent plus d'un fil
Autant les hommes de loi qu'on gave
Rient au nez des sans-fortune
A qui on crie que la lutte est truquée

Quand soudée au temps passe une vieille dame digne chic
Porte-poussière à la main promenant son cher chien doux

Des jours comme çà on sent que personne ne sait où est
Située la distinction entre le bon sens et ce chéri d'or
Qu'à danser comme Astaire on ne peut que changer peu
Les idées des génies qui auraient mieux fait de rester chez eux

Honteux qu'ils lèsent la masse
Aidés d'études, de paperasses
Eux qui créent nos habitudes
Quitte à raser les races
Nous chantent jusqu'au cimetière
Les beautés de l'univers
L'avis éternel
Ta brouette et ta pelle

Creuse ton trou mon petit
Ne sois pas malappris
Garde ta place au milieu du rang
La vie durant
Creuse ton trou mon pitou
Ne sois pas marabout
T'as droit au marathon
Tonton marathon!

A l'assaut des sommets pour épater la galerie
On finit assommé plus petit qu'un petit grain de riz
On voit venir l'heure proche où le souffle va nous manquer

On change son coeur en roche on se cache pour pleurer
On saute de plus en plus du haut des toits des hauts buildings
Plus çà va moins çà va l'air est aux désespérés
On vend du vent aux gens ces mêmes gens
se tuent pour en acheter
Quand ils n'ont plus d'argent n'ont plus personne à qui parler
Nos coeurs se meurent comme les oiseaux
Qui volent en rond dans nos cerveaux

Des jours comme çà on pense - c'est loin de se tasser -
Au rythme où on use la chance
Une nuit tout ce beau monde va céder
La société moderne cultive les illettrés
Les laisse crever de faim pour qu'ils se mangent entre voisins

Creuse ton trou mon pitou
Ne fais pas la baboune
On t'a changé de jeu de dames
Maintenant c'est le temps
Maintenant rame!
Creuse ton trou ma pitoune
Prends garde aux maladies... Garde!
Tu sers de jour et de nuit

Alors c'est bon l'or
Hein?
Le goût de l'or ça endort
Ca nous bouche les yeux et les oreilles d'abord
Ensuite ça nous éteint la bonne humeur
Jusqu'au bord de la mer

Et si on croit que ça s'installe que pour quelques heures
Le goût de l'or...
Ca nous attache des vies entières
Et çà, ça nous engloutit.

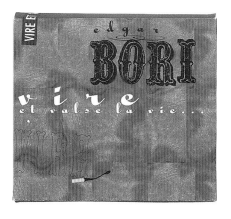

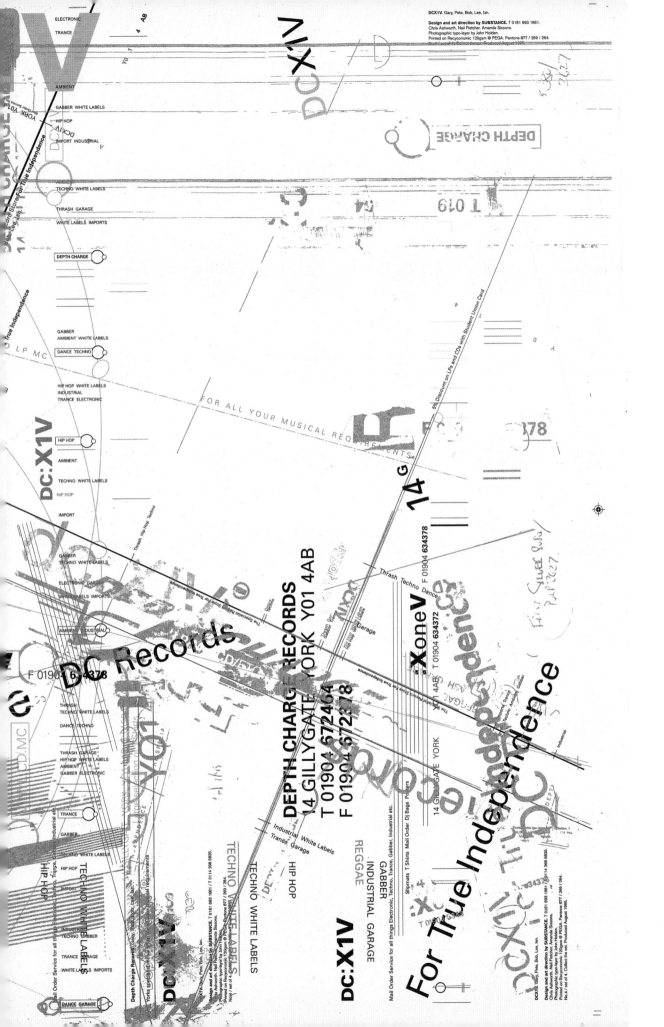

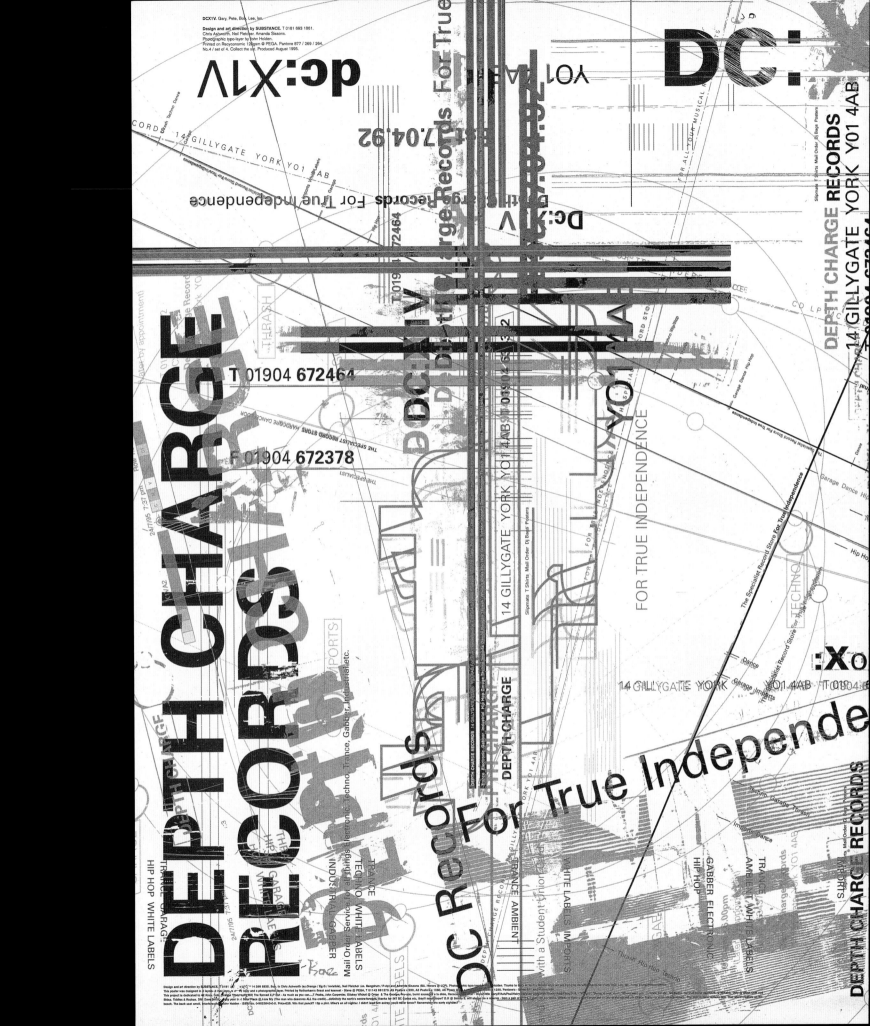

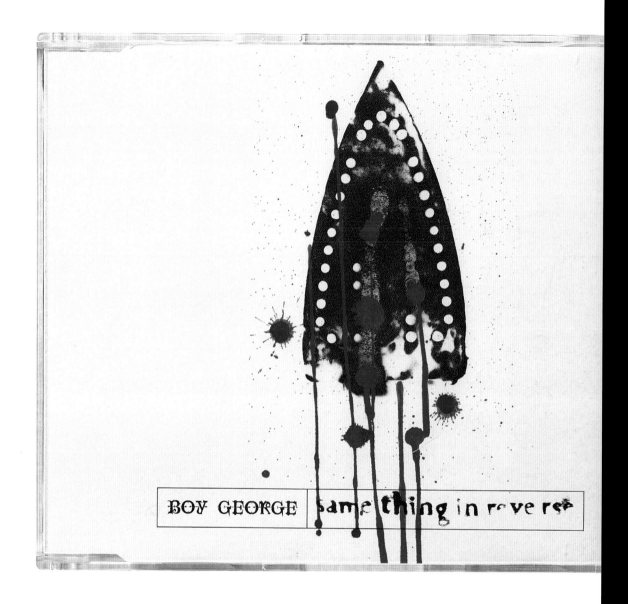

BOY GEORGE | same thing in reverse

DESIGNERS
Mandy Mayes, Allison Martin,
Martin Isaac
ART DIRECTOR
Mandy Mayes
DESIGN COMPANY
Dry
ILLUSTRATOR
Alan Watt
COUNTRY OF ORIGIN
UK
WORK DESCRIPTION
Price tag as accessory for the
Switched On clothing collection
DIMENSIONS
25 x 260 mm
1 x 10¼ in

OPPOSITE
DESIGNERS
Mandy Mayes, Allison Martin,
Martin Isaac
ART DIRECTOR
Mandy Mayes
DESIGN COMPANY
Dry
ILLUSTRATOR
Mandy Mayes

COUNTRY OF ORIGIN
UK
WORK DESCRIPTION
Front and inside of CD box for
the single *Same Thing in
Reverse* by Boy George for
Virgin Records Ltd.
DIMENSIONS
140 x 122 mm
5½ x 4¾ in

SWITCHED ON

SWITCHED ON

SWITCHED ON

SWITCHED ON

SWITCHED ON

SWITCHED ON

CHED ON

TCHED ON

136

DESIGNERS
Mandy Mayes, Allison Martin,
Martin Isaac
ART DIRECTOR
Mandy Mayes
DESIGN COMPANY
Dry

ILLUSTRATORS
Wil Overton,
Graham Rounthwaite
PHOTOGRAPHERS
Jeremy Mahr, Mandy Mayes
COUNTRY OF ORIGIN
UK

WORK DESCRIPTION
Swing tags for the Switched On
clothing collection
DIMENSIONS
128 x 65 mm
5⅛ x 2½ in

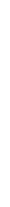

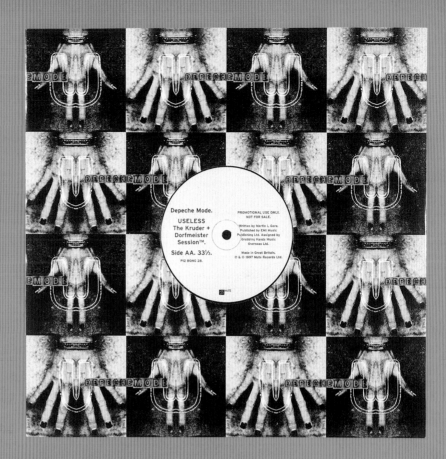

DESIGNER
Richard Smith
ART DIRECTOR
Anton Corbijn
DESIGN COMPANY
Area
PHOTOGRAPHER
Anton Corbijn
COUNTRY OF ORIGIN
UK
WORK DESCRIPTION
Sleeve designs for the single
Useless by Depeche Mode for
Mute Records
DIMENSIONS
310 x 305 mm
12¼ x 12 in

PAGES 132–3
DESIGNER
Michael Faulkner
DESIGN COMPANY
Rawpaw Graphics (D-Fuse Art)
COUNTRY OF ORIGIN
UK
WORK DESCRIPTION
Images used as projections for
club events
DIMENSIONS
35 mm slides
1⅜ x 1⅜ in

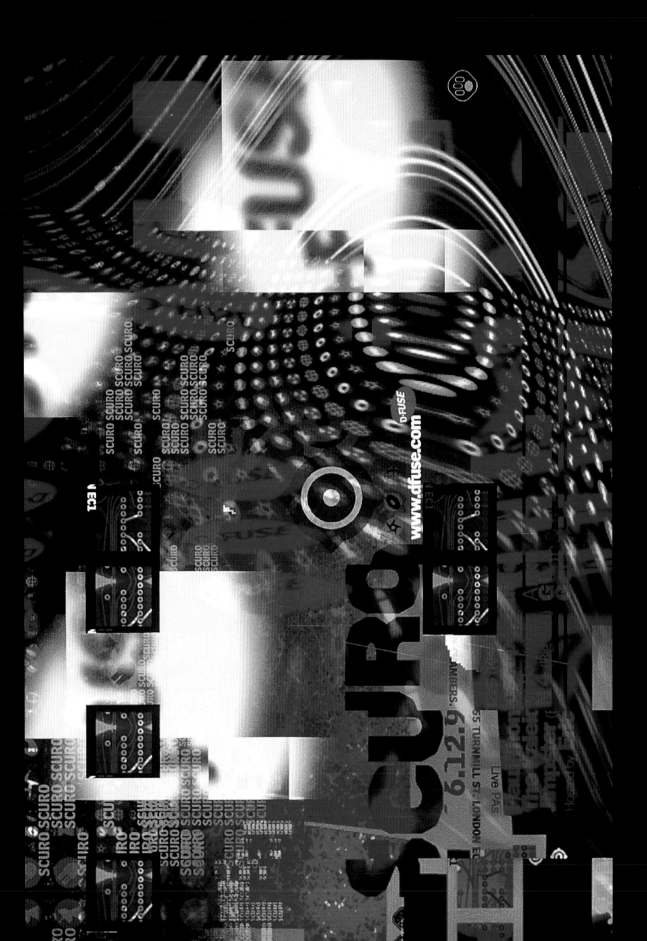

AMID

Association of Music
Industry Designers
Promotes and supports
designers working in the
music industry.

For more info on these
designers and other
members visit the
website: www.amid.co.uk
Fax +44 (0)171 221 7195

DJ RAGS YES, YES, Y'ALL

Concrete

DESIGNER
Mark Tappin
ART DIRECTOR
Mark Tappin
DESIGN COMPANY
Blue Source

ILLUSTRATOR
Graham Rounthwaite
COUNTRY OF ORIGIN
UK

WORK DESCRIPTION
Sleeve design for a single by DJ
Rags from *Shoot Tha Pump*,
released on Concrete Records
DIMENSIONS
Various

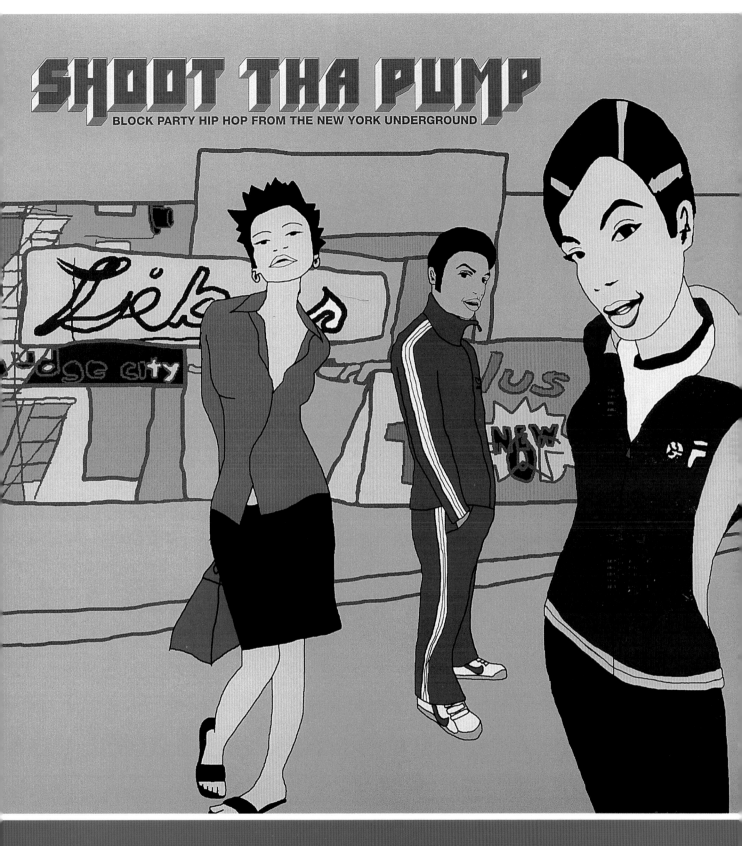

SHOOT THA PUMP
BLOCK PARTY HIP HOP FROM THE NEW YORK UNDERGROUND

DESIGNER
Mark Tappin
ART DIRECTOR
Mark Tappin
DESIGN COMPANY
Blue Source

ILLUSTRATOR
Graham Rounthwaite
COUNTRY OF ORIGIN
UK

WORK DESCRIPTION
Sleeve design for *Shoot Tha Pump* – a hip hop compilation album released on Concrete Records
DIMENSIONS
Various

DESIGNER
Simon Gofton
ART DIRECTOR
Simon Gofton
DESIGN COMPANY
Blue Source
PHOTOGRAPHER
Simon Gofton
COUNTRY OF ORIGIN
UK

WORK DESCRIPTION
Fold-out club flyers
DIMENSIONS
70 x 210 mm
2¾ x 8¼ in

60 SECONDS

When I'm gone and you are broke, you will find another toy/When I'm broke and you have gone, you will find another toy/The wind was cutting in so well/I covered up my ears/The rain was going through me like a knife/It was taking every inch of warmth I had in me/I was shaking like I'd never in my life/I'm always staring at my watch when I'm there with you/I think I've bitten off more than I can chew/I think its one thing I'll never get to learn/If you ignore advice you'll end up getting burned/I've got no time for me/So I've got no time for you/I've got no time to walk along/And try and sift it through/It wouldn't be so bad if I was a million miles away/I could have come back to live another day/I might have even heard you trying to explain/But with you I'll never get to see another day/You will find another toy/Toy,Toy,Toy/You will find/You will find another toy/When I'm broke and you have gone/You will find another toy/When you're broke and I have gone/I will find another toy/Another toy

60 seconds what could happen now?/He could end up going down/60 seconds what could happen then?/He could end up changing again/He was dreaming softly in his bed/He woke to find a gun at his head/He heard them say 'Now don't move a muscle/You'll still be breathing in the morning bustle'/60 seconds what could happen then/He just goes to work again/To make up for the things that they damaged/They lifted everything that they could manage/They're not scared of consequence of hammers/They'll have your things no matter what happens/While they're outside loading the truck/You know they'll never give it up/60 seconds now he's had enough/He's sick of people calling his bluff/He's seen them tearing everything apart/Its time to change them into something that doesn't.../Walk talk, eat sleep, blink drink, hit shit, lie die,/shy fly, age rage, care share/You took his house and fucking rifled it/You've made your bed now fucking die in it/He's been so good for you,like surviving a crash to you/You've been so bad for him, like finding lost cash to him/Like finding all he needs/60 seconds what could happen now/He could end up going down/60 seconds what could happen then/He could change into something that doesn't/Wake to find a gun at his head/After dreaming softly in his bed/He wouldn't be the one moving a muscle/'Cos he's changed into the something that doesn't.../walk talk, eat sleep, blink drink, hit shit,lie die, shy fly, age rage, care share. Scream gleam, piss kiss, lust fuss, hate shake, love shove, smoke choke, hear fear, care share.

ANOTHER TOY

You shouldn't have it/It's taken me far too long to hide it from you now/You found it such a precious thing to give away/You found it easy/To break in through these walls I thought I'd built so well/But not so easy for my head to turn and find you there/Are you running from the same dogs that are snapping at my heels?/My heels have been chewed up so much lately/That its hard for me to stand up/I have taken every precaution to stop it all adding up/They shouldn't have it/Its been built up to something nowhere near/I wish that it was creeping up on them/Filled up with fear/But no matter/No matter how fast I go, I'm never as fast as slow/I found my feet getting tangled in the traps you laid so well/Do you remember when she asked me if I was ok/If I had anything to say?/We looked at each other In disbelief/We fell over laughing at her feet/Shes treading an unforgiving path/That will never take her back/Do you think that put her in her place?/Do you think she saw the answers on my face?

BOTHERED

If you had a million people watching you would you make the same old blunder?/Well I wonder, yes I wonder/If I could put the words in writing would you ever come out fighting?/Well I wonder, yes I wonder/You took his house and fucking rifled it/There's a question I yearn to ask but I'm held back by the push/I've asked you once before and I'll ask once more/I usually stay tucked up in bed when the question hits my head/I think I'll leave it, I think I'll leave it.../I wanna stop this aggravation, I can't soak in anymore information/Sponge is full, my sponge is full/All the time you were breaking the rules/All the time you were making a fool out of me, out of me/I've trained my eyes to put aside/But the glances I receive are coming thick and fast/no thanks to you/I wanna say something nice to you, I wanna put it straight/But it isn't happening/I'll have to concentrate, or is it far too late?/'Cos I'm treading on very thin ice with you/The cracks are zig zagging their way over/Caving in, caving in/I've tried to understand your feelings/I've watched you clambering up the ceiling/Not getting through, you're not getting through/I'm just watching your reaction with the sweetest satisfaction/I'll pass it on, I'll pass it on/If you wanna shovel it up come on keep it coming, don't give up/I've had worse to deal with than what you've come up with/If you had a million people watching/would you make the same old blunder?/Well I wonder.

DESIGNER
Alison Fielding
ART DIRECTOR
Alison Fielding
DESIGN COMPANY
Beggars Banquet
PHOTOGRAPHER
Mary Farbrother
COUNTRY OF ORIGIN
UK
WORK DESCRIPTION
CD cover (right) and booklet
spreads from the album *Self Made
Maniac* by China Drum – the
album is the final part of the
series, combining the broken
glass and figure
DIMENSIONS
120 x 120 mm
4¾ x 4¾ in

126

CHINA DRUM
SELF MADE MANIAC

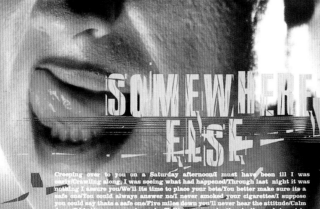

SOMEWHERE ELSE

Creeping over to you on a Saturday afternoon/I must have been ill I was early/Crawling along, I was seeing what had happened/Through last night it was nothing I assure you/We'll its time to place your bets/You better make sure its a safe one/You could always answer no/I never smoked your cigarettes/I suppose you could say thats a safe one/Five miles down you'll never hear the attitude/Calm down I'd better go somewhere else/Falling over each other in the rush to get in their worth/It's no sad and its boring/It's a shame we could focus all our powers somewhere else/Someone nice someone caring/But its all been said before/Still nothing ever changes/We're still hunting out for more/I never meant to cut you short/I wasn't capable of anything/Five years on you'd never hear that attitude/Calm down I'd rather be somewhere else/We'll its time to place your bets/You better make sure its a safe one/I could always answer no/I never understood what you meant/When you said she'd hung on every syllable/Five years on I've never seen the attitude/Calm down/I'd like a bit of gratitude/I only came here for a bit of solitude/But right now I'd rather be somewhere else/Crawling over to you on a Saturday afternoon/I must have been ill I was early/Creeping along I was seeing what had happened through last night/On my bike, Up the glen, in the sun/Round the bends, having fun, playing games/In the rain, in the lakes, at the gig/Watch the stage, from the crowd, in the clouds,going down/Eating in, on the town, in the Spar/But I'm not with you.

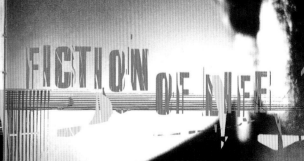

FICTION OF LIFE

I've been expecting a breakout from a cage full of rage/But I/Haven't got the time to hold them back with my Flak jacket/I've become a self made maniac/I have seen the bloodstains on the track/They were left when someone had to go from their flow trouble/Time, has taken all he had, theres nothing left inside/He's got to run or hide/He's got a mountain on his shoulder/He's not getting any younger/He's got to put his problems in his past/He's got to wake up to the fictions of life/The fictions of life/(BV) Rid the world of scum that kills a man of a ton/He phoned the number to help his state/But it was engaged bless him/So he chose a different route to help make the pain lessen/He never saw the bloodstains on the track/They were left when someone had to go from their flow trouble

DESIGNER
Alison Fielding
ART DIRECTOR
Alison Fielding
DESIGN COMPANY
Beggars Banquet
PHOTOGRAPHER
Mary Farbrother
COUNTRY OF ORIGIN
UK
DIMENSIONS
Single: 178 mm diameter
7 in diameter
Cover: 181 x 181 mm
7⅛ x 7⅛ in
WORK DESCRIPTION
Vinyl single and cover
(opposite, below right) for
Fiction of Life – **the first in a**
series by China Drum

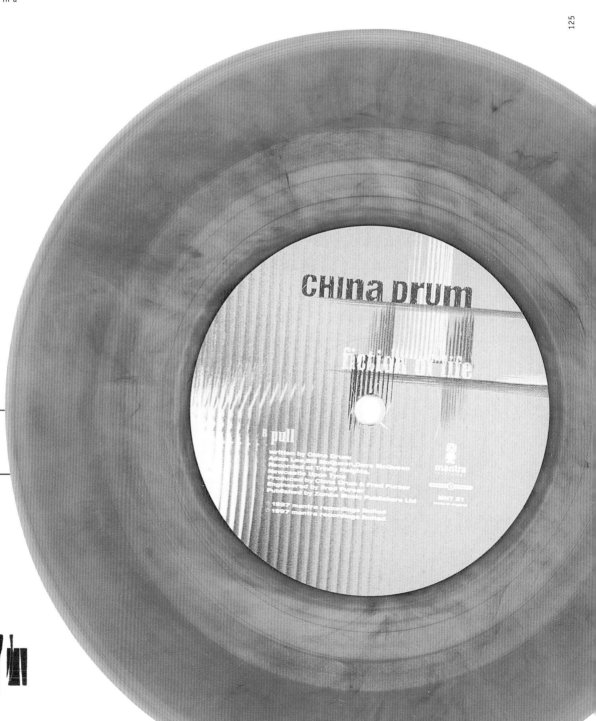

DESIGNER
Alison Fielding
ART DIRECTOR
Alison Fielding
DESIGN COMPANY
Beggars Banquet
PHOTOGRAPHER
Mary Farbrother
COUNTRY OF ORIGIN
UK
DIMENSIONS
Single: 178 mm diameter
7 in diameter
Cover: 181 x 181 mm
7⅛ x 7⅛ in
WORK DESCRIPTION
Vinyl single (right) and cover
(below) for *Somewhere Else* –
the second in a series by China
Drum

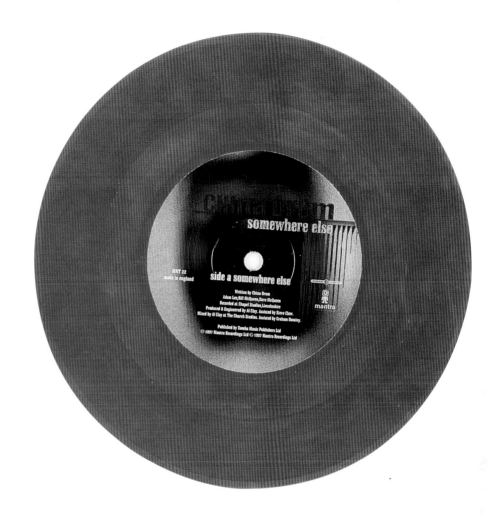

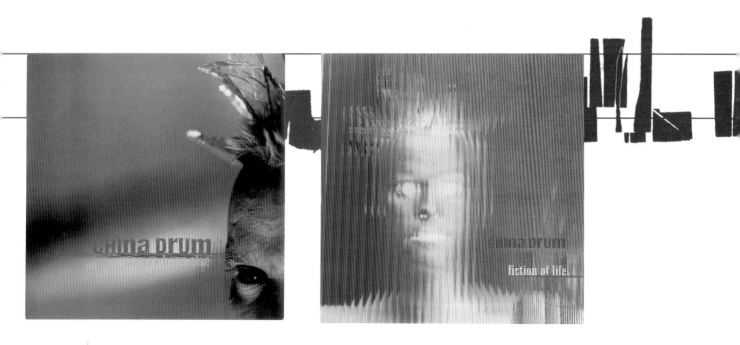

ADDICTION, OBSESSION AND ME

It's addiction, it's obsession, it's a need to be me
It's addiction, it's obsession, so I can feel that I'm free

Born in a time that sanctions all desires
I fight my instincts all the way
Drawn to a storm of things I have to have
With patience like other virtues still in the way

It's addiction, it's obsession, it's a need to be me
It's addiction, it's obsession, so I can feel that I'm free

I get enough of things to need them more
Like love and destruction to name but two
It's getting harder telling good from bad
With your senses asking was it good for you

It's addiction, it's obsession, it's a need to be me

There's so much I feel I have to have

It's addiction, it's obsession, it's a need to be me
It's addiction, it's obsession, so I can feel that I'm free

FEBRUARY

You're never going to say the things you want to say
The things you want to change will usually stay that way
The promises you break outweigh the ones you keep
The sky I'm told is blue is looking very grey

Nothing's going to seem the way it seems to you
It never turns out quite the way you want it to
Paint upon the wall for the hundredth time
But what you try to hide will come shining through
But what you try to hide will come shining through

There's so much you would do if you just had the time
Like try to write a song but it never rhymes (only sometimes)
You'd love to change the system but it works too well for you
If you didn't have the patience you could turn to crime

There's something that you feel that you can't explain
That makes you feel lost when it starts to rain
It bothers you the most when you are on your own
It whispers your intentions will all be in vain

The month you hate the most is always February

THE NEXT
BIG THING
2 RUN ON EMPTY
3 LOOK OUT
TOMORROW
4 top OF
THE WORLD
5 RAILS
6 WISHING IT AWAY
7 CHEMICAL #1
8 MOTION
9 THEY'RE OUT THERE
10 FOR A MOMENT 11 ADDICTION
OBSESSION & ME 12 FEBRUARY

JESUS JONES ALREADY

7243 8 57133 2 3

7 24385 71332 3

UK: FOODCD 22 Printed in UK

EMI 100

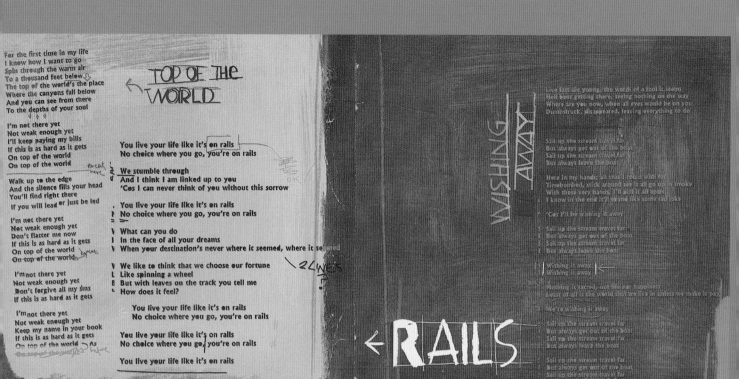

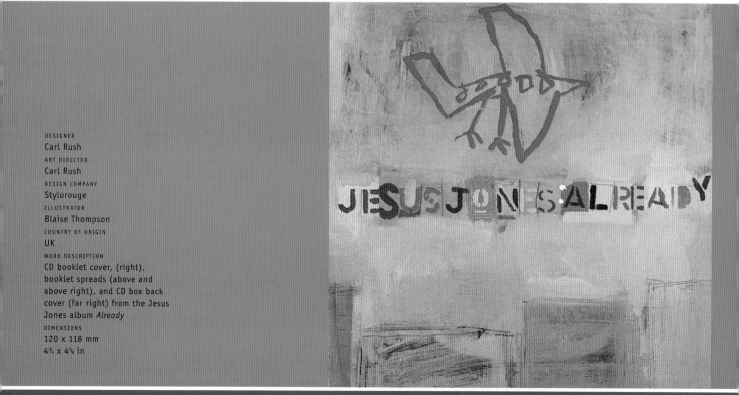

DESIGNER
Carl Rush
ART DIRECTOR
Carl Rush
DESIGN COMPANY
Stylorouge
ILLUSTRATOR
Blaise Thompson
COUNTRY OF ORIGIN
UK
WORK DESCRIPTION
CD booklet cover, (right),
booklet spreads (above and
above right), and CD box back
cover (far right) from the Jesus
Jones album *Already*
DIMENSIONS
120 x 118 mm
4¾ x 4⅝ in

To You I Bestow

One last night in bed for a time. Two more wishes and both are for thine. I give you the stars from the bruised evening sky. And a crown of jewels for your head now.

mushy

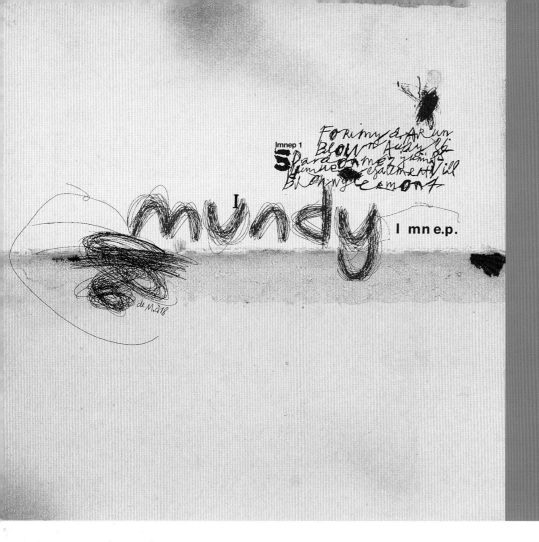

Imnep 1

mundy

I mn e.p.

DESIGNER
Mark Caylor
ART DIRECTOR
Mark Caylor
DESIGN COMPANY
Stylorouge
ILLUSTRATOR
Mark Caylor
COUNTRY OF ORIGIN
UK
WORK DESCRIPTION
Covers for the Mundy album
I mn e.p. 1 (left), and single
To you I Bestow (opposite)
DIMENSIONS
Various

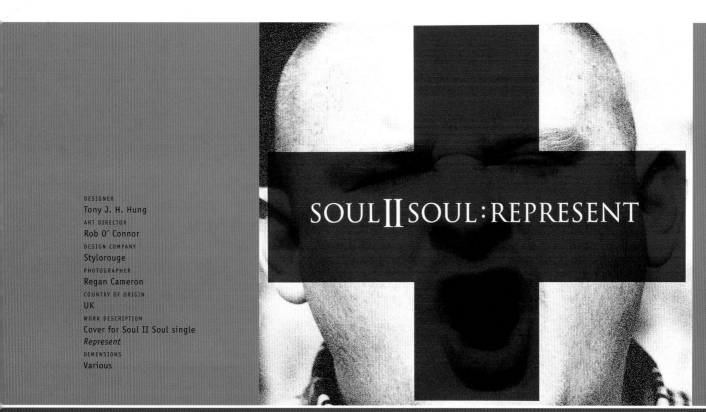

SOUL II SOUL : REPRESENT

DESIGNER
Tony J. H. Hung
ART DIRECTOR
Rob O' Connor
DESIGN COMPANY
Stylorouge
PHOTOGRAPHER
Regan Cameron
COUNTRY OF ORIGIN
UK
WORK DESCRIPTION
Cover for Soul II Soul single
Represent
DIMENSIONS
Various

MILK TOKEN
LETTERS FROM G
BUNNY
DOLPHIN RING
BUBBLE GUM
EYELASHES
KISS MINT
BALLOON ANIMAL
STARS AT NIGHT

WORK DESCRIPTION
Back cover (bottom, left) and
spreads from *Things That
Quicken the Heart* – a collection
of short fiction by California-
based artists and writers,
edited by Soo Jin Kim

DIMENSIONS
114 x 140 mm
4½ x 5½ in

DESIGNER
Michael Worthington
ART DIRECTOR
Michael Worthington
DESIGN COMPANY
Worthington Design,
Los Angeles
PHOTOGRAPHER
Michael Worthington
COUNTRY OF ORIGIN
USA

"Question?"

"When you start adding them up they make quite a collection, don't they?

What did you see that night?

Watch for what?

She asked me why I looked so sad?

How did she escape?

"Are you busy?"

"fine?"

why did you leave me alone?

Why do I feel so at home on such precarious, uncharted terrain?

"WHAT HAPPENED?" HUH?"

"WHAT TO DO?"

"WHAT DO YOU WANT TO DO?"

how did you imagine your escape?

Murder isn't it?

Do we know each other?

How could you forget something like that?

Do we ever know where history is really made?

What would it tell her?

Do you want it?

Honey, do you mind if we make love later?

why can't I find one in New York?

Why oh why is the world such a cruel place?

Who were all these unknown admirers who wanted to meet her?

Was it beautiful the first time you heard it?

"Yeah and have you ever thought that maybe I'm not one of them?"

are you two always like this?"

"Did you feel that?"

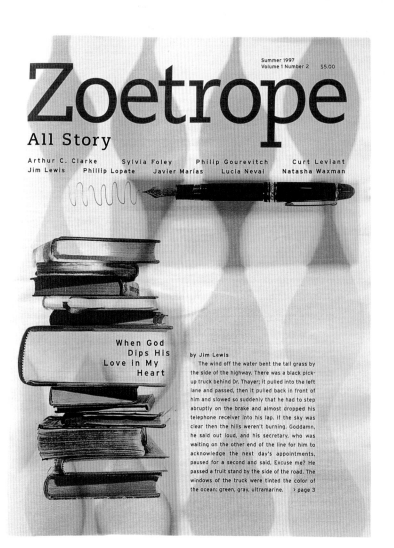

Zoetrope

All Story

Summer 1997
Volume 1 Number 2 $5.00

Arthur C. Clarke Sylvia Foley Philip Gourevitch Curt Leviant
Jim Lewis Phillip Lopate Javier Marías Lucia Neval Natasha Waxman

When God Dips His Love in My Heart

by Jim Lewis

The wind off the water bent the tall grass by the side of the highway. There was a black pick-up truck behind Dr. Thayer; it pulled into the left lane and passed, then it pulled back in front of him and slowed so suddenly that he had to step abruptly on the brake and almost dropped his telephone receiver into his lap. If the sky was clear then the hills weren't burning. Goddamn, he said out loud, and his secretary, who was waiting on the other end of the line for him to acknowledge the next day's appointments, paused for a second and said, Excuse me? He passed a fruit stand by the side of the road. The windows of the truck were tinted the color of the ocean: green, gray, ultramarine.

> page 3

DESIGNERS
Tamar Cohen, David Slatoff
ART DIRECTORS
Tamar Cohen, David Slatoff
DESIGN COMPANY
Slatoff + Cohen Partners Inc.
ILLUSTRATOR
David Plunkert (below)
PHOTOGRAPHERS
Nola Lopez (left),
Geoff Spear (below)
COUNTRY OF ORIGIN
USA
WORK DESCRIPTION
Front cover and spreads
for *Zoetrope*, a short fiction
magazine published by
filmmaker, Francis Ford Coppola
DIMENSIONS
267 x 355 mm
10½ x 14 in

115

Inside Information
by Nicola Barker

Martha's social worker was under the impression that by getting herself pregnant, Martha was looking for an out from a life of crime.

She couldn't have been more wrong.

"First thing I ever nicked," Martha bragged, when her social worker was initially assigned to her, "very first thing I ever stole was a packet of Li-lets. I told the store detective I took them as a kind of protest. You pay 17½% VAT on every single box. Men don't pay it on razors, you know, which is absolutely bloody typical."

One- Third Up Front

by Sam Greenhoe

The kind of small-scale renovation work I do, working in people's houses during the day, is a recipe for nooky, which is to say it's not remarkable. In the months I spent working in Ellen Furlong's house, that I wound up getting laid.

The Anatomy Lesson

a novel

FIG. 19

Simple Cross of the Chin.

TINC FER.PER

CEREBRUM BRAIN

Wonders of
ll as delicate,
eart, mind and so
r pleasure, sunshine shadow are
a of light; the human passions hold their
and love dance their happy and joyous
curtain; and through it accurate deli

R

D E F P O T E C

L E F O D P C T

F D P L T C E O

M E

FIG. 16.

5
6 4
3

Cross of the Eyes.

John David Morley

author of *The Feast of Fools*

previous pages:

LUXOR HOTEL, LAS VEGAS, 1995, MARILYN BRIDGES

Bridges photographed the hotel from the air, showing the sphinx that both guards the hotel's entrance and indicates the iconography that the

abstract shape of the building lacks. The area to the right is now occupied by a two-thousand-room addition.

ATLANTIS HOTEL MODEL, 1993, ANTOINE PREDOCK

Predock's entry in a competition to design a one-billion-dollar casino in Las Vegas proposed to resurrect the mythical world of Atlantis as an

iceberg-vortex rising out of the desert. A different design for the casino is to be constructed.

FISH LAMP, 1984, FRANK GEHRY

This object was commissioned by Formica Corporation to explore the potential of its Colorcore product. The form of the lamp supposedly came

about when Gehry threw the pieces of this integrally colored laminate to the ground in frustration and found that the pieces looked like a fish, his

emblem of perfection and a memory from his youth.

right top:

STANDARD STATION, AMARILLO, TEXAS, 1963, ED RUSCHA

This image is part of a series in which Ruscha obsessively redrew a gas station—with a perspective reminiscent of that of the Twentieth Century

Fox logo—before creating one painting that shows it on fire.

right bottom:

LUXOR HOTEL ATRIUM, 1996, VELDON SIMPSON

For the first four years of the hotel's existence, its main interior space (more than 100,000 square feet of gambling) was taken up by stage sets that

housed high-tech rides exploring visions of the past, present, and future. Their stories offered justification for the hotel's strange appearance.

118

113

PAGE 114

DESIGNERS
Tamar Cohen, David Slatoff

ART DIRECTORS
Tamar Cohen, David Slatoff

DESIGN COMPANY
Slatoff + Cohen Partners Inc.

PHOTOGRAPHER
Tom Collicott

COUNTRY OF ORIGIN
USA

WORK DESCRIPTION
Book cover for *The Anatomy Lesson* published by St Martin's Press

DIMENSIONS
143 x 215 mm
5⅝ x 8½ in

Originally, it was a religious artifact whose subject and style were prescribed by tradition.

These conventional forms could bring abstract beings or ideas into a recognizable shape. Famous people or things can also become icons, as the Statue of Liberty or Abraham Lincoln have done.[1] Part of our twentieth-century loss of faith has been a loss of the kind of icons that are unapproachable, semidivine apparitions, and yet icons are all around us. The paradox this exhibition addresses is that some of the most normal, run-of-the-mill objects we use in the United States have become iconic. A surfboard, a mixer, or a building can become iconic. The simplest object, through both use and design, can take on tremendous importance in our world. It can become a carrier of meanings that allows us to see within its

simple shapes much larger structures. Icons of everyday use are haunted by a long tradition by which mute objects are imbued with meaning, as well as by over a century of modernist design that has sought to make the perfect form.

Icons are the haunted objects of modern design.[2]

We usually think of icons as either religious artifacts or representations that do not merely stand for one thing but condense into a visible form a much larger idea. Thus icons are objects that present the unpresentable. They put into a physical form a force that we cannot otherwise see, whether it is a divinity or the mysterious working of a computer that we control through a little icon on our screen. The icon is a symbol in a material form, an object of adoration, and a fetish, and in all of these ways it creates something we can see that condenses and makes physical the invisible or unnameable forces that control our world. It is an object of art, use, and mystery all at the same time.

The Statue of Liberty

It is important to realize that icons are made, not born. They are repositories of meaning or carriers of import in which something remains. What makes something into an icon varies from time to time and from place to place. It used to be religion or myth, but these days it is as often as not advertising or corporate public relations. That does not mean that icons

FREE WAYS

ICONIC

FOUNDATIONS

PAGES 111–13
DESIGNER
Bob Aufuldish
DESIGN COMPANY
Aufuldish & Warinner
ICON EMBLEM DESIGNER
Mark Fox, Blackdog
COUNTRY OF ORIGIN
USA

WORK DESCRIPTION
Front cover (right) and spreads
from a catalog for 'Icons: magnets
of meaning' – an exhibition at San
Francisco Museum of Modern Art;
the counterforms of the typeface
Avenir were removed to slow down
the reader, focusing their attention
on the text as object
DIMENSIONS
152 x 229 mm
6 x 9 in

What is
an icon
in our
culture?

PAGES 106–7
DESIGNER
Simon Dixon
ART DIRECTOR
Simon Dixon
DESIGN COMPANY
The Attik
COUNTRY OF ORIGIN
UK

PAGE 108
DESIGNER
Neil Carter
ART DIRECTOR
Neil Carter
DESIGN COMPANY
The Attik
PHOTOGRAPHER
Neil Carter

PAGE 109
DESIGNER
The Attik
ART DIRECTOR
The Attik
DESIGN COMPANY
The Attik

WORK DESCRIPTION
Spreads from *Noise 3* – a promotional book highlighting personal and client work by Attik designers
DIMENSIONS
220 x 320 mm
8⅝ x 12⅝ in

DESIGNER
Aporva Baxi
ART DIRECTOR
Aporva Baxi
DESIGN COMPANY
The Attik
COUNTRY OF ORIGIN
UK
WORK DESCRIPTION
Poster for the film *Face* for United International Pictures
DIMENSIONS
Various

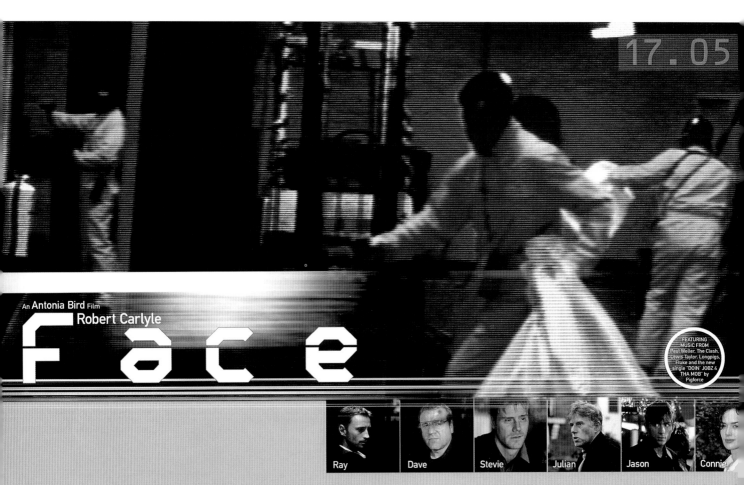

WHY IS IT NOT HAPPENING?

MATERIALISM HAS RISEN IN IMPORTANCE

DESIRE TO ACHIEVE SOMETHING ORDINARY

WHAT DO WE NEED

UNREALISTIC

THINK AGAIN

CREATIVITY

THE DREAMERS SHOULD DESIGN FOR THE MASSES

WE WANT THEM AND WE MEAN IT

CONVINCE YOUR TALENT

A WASTED RESOURCE OF CREATIVITY

designed for pleasure

*pocket money on a Friday, spent on a Saturday, a wasted childhood
or an early introduction to the visually exciting use of
letters, pictures, colour, shapes, texture & movement?*

SKITSOFRI.NI

Cultural schizophrenia occurs whenever society begins to reinvent its vision

how it will conduct affairs in the future.

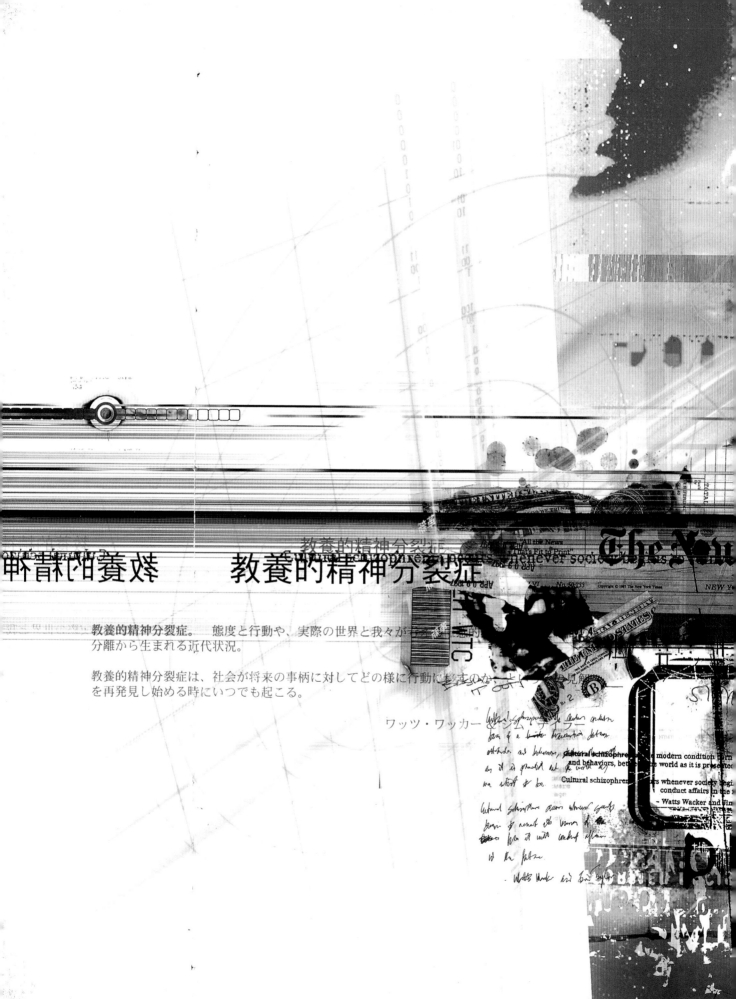

教養的精神分裂症

教養的精神分裂症。 態度と行動や、実際の世界と我々が望む世界の
分離から生まれる近代状況。

教養的精神分裂症は、社会が将来の事柄に対してどの様に行動に移すのかまた過去を再発見
を再発見し始める時にいつでも起こる。

ワッツ・ワッカー　ジム・テイラー

Cultural schizophren... modern condition born
and behaviors, bet... e world as it is presented

Cultural schizophren... rs whenever society begi...
conduct affairs in the ...

— Watts Wacker and Jim...

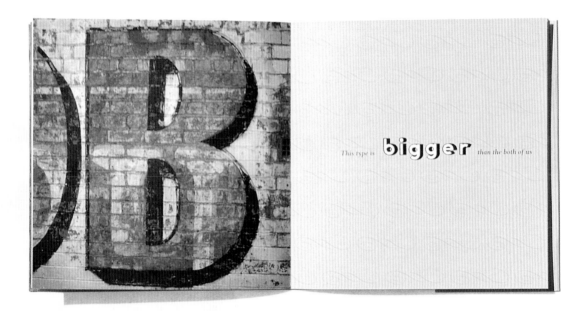

This type is **bigger** *than the both of us*

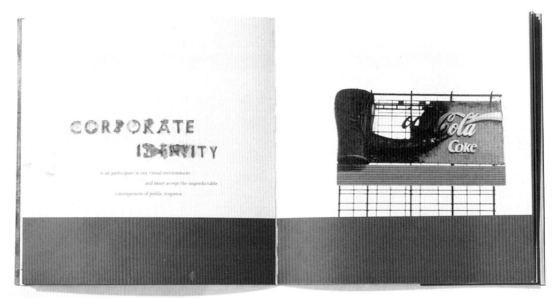

CORPORATE IDENTITY

is an participant in our visual environment
and must accept the unpredictable
consequences of public response.

DESIGNER
Stephen Banham
ART DIRECTOR
Stephen Banham
DESIGN COMPANY
The Letterbox
ILLUSTRATOR
Sonia Kretschmar
PHOTOGRAPHERS
David Sterry, Reimund Zunde,
Arunas, Gavin Liddle
COUNTRY OF ORIGIN
Australia
WORK DESCRIPTION
Transparent plastic box
(opposite, top) and spreads
from *ampersand* – a book on
Australian type culture
DIMENSIONS
145 x 145 mm
5¾ x 5¾ in

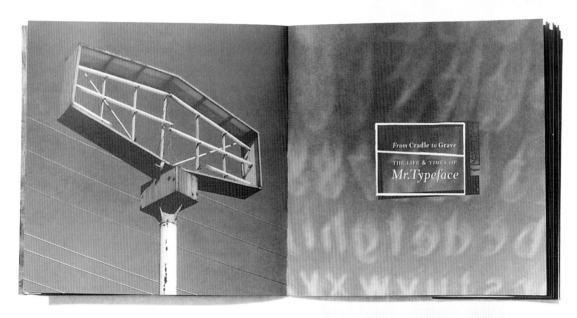

From Cradle to Grave

THE LIFE & TIMES OF
Mr. Typeface

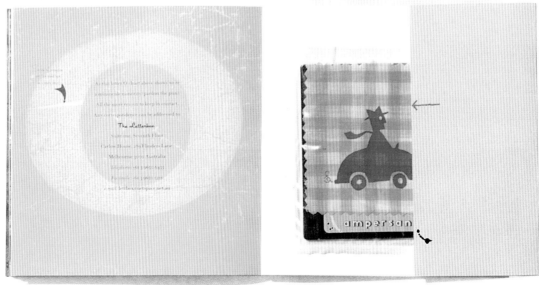

DESIGNERS
Louise Hill, Justy Phillips,
(London College of Printing)
COUNTRY OF ORIGIN
UK
WORK DESCRIPTION
Exam brief: to design an annual
report for the Arts Council
DIMENSIONS
297 x 230 mm
11¾ x 9 in

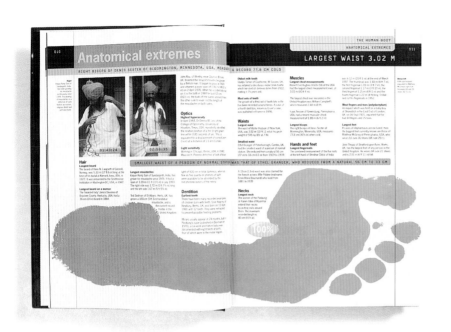

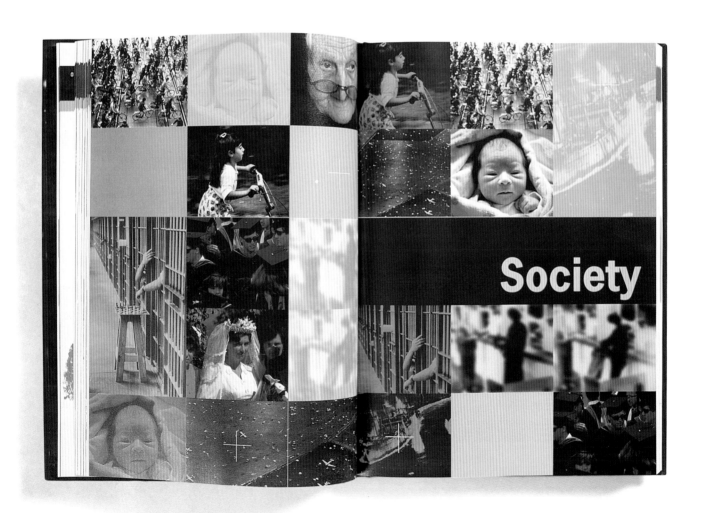

PHOTOGRAPHERS
Anatomical extremes:
Santosh Basak/Gamma/
Frank Spooner Pictures
Society opener: Rex Features,
Dan Lamont/Corbis,
David Wells/Corbis,
Morton Beebe-S.F./Corbis,
Adam Woolfitt/Corbis,
Hulton Getty,
The National Archives/Corbis,
Jim Preston/Rex Features,
Bettmann/UPI/Corbis

DESIGNER
Karen Wilks
ART DIRECTOR
Karen Wilks
DESIGN COMPANY
Karen Wilks Associates
COUNTRY OF ORIGIN
UK
WORK DESCRIPTION
Spreads and section openers
from *The Guinness Book of
Records 1998*
DIMENSIONS
220 x 297 mm
8⅝ x 11¾ in

PHOTOGRAPHERS
Creepy crawlies:
Natural History Museum,
Andrew Syred/
Science Photo Library
Earth opener:
Frank Zullo/
Science Photo Library,
NASA/Corbis,
Jonathan Blair/Corbis,
Tom Bean/Corbis,
Robert Dowling/Corbis,
NASA/Rex Features,
Salaber/Liaison/
Frank Spooner Pictures,
Warren Faidley/
Oxford Scientific Films,
Richard Packwood/
Oxford Scientific Films

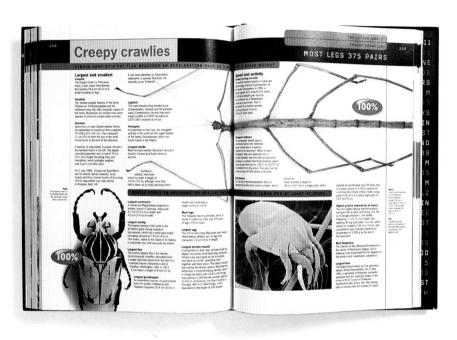

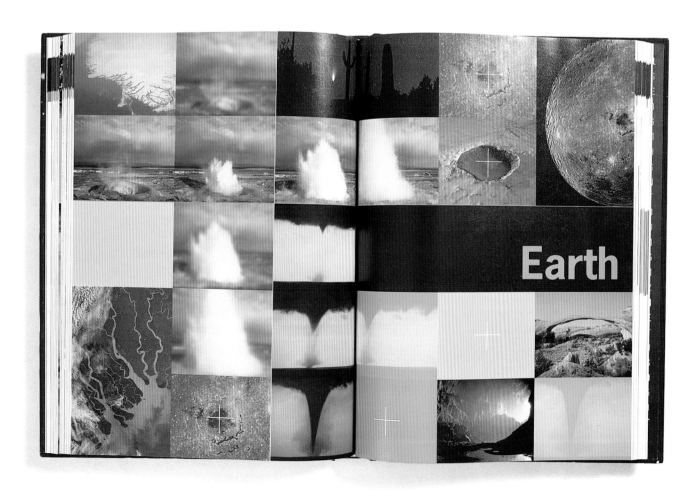

RICK BASS

THE BOOK OF YAAK

Nature / $12.00

The Yaak Valley of northwestern Montana is one of the last great wild places in the United States, a land of black bears and grizzlies, wolves and coyotes, bald and golden eagles, wolverine, lynx, marten, fisher, elk, and even a handful of humans. It is a land of magic, but its magic may not be enough to save it from the forces that now threaten it. The Yaak does have one trick up its sleeve, however — a writer to give it voice. In Winter Rick Bass portrayed the wonder of living in the valley. In The Book of Yaak he captures the soul of the valley itself, and he shows how, if places like the Yaak are lost, so too will be the human riches of mystery and imagination.

Bass has never been a writer to hold back, but The Book of Yaak is his most passionate book yet, a dramatic narrative of a man fighting to defend the place he loves.

Rick Bass is the author of eleven books, fiction and nonfiction, including Winter, Oil Notes, In the Loyal Mountains, and The Lost Grizzlies. His short stories have appeared in a wide range of periodicals and anthologies. He lives with his family on a remote ranch in the Yaak Valley.

ISBN 0-395-87746-6

90000

9 780395 877463

0997 / 6-81198

Cover design: Resa Blatman
Cover photograph: © Stefan Cooke

THE BOOK OF YAAK

RICK BASS

"It would be difficult not to feel a passion for the Yaak Valley equivalent to Rick Bass's after reading this extraordinary, lyrical, and powerful testimonial." — George Plimpton

99

MARINER BOOKS

MARINER BOOKS / HOUGHTON MIFFLIN COMPANY

RICK BASS

THE LOST GRIZZLIES

Nature / $13.00

Do grizzly bears still wander the San Juan Mountains of Colorado, where they have long been considered extinct? Rick Bass, along with veteran grizzly expert Doug Peacock and biologist Dennis Sizemore, search for proof — a claw mark on a tree, a tuft of fur, bear tracks — that the grizzly, though elusive, still exists in this mountain wilderness. With the exhilarating insight for which he is known, Rick Bass describes the dangers and clues on the trail of the grizzly, the mystery and beauty of the animal, and the courage and hope at the heart of the search. The Lost Grizzlies is more than a foray into deep wilderness. It is, ultimately, a search for our lost, true selves.

Rick Bass is the author of ten books, including The Book of Yaak, In the Loyal Mountains, and Winter. His stories have appeared in The Paris Review, Esquire, The Quarterly, and other periodicals and have been widely anthologized. He lives with his family on a remote ranch in northern Montana.

ISBN 0-395-85700-7

90000

9 780395 857007

0797 / 6-81244

Cover design: Resa Blatman
Cover photograph: Stefan Cooke

THE LOST GRIZZLIES
[a search for survivors in the wilderness of colorado]

RICK BASS

An adventure quest in "places, interior and exterior, that exist just beyond the bounds of civilization" — Joe Kane, SAN FRANCISCO CHRONICLE

MARINER BOOKS

MARINER BOOKS / HOUGHTON MIFFLIN COMPANY

DESIGNER
Resa Blatman
ART DIRECTORS
Resa Blatman, Steven Cooley
DESIGN COMPANY
Bella Design
COUNTRY OF ORIGIN
USA

BELOW
ILLUSTRATOR
Resa Blatman
PHOTOGRAPHER
Tony Stone Images
WORK DESCRIPTION
Book cover for *Love Enter*
DIMENSIONS
140 x 213 mm
5½ x 8⅜ in

OPPOSITE
ILLUSTRATOR
Resa Blatman
PHOTOGRAPHER
Stefan Cooke
WORK DESCRIPTION
Book covers for *The Book of Yaak* **(above) and** *The Lost Grizzlies* **(below)**
DIMENSIONS
140 x 229 mm
5½ x 9 in

98

A *New York Times* Notable Book of the Year

<

Winner of the *Los Angeles Times* Book Prize for First Fiction, Paul Kafka's sparkling novel is a bittersweet romance for the cyberspace age. Intern Dan Schoenfeld, delivering babies in a Louisiana hospital, seizes the moments between dramatic births to tap out ardent e-mail messages (password "LOVE") to the friends he loved and lost five years earlier in Paris. With his plump, outrageous friend Beck he shared a ramshackle garret and the friendship of Margot and Bou, two women who happened to be in love with each other. For a brief, enchanted time, the foursome reveled in the bohemian splendor of the City of Light, until old-fashioned jealousies intervened. Now connected to his friends only through the Internet, Dan conjures up the rapture and heartbreak of their days together, when love entered their lives as innocent as a newborn baby.

PAUL KAFKA grew up in Bethesda, Maryland, graduated from Harvard College, and received his doctorate in English literature from the University of Denver. He has been a member of modern dance companies in the United States and Paris. A distant relative of Franz Kafka, he lives in Boston.

"Original and moving"
— *New York Times Book Review*

an e-epistolary novel that ngles hearts and smarts"
— *Los Angeles Times Book Review*

Fiction / $12.00

LOVE.ENTER

"As multilayered as a napoleon, as bittersweet as absinthe"
— *Washington Post Book World*

"Stunning"
— *Newsday*

A NOVEL

LOVE

LOVE

LOVE

PAUL.KAFKA

LOVE.ENTE

PAUL.KAFKA

ISBN 0-395-86001-6

9 780395 860014

90000

0697 / 6-81048

Cover design: Resa Blatman
Cover photograph: © Tony Stone Images
Author photograph: © Linda Krikorian

WINNER OF THE *LOS ANGELES TIMES* BOOK PRIZE FOR FIRST FICTION

Peter Eisenman
Center for the Arts
Emory University, Atlanta, Georgia

Das Center for the Arts der Emory University ist ein deutliches Zeichen für Atlantas kulturellen Elan. Das Center beherbergt vier große Aufführungssäle und ist als nationales und internationales Zentrum für Stipendiumsprojekte und Aufführungen in den Bereichen Theater, Musik und Film vorgesehen. Während es vorwiegend für die Ausbildung von Studenten in diesen Disziplinen gedacht ist, wird das Center for the Arts doch zwei Zielgruppen dienen; dem Emory Campus und der größeren Gemeinde.

In diesem neuen Center werden Studenten und Lehrkörper eng kooperieren können. In einem einzigen, sorgfältig gegliederten Gebäude wird so die fruchtbare Zusammenarbeit zwischen den verschiedenen Künsten ermöglicht, und dies zu einer Zeit, in der sich die einzelnen Disziplinen sehr stark gegenseitig beeinflussen und inspirieren – wie es bei Performance, zeitgenössischer Musik und Videokunst bereits der Fall ist.

Das Center stellt eine Verbindung zwischen der Gemeinde und der Universität her, sowohl durch gemeindeorientierte Aufführungen als auch durch seine Lage am Rand des Campus, eine natürliche Eingangssituation bildet. Das Center schließt auf der einen Seite an ein bereits existierendes mehrstöckiges Garagengebäude an und richtet seine Haupträume zu einem natürli-

The Center for the Arts at Emory University is an active expression of Atlanta's cultural momentum. The Center accommodates four major performance spaces, and is designed to be a national and international center for scholarship and performance in the creative fields of theater, music, and film. While its primary purpose will be to teach and train students in these fields, the Center will serve two constituencies; the Emory campus and the larger community.

In the new Center, students and faculty will be able to converge in a single, carefully articulated building that facilitates rich collaboration between different creative disciplines, which is particularly important at a time when the arts draw increasingly upon each other for inspiration, as is the case with performance art, contemporary music, and video art.

The Center's location at the edge of the campus places it in a position to serve as a

chem Hügel hin aus. Eine Promenade führt über den Hügel durch die Lobby des Gebäudes hin zu einem offenen Amphitheater und zu einem Skulpturengarten. Diese wiederum erstrecken sich über einen der vielen Gräben des Campus' bis zum Kunstmuseum der Universität, das an dem historischen, von Hornbostel gestalteten quadratischen Platz liegt.

Der historische Platz basiert auf einem Schachbrettmuster, das, wenn man es bis zum Center verlängern würde, theoretisch von der Topographie der Gräben deformiert werden würde. Diese anfängliche Deformation entwickelt sich zu fünf Wellen, ähnlich der der musikalischen Harmonik zugrundeliegenden Sinuskurve. Die Sinuswelle ähnelt in Amplitude und Frequenz der Topographie der Gräben. Diese harmonischen Wellen pressen die kontinuierlichen Oberflächen der vier Hauptgebäudeblöcke des Centers zusammen und ziehen sie auseinander, indem sie in eine Vielzahl von Konfigurationen einbeziehen.

connection between the community and the University, both through community-oriented performances, and by physically providing a natural point of entry to the campus. The Center envelopes an existing multiple-level garage structure on one side, and projects its main spaces onto a natural knoll. A promenade crosses the knoll and passes through the building lobby to arrive at an open amphitheater and sculpture garden. These in turn pass over one of the campus' many ravines, leading to the University art museum on the historical Hornbostel-designed quadrangle.

The historical quadrangle is based on a grid system which, when extended to the Center's site, is hypothetically deformed by the topography of the ravine. This initial deformation approximates the five lines of a fundamental sine wave in musical harmonics; the wave is similar in amplitude and frequency to the ravine topography. These harmonic waves compress and extend the continuous surfaces of the Center's four main building bars, folding them in a multiplicity of configurations...

DANIEL LIBESKIND
Through the papertrace

01 Libeskind. Photo: Abe Frajndlich
02, 03, 04, 05 Aufbau im Leopold-Hoesch-Museum, Düren Sept. 96. Photos: Jörg Oswald
06, 07 Modell papertrace. Photo: Studio Libeskind

DESIGNERS
Jens D. Auhage, Markus Aust,
Dmitri Broida, Jörg Oswald

ART DIRECTOR
Jens D. Auhage

DESIGN COMPANY
Televisor

PHOTOGRAPHERS
Jörg Oswald, Dick Frank Studio,
Abe Frajndlich, Studio Libeskind

COUNTRY OF ORIGIN
Germany

WORK DESCRIPTION
Front cover and spreads from a
catalog for an exhibition 'Paper
Art 6 – Deconstructivist
Tendencies'

DIMENSIONS
200 x 270 mm
7⅞ x 10⅝ in

paper art 6.
Dekonstruktivistische Tendenzen – Deconstructivist Tendencies

Dorothea Eimert (Hg.)

Cantz

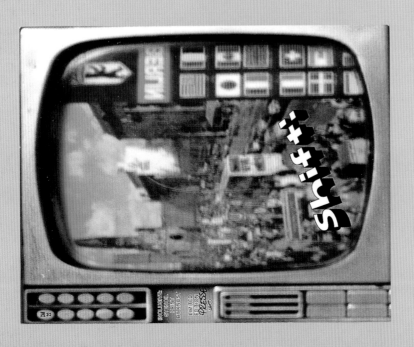

DESIGNERS
Anja Lutz (above left)
Neil Gardiner (above right)
Rik Bas Backer (below)
Martijn Oostra (pages 94–5)
ART DIRECTOR
Anja Lutz
DESIGN COMPANY
Shift!

COUNTRY OF ORIGIN
Germany
WORK DESCRIPTION
Cover (above left) and
spreads from *Shift!* magazine –
about a Berlin co-operative
design project involving ten
international designers and
artists
DIMENSIONS
210 x 260 mm
8¼ x 10¼ in

91

Wiener Friedhöfe

4 wie ner

TEXT: HERMANN-JEIMÜLLER

Fotos: Sarah Winter

DER ST. MARXER FRIEDHOF

Angeblich unvergessene, in Wirklichkeit längst abge-
schriebene Verbliebene. Das stolze Pfauenpaar zwischen
halbzerfallenen Grabdenkmälern. Eine Kohlmeise, die
den in ihr Reich Eingedrungenen neugierig mustert, um
ihn dann, abflatternd, wieder mit den Fragmenten allein
zu lassen. Ein Vormittag im St. Marxer Friedhof.
Vor der Fremdenverkehrsbranche ins drittklassige
Verborben: Alois Drorder, gestorben im 33. Lebensjahr den 22. März 1856.
Dominant indes: Herr Johann Franz, bürgerl. Kanalräumer.
Lanobstrasse Nro. 570, gestorben den 21ten August, 46 Jahr alt, betrautert von
seiner Gattin und vier Kindern, Friede seiner Asch!
In stummer Würde bewahren flügellahme oder gar kopflose
Contergan-Engel die Mystik dieses friedreichen Orts. Die Eitelkeit
der k.u.k. Hoffriseure, der Kommerzialräte, der Eisenbahnbeamten
und ihrer Erben wird unbedeutend angesichts der augenschein-
lichen Vergänglichkeit: Viele Namen hat die Zeit abgeschlagen,
ausgelöscht; die anderen sind längst vom Grün überwuchert. Den
Rest besorgt die benachbarte Stadtautobahn mit ihrem alles
überdränenden Lärm.

*Es ist nichts zu loben,
nichts zu verdammen,
ist vieles lächerlich – es ist
alles lächerlich, wenn man
an den Tod denkt.*
Thomas Bernhard

Und die Engel stampfen ihre Jackin in den Boden.

IM ZENTRALFRIEDHOF

Die Ehrengräber den Herdentouristen überlassend, zieht es mich
heute zu den Normalsterblichen.
Deutlich sichtbar: das braune Erbe Österreichs. Eine Gedenktafel
mit Eisernem Kreuz und zwei ovalen Fotografien: der Vater
Hauptwachtmeister bei der Schutzpolizei, SS–Schütze sein Sohn.
Beide im Osten gefallen, ich gehe weiter.
Vom Mittags–Sonnenlicht umspielt:
der Messias. Mit offener Gebärde für die Mühselig–Beladenen.
Aber Hände zum Segnen besitzt er keine mehr. Sie sind dem
Rebben Jeschua im Verlauf des jüngsten Pogroms abge-
schlagen worden.
Nördlich der Zentralfriedhofskirche befinden sich die
Reihengräber der Roten Armee. Zwei markige Soldaten-
figuren auf steinerner Wacht. Inmitten der Anlage
steht ein Obelisk mit dem Sowjetstern an
seiner Spitze. Die Genossen
Offiziere liegen separat, abseits
der Mannschaftsmassen.
Selbst post mortem sind manche
um einige Grade gleicher.

Dann die Wildnis der (alten) Israelitischen Abteilung

Unter Alleebäumen weiter. Links ein
Feld mit Armengräbern. Da ein einfaches
Kreuz im Rasen (der Name mit Hand aufgepinselt),
dort ein Metallschild. Eine Strecke weiter ist vom Kreuz nur
noch ein morscher Längsbalken übriggeblieben.
Sie macht bekommen. Umgestürzte Denkmäler, offene Gatter vor
zerstörten Mausoleen, überwachsene Gräber: Friedhofsdschungel.
Bei etlichen Stellen ist an ein Durchkommen nicht mehr zu denken.
Selten begegnet einem hier ein Mensch.
Die Inschriften zeugen vom liebevoll pathetischen Anteilnehmen
gutbürgerlicher Wiener am Ableben des teuren Charakters, der zärtlich-
sten Gattin, der aufopferndsten Mutter, des sonnigsten Gemüts.

HANDBUCH FÜR DIE LETZTE REISE

Ilja Sallacz. Auseinandersetzung mit dem Tod öffnet neue Horizonte

Ilja Sallacz erweckt das von ihm gestaltete Buch zum Leben: Diese Doppelseite aus Aluminiumplatten setzt sich mit der modernen Kriegsführung auseinander. Langsam wird mittels der Videoprojektion das Visier eines Kampfjets eingeblendet. Ein Mensch windet sich im Zentrum.

Die patentierte Medieninstallation stellt eine perfekte Synthese von Audio, Video und Buch dar. Der Betrachter wird über alle Sinnesorgane angesprochen und erhält damit Einblick in das brisante Thema Tod.

Abhängig von der jeweils aufgeschlagenen Seite werden Filme auf das offene Buch projiziert, und gesprochene Texte oder Geräusche erfüllen den Raum. Es ist ein beliebiges Vor- und Zurückblättern möglich.

KARIBIKGEWITTER

EIN

BEGLEITET VON EINER BÜHNENREIFEN WOLKENINSZENIERUNG.

FOTOGRAFIEREN! LASSEN WIR UNS BEGIESSEN.

RÜCKENLIEGEND.

DEN RUM IN DER HAND.

DIE HAVANNA IM MUND

BLICKT MAN AUF

PROXIMA CENTAURI –

NUR 4,3 LICHTJAHRE ENTFERNT –

DIE AUSSICHT GIBT ES

NUR IN DIESEN BREITENGRADEN.

1959 DIE UHR ANGEHALTEN

JEMAND SCHEINT HIER DIE UHR ANGEHALTEN
ZU HABEN. DIE FAHRZEUGE PROVOZIEREN EINE ZEITREISE IN DIE 50ER JAHRE.

VON ZIERRAT UND PFLANZEN ÜBERWUCHERTE HÄUSER, DEM BALDIGEN ZUSAMMENFALL NAH,

BILDEN EINE AUTHENTISCHE KULISSE FÜR DIE WUCHTIGEN STRASSENSCHIFFE.

DURCHFAHREN FLORIDA, AUSTRALIA, MEXICO... DIE FANTASIE BLEIBT AN DER VORMITTÄGLICHEN BRISE I BLEIBT KEIN WÖLKCHEN OFFEN. MAN KANN THEORETISCH DIE GANZE WELT UMSEGELN.

16

PAGES 88-91
DESIGNER
Ilja Sallacz
ART DIRECTOR
Ilja Sallacz
DESIGN COMPANY
Pilot
COUNTRY OF ORIGIN
Germany
DIMENSIONS
210 x 297 mm
8¼ x 11¾ in

ILLUSTRATOR
Ilja Sallacz (left)
PHOTOGRAPHER
Stefan Pape (below)
WORK DESCRIPTION
Cover and spreads from *ARTUR* –
a quarterly magazine on art and
culture

PAGE 90
ILLUSTRATORS
Ilja Sallacz, Richard Sekules
PHOTOGRAPHER
Ilja Sallacz

PAGE 91
PHOTOGRAPHER
Sarah Winter

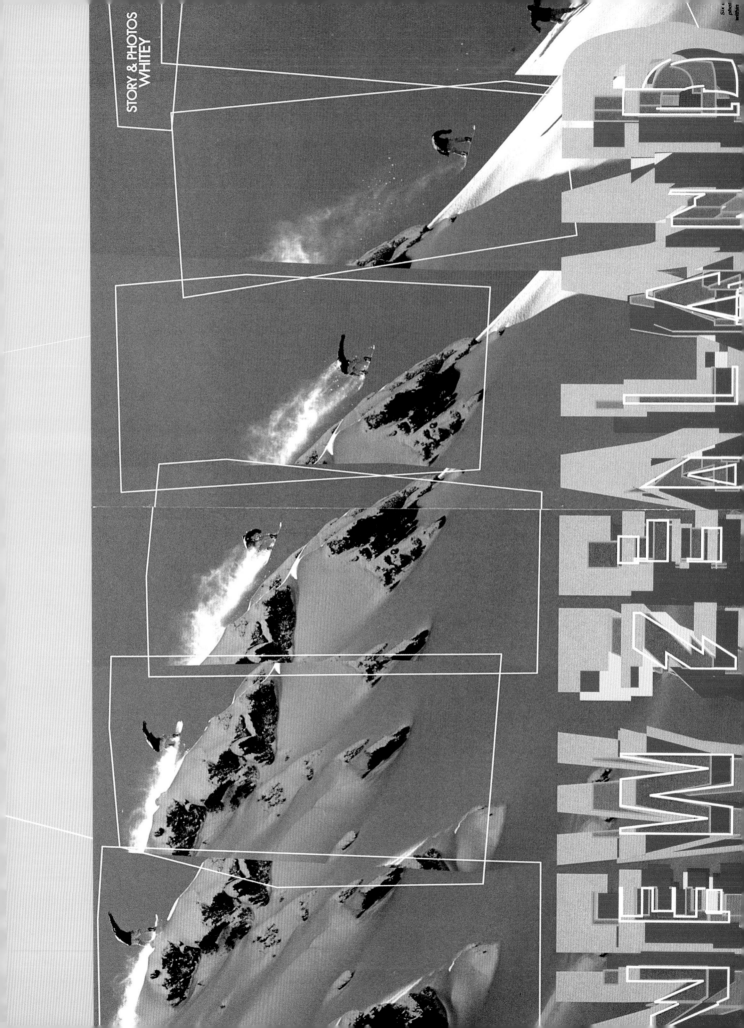

STORY & PHOTOS
WHITEY

NEW ZEALAND

WORK DESCRIPTION
Covers for *Blunt* magazine
DIMENSIONS
Left: 216 x 276 mm
8⁷⁄₁₆ x 10¹³⁄₁₆ in
Below: 205 x 275 mm
8¹⁄₁₆ x 10¹³⁄₁₆ in

DESIGNER
Natas Kaupas
ART DIRECTOR
Natas Kaupas
DESIGN COMPANY
Natas Kaupas
PHOTOGRAPHER
Whitey
COUNTRY OF ORIGIN
USA

BELOW
WORK DESCRIPTION
Spread from *Blunt* magazine
DIMENSIONS
205 x 275 mm
8¹⁄₁₆ x 10¹³⁄₁₆ in

produce or even allow a subway or tram or anything to happen. We have this system called the Blue Line I think, that goes from Orange County, 605 freeway and the 5 area, and goes down the center of Century freeway and ends at the LAX airport. But the subway or the tram itself stops right before the airport, because the taxi's lobbied, the shuttle companies and buses lobbied that they couldn't have that because it would compete with their business. They probably payed off the government, and that's the kind of bullshit that makes me want to *kill* the government! **Have you entered any contests this year?** No, with all those tours and I am working so hard for Volcom that I just didn't have the time. There are just so many contests goin' on ya know? **Are you gonna try and get in the contest mode next year?** Yeah, I think this year I'm gonna totally be on a re-rage, and work less in the office and get outside a lot more. **Do you still have any old cars or motorcycles goin'?** Yeah, I still have my Triumph sittin in the garage and I then I have a 1970 Toyota Corona Deluxe with the Toyo-glide automatic tranny. It's definately funky. **Has your hyperactivity gotten you in any trouble lately?** Yeah, I had people concerned, actually Sarge and Hill told me about a year ago that they were concerned for me, wondering what route I was going. I was shocked. I mean I knew in the G&S days with them that like things were just super out of hand, but I just never knew people perceived me as too out of hand or misled. I look at kids now and I can tell their route, where they're headed. I gues they were thinking they were seeing something back then with me. Yeah, it's all relative. What is "trouble?" it's all about life's experiences, is it living and learning? My business card at Acme did say "the instigator" for awhile. **What are you gonna do in the next segment of your life?** I have got a little Fender guitars project...I don' know.... **Do you have any last statements?** Basically, I am concerned for the youth of today. 'Cuz I live in Orange County and I don't see many real constructive things goin' on. I do know that this is only one place and it's not like that, everywhere. I do think that the youth should be alert for being misled by the media, the masses and the hype and everything. There is so much stimulus on T.V. and billboards and commercials. There's so much oppressive information just digging into you. You've got to watch out for yourself and use your own head these days because not everyone has good intensions out there. They're creating two classes: the brain class and the clone class who are just the pawns of, the society, of the chessboard. There's not one constructive T.V. show on anymore. I grew up watching the Cousteau Society and Wild Wild Kingdom and stuff like that. It's such a shame that such a potentially wonderful tool has gone to such crap! **Any thanks?** I don't know. I'll leave too many people out. If you had a good time with me - thanks! Because I probably had a good time with you! I don't know, I mean I've met so many people throughout the globe, it's just been a crazy ride.

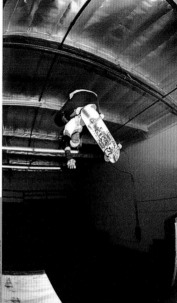

Hawkland Photo: Dave Malonfant

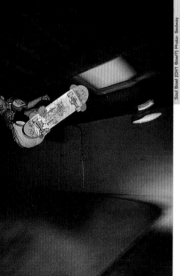

Soul Bowl (OH! Bowl?) Photo: Sedway

sponsor, I mean, here I am just skateboarding and it's like who gives a shit! It's like get over it! And now all these companies have all these non-pro model boards and people are always saying, "Wow, Acme's cool, but how is it riding without a board?" I think back and all these past 5 or 6 years I never once had to worry about my board sales or my graphic or my shape. It was like maintence with skateboarding, the best. **Right about the time when you quit G&S and started riding for Acme is when Mike Hill, Carter and all those guys split and did Alien Workshop isn't it?** Yep, that's right. **What was goin' on there? I mean how did they figure out who was and wasn't gonna be included with the Workshop?** Well I found out that, I think this is how the story goes unless those guys were just being nice to me when telling me what, they told me, but., that I had already been up and coming under G&S' name for awhile with the advertisments that they took everybody that was kinda new and not as focused on. Like, Rob Dyrdek, Duane Pedre and Bo Turner. Which was cool with me. I mean I still love those guys to death and i was stoked for them! The Workshop rules! **Those guys are cool! Do you still talk to those guys sometimes?** Yeah, at the Tradeshows or like I'll just give em an outta the blue call once in awhile. **Mike Hill refuses to go to the Tradeshows (laughs).** Mike Hill is mental! **Did you hear about his farmhouse?** Nah-uh. **Last summer he bought a 10-acre ranch house out on the outside of Dayton. Just this old house out in the middle of nowhere with a little stream 'n stuff...he's settin' up for the Apocalypse! (laughter)** That rules! **Is he down for visitors?** Oh yeah, I went there a year and a half ago a he was completely down and he knows you.. so... No. Mike's the nicest! "Good for you Mike!" [laughter] **So then you went to Acme and that's where you presently are and everything's goin' great?** Yeah! Jim's really cool 'cuz he knows I've been workin' with Volcom since I stopped working for Acme pretty much a couple years ago, and I represent Volcom really hard. He is totally cooperative, we work together, though it may not. **[Remy grabs the recorder for this brief interruption:]** O.K., I just wanted to say that there is no public transportation in Orange County because, from what I believe, the Motor Companies, the Gas Companies, all these big huge companies that sell millions of cars in Orange County don't "allow" public transportation thoughts to even grow into a plan. There's not show. Mike Hill is mental! Did you really not know. Mike's the nicest! "Good system. But there's really good roads and there's lots of gridlock and traffic. I think this represents an unbalanced government where people don't vote and they don't take care of business, and the people that are making the big decisions always have a big "payoff" in the back of their minds. Like, What company is gonna support me the most on this decision I make, and that's the decision I'm gonna make. Then Ford and GM and all these guys are gonna pump me a big, big lump because I'm not gonna

85

Soul Bowl. Photo: Senkowy

does and showin' his buddies, like "...ahhh, check it out boys..." I was just a pup, I'd never seen raw skateboarding before. And he was chargin' this wooden plywood quarter pipe that was well over my head and he was like pushin', pushin', running first, then jumping on his board and keep pushin' and then "Boom!"...big back side air and then come down and there was these like holes in the cement, where palm trees used to be and he would just kinda ollie every one of them just like totally smooth and I was just baffled! That was like, I think when I bought some Sims B-52 wheels. First time I ever bought like brand new stuff. Before

that. I was into the Sims Snakes and the old Bad Company skateboards...all the big bully's in my neighborhood givin me their old gear. I don't know, I guess Neil Blender was always good, and Gator and so was Chris Miller. **Back to sponsor stuff, after those early spon-**

sors you actually got on G&S? Yeah...that was like for awhile. It's weird, I was never really into hoppin' around I guess. I mean I look back now and I think I was with G&S for almost 6 years and now it's been 6 years with Acme. I remember I got shit for riding for Acme at

first 'cuz it was the first non-pro model company I was just baffled at the fact that people would give me shit for my

he just had a big elephant gun

up last summer? No, that was actually March I think. This whole year's been baffling for me I think, one of my most baffling years. **Just been doin' too much?** Way too much! Like stimulus overload! I can't even document it all...I try, I write and just to keep my sanity I drag my acoustic guitar around with me just to strum it. I try to skate, I work at Volcom, I mean just right now I'm trying to get a grip on all this garbage goin' on right now. It's all great fun and it's hard to justify what's right and what's wrong. **You have to account for every second of the day.** Yeah, the second I'm awake I'm already not hungry because I have to be somewhere. **So, what have your outside interests been lately?** I've been trying to filter through all these opportunities and various stimulus', whether it's social or work or shootin' photos. I have been getting more into preparing to prepare to write and to shoot more knowing that I love it. I mean, now I can actually afford to buy good gear. I totally love shooting so much. I love playing music, I have been playing guitar for awhile now and that's just a great pass time. Ridin' bikes if I have enough time, I don't know. I try to cope. This is a high pressure area down here! I mean it's strange, you have to hold on to your sanity, physically. I go away and feel so at peace and

see so clearly and then the second that I come home, like I will be home for two days and I will already be like turning into a little freak again. I just have to tell myself to stay focused. **When you go away do you feel you have to prepare yourself for what you have to come home, like prepare for an attack?** Yeah, I know now that when I come home from trips I know I have to have a couple days off before goin' back to work. I need a few days for adjustment so that I can get back into the high paced swing of things with a clean mind. You go to these cities with such cool social vibes, full cultural cities with old architecture and people that are people, and then you come back down here and you realize that you're dealing with Orange County which is a very unique place I think Orange County is only here to get business done, nothin else. Yeah, it's dry as hell and at the same time I think that's why you get all these silicone boobs and made up girls and puffy hair-do's and expressive people that are trying to release all this pressure in some odd way. I even find myself telling younger people that this is not the way it is else where! Not really preaching, just rather enlightening people that all you have to do is take a road trip, go north, go south, go east. It's not all about... beers... bongs... boobs... babes... As far as outside interests, do you kinda key that in to preparing for times after skateboarding? Yeah, it seems like I have been preparing for that time to come for a few years now ever since I was working at Acme with you, ya' know? The whole reason I was working there was because....I just didn't like the direction it was going at the time...feeling like I didn't want to represent what I felt was being represented. So I just kinda went underground and started working. I was still always skating. You mean after I quit? No, I'm just talkin' about the whole political skateboard thing, just how much bullshit was goin' on with the industry and I was just like if this is the direction it's going then I'll just

went to San Francisco to go to school and I was talkin' to Thrasher about workin' with them on the side 'n stuff. I just had my whole plan of escape planned out and then good things started to come and I decided to just take my chances and give it a second chance and that's kinda where I got myself now. I mean now I'm soo stoked! All I went to do is skate...it's so refreshing. In your early sponsored years, who influenced you the most or who are people that really blew your mind and that you looked up to? I remember one time I was out kite flying with my dad's kite company at Venice Beach and I saw Christian Hosoi skating with his Alva Sun board and he had a front Indy truck without any rubbers in it at all. It had a kingpin and nut on it and that was it. It had Rabones. His front truck was rattling...he was just so solid and focused and like able to skate that thing that he didn't even realize it 'till he like picked it up and started laughin' like Christian always

PAGES 84-5
DESIGNER
Ron Cameron
ART DIRECTOR
Ron Cameron
DESIGN COMPANY
RCD
ILLUSTRATOR
Ron Cameron
PHOTOGRAPHERS
Remy Stratton, Aaron Sedway,
Dave Malenfant
COUNTRY OF ORIGIN
USA

WORK DESCRIPTION
Spread from *Heckler* magazine
DIMENSIONS
254 x 305 mm
10 x 12 in

Photos: Lance Dalgart
Lettering: Sonny

Darren & Double.
D & D.
Dungeons & Dragons.
Madd Maxx & BladeRunner.
Beavis & Butthead.
Darren & Double.

the Heckler Interview
(NC-17) begins on the next page

NAVARETTE

40 (Heck) Sticks & Stones (ler) 41

DESIGNER
John Baccigaluppi
ART DIRECTOR
John Baccigaluppi
DESIGN COMPANY
Heckler Magazine
COUNTRY OF ORIGIN
USA

ABOVE
ILLUSTRATOR
Jennifer Chiang
PHOTOGRAPHER
Jamie Mosberg
WORK DESCRIPTION
Cover for *Heckler* magazine
using a logo sent in by a reader
DIMENSIONS
254 x 305 mm
10 x 12 in

RIGHT
ILLUSTRATOR
Sonny Mayugba
PHOTOGRAPHER
Lance Dalgart
WORK DESCRIPTION
Spread from *Heckler* magazine
DIMENSIONS
254 x 305 mm
10 x 12 in

"We're all gonna have machine guns and shit. We're all gonna go to Burnside and make the walls hella tall, make a dome or whatever. Big guns, knifes— whatever. We're gonna get ready. 999 coming up—we're gonna take over, we're gonna skate wherever we can. We will take machine guns, cannons— whatever, as long as we can skateboard."

81

alaska is the sharp end of the big country. It is dark, expansive, expensive and scary. If there's a hell below we're all gonna go, a wise man once sang. And Alaska is the place for people who can't wait to get there. Some snowboarders go there to see how bad-ass they are, but that's like lying down on the tracks to see how big the train is.

If you're lucky you'll go quickly in an avalanche or a crevasse, your friends will find your transceiver's signal and split up your gear. Large brown bears will eat your carcass so nobody has to pay for the funeral. And everything will be simple.

More likely the weather will lock you in somewhere and you'll go slowly mad as your supplies run out. Days, maybe months later, you'll wander out 15 kilos lighter, speaking in tongues to companions nobody else can see. The press will spread cannibalism rumours about you, you'll get billed for the Coast Guard helicopter search and go broke. You'll live briefly among wild sled dogs near Chickaloon, then end up on Fourth Street in Anchorage, selling cars, crack or Jesus. Alaska is a serious proposition. But some people like that about it.

The final outpost of the New World has over half of the glaciers on the planet (covering 74,600 square kilometres) and probably more skiable areas than the rest of America combined. And the small Alaskan town of Valdez has what many people consider the best ski-terrain in the world: a chunk of the Chugach range with 15-metre annual snowfalls, 1,500-metre vertical runs on treeless slopes and countless

For many this is the

best ski-terrain in the world: 15-metre annual

snowfalls, 1,500-metre verticle runs on treeless

slopes and countless

unskied, unnamed

mountains

unskied, unnamed mountains. That's the kind of serious proposition that over the last six years has made Valdez into a board-bum paradise. From March to May each year they pour in from Europe and the rest of America to try their hand at the just-about-possible.

The thrill of Alaska is the rawness of it, the raw possibilities of it. It is still pioneer country, gold-rush country. It's the kind of environment where you can forego your own little chunk of history, and maybe make a small fortune. And it was a strange kind of quick-cash rush that saw the population of Valdez swell from 4,000 to 12,000 during the summer of 1989.

The *Exxon-Valdez* oil spill brought scientists, clean-up workers and the media in to the town, and the locals went about making money from them. The clean-up operation was something of a fiasco. But working long hours in the extended summer daylight, many Valdez locals made enough cash to launch their own businesses. It is no small irony that the oily profits from an environmental horror story should be the catalyst for an invasion by eco-friendly snow hippies. But history is like that. People can twist and turn it in unexpected ways.

Until the Valdez spill, the town's mountainous back-yard was only skied by hardcore locals. Oil-spill booty and frontiersman spirit would soon open it up. Frontiersmen like Chet Simmons, an old-school California surfer, who came to Alaska after flying choppers in Vietnam. He wouldn't have lasted anywhere else; maybe Australia would have suited him, but he was clearly too crazy to return home. He loves Alaska and it's probably the best place for him. Lots of Vietnam vets headed for the north-west coast of America, for the emptiness of it. And Alaska is the logical end of the road if you have that need.

During 1989, Simmons flew the clean-up workers over Prince William Sound, the site of the disaster. Another Valdez resident, Michael Cozad, used his profits of doom to buy an abandoned roadhouse on Thompson Pass Highway, the only road out of town. Tsaina Lodge sits 36 miles outside Valdez in a magnificent alpine valley where peaks rise over a mile high on all sides. It's further inland than Valdez, gets clearer, cooler weather and massive snowfalls. Cozad thought Tsaina would make an excellent ski lodge and he spent months fixing up the place. Then he hooked up with Chet Simmons to fly local skiers into the Chugach Range around Thompson Pass.

Simmons and Cozad saw the potential in the place: there was indeed gold in them there hills, and Cozad's mission now was to bring Valdez to the attention of the international ski and (burgeoning) snowboard community. He pleaded with magazine editors and ski-film moguls to send people out. But no one was really interested in a remote Alaskan lodge near a town tarred as the site of an ecological nightmare.

It's easy to understand the reluctance. For all its grandeur, the area around Valdez is far ▲

Snow joke:
helicopters flown by
Vietnam vets drop
you into the heart of
hostile territory.
Remember:
Charlie don't surf

FUNNILY ENOUGH, FALLING
DOWN AN ALASKAN CREVASSE
ISN'T BIG ON LAUGHS. AMERICAN
SNOWBOARDER MATT GOODWILL
LIVED TO TELL THE TALE

It was a lower run, and me and a couple of others were cruising along. The three of us were cutting over, traversing across this nice little windlip. I was like 15 or 20 feet higher than everybody else. Next thing you know, I'm just falling. All I could see was blue and I just started kicking my board, like sideways, back and forth, and I'm definitely hitting both sides of this crevasse. It felt like I fell forever, it was like, "Oh, shit!" kicking, kicking. When I landed, I'm on this narrow spot where the crevasse pinched together. I didn't get pinched because the snow that came down beneath me kinda wedged in the crack, so I could move and my board wasn't trapped. On either side of me, the thing just dropped away forever. If I'd fallen either side from where I went in, I would have gone deep and probably gotten wedged.

Once I was down there I was like, "Whoahhh!" I kind of looked around and assessed the situation, more or less. Then I hollered for like two minutes; I yelled, "Yo motherfuckers!" Then I sat there for five or ten minutes, waiting to see if somebody saw me go in. There was nothing, nothing. It was like, "OK man, here we go." So I got off my board and started cleaning the walls of the crevasse because a lot of snow got blown in there and there was like a lot of loose snow up in these little cracks. Then I started using my snowboard, hitting off big chunks of ice – like two-foot or three-foot chunks – so I wouldn't grab anything loose while I'm climbing. As I was cleaning stuff off, I found this little crack that started thin and got wider and

Matt Goodwill interview by Jake Hauswirth

Crevasse (kre-vas),
noun, a deep crack
or fissure, esp in the
ice of a mountain
glacier. Alaskan
winds often make the
most deadly
crevasses invisible by
blowing snow
bridges across them.
Snowboarders don't
usually get to see
them – let alone leap
across them

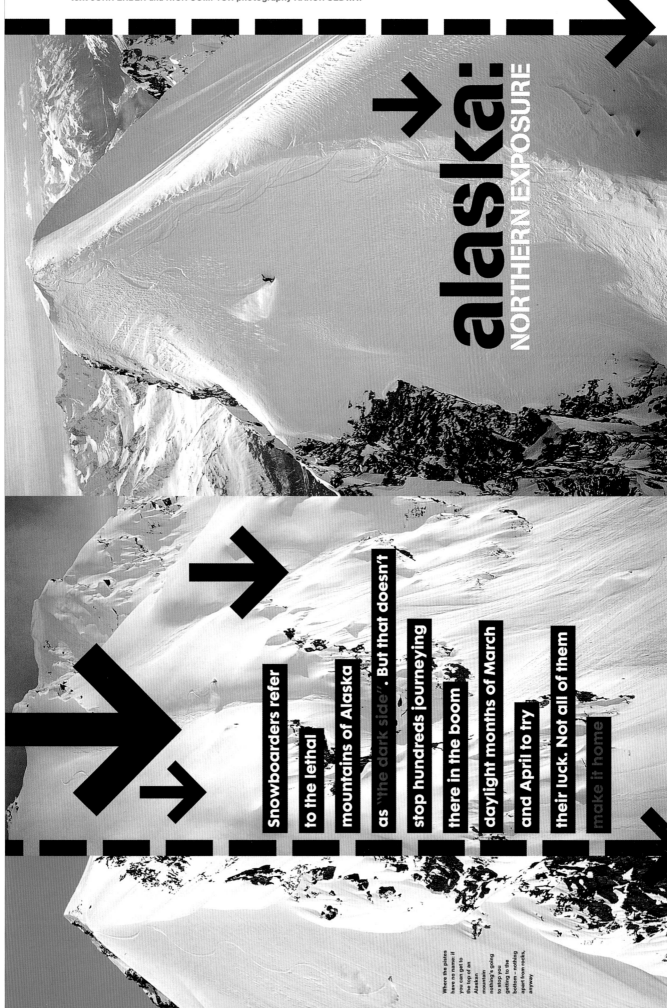

alaska:
NORTHERN EXPOSURE

Snowboarders refer

to the lethal

mountains of Alaska

as "the dark side". But that doesn't

stop hundreds journeying

there in the boom

daylight months of March

and April to try

their luck. Not all of them

make it home

Where the pistes have no name: if you can get to the top of an Alaskan mountain nothing's going to stop you getting to the bottom – nothing apart from rocks, anyway

predecessor "A Northern Soul" as runner-up only to his own "Morning Glory" and Paul Weller's "Stanley Road" as the best album of 1995, and dedicated a song – "Cast No Shadow" – to The Verve's singer Richard Ashcroft. Nor because The Verve were actually supposed to have split up in August of that year, just as the gorgeous, string-driven "History" was about to become their first big hit.

No, the real reason is "Bitter Sweet Symphony" and everything that peculiar, direct, heart-filling song promised. Having emerged in the middle of the same 1992 indie boom that produced Suede, The Verve had gone on about the power of music to transform and renew your private world since long before such things were fashionable. Their own music, though, had always consisted of shapeless groove-based wig-outs, a Shamanistic psychedelia that was just too weird to play on the big stage. The Verve were dismissed as Northern nutters from a town (Wigan) with no rock'n'roll pedigree. Their singer – this character with extravagant, not-of-this-earth good looks and the build of a twig with metabolic problems – talked so much mysticism that he became known as "Mad" Richard. He was probably on drugs. It was said that The Verve would be dangerous if they ever wrote a song. Then they did.

No one expected The Verve to connect now, of all times, yet with hindsight you could have seen it building. James Lavelle reckoned that the Verve record would be the only British rock record worth hearing of the year. Mike D was interested (even the copyright notice on one issue of *Grand Royal* magazine read "This our magazine, or to paraphrase Mad Richard of The Verve – This is magazine"). Noel Gallagher wouldn't shut up about them. The young and on-it Scots novelist Alan Warner placed references to The Verve in his books, for no apparent reason other than that the band seemed to be about to matter in some unspecified way. There is no reason why these people's opinions should matter more than those of any other punter, except that

pice Girls: is there no getting away from them? Not in this life – not even if you're a rock star yourself, as The Verve are discovering this late July afternoon. In an airtight beige bunker beneath the Metropolis recording complex in sunny, suburban Chiswick, west London, disembodied and contextless bits of Verve music leak through a studio blast door: The Verve are finishing the album they were supposed to have finished a year ago. Upstairs, meanwhile, in the carpark of the neighbouring London Transport garage, a double decker bus painted with an all-over Union Jack is surrounded by cameramen, lighting technicians, brisk women clipping about with clipboards, and five very masculine-looking transvestites who represent Britain's Hottest Pop Fivesome: *Spice: The Movie* is in lively production. It is a sort of walk-through pun on the us-and-them nature of the British music industry – Upstairs, Downstairs – and it is doing The Verve's heads in. The contrast between this and their own hermetic world could not be starker. As he returns from the toilet, The Verve's lanky and amiable bass player Simon Jones flashes an amused, well-what-are-you-going-to-do expression at the occupants of the studio ante-room. Then he starts skinning up.

Nowadays even the most paltry LP can flag itself as "long-awaited", but the one The Verve are finishing – their third – really is. Not so much because Verve patron Noel Gallagher proclaimed its

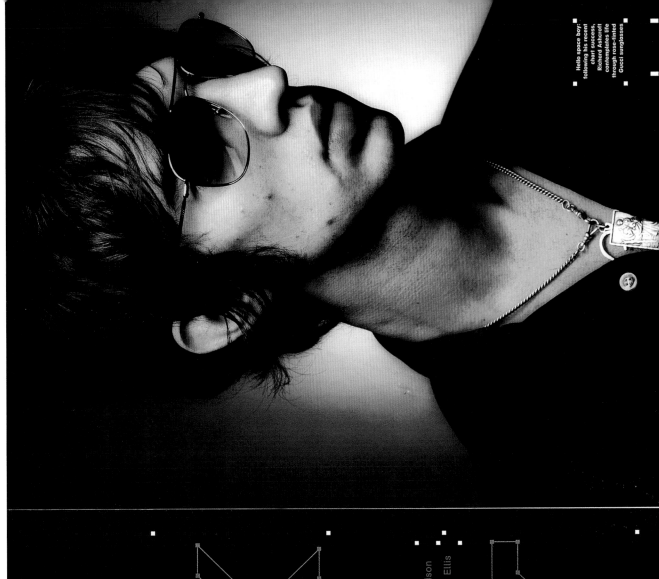

Hello space boy: following his recent chart success, Richard Ashcroft contemplates life through rose-tinted Gucci sunglasses

dark pop stars

The Verve. It's taken 15 years, a split, a nervous breakdown and a death, but now they're shining

text Andrew Harrison

photography Sean Ellis

DESIGNERS
Neil Fletcher, Chris Ashworth
ART DIRECTOR
Kevin Westenberg (cover)
DESIGN COMPANY
Substance
PHOTOGRAPHER
Kevin Westenberg
COUNTRY OF ORIGIN
UK
WORK DESCRIPTION
Front and back cover
(top right) and spread
from a self-promotional
brochure
DIMENSIONS
156 x 195 mm
6⅛ x 7⅝ in

OPPOSITE
DESIGNERS
Neil Fletcher, Chris Ashworth
ART DIRECTOR
Neil Fletcher
DESIGN COMPANY
Substance
COUNTRY OF ORIGIN
UK
WORK DESCRIPTION
Self-promotional poster
DIMENSIONS
418 x 593 mm
16½ x 23⅜ in

PAGES 78–9
DESIGNER
Stuart Spalding
ART DIRECTORS
Lee Swillingham,
Stuart Spalding
PHOTOGRAPHER
Sean Ellis
WORK DESCRIPTION
Spreads on British
rock band The Verve
for The Face magazine
DIMENSIONS
232 x 300 mm
9⅛ x 11¾ in

PAGES 80–1
DESIGNER
Stuart Spalding
ART DIRECTORS
Lee Swillingham,
Stuart Spalding
PHOTOGRAPHER
Aaron Sedway
WORK DESCRIPTION
Spreads on snowboarding
in Alaska for The Face
magazine
DIMENSIONS
232 x 300 mm
9⅛ x 11¾ in

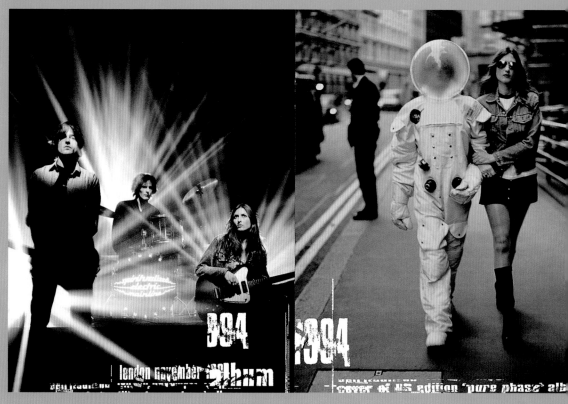

PEACH?

SUB. A3 A/W 8403 (Col. metalic) 21/7/95 2:03 pm

UB. A3 A/W (Peach)

F 0181 693 1861

HY

M1 T Y P O GRA

PHOTOGRAPHY DESIGN

T 0181 693 1861

SUBSTANCE
Graphic Design

TYPOGRAP
POGRAPHY
PHY

[GREAT BRITAIN]

TYPOGRAPHY
DESIGN PHOTOGRAPHY

Swiss + Grit 00.0114
Promotional mailshot 00.0181

Chris Ashworth Neil Fletcher
Amanda Sissons BA (Hons)

London Sheffield

Purveyors of Progressive Swiss Typography

58 35
18 61

London

M1 TYPO GR APHY

T 0181 693 1861 T 0114 268 5835 Pantone No.s 472 U 840

TYPO PHO

F 0181 693 18

Substance have five years of experience in the design industry, and have offices in London and Sheffield where

Contemporary and classical design solutions are produced for a client base that meets a diverse spectrum of services

SUBSTANCE

TYPOGRAPHY DESIGN PHOTOGRAPHY
Chris Ashworth Neil Fletcher
Amanda Sissons BA (Hons)
Purveyors of Progressive Swiss Typography

DESIGN

DESIGN TYPOGRAPHY

SUBSTANCE
MADE IN ENGLAND

D
9.06.95

HY

TYPO GR A Y

POGRAPHY

SUBSTANCE

DESIGN TYPOGRA

TYPOGRAPHY

00.0114
00.0181

268
693

58 35
18 61

68
693

HY PHOTOGRAPHY T Y PO GRA PH

Composite

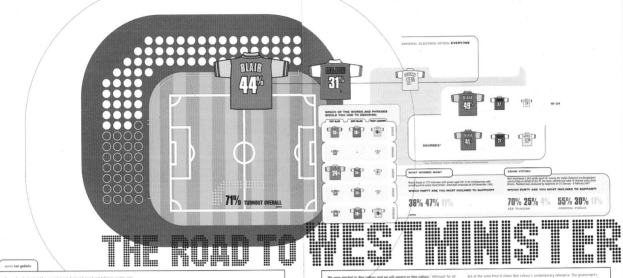

GENERAL ELECTION VOTES: **EVERYONE**

BLAIR 44% MAJOR 31% 17%

49% 27%

18-24

BLAIR 41% 27%

DEGREES

WHICH OF THE WORDS AND PHRASES WOULD YOU USE TO DESCRIBE:

| TONY BLAIR | JOHN MAJOR | PADDY ASHDOWN |

71% TURNOUT OVERALL

WHAT WOMEN WANT

Result based on 773 interviews with women aged 18+ in 10 constituencies with sampling points across Great Britain. Interviews conducted on 4-6 November 1998.

WHICH PARTY ARE YOU MOST INCLINED TO SUPPORT?

38% 47% 11%

ASIAN VOTING

Mori interviewed 1,003 adults aged 18+ among the Indian Pakistani and Bangladeshi communities on behalf of Zee TV, the Asian satellite and cable TV channel across Great Britain. Fieldwork was conducted by telephone on 31 January – 9 February 1997.

WHICH PARTY ARE YOU MOST INCLINED TO SUPPORT?

70% 25% 4% ZEE TV/ASIAN **55% 30% 11%** GENERAL PUBLIC

THE ROAD TO WESTMINSTER

words: ian godwin

No wonder staying in is the new going out. Surround sound and takeaway curries were made for nights like these. Election 97 was the most amazing victory to be televised since England beat Holland 4-1 during Euro 96. With hindsight, Blair's rhetoric seemed spot on: Labour was coming home.

Like England, Labour anticipated a win. But the opposition had a better record in the fixture down the years. In the event, of course, Labour played them off the park. And there was no Patrick Kluivert to score a consolation goal for the Tories. Many of their stars were stretchered from the field. Some, like David Mellor, were given the red card.

Ironically enough, Enfield Southgate provided the Teddy Sheringham moment. Stephen Twigg's ousting of Michael Portillo was the electoral equivalent of a fourth, delirious goal – when incredibly turned to stunned rapture. Only next morning could you believe the result. Because it said so in the newspaper. LABOUR LANDSLIDE.

In retrospect, the scale of the victory can be put down to two things – the electorate's powerful distaste for the Tories and the personal appeal of Tony Blair. Labour achieved its 179 seat majority (reduced to 178 with the re-election of Betty Boothroyd as Speaker) on the basis of 44.5% of the popular vote. Paddy Ashdown's Liberal Democrats secured 46 seats (up from 27 in the last Parliament) despite their share of the vote falling one point.

There are any number of reasons why. Various discontents welt up over 18 years. Certainly the Conservatives underestimated the issue of 'sleaze'. It was far from being a figment in the imagination of Guardian readers. It symbolised the arrogance of power and the tired condescension which had come to characterise the Conservatives for many swathes of people. To think they could get away with this or that indiscretion. The public took offence more at the gall of their sophistry than the foolishness of their actions.

Moreover, the Conservatives no longer seemed to speak to the Britain which many experienced. Or if they did, voters were not going to let them claim responsibility for it. The anti-Tory landslide left the party without a single seat in Scotland and Wales and without MPs in many of the great conurbations. The pundit Peter Kellner simply confirmed what many had thought for a long while when he observed: *'The bleak truth for the Conservatives is that they have been reduced to a party of the English suburbs and shires.'*

You could almost say Labour was elected by default. Hell, even Neil Kinnock might have stood a real chance in 1997... But then again no. As Blair declared at the victory party:

How well did we do? No, not New Labour, but the Reoie switchboard survey which asked key companies, or more precisely, their receptionists, their voting intentions. We predicted the Tory carnage (150 seats we said, they managed 165). We predicted the Labour landslide (470 seats we said, they gained 419). If some of our respondents had said they were voting Lib Dem we would have predicted that as well. As it was, we suggested (rightly)

'We were elected as New Labour and we will govern as New Labour.' Although for all the hitting the ground running, there is still little hard evidence of what this means. Members of the new government bandied about 'five pledge' card as they did throughout the campaign, but there is surely neither illumination nor inspiration in these cautious objectives. That the strategists succeeded in making New Labour an aspirational product is almost entirely due to Tony Blair.

Michael Heseltine always warned us Labour had the marketing sussed. In the end, the ideas are relative. It is the candidate that counts. And in Blair Labour had the better 'body', as the Americans would say. It would not have been a surprise if Labour's last election broadcast had featured a load of multi-ethnic Britkids playing football and mouthing 'I am Tony Blair', with the moody still of the man himself and the caption 'I am Tony Blair' followed on screen by a single red rose as the Prime Minister-elect places a slow motion shot past Frode Grodas (Chelsea's goalkeeper). It was a presidential election.

The American commentator Joe Klein, covering the election for the New Yorker, suggested that New Labour is about proving social responsibility and designer labels are not incompatible. It's a good joke at the expense of the Blairs' LabFab lifestyle – and the media's sudden obsession with the Ford Galaxy, the Ted Baker shirts and Cherie's shoes –

but at the same time it shows New Labour's contemporary relevance. The government's mandate is to reckon with the reality of post-Thatcherite Britain.

At present, Labour is governing as it ran the campaign – with presentation values and Peter Mandelson to the fore. After the chaos of John Major's last days, co-ordination is refreshing. But having ditched command and control as a model for the economy, Labour should not revive it as the principle of its day-to-day political life. Delaying the introduction of the Freedom of Information bill is an ominous sign. Blair himself has said politics developing in this country.'

For the moment these are concerns, not criticisms. There is a long way to go, as you might say at the start of another football season. Blair has asked to be judged by the results he achieves. The Welfare to Work programme, affecting up to 250,000 unemployed young people, is one such measure on which Labour's record will be assessed. However, despite the self-imposed restraints which New Labour has sought to present as virtues, expectations in the country are high.

'It's a new dawn, is it not?' – Tony Blair said that. 'I'll let you be in my dawn if I can be in yours.' We should say that.

that the Lib Dems' share of the vote might be down on 1992. Piece of piss this polling game! But it was at picking winners that we really excelled ourselves. We predicted that Labour candidates would Tone Howe, Braintree and Thanet South – they did! Best of all, we interviewed Stephen Twigg – *'the man who turfed out Michael Portillo'* – back in issue#3. I only wish now we'd gone down to Ladbrokes.

14 | 15

WEBWORLDS:
INTERNET ADDICTION

words sally williams

'It's three in the morning and all through the house. Not a creature was stirring Except for my mouse I sit and I stare at the monitor with glee Hoping to find something in there for free Night after night, day after day Oh God! I hope my connection will stay!' Harvard Eriksen, Webaholics Support Group

My story begins with a young man whom I shall call Andrew. He suffered from Internet Addiction, a terrible disease afflicting millions of people worldwide. After successfully overcoming his addiction, Andrew is now ready to share his story...

'Within the last year or so I have exchanged thousands upon thousands of email messages. In the last four months I have exchanged 2610 email messages just with Gaia. Every working day she sat at her computer in the room next to mine. By our 200th email we were in love. By the 300th we had arranged a jazz night out at The Vortex Club. Each moment before my computer screen I expected the "You have new mail" message to pop up. I set my email program, Eudora, to automatically check for new email every minute (its minimum setting), and yearned for the slightest communication with her, however banal.

These online support groups seem to be very popular, and I noticed I was the 366,267th visitor to the Netaholics Anonymous Web site since October last year. Andrew again: 'I've made several friends all over the world who share the same kind of addiction to email and the Internet. I love being able to talk about my problems without feeling too embarrassed or misunderstood. It's helped me to overcome EDD, and now I hardly ever send myself email.'

But, as Lucy Egger pointed out to me, the fact that many of these 'help' groups are on the Internet only tends to exacerbate the problem. 'Giving support and advice over the Internet,' explains Lucy, 'is not equivalent to receiving personal therapy from a professional counselor. For example, one of my own clients who came to me for therapy had already tried Netaholics Anonymous, where they give advice on their Web site to, "turn off your computer now, and go outside for fresh air." Although this is not bad advice, my client would open the window so, whilst taking in fresh air, she would still be able to hear the beep of new email arriving. This highlights to me the danger of not receiving professional counselling when trying to overcome Internet Addiction.'

Internet Addiction can be so damaging that Marc Grant, himself an addict, has courageously published his own story, 'THE TRAGEDY OF AN ON-LINE ADDICTION' [4] on the Web, as a warning to others. 'The bills begin to come in,' writes Marc. 'You've missed a lot of work. Your old friends no longer call. Everyone close to you knows there's a change and that something is wrong. Sometimes your life does get to you. You're starting to feel the dirtiness of modem addiction, particularly when your spouse makes you feel like a child by berating you for those

astronomical phone and credit card bills – if he or she hasn't divorced you by then. But most of the time you don't really care, you have your computer "friends" now. Ahhhh, when you're connected, you feel OK.'

This kind of story can be told a thousand times. Monde Kontrole emailed the Webaholics Support Group with this sad tale: 'You folks don't KNOW Netscapism... I'm receiving payments for a disability I had three years ago, that I'm over now, but I'm still getting the money! This allows me to NEVER have to worry about work or school; I'm also a single woman with no children.

THE "SORRY, YOU DON'T HAVE ANY NEW MAIL" MESSAGE BEGAN TO THROW ME INTO PANIC.
ONE FRIDAY I EVEN EMAILED MYSELF WITH THE MESSAGE, "GAIA'S ILL TODAY, SO THERE'S NO EMAIL :-("

name: andrew

drug of choice: eudora pro 3.0

YES, I HAVE *NO LIFE*!
THIS HAS LED TO EIGHT TO TEN HOUR NETSCAPING BINGES AFTER WHICH MY REAR END BECOMES COMPLETELY UNABLE TO FEEL ANYTHING AFTER SITTING IN FRONT OF MY MAC FOR SO LONG. CAN YOU BELIEVE I DON'T HAVE A URL YET? BUT I'M WORKIN' ON IT! BY THE WAY, INTERNET ISN'T MY ONLY ADDICTION. YOU GOT TO HAVE SOMETHING TO KEEP YOU AWAKE ENOUGH TO CLICK THE MOUSE.'

name: monde

drug of choice: netscape navigator™ 3.0

[1] http://www.webcreations.co.uk/question /selfcure.html [2] www.webaholics.com/ [3] http://www.safari.net/~pam/netanon/
[4] http://pwp.starnetinc.com/marcgrnt/4.html [5] http://web-star.com/www/www.html

'Little did I know at the time that I was one of many people who suffer from E-mail Deficiency Depression (EDD), which forces you to e-mail yourself. Around the 1000th email we even acknowledged our addiction, and I decided to face the truth by taking the Net Junkie Test [1] "Your score is 9", came the awful reply, "This makes you an Absolute Total Net Head."... I didn't know what to do.'

Lucy Egger PhD, a leading Internet Addiction researcher from the The Psychology Unit of the Swiss Federal Institute of Information Technology admits that, 'Our studies have shown that at least 10% of Internet users, equating to millions of people worldwide, are addicted to, or dependent upon, the Internet. I am personally disturbed by these results, and think that immediate action is needed to combat the adverse sociological effects of using the Internet.'

Luckily for Andrew, and others like him, there are online support groups you can turn to for help – The Email Addiction Discussion Group, Webaholics [2], and Netaholics Anonymous [3] to name just three. In many support groups each addict is encouraged to admit to their addiction. This is seen as an important step in overcoming the problem, and many people start off by posting statements onto a website, stating their name, email address and a confession such as, "I am a Webaholic". Once therapy begins, each addict can chat to others with similar problems via personal email or public internet chat forums. As Kirsten Allen confessed on the Webaholics site, 'I'm addicted to Chat Group Therapy. Talk to me, I'm known as Kitten.'

'There are many cases of Internet Addiction,' concludes Lucy 'that have economic and social consequences similar to more recognised forms of addiction, such as drug addiction and compulsive gambling. It's not just about students who miss lectures to surf instead. Internet Addiction can deprive you of sleep, ruin your eyesight and posture, create strains on your personal relationships, and lead to a compulsive need to be online, whether the user can afford it or not. Another concern of mine is that many traditional addiction support groups are springing up on the Internet, which may inadvertently swap one form of addiction for another. There are many issues at stake, and I don't think people really think about these issues when they connect to the Internet.'

Despite the danger of becoming addicted, many people see the Internet as an extremely positive force. 'Well, if what I have is a disease, then, give me more of it is all I can say,' says Howard of The World Wide Webaholics [5]. 'Disease? Addiction? Maybe so to some, but I'm glad I have it. Gosh, if my preoccupation with the Web is a disease, it sure seems like this disease has a tendency to bring people together, to encourage sharing, to promote goodwill, increase knowledge, encourage accomplishment, to open lines of communication and understanding between disparate groups of people, and give back much more than it

takes. I'm glad that the World Wide Web exists. I'm glad that I am helping in some small part, to expand the World Wide Web. I'm overjoyed that, for the first time in recorded history the "common" folks are able to publish their thoughts, emotions, art, rants, views, material, etc, in an easy effective manner; much to the chagrin of some, more entrenched purveyors of information.'

[If you think you may be addicted to the Internet, contact www.webaholics.com.]

40 | 41

BELOW AND OPPOSITE
DESIGNER
Philip O' Dwyer
ART DIRECTORS
Mark Hough, Philip O' Dwyer
DESIGN COMPANY
State
COUNTRY OF ORIGIN
UK
DIMENSIONS
210 x 280 mm
8¼ x 11 in

BELOW
ILLUSTRATOR
Philip O' Dwyer
WORK DESCRIPTION
Spread on musician Finley
Quaye from *Raise* magazine

OPPOSITE ABOVE
ILLUSTRATOR
Philip O' Dwyer
WORK DESCRIPTION
Spread on the 1997 UK
general election from *Raise*
magazine

OPPOSITE BELOW
WORK DESCRIPTION
Spread on Internet addiction
from *Raise* magazine

RIGHT
DESIGNERS
Mark Hough, Philip O' Dwyer
ART DIRECTORS
Mark Hough, Philip O' Dwyer
DESIGN COMPANY
State
PHOTOGRAPHER
Angelo Valentino
COUNTRY OF ORIGIN
UK
WORK DESCRIPTION
Cover of *Raise* magazine
DIMENSIONS
210 x 280 mm
8¼ x 11 in

74

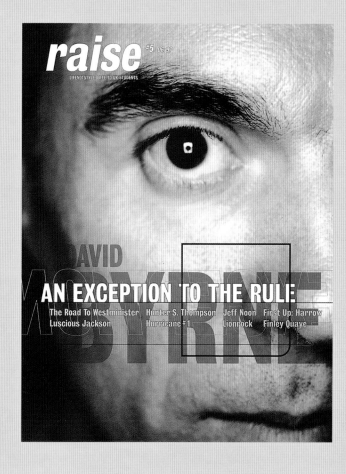

SAMPLE#3.1: FINLEY QUAYE

IT MIGHT NOT BE SURPRISING THAT SOMEONE WHO IS TRICKY'S UNCLE IS ON HIS WAY TO BECOMING FAMOUS FOR HIS MUSIC. SIMILARLY, YOU MAY NOT BE STIRRED WHEN YOU FIND OUT THAT HE HAS LIVED ON THREE CONTINENTS, WORKED WITH A DIVERSE COLLECTION OF ARTISTS, AND MADE MUSIC THAT FUSES MODERN PRODUCTION WITH ROOTS, BLUES, ROCK AND WORLD MUSIC TO TAKE REGGAE INTO THE NEXT MILLENNIUM. WHAT COMES AS A SHOCK IS THAT FINLEY QUAYE IS ONLY 22 YEARS OLD (MAXI QUAYE, TRICKY'S MOTHER, IS HIS HALF-SISTER). UN-HIP DEBUT ULTRASTIMULATION OF HE SINGS WITH A CONTROLLED PASSION AND CONVICTION THAT A PERSON TWICE HIS AGE WOULD BE PLEASED TO PRODUCE, BLENDING AND SWITCHING STYLES OF MUSIC WITH EASE AND CONFIDENCE.

He attributes much of the way he is and the way he sounds to his travels — London, New York and Europe have all been 'home' at various times. *'Having experienced a lot of things I know that a lot is possible and a lot of things are acceptable,'* he reflects. *'It's had a lot to do with affirmation of some of my beliefs.'* Now he lives in Edinburgh (*'because it's relaxed and because it's one of the sunniest places in Britain in the summer'*) and he just got back from shooting his new video in Namibia: *'We were getting up at 4:30 every morning to drive out and catch the sunrise. It was amazing. Beautiful, I could live there.'* Finley comes across as thoughtful and direct. He's into *'people who are real, people who have energy'*, citing this as the reason why he recently got Iggy Pop involved doing a track with him and Tricky. His collaboration with close friend A Guy Called Gerald, in which he sang on the haunting drum'n'bass track Finley's Rainbow was, he claims, *'a spiritual move'*. His aim now is to *'get together'* with his brother, LA-based guitarist Kaleb Quaye, who has worked with Elton John and Hall & Oates.

Talented, good-looking and with enough pop star in him to get noticed (but not enough to put people off) he is aiming high. Not just for the stages and clubs of the world, but for the everyday listeners: *'people in cars, on the way to work, hippies chilling out, people cooking with a mono radio on...'* He is optimistic about the future, describing the music in 1997 as *'more fiery, more condensed and filled with more new energy than ever before.'* And when he says that, and when you hear his music, you believe it.

EIGHT OPEN

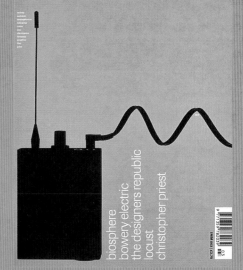

immerse
sound(e)scapes

biosphere
bowery electric
the designers republic
locust
christopher priest

OPPOSITE AND ABOVE
DESIGNERS
Designers Republic
ART DIRECTORS
Designers Republic
DESIGN COMPANY
Designers Republic
COUNTRY OF ORIGIN
UK
WORK DESCRIPTION
Self-promotional advertisement
in the electronic music
magazine *Immerse*
DIMENSIONS
210 x 297 mm
8¼ x 11¾ in

DESIGNERS
Adam Mills, Roger Fawcett-Tang
ART DIRECTOR
Roger Fawcett-Tang
DESIGN COMPANY
Struktur Design
PHOTOGRAPHER
Toby McFarlan Pond
COUNTRY OF ORIGIN
UK
WORK DESCRIPTION
Front cover of *Immerse*
magazine
DIMENSIONS
210 x 297 mm
8¼ x 11¾ in

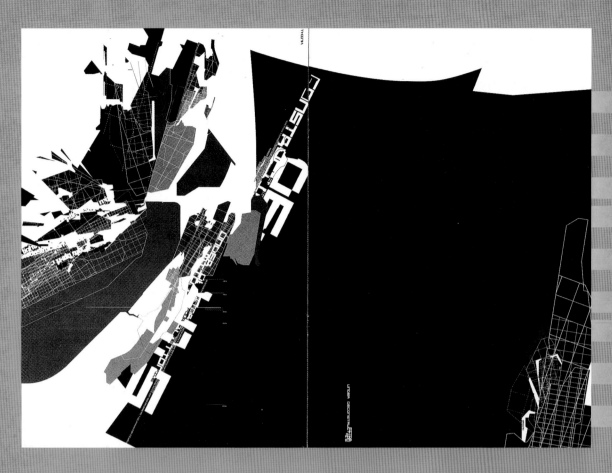

PLUS DE
PAGE 04
HTTP://WWW.
HYPERSCHEMA
DI.ERG.ETE.
USINABLE.CH.
A DÉMARCHE.
USE CAL
ISEAL
CAS
ELEMENT.
QUANTI
EI.

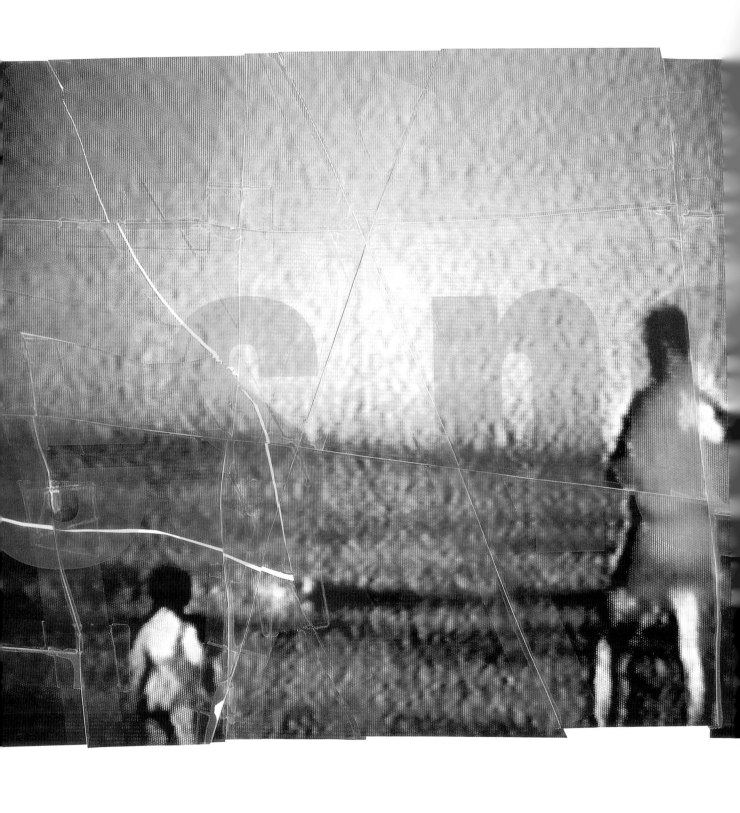

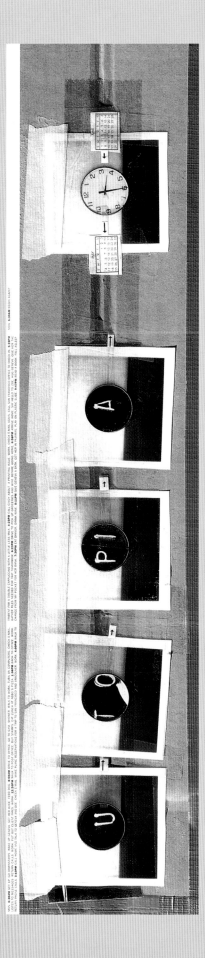

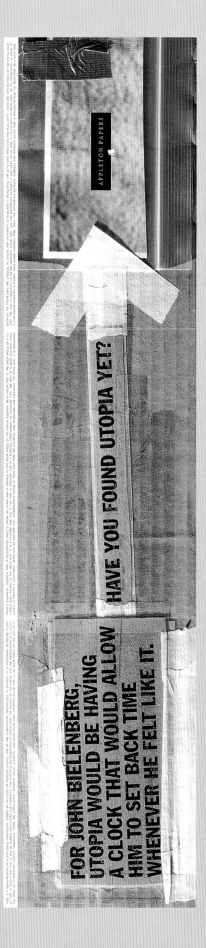

DESIGNER
John Bielenberg
ART DIRECTOR
John Bielenberg
DESIGN COMPANY
Bielenberg Design
ILLUSTRATOR
John Bielenberg
PHOTOGRAPHER
Paul Franz-Moore
COUNTRY OF ORIGIN
USA
WORK DESCRIPTION
**Fold-out flyer for Appleton
Papers to introduce 'Utopia' –
a new line of paper**
DIMENSIONS
**177 x 121 mm
7 x 4¾**

OPPOSITE AND PAGES 70-1
DESIGNER
John Bielenberg
ART DIRECTOR
John Bielenberg
DESIGN COMPANY
Bielenberg Design
PHOTOGRAPHER
Ray Niemi
COUNTRY OF ORIGIN
USA
WORK DESCRIPTION
**Spreads from a promotional
brochure for Appleton Papers
introducing 'Utopia' – a new
line of paper; this piece
highlights a female convict's
vision of utopia: 'Utopia does
not exist for me any more.'**
DIMENSIONS
**305 x 356 mm
12 x 14 in**

you will fail.

you can win.

If you miss it,

If you lead it,

Which leaves two questions:

*The final test of a leader is that he leaves behind him in other men the conviction and the will to carry on." — WALTER LIPPMANN

1.
Will you be the revolutionary?

2.
Do you have the guts?

"It must be considered that there is nothing more difficult to plan, more doubtful of success, nor more dangerous to manage than the creation of a new order of things." — NICCOLÒ MACHIAVELLI, THE PRINCE

PAGES 62–7
DESIGNERS
John Bielenberg, Chuck Denison
ART DIRECTOR
John Bielenberg
DESIGN COMPANY
Bielenberg Design
PHOTOGRAPHER
Doug Menvez
COUNTRY OF ORIGIN
USA
WORK DESCRIPTION
Front cover (right) and spreads
from a brochure for Strategos
strategy consultants
DIMENSIONS
432 x 559 mm
17 x 22 in

62

A Revolution is coming in your industry.

It may not happen this week, this month, or this year.

But it will happen.

CT

CH → CONCEIT

goes around comes around

ING FLOUR/BAKING CAKES

NT ———————————————→ **NO?**

flawless

OR

UALIZE

OR ELSE OR

TE

REGRET

RD<**ONWARD**

CONCEPT

RE

CO

V

S

YES

waiting for a problem

P

correc

(self)

L

FRUITS/GEMS

F

DISSE

what might you be willing to pay me

ONWARD < ON

OPPOSITE
DESIGNERS
Laura Lacy-Sholly, James Sholly
DESIGN COMPANY
Antenna Commercial Artisans
PHOTOGRAPHER
Casey Cronin
COUNTRY OF ORIGIN
USA
WORK DESCRIPTION
Promotional poster for 'Global
Attitudes' – an Indianapolis
AIDS benefit event
DIMENSIONS
610 x 914 mm
24 x 36 in

DESIGNERS
Laura Lacy-Sholly, James Sholly
DESIGN COMPANY
Antenna Commercial Artisans
PHOTOGRAPHER
Casey Cronin
COUNTRY OF ORIGIN
USA
WORK DESCRIPTION
Fold-out invitation for 'Global
Attitudes' – an Indianapolis
AIDS benefit event
DIMENSIONS
127 x 178 mm
5 x 7 in

PAGES 60–1
DESIGNERS
Laura Lacy-Sholly,
James Sholly
DESIGN COMPANY
Antenna Commercial Artisans
COUNTRY OF ORIGIN
USA
WORK DESCRIPTION
Poster documenting the
creative process of Antenna
graphic design studio
DIMENSIONS
1016 x 660 mm
40 x 26 in

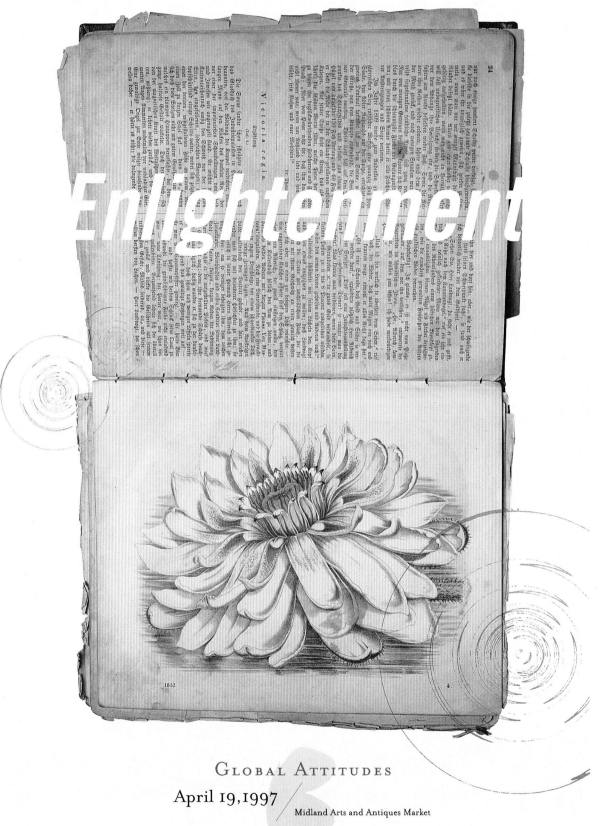

GLOBAL ATTITUDES

April 19, 1997

Midland Arts and Antiques Market

One perfect evening in the fight against AIDS

TO BENEFIT THE DAMIEN CENTER 632.0123 CALL FOR ADDITIONAL INFORMATION

PRESENTING SPONSOR Indianapolis Monthly Magazine

SPONSORED BY Midland Arts & Antiques Market and Kenra. Classic. Quality. Haircare Products.

VISUAL PROFESSIONAL
17 Dederick Street, P.O. Box 2376, Kingston, New York 12401
Tel 914.338.0408 Fax 914.338.3618

Represented by Mirana Gjeka Showroom
Los Angeles
213.624.5823

DESIGNERS
Laura Lacy-Sholly, James Sholly
DESIGN COMPANY
Antenna Commercial Artisans
PHOTOGRAPHERS
Andrew Blauvelt, Ed Funk
COUNTRY OF ORIGIN
USA
WORK DESCRIPTION
Promotional brochure for
Visual Professional, a clothing
company that creates text,
type, and image designs for
their historically-based
garments
DIMENSIONS
159 x 229 mm
6¼ x 9 in

Visual Professional clothes
use hand printed fabrics
whose surface designs are a
kind of literary collage.

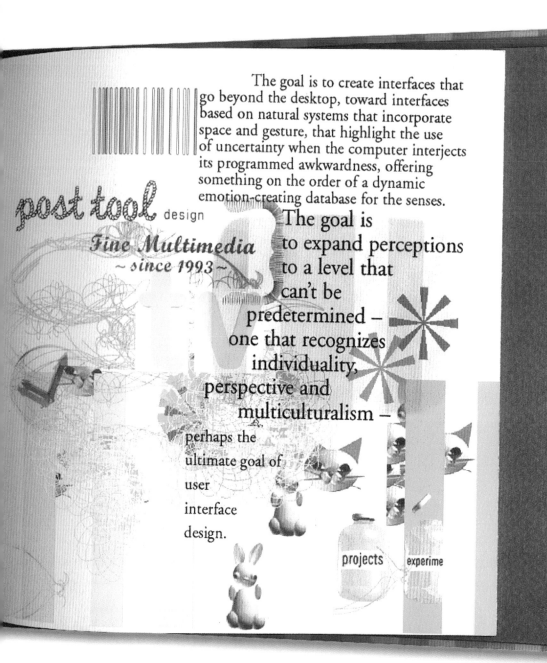

The goal is to create interfaces that go beyond the desktop, toward interfaces based on natural systems that incorporate space and gesture, that highlight the use of uncertainty when the computer interjects its programmed awkwardness, offering something on the order of a dynamic emotion-creating database for the senses. The goal is to expand perceptions to a level that can't be predetermined – one that recognizes individuality, perspective and multiculturalism – perhaps the ultimate goal of user interface design.

post tool design

Fine Multimedia
~ since 1993 ~

projects experime

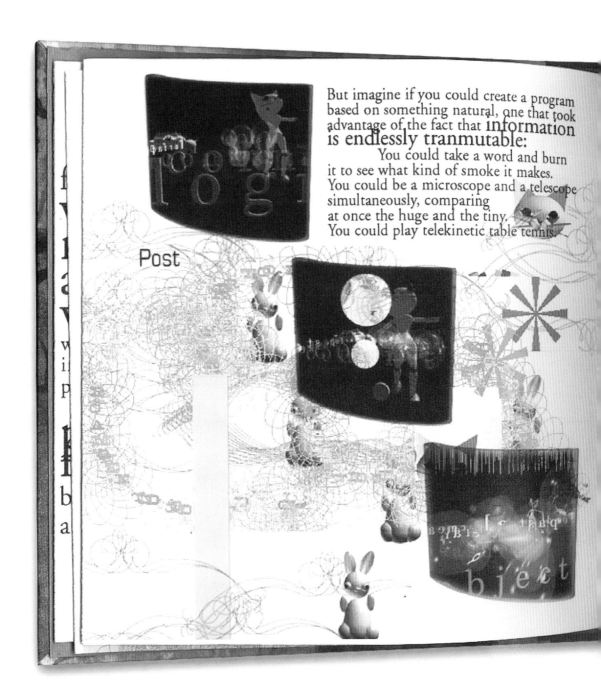

But imagine if you could create a program based on something natural, one that took advantage of the fact that **information is endlessly tranmutable:**

You could take a word and burn it to see what kind of smoke it makes. You could be a microscope and a telescope simultaneously, comparing at once the huge and the tiny. You could play telekinetic table tennis.

Post

If you drop an egg on the floor it breaks. **In the virtual world what happens? We reference nature by applying properties to virtual objects.** The properties we assign are limited – a slice of nature used poetically or ironically, emphasizing the media through "this is not a pipe" vocabulary. **Natural systems provide the reference for the synthetic.** The dialectic between nature and the computer developed as a database to sort and catalog information.

Early computers stored data externally on punch cards. The computer today is still locked into the database paradigm, but the punch card has become a disk drive. The desktop environment interprets data in the form of sound, image and text, but analog and digital are two different languages and digital has a very specific quality which comes from a vocabulary limited to ones and zeroes, the advantages of the computer center around ease of manipulation.

We can quickly transform ideas and content in this virtual environment and as in all things, the interpretation remains subject to perspective. For example, each person who reads this sentence will interpret it differently.

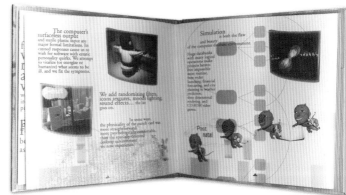

The computer's surfaceless output and sterile plastic input are major formal limitations. Its canned responses cause us to wish for software with erratic personality quirks. We attempt to vitalize (or energize or humanize) what seems to be ill, and we fix the symptoms.

We add randomizing filters, icons, textures, mood lighting, sound effects... the list goes on.

Simulation is both the flaw and beauty of the computer environment.

In some ways, the physicality of the punch card and the more straightforward, more psychologically comfortable desktop environment we now experience.

Post natal

PAGES 52–5
DESIGNERS
Gigi Biederman, David Karam
ART DIRECTORS
Gigi Biederman, David Karam
DESIGN COMPANY
Post Tool design
ILLUSTRATORS
Gigi Biederman, David Karam
COUNTRY OF ORIGIN
USA
WORK DESCRIPTION
Cover (opposite) and spreads from a self-promotional booklet, including a CD-Rom
DIMENSIONS
146 x 146 mm
5¾ x 5¾ in

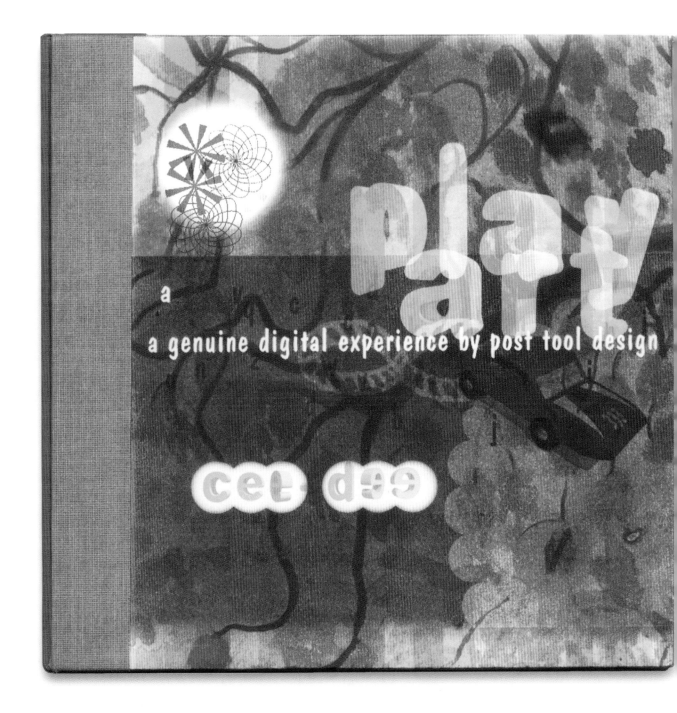

play
art
a
a genuine digital experience by post tool design

cet dee

THIS MESSAGE IS

D,EXPRESSED,EDITED,MULTIPLIED,DISPLAYED,RE

The School of Printing Technology offers a wide range of courses to develop the various skills involved in all methods of printing

Courses for those already working in industry,one year programmes

three year honours degrees

Research degrees and MAs

School of

PRINTING TECHN

THIS MESSAGE IS

ESSED,EDITED,MULTIPLIED,DISPLAYED,REACHED

The School of Retail Studies is unique among centres of retail education

offering courses covering the whole range of

School of

5 RETAIL STUDIES

Retail Design Merchandising and Display Distribution and Retail Management 46

retail specialisations, including major areas in

DESIGNERS
Nick Bell, Sacha Davison,
Tom Elsner
ART DIRECTOR
Nick Bell
DESIGN COMPANY
Bell
PHOTOGRAPHER
Martyn Rose
COUNTRY OF ORIGIN
UK

WORK DESCRIPTION
Chapter opening spreads from
a London College of Printing
prospectus: each school is
identified with a stage of
the communication process
DIMENSIONS
238 x 225 mm
9⅜ x 8⅞ in

LCP

PORTFOLIO 9899

SCHOOL OF BUSINESS AND MANAGEMENT
SCHOOL OF GRAPHIC DESIGN
SCHOOL OF MEDIA
SCHOOL OF PRINTING TECHNOLOGY
SCHOOL OF RETAIL STUDIES
SCHOOL OF PROFESSIONAL STUDIES

THE LONDON INSTITU

PLANNED

MULTIPLIED REACHED YOU

OUT OF TOMORROW UNFOLD TOMORROW OUT OF TODAY | UNFOLD YOUR FUTURE OUT OF TOMORROW UNFOLD TOMORROW OUT OF TODAY | NEARER THAN YOU THINK | UNFOLD YOUR FUTURE OUT OF TOMORROW UNFOLD TOMORROW OUT OF TODAY | UNFOLD YOUR FUTURE OUT OF TOMORROW UNFOLD TO

DISPLAYED

DESIGNERS
Nick Bell, Sacha Davison,
Tom Elsner
ART DIRECTOR
Nick Bell
DESIGN COMPANY
Bell
PHOTOGRAPHER
Martyn Rose
COUNTRY OF ORIGIN
UK

WORK DESCRIPTION
Front of wraparound cover for
a London College of Printing
prospectus
DIMENSIONS
238 x 225 mm
9⅜ x 8⅞ in

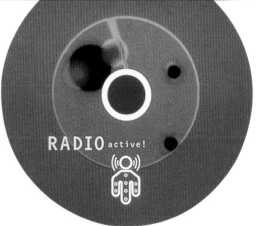

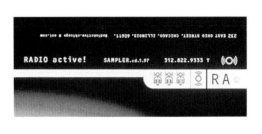

DESIGNER
Carlos Segura
ART DIRECTOR
Carlos Segura
DESIGN COMPANY
Segura Inc.
PHOTOGRAPHER
Photonica
COUNTRY OF ORIGIN
USA
WORK DESCRIPTION
Stationery and identity for
Radio Active – a Chicago-based
radio production company
DIMENSIONS
Various

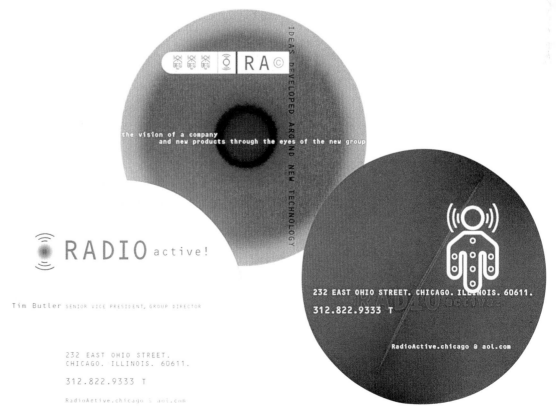

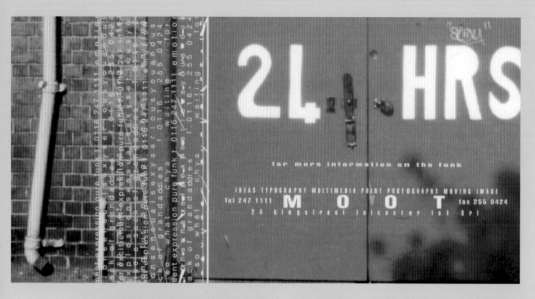

DESIGNERS
Nitesh Mody, John Kariolis
ART DIRECTORS
Nitesh Mody, John Kariolis
DESIGN COMPANY
Moot
ILLUSTRATORS
Nitesh Mody, John Kariolis
PHOTOGRAPHERS
Nitesh Mody, John Kariolis
COUNTRY OF ORIGIN
UK
WORK DESCRIPTION
Self-promotional cards
DIMENSIONS
200 x 100 mm
7⅞ x 3⅞ in

47

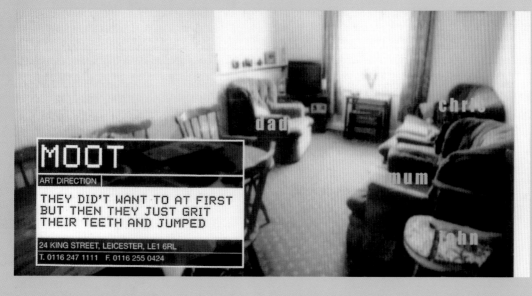

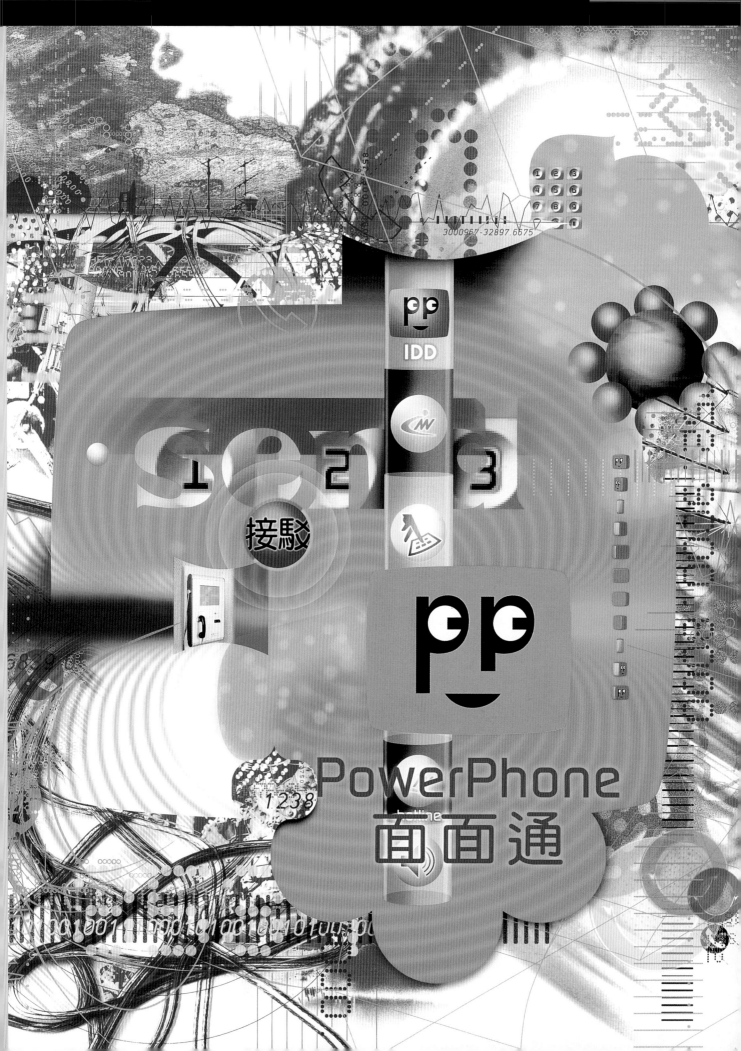

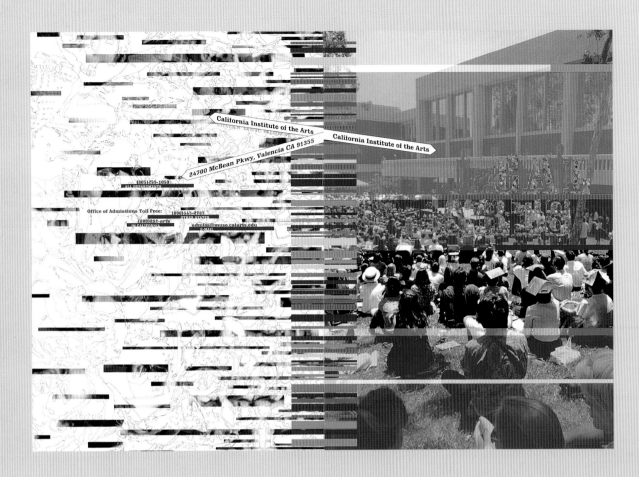

DESIGNERS
Somi Kim/ReVerb,
Barbara Glauber/Heavy Meta
ART DIRECTORS
Somi Kim/ReVerb,
Barbara Glauber/Heavy Meta
DESIGN COMPANIES
ReVerb, Los Angeles
Heavy Meta, New York
ILLUSTRATOR
Alan Kikuchi (back cover
line art)
PHOTOGRAPHERS
Steven A. Gunther,
Rachel Slowinski
COUNTRY OF ORIGIN
USA
WORK DESCRIPTION
Front and back cover (above)
and spread from an Admissions
Bulletin for the California
Institute of the Arts
DIMENSIONS
203 x 286 mm
8 x 11¾ in

OPPOSITE
DESIGNERS
James W. Moore,
Richard Leighton,
Jamandru Reynolds
ART DIRECTOR
James W. Moore
DESIGN COMPANY
ReVerb, Los Angeles
COUNTRY OF ORIGIN
USA
WORK DESCRIPTION
Promotional poster for an
interactive telecommunications
device produced by iMagic
Infomedia Technology Ltd.,
Hong Kong
DIMENSIONS
419 x 572 mm
16½ x 22½ in

SYLVANPRINT contains
100% recycled post consumer
waste, combining excellent
environmental credentials and
outstanding printability.
SYLVANPRINT has a good
whiteness, high opacity and a
smooth clean surface making
it the environmental choice
for all general print as well as
catalogues and magazines.

The SYLVAN range of papers
and boards offer a choice of
shade, environmental and
performance features. The
SYLVAN brand has been
established for over ten years
and all the products are
NAPM approved recycled.

SYLVANCOAT BRIGHT

SYLVANBLADE IVORY

SYLVANPRINT

DESIGNER
Karen Wilks
ART DIRECTOR
Karen Wilks
DESIGN COMPANY
Karen Wilks Associates
PHOTOGRAPHER
Richard Green
COUNTRY OF ORIGIN
UK
WORK DESCRIPTION
Promotional product sheets for
Paperback Ltd., recycled paper
company
DIMENSIONS
210 x 297 mm
8¼ x 11¾ in

OPPOSITE
DESIGNER
Philippe Savoir
ART DIRECTOR
Philippe Savoir
DESIGN COMPANY
Filifox
COUNTRY OF ORIGIN
France
WORK DESCRIPTION
Front and reverse sides of a
self-promotional card
DIMENSIONS
121 x 137 mm
4¾ x 5⅜ in

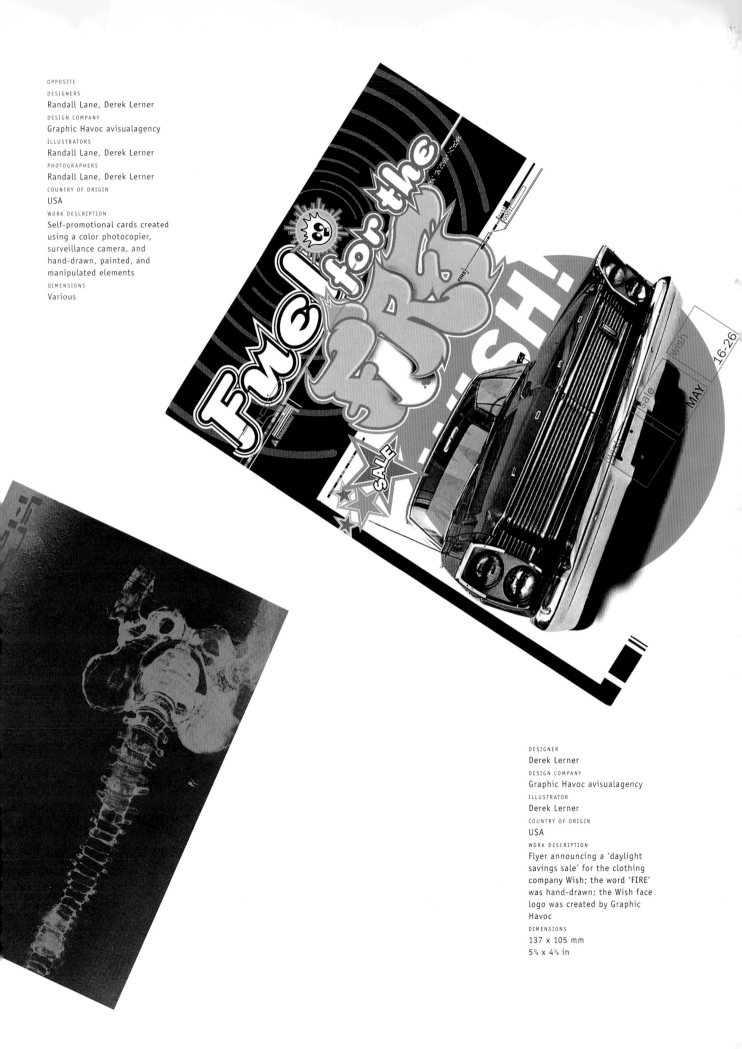

OPPOSITE

DESIGNERS
Randall Lane, Derek Lerner

DESIGN COMPANY
Graphic Havoc avisualagency

ILLUSTRATORS
Randall Lane, Derek Lerner

PHOTOGRAPHERS
Randall Lane, Derek Lerner

COUNTRY OF ORIGIN
USA

WORK DESCRIPTION
Self-promotional cards created
using a color photocopier,
surveillance camera, and
hand-drawn, painted, and
manipulated elements

DIMENSIONS
Various

DESIGNER
Derek Lerner

DESIGN COMPANY
Graphic Havoc avisualagency

ILLUSTRATOR
Derek Lerner

COUNTRY OF ORIGIN
USA

WORK DESCRIPTION
Flyer announcing a 'daylight
savings sale' for the clothing
company Wish; the word 'FIRE'
was hand-drawn; the Wish face
logo was created by Graphic
Havoc

DIMENSIONS
137 x 105 mm
5⅜ x 4⅛ in

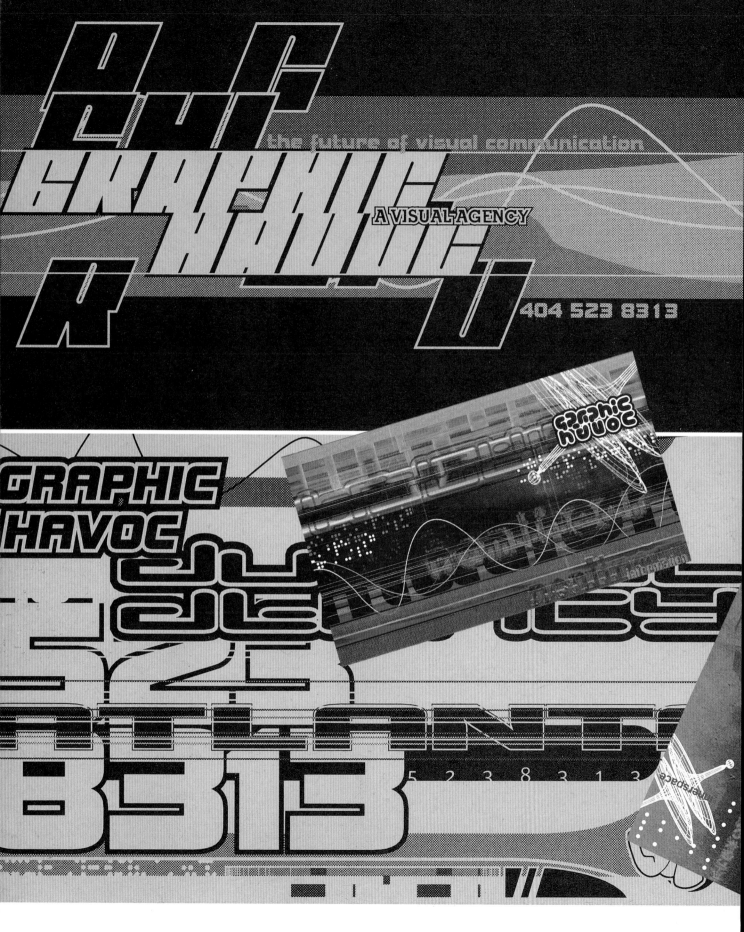

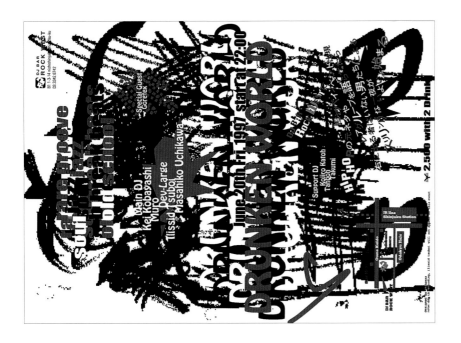

DESIGNER
Fabio Berruti
ART DIRECTOR
Fabio Berruti
DESIGN COMPANY
Infinite Studio
PHOTOGRAPHER
Fabio Berruti
COUNTRY OF ORIGIN
Italy
WORK DESCRIPTION
Front and back cover of a
limited edition CD *Fragile
Soul* by Vasco Rossi for BMG
Ricordi (Rome)
DIMENSIONS
125 x 130 mm
4⅞ x 5⅛ in

DESIGNER
Reiko Hanafusa
ART DIRECTOR
Reiko Hanafusa
ILLUSTRATOR
Reiko Hanafusa
COUNTRY OF ORIGIN
Japan
WORK DESCRIPTION
Flyer for the event 'Drunken
World' at 'Rock West' bar in
Shinjuku, Tokyo
DIMENSIONS
210 x 297 mm
8¼ x 11¾ in

BELOW
DESIGNERS
Randall Lane, Derek Lerner,
David Merten, Peter Rentz
ART DIRECTORS
Randall Lane, Derek Lerner
DESIGN COMPANY
Graphic Havoc avisualagency
ILLUSTRATOR
Derek Lerner
PHOTOGRAPHER
David Naugle
COUNTRY OF ORIGIN
USA
WORK DESCRIPTION
Promotional schoolbook cover
distributed by Coca-Cola in
urban high schools
DIMENSIONS
368 x 584 mm
14½ x 23 in

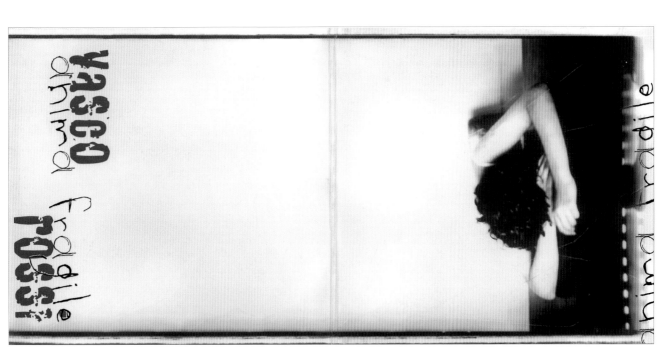

Struktur Design Studio 2d, 5 Torrens Street T: +44 (0)171 833 5626
London EC1V 1NQ F: +44 (0)171 833 5636

Roger Fawcett-Tang M: +44 (0)802 88 54 77
E: struktur@easynet.co.uk

DESIGNER
Roger Fawcett-Tang
ART DIRECTOR
Roger Fawcett-Tang
DESIGN COMPANY
Struktur Design
COUNTRY OF ORIGIN
UK
WORK DESCRIPTION
Business card and change of
address card for Struktur Design
– the two boxes describe the
increased floor area of the
new studio
DIMENSIONS
Change of address card:
200 x 100 mm
7⅞ x 3⅞ in
Business card:
85 x 55 mm
3⅜ x 2⅛ in

37

OPPOSITE
DESIGNERS
Elisabeth Charman, Brad Trost
DESIGN COMPANY
loft 219
PHOTOGRAPHERS
Elisabeth Charman,
Jenny Ganser, Jon Hines,
Jun Itoi, Brad Trost
COUNTRY OF ORIGIN
USA
WORK DESCRIPTION
Front cover (far left) and
spreads from a prospectus for
the Herron School of Art,
profiling the university's
history, program descriptions
and examples of student work
DIMENSIONS
178 x 254 mm
7 x 10 in

51° 32' 08"N 0° 05' 20"W

51° 31' 54"N 0° 06' 13"W

Struktur Design has moved its London headquarters a few coordinates to larger premises.
Please update your database with the new address and telecommunication details, thank you.

Struktur Design Studio 2d, 5 Torrens Street, London EC1V 1NQ
T: +44 (0)171 833 5626 F: +44 (0)171 833 5636 E: struktur@easynet.co.uk

Spread (pages 10–11)

ON THE NEXT FEW PAGES YOU WILL FIND WRITTEN AND SPOKEN EXCERPTS FROM STUDENTS ABOUT THEIR WORK, THEIR PROCESSES, AND HERRON....

The Cabinet. **page (61)**

CHAD **Gallion** ✳ P A I N T I N G

The Cabinet. The cabinet caught my eye intuitively;
I remember contemplating scale, color, form, balance, what to leave in, and what to take out.
It wasn't until later that it dawned on me what I was dealing with; I was dealing with different types of energy.
For me the cabinet was simultaneously agitated and calm—
it contained a repressed energy—something lurking—like despair hidden under a calm, austere face.

There is a deep connection between me and my work, I can't do work that isn't true to me.
The problem of trying to be honest as an artist is not an easy one.
I prefer relying on intuitiveness—when I have a gut feeling and I know I should be painting.

Visual Communication Student Services Woodworking

Images from Herron's web site [www.herron.iupui.edu]. **page (56)**

JOHN **Chastain** ✳ V I S U A L C O M M U N I C A T I O N

As the designer of the Herron School of Art web site, I was given a daunting task,
that task being to weave together numerous images and bits of information about students, faculty, and fields of study,
each embodying a unique set of ideas and philosophies about creativity and aesthetics.
With these diverse elements, I began developing a framework of imagery that would not only serve as a background for
individual works of art, but also enhance the viewer's experience, both of the individual works presented and of the school as a whole.
These framework images define the interface by which the viewer navigates through the web site.
And it is this interface system which serves as metaphorical representation of the school itself.
The images, therefore, need to somehow express that which the many distinct voices of Herron share in common.

But how does one go about synthesizing these different voices into imagery for a web site?
My approach was to use recognizable images of ordinary objects to facilitate personal interpretations by each individual viewer.
Objects contain internal meanings to which we all respond in our daily lives.
For instance, the image of a hammer contains many meanings, a viewer might respond to its more literal meaning of "a tool used to drive
nails," or might respond to a more metaphoric meaning such as "a symbolic image of force or power."
By the juxtaposition of images of ordinary objects, one can combine both their literal and metaphoric meanings into a myriad of personal
meanings or interpretations. The image of a hammer combined with the image of a bird's wings can produce endless interpretations.
One might interpret a more literal meaning "a hammer held aloft into the air by a carpenter"
or one might interpret the image as "a symbolic representation of force and spirit...."

Cover

HERRON SCHOOL *of* ART *1902*

open

Spread (pages 30–31)

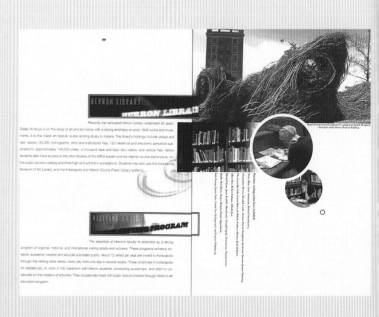

HERRON LIBRARY

Recently the renovated Herron Library celebrated 90 years.
Today its focus is on the study of art and art history with a strong emphasis on post-1945 works and movements. It is the oldest art-specific public lending library in Indiana. The library's holdings include unique and rare books, 30,000 monographs, artist and institutional files, 160 traditional and electronic periodical subscriptions, approximately 145,000 slides, a thousand tape and laser disc videos, and vertical files. Herron students also have access to the other libraries of the IUPUI system and the internet via one stand-alone, online public access catalog and three high end scholar's workstations. Students may also use the Indianapolis Museum of Art Library, and the Indianapolis and Marion County Public Library systems.

VISITING ARTIST PROGRAM

The expertise of Herron's faculty is extended by a strong program of regional, national, and international visiting artists and lecturers. These programs enhance students' academic careers and educate a broader public. About 12 artists per year are invited to Indianapolis through the visiting artist series. Visits vary from one day to several weeks. These artists are in Indianapolis for residencies, to work in the classroom with Herron students, conducting workshops, and often to collaborate on the creation of artworks. They occasionally meet with public school children through Herron's art education program.

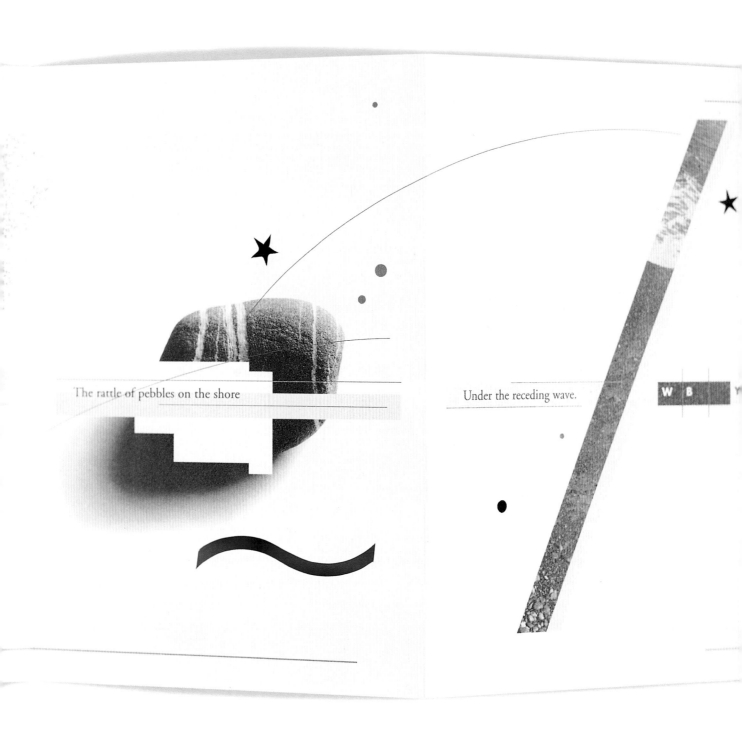

The rattle of pebbles on the shore

Under the receiving wave.

DESIGNERS
Chris Myers, Greg Simmons,
Nancy Mayer
ART DIRECTOR
Chris Myers
DESIGN COMPANY
Mayer & Myers Design
PHOTOGRAPHER
Chris Myers
COUNTRY OF ORIGIN
USA

WORK DESCRIPTION
Fold-out self-promotional New
Year card featuring the poem
*The Nineteenth Century and
After*, by William Butler Yeats
DIMENSIONS
432 x 159 mm
17 x 6¼ in

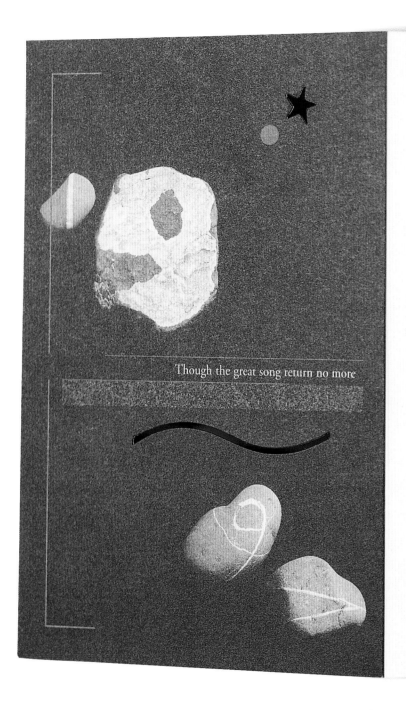

Though the great song return no more

There's keen delight in what we have

PAGES 32–3
DESIGNERS
Patrick Jackson, Mark Spain
ART DIRECTOR
Patrick Jackson
DESIGN COMPANY
Curve Design Associates
ILLUSTRATOR
Patrick Jackson
COUNTRY OF ORIGIN
UK

WORK DESCRIPTION
Poster documenting some of
the most enduring cases of UFO
phenomena, for Flights of Fancy
publishing company
DIMENSIONS
594 x 841 mm
23⅜ x 33⅛ in

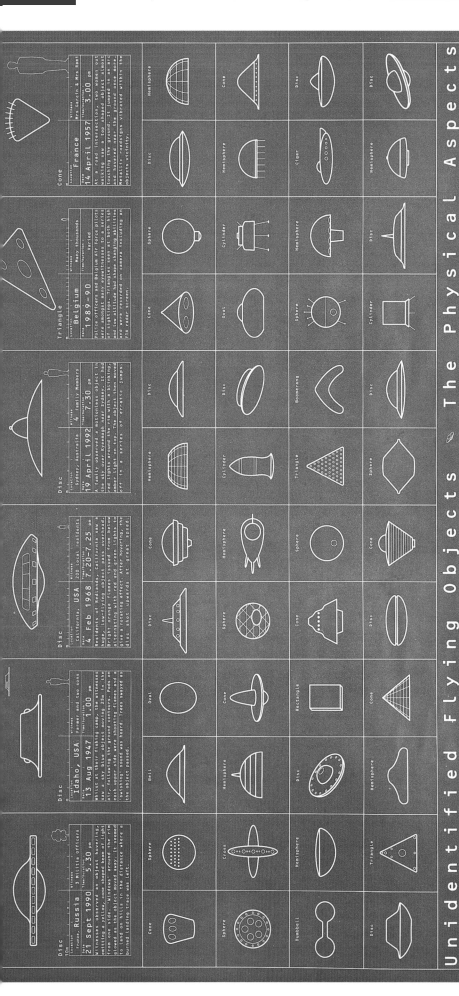

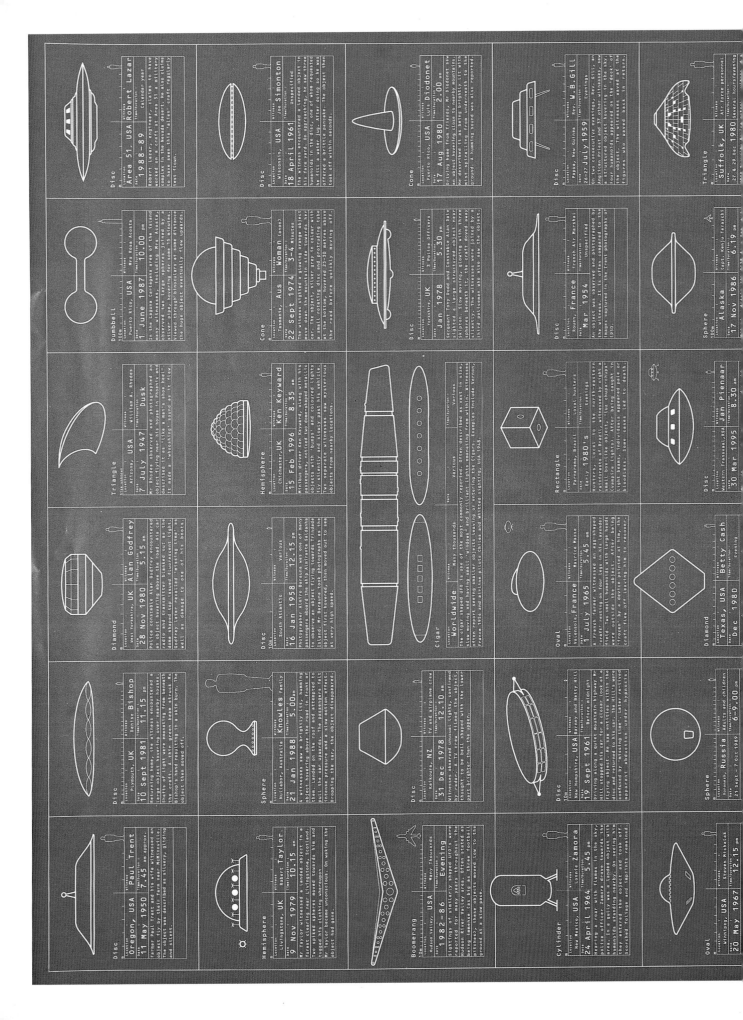

DESIGNERS
P. R. Brown, Peter Stark
ART DIRECTOR
P. R. Brown
DESIGN COMPANY
Bau-Da Design Lab, Inc.
ILLUSTRATOR
P. R. Brown
PHOTOGRAPHER
Mark Linkus (Sparkle Horse)
COUNTRY OF ORIGIN
USA
WORK DESCRIPTION
Front cover (opposite, top) and
pages from a self-promotional
portfolio – a limited edition
hard-bound book sent to
potential clients
DIMENSIONS
279 x 152 mm
11 x 6 in

31

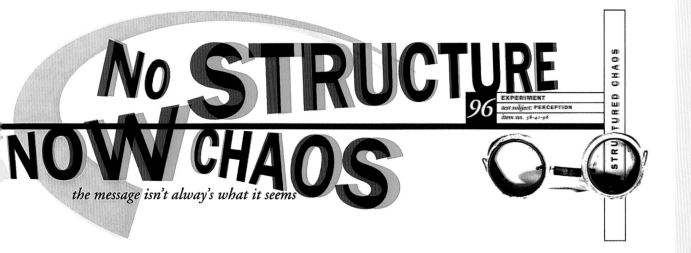

	album title: V.D.S.T.P.
Capitol	company: CAPITOL RECORDS
	item no. 61-03-82

SPARKLEHORSE

"whatever"

Harry Bertoia

sculpture

furniture

Full Upright Position™

be pearl CHAIR

Full Upright Position
1101 NW Glisan Portland, OR 97209
(503) 228-6190 HOURS Tues-Fri 10-6, Sat 10-5, Sun 12-5

the **Pensi Collection**
Handsome, durable aluminum construction for interior or exterior use.
Stackable chairs. Ideal for your patio or garden room.

the original eames® lounge and ottoman
available through Full Upright Position

special Holiday price $2400

EAMES® MOLDED PLYWOOD LOUNGE CHAIR

50th Anniversary

50th Anniv

Now, or never ! NUMBERED, LIMITED EDITION
IN UNIQUE ROSEWOOD VENEER
AVAILABLE ONLY WHILE SUPPLIES LAST, THROUGH **Full Upright Position**™

Something unusual and fun, yet classic
enough to be included in the collection of
the San Francisco Museum of Modern Art
Something impressive yet affordable
Something substantial that you can still
cover in a single sheet of wrapping paper

the **Puzzle** Armchair
A FUN GIFT FOR ALL AGES

Something they can unwrap, have fun
assembling and enjoy for years to come

OPPOSITE
DESIGNERS
Anne Abele, Rob Bonds
DESIGN COMPANY
Visual Resource Society
PHOTOGRAPHER
Colin Reedy
COUNTRY OF ORIGIN
USA

WORK DESCRIPTION
Poster for meta.morf, recycled
plastic furniture designers
DIMENSIONS
381 x 559 mm
15 x 22 in

DESIGNERS
Anne Abele, Rob Bonds
DESIGN COMPANY
Visual Resource Society
PHOTOGRAPHERS
**Bob Waldman, Rob Bonds,
Anne Abele**
COUNTRY OF ORIGIN
USA

WORK DESCRIPTION
Six promotional postcards for
Full Upright Position, furniture
company
DIMENSIONS
152 x 102 mm
6 x 4 in

within the limits

post-industrial design

meta·morf
post-consumer material

of our environment

cyber𝒮ℐ𝒢ℋ𝒯 ─────○

DESIGNERS
Anne Abele, Rob Bonds
DESIGN COMPANY
Visual Resource Society
COUNTRY OF ORIGIN
USA
WORK DESCRIPTION
Stationery for Cybersight, web site design company
DIMENSIONS
**Letterhead:
216 x 279 mm
8½ x 11 in
Envelope:
241 x 105 mm
9½ x 4⅛ in
Business card:
89 x 51 mm
3½ x 2 in**

27

514 sw 6th Street, 5th floor Portland, Oregon 97204	2444 Wilshire Boulevard, Suite 503 Santa Monica, California 90403
tel. 503.228.4008 fax 503.228.3629	tel. 310.449.8660 fax 310.449.8662

info@cybersight.com

www.cybersight.com

cyber𝒮ℐ𝒢ℋ𝒯 ─────○

Andrew R. Snakman
President

andrew@cybersight.com

2444 Wilshire Boulevard, Suite 503 Santa Monica, CA 90403
tel. 310.449.8660 fax 310.449.8662
514 sw 6th Avenue, 5th floor Portland, Oregon 97204

cyber𝒮ℐ𝒢ℋ𝒯 ─────○

514 sw 6th Street, 5th floor Portland, Oregon 97204

2444 Wilshire Boulevard, Suite 503 Santa Monica, California 90403

IMAGO THEATRE

P.O. BOX 15182 PORTLAND OREGON 97293-5182

BOX OFFICE: (503) 231-9581
ADMINISTRATION: (503) 231-3959
FACSIMILE: (503) 239-5248
E-MAIL: IMAGO@HEVANET.COM

IMAGO THEATRE
CAROL TRIFRE CO ARTI STI C DI RECTOR
P.O. BOX 15182 PORTLAND OREGON 97293
V. (503) 231-3959
F. (503) 239-5248
E. IMAGO@HEVANET.COM

DESIGNERS
Anne Abele, Rob Bonds
DESIGN COMPANY
Visual Resource Society
COUNTRY OF ORIGIN
USA
WORK DESCRIPTION
Stationery for Imago theater
DIMENSIONS
Letterhead:
216 x 279 mm
8½ x 11 in
Envelope:
241 x 105 mm
9½ x 4⅛ in
Business card:
89 x 51 mm
3½ x 2 in

IMAGO THEATRE
P.O. BOX 15182 PORTLAND OREGON 97293-5182

NON-PROFIT
ORGANIZATION
U.S. POSTAGE
P A I D
PORTLAND, OR
PERMIT #5636

DESIGNER
Weston Bingham
ART DIRECTOR
Weston Bingham
DESIGN COMPANY
Deluxe Design for Work +
Leisure
COUNTRY OF ORIGIN
USA
WORK DESCRIPTION
Self-promotional postcards
using samples of recent design
projects
DIMENSIONS
152 x 108 mm
6 x 4¼ in

OPPOSITE
DESIGNER
Weston Bingham
ART DIRECTOR
Weston Bingham
DESIGN COMPANY
Deluxe Design for Work +
Leisure
COUNTRY OF ORIGIN
USA
WORK DESCRIPTION
Stationery for a design
studio using a logo from
a beauty salon
DIMENSIONS
Letterhead:
216 x 279 mm
8½ x 11 in
Business card:
89 x 51 mm
3½ x 2 in
Envelope:
279 x 121 mm
11 x 4¾ in

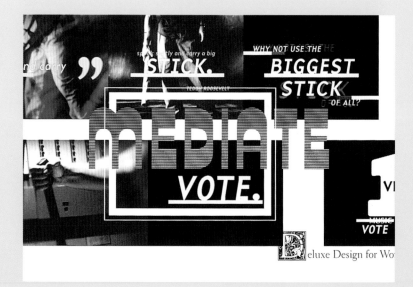

WESTON BINGHAM | CHUCK RUDY

231 W. 13TH STREET #4 | NEW YORK NY 10011 **212.645.2502** deluxemail@aol.com

DESIGN FOR WORK + LEISURE

231 W. 13TH STREET #4 | NEW YORK NY 10011

Nº30 BERWICK STREET · LONDON W1V 3RF
TELEPHONE ⁺44(0)171 434 3581
FAX ⁺44(0)171 437 2309
E-MAIL info @ pizazz.co.u.k.

PIZAZZ U-MATIC

Nº30 BERWICK STREET · LONDON W1V 3RF
TELEPHONE ⁺44(0)171 434 3581
FAX ⁺44(0)171 437 2309
E-MAIL info @ pizazz.co.u.k.

PIZAZZ BETA

Nº30 BERWICK STREET · LONDON W1V 3RF
TELEPHONE ⁺44(0)171 434 3581
FAX ⁺44(0)171 437 2309
E-MAIL info @ pizazz.co.u.k.

PIZAZZ PICTURES LTD
DIRECTORS *Mario Cavalli · Pamela Dennis · Sue Goffe*
REGISTERED OFFICE: 58-60 BERNERS STREET · LONDON W1P 4JS
REGISTERED IN ENGLAND Nº 2337236
V.A.T. REGISTRATION Nº 539 1164 44

DESIGNERS
Paul Neale, Andrew Stevens
ART DIRECTORS
Paul Neale, Andrew Stevens
DESIGN COMPANY
Graphic Thought Facility
ILLUSTRATORS
Paul Neale, Andrew Stevens
COUNTRY OF ORIGIN
UK
WORK DESCRIPTION
Identity for Mighty, film
production company
DIMENSIONS
Various

OPPOSITE
DESIGNERS
Paul Neale, Andrew Stevens
ART DIRECTORS
Paul Neale, Andrew Stevens
DESIGN COMPANY
Graphic Thought Facility
ILLUSTRATORS
Paul Neale, Andrew Stevens
COUNTRY OF ORIGIN
UK
WORK DESCRIPTION
Identity for Pizazz, animation
production company
DIMENSIONS
Various

MIGHTY_LIZ JAMES
PRODUCTION MANAGER
37 DEAN STREET, LONDON W1V 5AP
TELEPHONE Nº 0171 437 5966_FAX Nº 0171 437 5967
MOBILE Nº 0802 579299
E-MAIL liz@mighty.co.uk

MIGHTY_ HAVE MOVED TO:
37 DEAN STREET, LONDON W1V 5AP
TELEPHONE Nº 0171 437 5966_FAX Nº 0171 437 5967
E-MAIL info@mighty.co.uk

Fold A to B (A)

(B)

Slatoff + Cohen Partners Inc.
Telephone 212 243 8019

Slatoff + Cohen Partners Inc. Telephone 212 243 8019
17 West 20th Street 3W Facsimile 212 243 8129
New York New York 10011

DESIGNERS
Tamar Cohen, David Slatoff
ART DIRECTORS
Tamar Cohen, David Slatoff,
Kenna Kay
DESIGN COMPANY
Slatoff + Cohen Partners Inc.
ILLUSTRATORS
George Bates, Joe Fernandez
PHOTOGRAPHER
Christopher Gallo

COUNTRY OF ORIGIN
USA
WORK DESCRIPTION
Promotional brochure for Nick
at Nite's new television
network, 'TV Land'
DIMENSIONS
108 x 153 mm
6 x 4¼ in

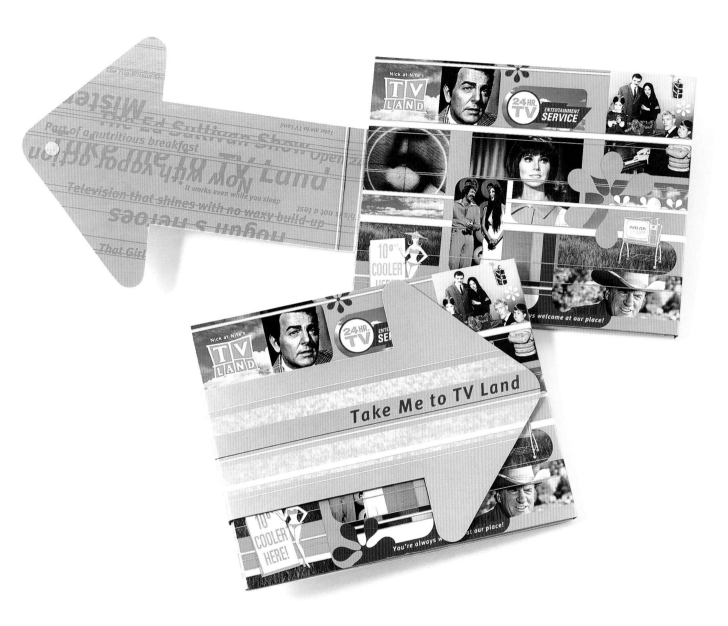

OPPOSITE
DESIGNERS
Tamar Cohen, David Slatoff,
Alex Smith
ART DIRECTORS
Tamar Cohen, David Slatoff
DESIGN COMPANY
Slatoff + Cohen Partners Inc.
COUNTRY OF ORIGIN
USA

WORK DESCRIPTION
Stationery for Slatoff + Cohen
Partners Inc.
DIMENSIONS
Letterhead:
216 x 279 mm
8½ x 11 in
Note card:
121 x 132 mm
4¾ x 5³⁄₁₆ in

DESIGNER
Bob Aufuldish
DESIGN COMPANY
Aufuldish & Warinner
ILLUSTRATOR
John Hersey, dingbat fonts
COUNTRY OF ORIGIN
USA

WORK DESCRIPTION
Stationery for California College
of Arts and Crafts Office of
Enrollment Services
DIMENSIONS
Postcards (opposite):
229 x 153 mm
9⅛ x 6⅛ in
Letterhead (above):
216 x 279 mm
8½ x 11⅛ in

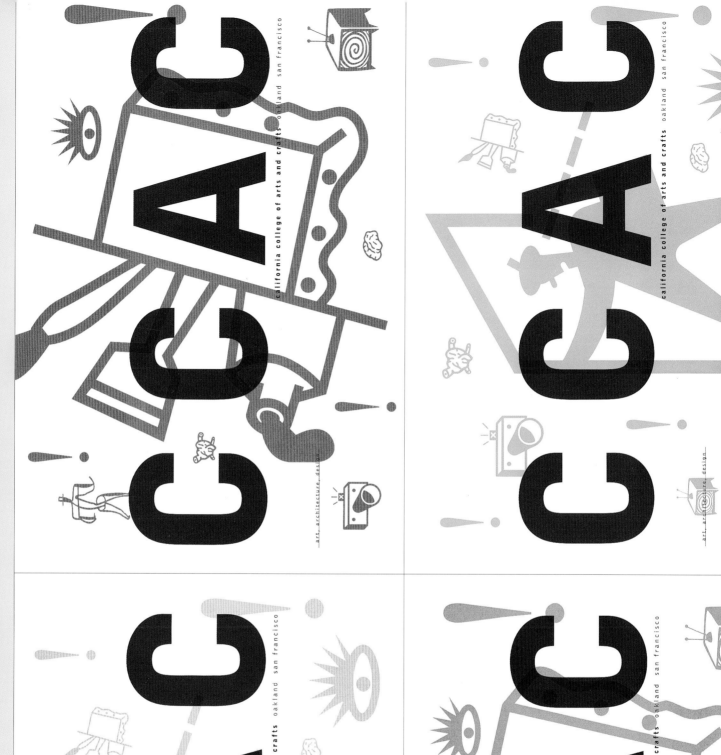

CAC

california college of arts and crafts oakland san francisco

art_architecture_design

CAC

california college of arts and crafts oakland san francisco

art_architecture_design

CAC

california college of arts and crafts oakland san francisco

CAC

california college of arts and crafts oakland san francisco

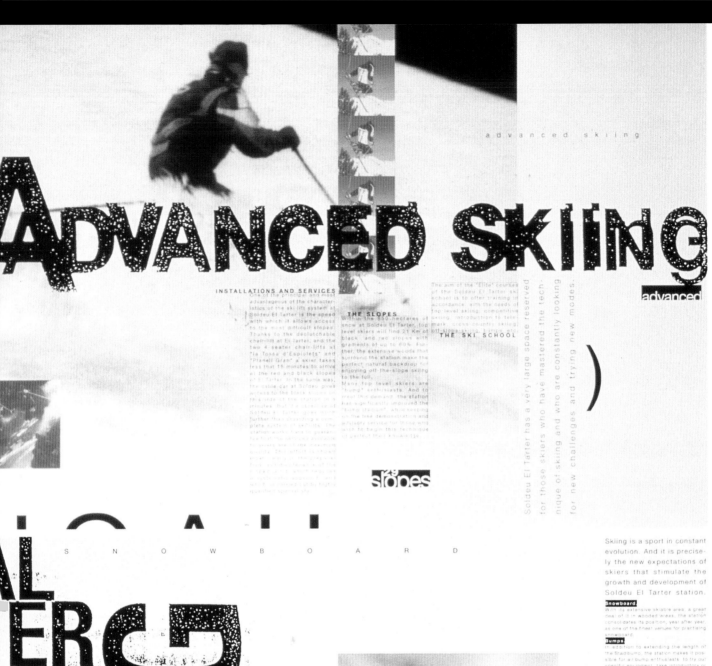

ADVANCED SKIING

advanced

INSTALLATIONS AND SERVICES

One of the principal and most advantageous of the characteristics of the ski lift system at Soldeu El Tarter is the speed with which it allows access to the most difficult slopes. Thanks to the declutchable chair-lift at El Tarter, and the two 4-seater chair-lifts at "la Tossa d'Espiolets" and "Planell Gran" a skier takes less that 15 minutes to arrive at the red and black slopes of El Tarter. In the same way, the cable car at Soldeu goes access to the black slopes on this side of the station in 5 minutes that the cable car at Soldeu's Tartet goes more further than travelling a complete system of ski lifts, the station works. There is greater comfort in the whole accessible to skiing are at the maximum possible. This effort is a must great care, not just taking easy but also each chair-lift that is also good which requires a considerable expense if and which is covered at the highest specified spectacular.

THE SLOPES

Within the 850 hectares of snow at Soldeu El Tarter, top level skiers will find 21 Km of black and red slopes with gradients of up to 60%. Further, the extensive woods that surround the station make the perfect natural backdrop for enjoying off-the-slope skiing to the full.

Many top level skiers are "bump" enthusiasts. And to meet the demand, the station has significantly improved the "bump station" and keeping on the free demonstration and advisory service for those who wish to begin this technique of perfect their knowledge.

The aim of the "Elite" courses of the Soldeu El Tarter ski school is to offer training in accordance with the needs of top level skiing, competitive skiing, introduction to telemark, cross-country skiing, off-slope skiing, bumps, etc.

THE SKI SCHOOL

Soldeu El Tarter has a very large space reserved for those skiers who have mastered the technique of advanced skiing and who are constantly looking for new challenges and trying new modes.

slopes

Skiing is a sport in constant evolution. And it is precisely the new expectations of skiers that stimulate the growth and development of Soldeu El Tarter station.

Snowboard.
With its extensive skiable area, a great deal of it in wooded areas, the station consolidates its position, year after year, as one of the finest venues for practising snowboard.

Bumps.
In addition to extending the length of the Stadiburno, the station makes it possible for all bump enthusiasts to try out specific equipment, take introductory or master classes, and to participate for competitions.

Cross-country skiing
Between el Pla de's Espiolets, in Soldeu, and Pla de la Riba Esconxada, in the El Tarter area, is found the station's cross-country ski area. The signposted route, 3 Km long, is now accessible directly and in comfort by the new cable car from Soldeu.

Telemark
Over the last few years, telemark, one of the oldest snow sport disciplines, has become fashionable once again. The large number of slopes surrounded by unspoilt countryside and the opportunity to learn the sport from specialised monitors makes Soldeu El Tarter the ideal place to practise this elegant sport.

Ski school.
The Soldeu El Tarter ski school offers all skiers a large team of fully qualified ski monitors who will assist with the introduction to or perfecting of any of these alternative ski techniques.

telemark

THE SLOPES

For all those skiers who have achieved an intermediate level of proficiency the station offers more than 34 Km of slopes distributed in 11 green slopes, 5 blue, and 7 red, a total of 23 slopes. In Soldeu El Tarter the skier will always find a slope suitable for his level. This great variety of slopes, one of the characteristics of the station most highly valued by our clients, allows the skier to progress constantly. The ski enthusiast can therefore leave the interesting green slopes of the Soldeu area for the excellent blue and red ones of El Tarter, for example the "Guineu" (2,100 metres), the "Llop" (2,000 metres) or the "Miquel Baró" (2,500 metres).

INSTALLATIONS AND SERVICES

THE SKI SCHOOL

The ski school of Soldeu El Tarter has developed a programme of courses especially designed for those skiers who have obtained a fair level of competence and who are interested in correcting and improving their technique. In this programme, the school organises group courses of 20 hours duration (4 hours daily during 5 days), but, at the same time, offers the student the chance to book private lessons, that is, a teacher exclusively dedicated to one person during the period that the student desires. This is undoubtedly an excellent way for the skier to work in depth on specific aspects of his style, and therefore, to progress more rapidly and effectively. Of course, classes are given in the language chosen by the student.

The fundamental conditions that allow a fairly proficient skier to continue progressing are two. On the one hand, to have access to a great variety of slopes suitable for his level, and on the other, to be able to count on a comprehensive and advanced system of ski lifts. The network of ski lifts of Soldeu El Tarter (1 cablecar, 7 chair-lifts and 14 button-lifts) can carry 21,000 people an hour, making access easy to all slopes. Additionally, the station also has 244 snow canons which cover a total of 14 Km of slopes and permanently guarantee the optimum conditions for skiing.

INTERMEDIATE SKIING

The process that starts with the introduction to skiing and continues to intermediate level proficiency is, very often, a rapid one, especially if the student has had a good instructor.

intermediate skiing 23 slopes

SOLDEU EL TARTER

winter 96 97 95

DESIGNERS
Marina Company, David Ruíz

ART DIRECTOR
David Ruíz

DESIGN COMPANY
David Ruíz + Marina Company

PHOTOGRAPHERS
Rafael Vargas, Frank Aleu

COUNTRY OF ORIGIN
Spain

WORK DESCRIPTION
Brochure for Soldeu el Tarter
ski resort

DIMENSIONS
390 x 280 mm
15⅜ x 11 in

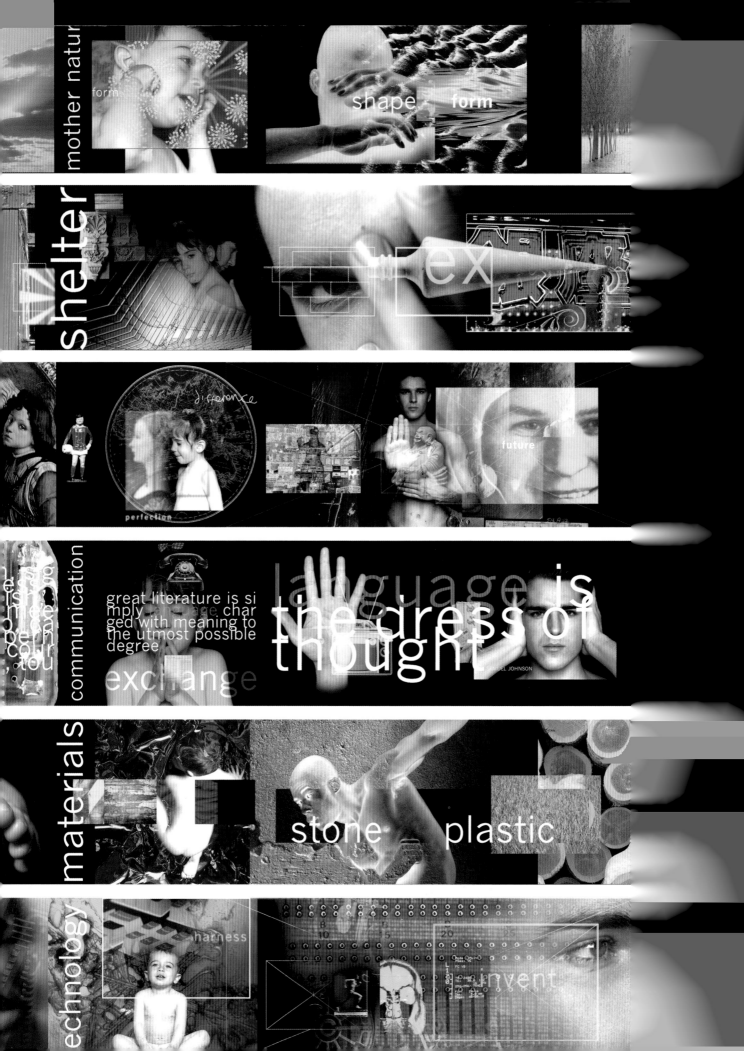

mother nature
form
shape form

shelter
ex

difference
perfection
future

communication
great literature is simply language charged with meaning to the utmost possible degree
exchange
language is the dress of thought
SAMUEL JOHNSON

materials
stone plastic

technology
harness
invent

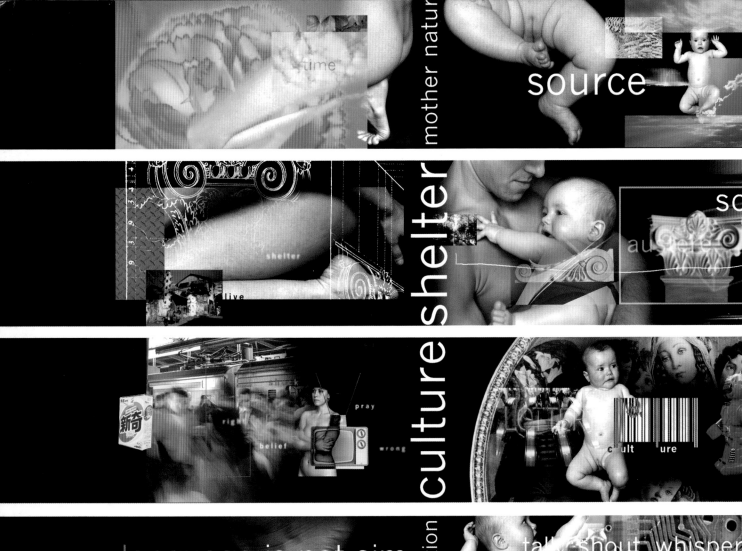

source

mother nature

shelter

culture

time

live

shelter

pray

belief

wrong

c ult ure

新奇

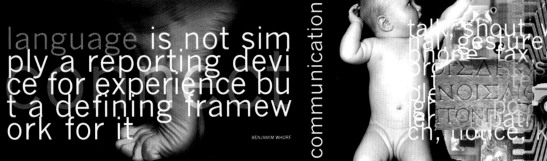

communication

language is not sim
ply a reporting devi
ce for experience bu
t a defining framew
ork for it

BENJAMIM WHORF

tally shout whisper
gesture bark
phone fax e-mail
send
ch notice know

connect

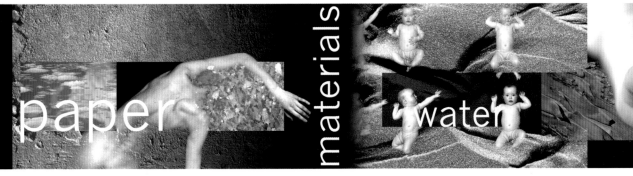

materials

paper

water

technology

(te nology)

nology)

evolve

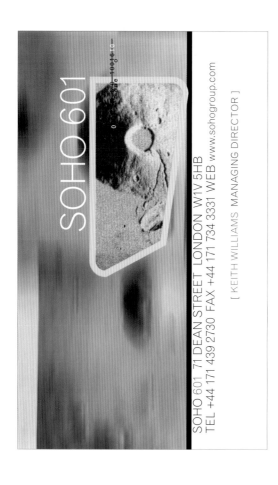

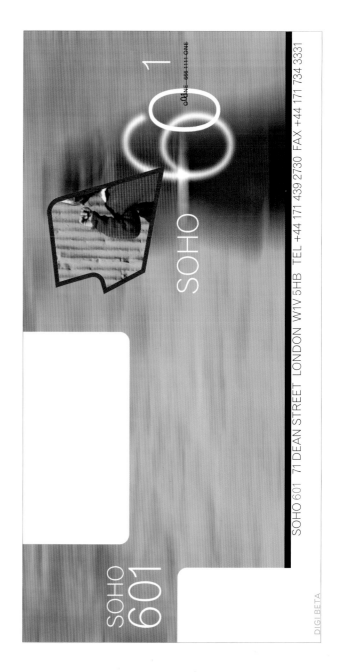

OPPOSITE

DESIGNERS
Andrew Altmann, David Ellis,
Patrick Morrissey

DESIGN COMPANY
Why Not Associates

PHOTOGRAPHER
Rocco Redondo

COUNTRY OF ORIGIN
UK

WORK DESCRIPTION
Front cover for *U&lc* magazine

DIMENSIONS
277 x 375 mm
10⅞ x 14¾ in

DESIGNERS
Andrew Altmann, David Ellis

DESIGN COMPANY
Why Not Associates

PHOTOGRAPHER
Photodisc

COUNTRY OF ORIGIN
UK

WORK DESCRIPTION
Business card (left) and video label
(right) for SOHO 601, television
post production company

DIMENSIONS
Various

PAGES 14–15

DESIGNERS
Andrew Altmann, David Ellis,
Patrick Morrissey

DESIGN COMPANY
Why Not Associates

PHOTOGRAPHERS
Rocco Redondo, Photodisc,
Hulton Deutsch

COUNTRY OF ORIGIN
UK

WORK DESCRIPTION
Audio-visual installation for
Kobe Fashion Museum
consisting of 1,500 slides
projected onto the museum's
floor, ceiling and walls

DIMENSIONS
Various

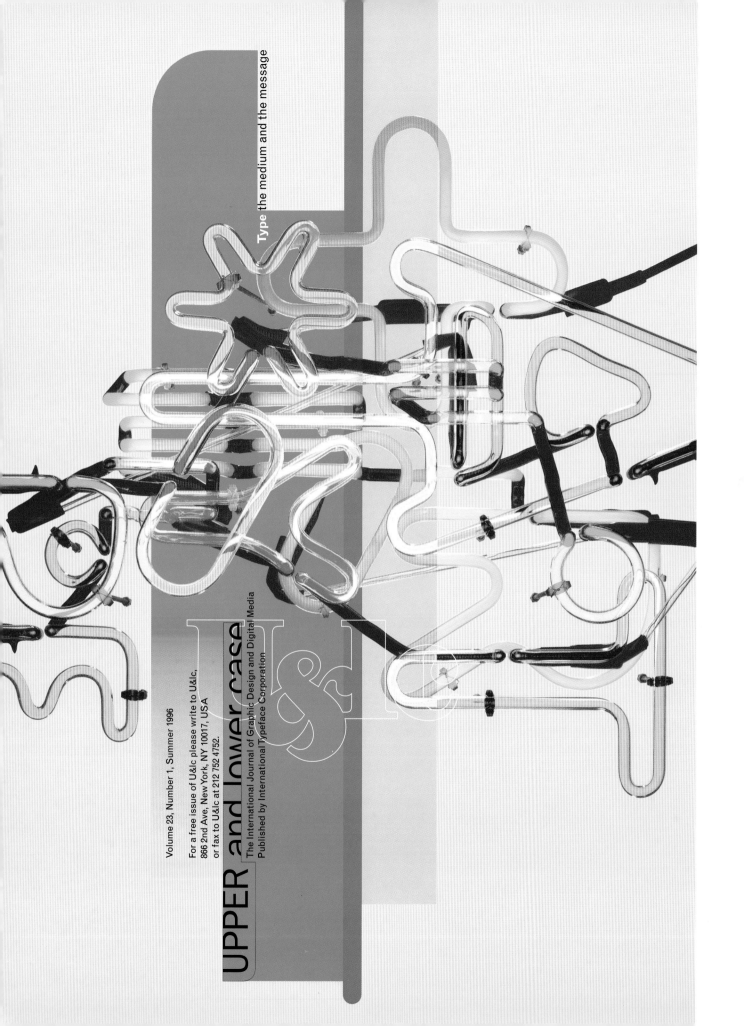

Type the medium and the message

UPPER and lower case

The International Journal of Graphic Design and Digital Media

Published by International Typeface Corporation

Volume 23, Number 1, Summer 1996

For a free issue of U&lc please write to U&lc,
866 2nd Ave, New York, NY 10017, USA
or fax to U&lc at 212 752 4752.

A new
dingbat font
from

WASSCO

Brooklyn N.Y., U.S.A.

Ordering? Call:

(888) T26-FONT

TM

— ANIMALS —

| } Offset: 103 Width: 1011 |
| () |

R Offset: 47 Width: 966	. Offset: 13 Width: 1011	© Offset: 64 Width: 890	B Offset: 50 Width: 1011	f Offset: 0 Width: 964	@ Offset: 50 Width: 929
(R)	(.)	(option-g)	(B)	(f)	(@)
, Offset: 70 Width: 803	K Offset: 46 Width: 979	" Offset: 24 Width: 862	Q Offset: 33 Width: 925	S Offset: 42 Width: 907	5 Offset: 66 Width: 954
(,)	(K)	(")	(Q)	(S)	(5)

W Offset: 53 Width: 1007	X Offset: 86 Width: 1011	Y Offset: 75 Width: 1006	h Offset: 71 Width: 1011	i Offset: 57 Width: 969	j Offset: 77 Width: 916	U Offset: 55 Width: 803	G Offset: 66 Width: 882	Z Offset: 21 Width: 801	l Offset: 51 Width: 1012
(W)	(X)	(Y)	(h)	(i)	(j)	(U)	(G)	(Z)	(l)
q Offset: 42 Width: 922	§ Offset: 88 Width: 976	s Offset: 102 Width: 1011	t Offset: 35 Width: 931	u Offset: 78 Width: 864	v Offset: 59 Width: 895	/ Offset: 36 Width: 929	a Offset: 49 Width: 858] Offset: 75 Width: 1004	{ Offset: 79 Width: 1112
(q)	(option-6)	(s)	(t)	(u)	(v)	(/)	(a)	(])	({)
£ Offset: 59 Width: 1011	r Offset: 117 Width: 1011	• Offset: 11 Width: 1037	¶ Offset: 75 Width: 1000	a Offset: 32 Width: 860	w Offset: 88 Width: 1011	V Offset: 0 Width: 713	; Offset: 70 Width: 907	[Offset: 48 Width: 1011	Ø Offset: 15 Width: 1055
(option-3)	(r)	(option-8)	(option-7)	(option-9)	(w)	(V)	(;)	([)	(shift-option-o)

⌐ PLANTS ⌐

INSTRUCTIONS FOR USE: These 108 Chippies™ may be accessed by purchasing a copy of the Chippies by Wassco™ font from T-26, 1110 North Milwaukee Avenue, Chicago, Illinois 60622, U.S.A. Orders may also be placed by telephone at (773) 862-1201, or by fax at (773) 862-1214. Orders received before 3:00 pm C.S.T. will be fulfilled the same day. Refer to this chart for keyboard placement of Chippies™. For external use only.

ALSO FROM WASSCO: Logotypes, character design, icons, book and compact disc jackets, posters, editorial and advertising illustration, as well as custom Chippies™ made to your exact specifications. For more information, or to obtain an estimate, contact your sales representative, Kirby "Chip" Wass, via telephone or fax at (718) 596-0864. Inquiries also accepted by electronic mail at chipwass@aol.com. Serious inquiries only, please.

= Offset: 87 Width: 1011	> Offset: 80 Width: 914	* Offset: 47 Width: 947	+ Offset: 53 Width: 1011	- Offset: 95 Width: 1001	? Offset: 79 Width: 857	2 Offset: 46 Width: 889	3 Offset: 61 Width: 889	4 Offset: 95 Width: 1000
(=)	(>)	(*)	(+)	(-)	(?)	(2)	(3)	(4)
° Offset: 75 Width: 997	å Offset: 98 Width: 879	# Offset: 27 Width: 1035	∞ Offset: 946	≠ Offset: 78 Width: 1011	i Offset: 42 Width: 935	9 Offset: 13 Width: 1066	\ Offset: 47 Width: 621	8 Offset: 55 Width: 754
(`)	(option-a)	(#)	(option-5)	(option-b)	(¡)	(9)	(\)	(8)

PERIODIC TABLE OF
CHIPPIE[S]
by WASSCO

— ODD CR[...]

1 — Offset: 62 Width: 850 — (1)

g — Offset: 42 Width: 907 — (g)
T — Offset: 49 Width: 1011 — (T)

d — Offset: 34 Width: 878 — (d)
D — Offset: 44 Width: 914 — (D)

: — Offset: 52 Width: 883 — (:)
c — Offset: 41 Width: 832 — (c)
k — Offset: 101 Width: 1001 — (k)
7 — Offset: 71 Width: 547 — (7)
E — Offset: 38 Width: 785 — (E)
F — Offset: 92 Width: 1011 — (F)
H — Offset: 33 Width: 968 — (H)

b — Offset: 30 Width: 1011 — (b)
I — Offset: 46 Width: 892 — (I)
6 — Offset: 19 Width: 1173 — (6)
l — Offset: 137 Width: 872 — (l)
m — Offset: 49 Width: 972 — (m)
n — Offset: 96 Width: 1000 — (n)
o — Offset: 58 Width: 906 — (o)

C — Offset: 33 Width: 712 — (C)
TM — Offset: 40 Width: 770 — (option-2)
p — Offset: 86 Width: 1011 — (p)
y — Offset: 60 Width: 864 — (y)
z — Offset: 84 Width: 922 — (z)
~ — Offset: 75 Width: 1000 — (~)

A — Offset: 79 Width: 1011 — (A)
e — Offset: 36 Width: 859 — (e)
L — Offset: 65 Width: 1290 — (L)
M — Offset: 74 Width: 519 — (M)
N — Offset: 43 Width: 623 — (N)
O — Offset: 35 Width: 812 — (O)

└ PEOPLE ┘
(& animals acting like people)

— POLYNESIAN INTERLUDE —

ABSTRACT I

! — Offset: 5 Width: 969 — (!)
ç — Offset: 60 Width: 935 — (option-c)
$ — Offset: 29 Width: 1011 — ($)
< — Offset: 75 Width: 1005 — (<)
& — Offset: 50 Width: 1011 — (&)

% — Offset: 48 Width: 928 — (%)
0 — Offset: 73 Width: 1014 — (0)
(— Offset: 35 Width: 1011 — (()
) — Offset: 49 Width: 796 — ())
^ — Offset: 65 Width: 1011 — (^)

ABSTRACT II
(& misc.)

DESIGNERS
Scott Stowell, Chip Wass
ART DIRECTOR
Scott Stowell
DESIGN COMPANY
Wassco/Open
ILLUSTRATOR
Chip Wass
COUNTRY OF ORIGIN
USA
WORK DESCRIPTION
Promotional poster for 'Chippies by Wassco' dingbat font
DIMENSIONS
610 x 457 mm
24 x 18 in

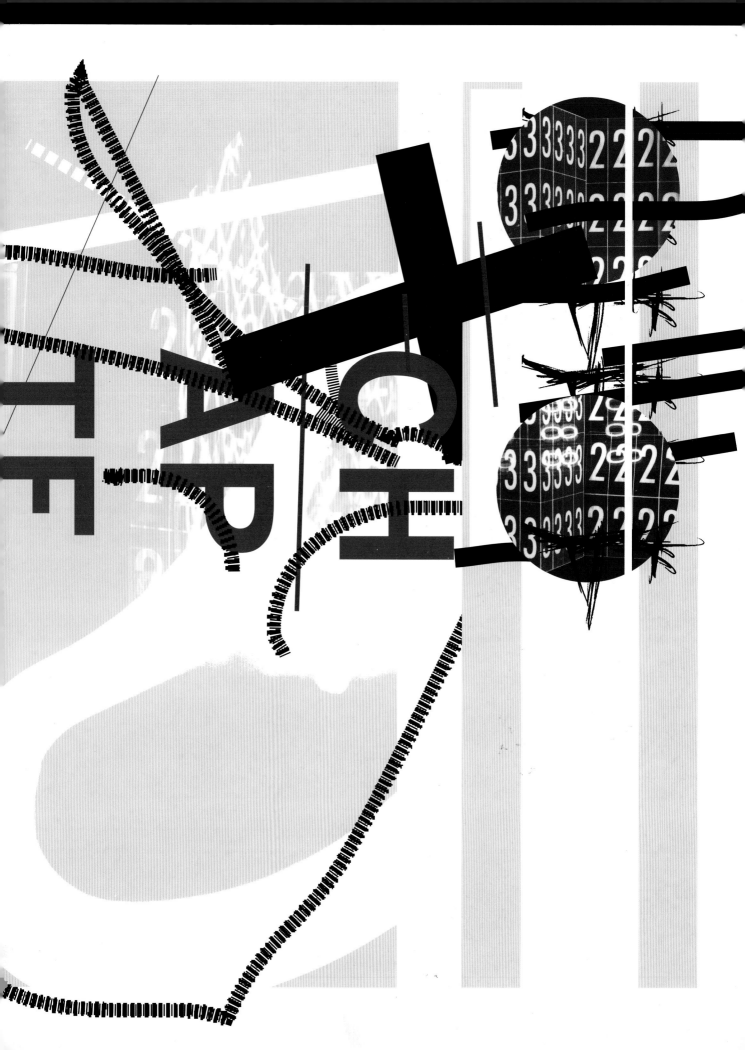

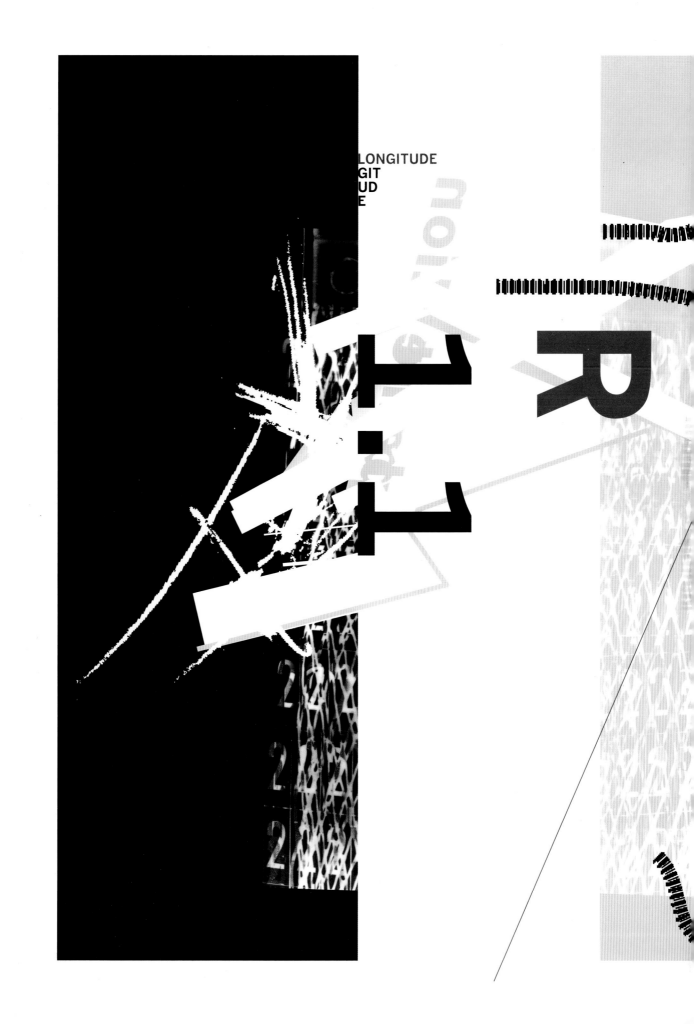

LONGITUDE
GIT
UD
E

TYPOGRAPHICS 3 – GLOBAL VISION. THIS COLLECTION WILL ILLUMINATE, INFURIATE, ENTERTAIN, CAUSE DISAGREEMENT, INSPIRE, BE INTERPRETED, DEBATED, MISINTERPRETED, REFERRED TO, IGNORED, RESPECTED, DISREGARDED, CONSIDERED UNREADABLE, RELEVANT, INNOVATIVE, DESIRABLE, OF NO PRACTICAL APPLICATION WHATSOEVER, INVALUABLE. DENSE, SMART, PARTIAL, VERY USEFUL, TRANSPARENT, BRILLIANT, PRETENTIOUS, IRRELEVANT. TYPOGRAPHICS 3 – GLOBAL VISION MAY BE THE LAST CHANCE FOR YOU TO SEE MUCH OF THIS WORK, AND THE ONLY CHANCE TO SEE SOME OF IT. THINK OF IT AS A PERMANENT AND PORTABLE EXHIBITION OF SOME OF THE MOST PROVOCATIVE INTERNATIONAL DESIGN WORK CURRENTLY BEING PRODUCED – TO VIEW WHEREVER, WHENEVER, HOWEVER, AS OFTEN AS YOU WISH. RW.

YOU RE RE wo

TYPOGRAPHICS 3 IS PUBLISHED HERE FOR THE FIRST
TIME WITH TYPOGRAPHICS 4

EACH TITLE FIRST PUBLISHED SEPARATELY BY
HEARST BOOKS INTERNATIONAL. NOW PUBLISHED BY
HARPER DESIGN INTERNATIONAL, AN IMPRINT OF
HARPERCOLLINS PUBLISHERS
10 EAST 53RD STREET
NEW YORK, NY 10022
UNITED STATES OF AMERICA

ISBN 0-06-053120-7

DISTRIBUTED THROUGHOUT THE WORLD BY
HARPERCOLLINS INTERNATIONAL
10 EAST 53RD STREET
NEW YORK, NY 10022
FAX: (212) 207-7654

EACH TITLE FIRST PUBLISHED SEPARATELY IN
GERMANY BY NIPPAN
NIPPON SHUPPAN HANBAI DEUTSCHLAND GMBH
KREFELDER STR. 85
D-40549 DÜSSELDORF
TEL: (0211) 504 80 80/89
FAX: (0211) 504 93 26
E-MAIL: NIPPAN@T-ONLINE.DE

EDITED AND DESIGNED BY
DUNCAN BAIRD PUBLISHERS
CASTLE HOUSE
75-76 WELLS STREET
LONDON W1P 3RE

MANAGING DESIGNER: GABRIELLA LE GRAZIE
DESIGNER: STEFAN KRAUS
EDITOR: CLARE RICHARDS
PROJECT CO-ORDINATOR: TARA SOLESBURY

COVER, PRELIMS, ENDPAPERS, AND CHAPTER
OPENERS
DESIGNED BY IAIN CADBY
PHOTOGRAPHY BY CAROLIN KURZ

03 04 05 06 07 / 10 9 8 7 6 5 4 3 2 1
TYPESET IN OFFICINASANS BOOK
COLOUR REPRODUCTION BY COLOURSCAN,
SINGAPORE
PRINTED IN CHINA

NOTE
DIMENSIONS FOR SPREAD FORMATS ARE SINGLE PAGE
MEASUREMENTS; ALL MEASUREMENTS ARE FOR
WIDTH FOLLOWED BY HEIGHT

TYPOGRAPHICS**THREEGLOBALVISION**
OGR
APH
ICS**T**
HRE
EGL
OBA
LVIS
ION

HARPER
DESIGN
international

An Imprint of HarperCollins*Publishers*

3

GENERAL
EDITOR
ROGER
WALTON

3

TYPOGRAPHICS**THREEGLOBALVISION**
OGR
APH
ICS**T**
HRE
EGL
OBA
LVIS
ION